Animation Writing and Development

FOCAL PRESS VISUAL EFFECTS AND ANIMATION

Debra Kaufman, Series Editor

**Animation Writing and Development
From Script Development to Pitch**
Jean Ann Wright

**3D for the Web
Interactive 3D Animation Using 3ds max,
Flash and Director**
Carol MacGillivray
Anthony Head

Character Animation in 3D
Steve Roberts

Stop Motion: Craft Skills for Model Animation
Susannah Shaw

**Producing Independent 2D Animation:
Making & Selling a Short Film**
Mark Simon

Essential CG Lighting Techniques
Darren Brooker

**A Guide to Computer Animation: for TV,
Games, Multimedia & Web**
Marcia Kuperberg

**Animation in the Home Digital Studio:
Creation to Distribution**
Steven Subotnick

Digital Compositing for Film and Video
Steve Wright

Producing Animation
Catherine Winder and Zahra Dowlatabadi

The Animator's Guide to 2D Computer Animation
Hedley Griffin

Focal Press

Visit www.focalpress.com to purchase any of our titles.

Animation Writing and Development

FROM SCRIPT DEVELOPMENT TO PITCH

Jean Ann Wright

AMSTERDAM • BOSTON • HEIDELBERG • LONDON
NEW YORK • OXFORD • PARIS • SAN DIEGO
SAN FRANCISCO • SINGAPORE • SYDNEY • TOKYO
Focal Press is an imprint of Elsevier

Acquisition Editor: Amy Jollymore
Project Manager: Carl M. Soares
Assistant Editor: Cara Anderson
Marketing Manager: Christine Degon
Design Manager: Cate Barr

Focal Press is an imprint of Elsevier
30 Corporate Drive, Suite 400, Burlington, MA 01803, USA
Linacre House, Jordan Hill, Oxford OX2 8DP, UK

∞ Recognizing the importance of preserving what has been written,
Elsevier prints its books on acid-free paper whenever possible.

Library of Congress Cataloging-in-Publication Data
Wright, Jean (Jean Ann)
 Animation writing and development / Jean Wright.
 p. cm.
 Includes index.
 ISBN 0-240-80549-6
 1. Animated films—Authorship. 2. Animated television
 programs—Authorship. I. Title.
 PN1996W646 2005
 808.2′3—dc22
 2004022863

British Library Cataloguing-in-Publication Data
A catalogue record for this book is available from the British Library.

ISBN: 0-240-80549-6

For information on all Focal Press publications
visit our website at www.books.elsevier.com

05 06 07 08 09 10 9 8 7 6 5 4 3 2 1

Printed in the United States of America

Contents

v

Acknowledgments

Many, many people have helped me to learn the animation writing and development techniques presented in this book. Others have reviewed sections and offered suggestions.

I first learned animation writing and development at Hanna-Barbera Productions, where, through a company training program, I was hired to work as an artist. My training was supervised by Harry Love, and the writing program was led originally by Ray Parker, later by Bryce Malek, and then Mark Young. Most of the Hanna-Barbera writing and development staff volunteered an evening to teach. Joe Barbera always took time out of his busy schedule to speak. Professionals like Alex Lovy, Marty Murphy, Art Scott, Bob Singer, Iwao Takamoto, and Tom Yakutis taught me storyboard techniques.

Since then I've attended seminars and classes from a host of Hollywood gurus and read many books. I'd especially like to thank Linda Seger. Currently, I attend Storyboard, a workshop on live-action feature scripts led by Hollywood screenwriting teachers. Before I worked at Hanna-Barbera I attended many children's book writing workshops. This book is the result of all of these influences.

For encouragement, and for the times that I wasn't there when I should have been, a big thank you to my husband Warren and to my daughters, grandchildren, and parents—especially to my journalist mother, who insisted early that I learn to write. For her great support and her infinite patience I thank my editor at Focal Press, Amy Jollymore. For their encouragement to teach, to consult, and to write this book, thanks to Zahra Dowlatabadi, B. Paul Husband, Heather Kenyon, Jan Nagel, Donie A. Nelson, Hope Parker, Linda Simensky, Rita Street, Pamela Thompson, Charles Zembillas, and The Ingenues. For taking the time to speak to my classes, thank you to Brian Casentini, Kim Christiansen, Joshua Fisher, Cori Stern, Jack Enyart, and especially Jeffrey Scott. For suggesting the series of articles on animation writing that served as a foundation for a few of these chapters, thank you to Heather Kenyon, Dan Sarto, Ron Diamond, and Darlene Chan at AWN online. For their time, suggestions, and input to this book, I'd like to thank Sylvie Abrams, Lisa Atkinson, Sarah Baisley, Jerry Beck, Russ Binder, Miguel Alejandro Bohórque, Alan Burnett, Karl Cohen, Kellie-Bea Cooper, Gene Deitch, Harvey Deneroff, Joshua Fisher, Euan Frizzell, Bill Janczewski, Bruce Johnson, Christopher Keenan, Kelly Lynagh, Brian Miller, Craig Miller, Linda Miller, Kevin Munroe, Eric Oldrin, Will Paicius, Jennifer Park, Suzanne Richards, Frank Saperstein, Fred Schaefer, Sander Schwartz, Tom Sito, Mark Soderwall, and Colin

South. For the Jackie Chan material, Cartoon Network material, storyboards, and the *How To Care For Your Monster* bible, thanks to Bryan Andrews, Claude and Thierry Berthier, Duane Capizzi, Shareena Carlson, David S. Cohen, Kelly Crews, Todd Garfield, Laurie Goldberg, Eric Jacquot, Michael Jelenic, Greg Johnson, Seung Eun Kim, Lorraine Lavender, Bob Miller, Courtenay Palaski, Victoria Panzarella, Maureen Sery, David Slack, Megan Tantillo, Genndy Tartakovsky, Tom Tataranowicz, Terry Thoren, and Edward Zimmerman. Thanks to Animation World Network, Cartoon Network, Klasky Csupo, Paramount Pictures, Sony Pictures Television, Toon Factory, and Viacom International, Inc. And a big thank you to Andrew Voss, Bret Drinkwater, and Primary Color for help in getting artwork ready for reproduction. Thank you to my talented illustrators, all professionals in the animation industry: Alvaro Arce (Chile) for the beautiful Poncho layout and the informational drawings in the storyboard chapter, Llyn Hunter and Jill Colbert (United States) for their very useful Camera Shots-Cheat Sheet, also found in the chapter on storyboards. Llyn and Jill have generously given permission to all readers to photocopy the Camera Shots-Cheat Sheet and use it as you work.
Credits:

Introduction and User's Manual

This material originally was developed to teach animation writing and development to members of Women In Animation in Los Angeles, California. The members of that organization are professional men and women who work in many aspects of the animation industry and students who look forward to working in the industry in the future. Since I started teaching, the material has been expanded, and I've lectured at a number of schools.

The chapters are organized so writers, artists, or students who wish to develop their own animation material can start by learning some animation basics and then dig right in and develop their own animation characters. Memorable characters are key in animation storytelling, but it is not necessary to read the chapters in the order in which they appear.

When I teach, I like to assign a project that can be completed and later pitched as a television series, film, or game. First I ask my students to develop three to eight original characters. If they're artists, they may want to design the characters as well. Then they develop the basic idea for their own television series, short film, feature, or game. For a series they'll create a bible; for a film they'll create a presentation to pitch their project. Next they'll write a premise or treatment, followed by an outline, and then a short script. Game developers write a concept proposal and walkthrough instead. They have time to work on this during each class, but most of this is homework. I provide feedback each step of the way.

For those teachers who prefer to work in a different way, there are exercises at the end of most chapters. Some of these can be done in the classroom, but others are better homework assignments. Feel free to pick and choose the exercises that might best fit your class. This is a menu of suggestions; you won't want to use all of them.

I've tried to make the book useful for everyone who wants to learn animation writing or development, whether they are in a classroom setting or on their own. And since animation production today is such an international industry, I've tried to make this book useful to animation professionals and future professionals all over the world. Much of this book teaches the accepted methods that are used to tell animation stories and all stories in Hollywood. When you see Hollywood films, television, and games enjoyed all over the world, it's a good indication that these methods work. All rules, however, are meant to be broken. If you can develop a story in a way that is fresh, unique, funny, or moving, but does not

follow the rules, by all means, try it your way! The most important ingredient in good storytelling is a writer who really cares about the story, the characters, and the audience, and succeeds in telling that story in the most effective way.

It's important that animation professionals learn *story*. Most animation schools teach artists who would prefer to draw rather than write. But the lack of a solid writing background is obvious throughout the industry. Whether professionals develop their stories as story development drawings, storyboards, or scripts, professional storytelling skills are all-important!

Introduction to Animation

What Is Animation?

The word *animate* comes from the Latin verb *animare*, meaning "to make alive or to fill with breath." We can take our most childlike dreams or the wackiest worlds we can imagine and bring them to life. In animation we can completely restructure reality. We take drawings, clay, puppets, or forms on a computer screen, and we make them seem so real that we want to believe they're alive. Pure fantasy seems at home in animation, but for animation to work, the fantasy world must be so true to itself with its own unbroken rules that we are willing to believe it.

Even more than most film, animation is visual. While you're writing, try to keep a movie running inside your head. Visualize what you're writing. Keep those characters squashing and stretching, running in the air, morphing into monsters at the drop of an anvil! Make the very basis of your idea visual. Tacking visuals onto an idea that isn't visual won't work. Use visual humor—sight **gags**. Watch the old silent comedies, especially those with Charlie Chaplin and Laurel and Hardy. Watch The Three Stooges. Many cartoon writers are also artists, and they begin their thinking by drawing or doodling. The best animation is action, not talking heads. Even though Hanna-Barbera was known for its **limited animation**, Joe Barbera used to tell his artists that if he saw six frames of **storyboard** and the characters were still talking, the staff was in trouble. Start the story with action. Animation must be visual!

Time and space are important elements of animation. The laws of physics don't apply. A character is squashed flat, and two seconds later he's as good as new again. He can morph into someone else and do things that a real person couldn't possibly do. Motion jokes are great! Wile E. Coyote hangs in midair. In animation the audience accepts data quickly. Viewers can register information in just a few **frames**. **Timing** is very important in animation, just as it is in comedy. The pace of gags is quick. Normally, there are more pages in an animation script than there are in a comparable, live-action script, partially because everything moves so fast.

Animation uses extremes—everything is exaggerated. Comedy is taken to its limits. Jokes that seem impossible in live-action are best, although with today's special effects, there is little that can be done in animation that cannot be done in live-action film as well.

The Production Process

The production process is slightly different at different studios around the world. Even at a specific animation studio, each producer and director has his or her own preferences. Children's cartoons are produced differently from prime-time animation because of the huge variation in budget. Television shows are not produced the same way as feature films. Direct-to-videos are something of a hybrid of the two. Independent films are made differently from films made at a large corporation. Shorts for the Internet may be completed by one person on a home computer, and games are something else altogether; 2D animation is produced differently from 3D; each country has its own twist on the process. However, because of the demands of the medium, there *are* similarities, and we can generalize. It's important for writers to understand how animation is produced so they can write animation that is practical and actually works. Therefore, the production process follows in a general way.

The Script

Usually animation begins with a script. If there is no script, then there is at least some kind of idea in written form—an **outline** or **treatment**. In television a one-page written **premise** is usually submitted for each episode. When a premise is approved, it's expanded into an outline, and the outline is then expanded into a full script. Some feature films and some of the shorter television cartoons may have no detailed script. Instead, creation takes place primarily during the storyboard process. Writers in the United States receive pay for their outlines and scripts, but premises are submitted on spec in hopes of getting an assignment. Each television series has a **story editor** who is in charge of this process. The story editor and the writers he hires may be freelancers rather than staff members. The show's producers or directors in turn hire the story editor.

Producers and directors have approval rights on the finished script. *Producer* and *director* are terms with no precise and standard meaning in the United States, and they can be interchangeable or slightly different from studio to studio. Independent producers may deal more with financing and budgets, but producers at the major animation studios may be more directly involved with production. Higher executives at the production company often have script approval rights. Programming executives also have approval rights, as do network censors and any licensing or toy manufacturers that may be involved in the show. If this is a feature, financiers may have approval rights as well.

Recording

About the time the script is finalized, the project is cast. The actors may be given a separate actor's script for recording. Sometimes they get character designs or a storyboard if they are ready in time. A voice director will probably direct. If this is a prime-time television project, then the director may hold a **table read** first, but usually there is no advanced rehearsal. At some studios the writer is welcome to attend the recording session. That is far from standard practice, however, and writers who do attend probably will have little or no input on the recording. Some studios still prefer to record all the actors at once for a television project,

as if they were doing a radio play. However, each actor may be recorded separately. This is especially likely if the project is an animated feature. Individual recording sessions make it easier to schedule the actors, work with each actor, move the process along, and fine-tune the timing when it's edited. Recording the actors together allows for interaction that is impossible to get any other way. Executives with approval rights have to approve casting and the final voice recording.

The directors usually work with a composer, who may be brought in early for a feature. Hiring might not be done until later in the process if this is a television show, although some directors bring in a composer early for TV as well.

The Storyboard

Storyboard artists take the script and create the first visualization of the story. Often these boards are still a little rough. In television and direct-to-video projects each major action and major pose is drawn within a frame representing the television screen. The dialogue and action are listed underneath each frame. Usually, an **animatic** or video of these frames is scanned or filmed from the board when it's complete. This animatic, which includes any recorded sound, helps the director see the episode in the rough and helps in timing the cartoon. Executives must approve the final storyboard or animatic.

The storyboard process may take about a year for a feature. The script or treatment will undergo many changes as the visual development progresses. Artists sometimes work in groups on sequences, or a team of a writer and an artist may work together. The development team pitches sequences in meetings and receives feedback for changes. The director and other executives have final approval. Feature storyboard drawings are cleaned up and made into a flipbook. Finally the drawings are scanned or shot, the recorded and available sound is added, and the material is made into a story reel. Any necessary changes discovered during the making of the animatic or story reel are made on the storyboard. The building of the story reel is an ongoing process throughout production. Later **breakdowns**, then penciled animation, and finally completed animation will be substituted. This workbook of approved elements is usually scanned and available on staff computers and serves as an ongoing blueprint. For CGI features a 3D workbook shows characters in motion in space as well.

Slugging

The timing director sets the storyboard's final timing, and the board is slugged. This does not mean that somebody gets violent and belts it with a left hook! Slugging is a stage when the overall production is timed out, and scenes are allotted a specific amount of time, measured in feet and frames. In television this information is added to the storyboard before it's photocopied and handed out. An editor conforms the audiotape.

Character and Prop Design

After the script has been approved, a copy goes to the production designer or art director. If the project is a television series, then the major and ongoing characters have already been

designed and fine-tuned during development. The approved drawings, as seen from various angles, are compiled into the model sheets (see Figure 1.1). If the ongoing characters have a costume change in this TV episode or feature sequence, or new characters are needed, that must be considered. Each TV episode or feature sequence also requires props that have not been used before. Sometimes the same designers create new characters, costumes, and props; sometimes designers specialize and design either characters *or* props. New drawings are compiled into model sheets for each specific television episode. The drawings may be designed on paper or modeled in a computer. Approvals are required.

Background Design

The production designer or a background designer is responsible for all location designs. In television or direct-to-video layout, artists will design these line drawings (layouts) from the

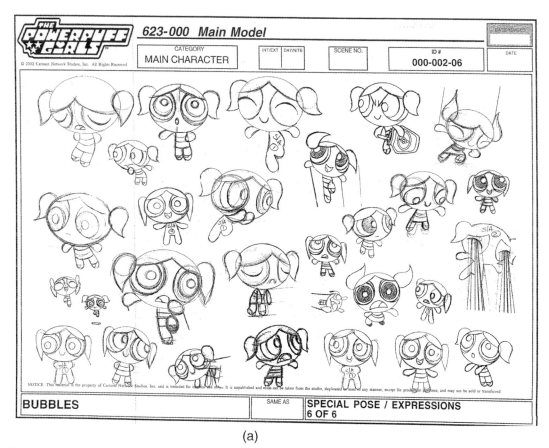

(a)

Figure 1.1 Bubbles (a) and Buttercup (b) from *The Powerpuff Girls* show off their acting skills on these model sheets.
The Powerpuff Girls and all related characters and elements are trademarks of Cartoon Network © 2004. A Time Warner Company. All rights reserved.

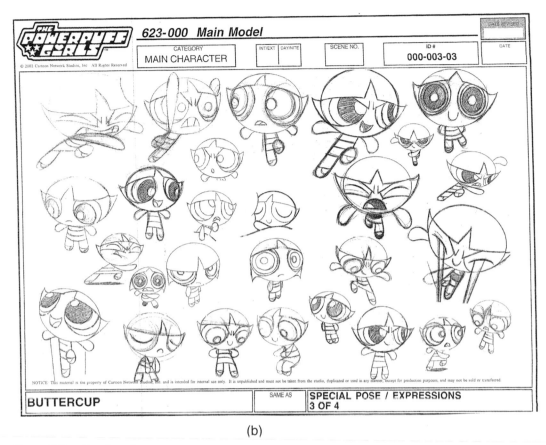

Figure 1.1 *Continued*

roughs done by the storyboard artist (see Figure 1.2). Then a background painter will paint a few key backgrounds (especially those for **establishing shots**) and ship them overseas to be matched by other painters painting additional backgrounds. Very little animation production is done in the United States due to the high costs. In feature production the visual development artists may be working on both story and design at once, making many concept drawings before the final designs are chosen and refined for actual production. Background artists usually paint in the traditional way, but some or all elements can be painted digitally. Digital backgrounds can be changed more easily. Major designs require approval.

Color

Color stylists, who are supervised by the art director, set the color palette for a show. It's important that they choose colors that not only look good together but that will make the characters stand out from the background. Different palettes may be needed for different lighting conditions, such as a wet look, shadowing, bright sunlight, and so on. If the project is CGI, texturing or surface color design is needed. Once again approvals are required.

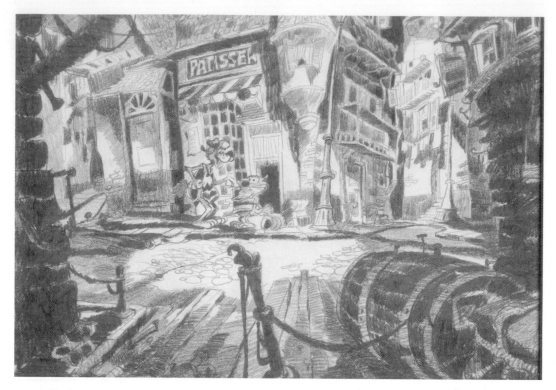

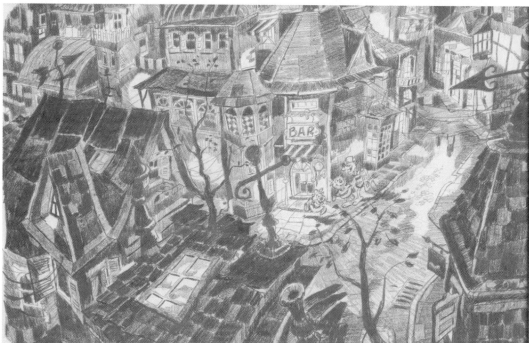

Figure 1.2 These drawings from *Poncho Puma and His Gang* are essentially background drawings with characters included for presentation and publicity purposes. Notice the use of perspective. *Poncho Puma and His Gang* © 1998 Alvaro A. Arce.

Layout

Layouts are detailed renderings of all the storyboard drawings and breakdowns of some of the action between those drawings. These include drawings for each background **underlay**, **overlay**, the start and stop drawings for action for each character, and visual effects. Layout artists further refine each shot, setting camera angles and movements, composition, staging, and lighting. Drawings are made to the proper size and drawn on model (drawn properly). Key layout drawings may be done before a production is shipped overseas, with the remainder done by overseas artists. Or layout may be skipped, basically, by doing detailed drawings at the storyboard stage. Later these can be blown up to the correct size, and elements separated and used as layouts.

Exposure Sheets

The director or sheet timer fills out exposure sheets (X-sheets), using the information found on the audio track. These sheets will be a template or blueprint for the production, frame by frame and layer by layer. The recorded dialogue information is written out frame by frame for the animator, and the basic action from the storyboard is written in as well. If music is important, the beats on the **click track** are listed.

Animation

The animator receives the dialogue track of his section of the story, a storyboard or workbook that has been timed out, the model sheets, copies of the layouts, and X-sheets. There are boxes on the X-sheets for the animator to fill in with the details, layer by layer, as the animation is being planned. Animation paper, as well as the paper used by the layout artists and background artists, has a series of holes for pegs so that it can be lined up correctly for a camera. For an animated feature, animation **pencil tests** may be made prior to principal animation to test the gags and the animation. In television and direct-to-video projects, key animators may animate the more important action before it is sent overseas for the major animation to be completed. Animators might be cast to animate certain characters, or they may be assigned certain sequences.

Clean-up artists or assistant animators clean up the rough animation poses drawn by the animator and sketch the key action in between. A breakdown artist or inbetweener may be responsible for the easier poses between those. Visual effects animators animate elements like fire, water, and props. For a feature production where drawings are animated on ones (rather than holding the poses for more than a single frame for a cheaper production), a single minute of film may take over 1,400 drawings. So you see how labor-intensive animation is!

Scene Planning

Scene planners break down each scene with all of its elements and check that the scenes are ready for scanning or shipping. A scene planner will set up all of the elements in the

computer or on a pegged animation disk and make sure that they will work correctly. These professionals have excellent technical knowledge. They check all math and verify that each scene and all the camera moves have been set up in the best way. They will also check that color effects are set up properly for the painters.

Shipping

A production coordinator assembles all the pre-production elements. The coordinator verifies that everything is accounted for, that all information is clear, and that everything is correct before shipping abroad.

Traditional Production

Once all the pre-production elements arrive overseas, the subcontractor finishes the work. Animators, their assistants, and inbetweeners finish the animation. Background painters complete the remainder of the backgrounds. All the paper or computer elements (X-sheets, animation, painted backgrounds) are checked by animation checkers to be sure they are complete and will work properly. Lines must be closed off for digital painting. The drawings are photocopied onto **cels** or scanned into the computer if they haven't been scanned already. Traditional painters receive **color models**, painted onto cels, and stacks of the photocopied cels. They paint each cel with water-based paints on the side that has no raised and photocopied lines. Digital painters recheck for lines that are not closed off and touch their computer screens to fill sections of each drawing with color from their palette. Final checkers check the work again.

If the artwork is digital, the final checker composites the work and makes sure it's ready for final output. For productions that are more traditional, the work is then shot frame by frame with an animation camera. Backgrounds are placed on a flat bed with pegs to hold them in place. Any underlays are placed on the bottom. The levels of cels are placed on top of the underlay one by one. Overlays are placed on top of that. Then the whole package is shot, replaced with the elements of another frame, and shot again until completion.

CGI Production

CGI productions are a merging of 2D animation and live action. Designs are usually created in 2D first, approved, and sent for **modeling** in 3D. Characters can be modeled on a computer—often from basic geometric shapes—and the parts fused, or sculptures can be **digitized** as a **wire-frame** model. **Rigging** adds a skeleton to the model. Animators then test movement possibilities. Modeling, rigging, and animation continue until all problems have been resolved. Texture and color are added with emphasis on correct lighting. Software programs also allow actors to be rigged with motion capture sensors, which convert the actor's movement to animation for a predesigned character.

Locations, sets, or environments are modeled as well. These will also be rough at first, or live-action backgrounds may be added.

A 3D workbook is created in low-resolution, with locations slowly refined. Characters are added to the locations and animation improved. Cinematography elements (camera position, angles, movements, lighting) are added and polished. Principal animation is done after the 3D workbook elements are approved. Refinements are made throughout the process. Once everything has been approved, the final animation focuses on subtleties. Lighting becomes the major focus after animation has been completed in each scene. Working with the technical directors, the effects animators then add visual effects. Along the line some **rendering** and **compositing** have been done to see how things are coming along. The full rendering and compositing of all the elements of a scene are not done until the end because fully developed scenes can take a long time to process. Rendered scenes are touched up, checked, and then rendered again for the final completed project.

Post-Production and Editing

The overseas studio returns the completed project. The director may require **retakes** from overseas or have a few minor changes made locally. Today overseas work can be monitored more closely over the Internet while it's being done so fewer changes will be required once the work is returned. After approval, the editors mix the voice track with **ADR**, sound effects (**Foley effects** or effects from a sound effects library), and music tracks (which may be original or also from a library). The tracks are then blended. The videotape is combined with the sound, the opening titles, and the credits. Transitions are added, and this editing is completed in an offline or online assembly. Sometimes a film is generated, and it must be color corrected. The directors, producers, and programming or financing executives view the completed work. Notes are given, changes are made, and retakes are done. Final approvals are given, and a release print is made. The completed project is now ready for delivery.

Stop-Motion Animation

Some animators prefer to work with puppets, using clay, a plastic material, or foam. These projects are more like live-action films. Characters must be made, sets built, and lighting rigged. Some people work with paper cutouts, sand, or **pinscreens**. For stop-motion animation, a digital video or film camera is placed on a tripod so the action can be filmed frame by frame, moving characters, objects, and camera after almost every frame. Computerized motion control equipment is available to make this process easier and more precise.

Game Production

Game production is quite different from TV or film production, and different kinds of games are obviously produced differently. The process is too complicated for the scope of this book, but remember that few games have budgets as large as feature films. Technical knowledge is essential for working in that industry.

Student Production

If you are making a student film or video, you'll abbreviate the traditional production process in a way that makes the best use of your expertise, crew, time, budget, and the equipment available to you. Ask your teacher for guidelines. There are many computer software programs that can help you make a film or video without a huge staff. Flash computer software makes it comparatively easy for you to make a film on a limited budget entirely by yourself. Attempt only what you can effectively produce. The longer the film, the better it should be to hold audience interest.

Other Production Considerations

The size of the budget is a consideration in all animation writing. Feature films made by large companies like Sony or DreamWorks have deep pockets, but their pockets aren't bottomless, especially in bad times. Smaller film companies work with tighter budgets. Some games have big budgets but not as big as those of a major film. Many game companies make low-budget games. The television industry can do a great deal on a very small budget.

In production, technology is a factor—what can be done and what can't. The larger companies have invested more in developing and buying high-end software. So it may be possible to produce animation with skin, fur, and water that looks real. It's conceivable to replicate actual people, but the cost is great, and there are legal issues. It is possible to make multiples of people, trees, or buildings for crowd scenes, forests, or cities. Again, the cost will probably be prohibitive for lower budgets. Software now makes it possible to animate those crowds without the digital actors running into or through each other as they did in earlier days. There have been great strides in computer character animation. Today, nuances in acting can be achieved that were impossible just a few years back, but, again, this comes with a high price tag.

Changes

Anyone who has ever worked at an animation company where at least some production is done on the premises has horror stories about changes to the script or characters after production has already started. If you knew the effect of casual changes on morale, meeting deadlines, and the budget, you would never, *ever* consider them after production has begun. Remember that even one scene may involve hundreds and hundreds of drawings or images. Because animation is so labor-intensive, even in CGI, scenes in a single episode of a television series might be spread out over many departments and sometimes even over different companies. In a big-budget feature scenes may be spread out over several companies and several continents. Overseas contract companies might suddenly find that they have more work than they can handle at any given time and farm out some of their work to a subcontractor.

Typically, scenes do not go through the pipeline in order. Instead, they go through as *fast* as possible. So if scene 108 is animated before scene 2 (because it is shorter, easier, or being animated by a faster artist), it moves on ahead to the assistant to clean up, and if that

assistant works quickly, then the scene proceeds ahead to the checking department, and so on in the process. At any given time, scene 108 may be moving faster than scene 2, but scene 2 might catch up later and even pass it. CGI scenes are constantly being improved, but each minor improvement takes time. Of course, scenes are tracked.

Changes can increase costs tremendously. There was a time in television animation where changes were simply not made once production started because of budget concerns. If a change is made in scene 2, it's likely that changes must be made in other scenes to match the original change. Artists are interrupted. Some scenes are changed and others are forgotten. Suddenly the orderly production process is like a gourmet dish of Eggs Benedict morphing into scrambled eggs with broken shells and a chicken feather poking out the top.

Be sure that the script, storyboard, and designs are in excellent shape before you begin production, even if that means falling behind a week or two (or even a month or two). Allow yourself plenty of time for **development** before the clock starts ticking.

Preparing for Tomorrow

The world is changing ever more rapidly. Who knows what direction the world will take tomorrow? Animation is now created for all age groups and for many media. The more that you can learn, the better you'll be able to write and develop for this industry. And you'll need to continue learning all your life just to keep up. Read about trends, fads, and predictions for the future. Learn to assess what you need to know, and take the responsibility of finding a way to learn it on your own.

Creativity Versus Profit

We all crave a good story well told. Our souls long for something fresh and creative. In school it's okay to experiment and fail. But let's consider the animation industry for a moment. The industry wants and needs creative people, but it is first and foremost a business. Business executives don't like failure! If executives perceive that a choice must be made between creativity, freshness, and art or staying out of bankruptcy and making lots of money, money will win out pretty much every time. If you want to work in the industry and be successful, you need to understand that basic fact. Keeping a job means producing what's practical and what will bring in money; unfortunately, sometimes creativity gets lost somewhere along the way. Don't lose your creativity or your love of animation! Try to be creative *and* remember the audience *and* the budget for your project. This is a book about it all: learning to write creatively and well, and working successfully in the animation industry.

 Exercises

1. Rent some old silent films like Laurel and Hardy or Charlie Chaplin. What did you learn?

2. Find a story that migrated from a less visual medium (like a book or play) to animation. Compare the story in both mediums. How did it change?

3. Pick a short story and make a list of all the ways you could make it more visual for animation.

4. Watch a couple of children's cartoons, or watch an animated feature film. How did the writer make the stories and humor visual?

5. Research puppet, clay, or cutout animation. Do any of these techniques interest you enough to use them on a future project?

6. Go to the library or surf the Internet for more on animation production.

7. Diagram the animation production pipeline.

8. Visit an animation studio.

9. Start the initial planning for a student film. What type of animation might you use? Traditional? 3D? Cutout? How will you get all the necessary production steps done in the time you have? Discuss in class.

10. What do you think the animation industry will be like in twenty years? In fifty? What influences might change it? Discuss.

The History of Animation

Beginnings

There are those who claim animation goes back as far as cave drawings that flickered in the light of early fires and danced on the walls like spirits coming to life. However, it wasn't until 1824 in the United Kingdom that Peter Mark Roget—the same Roget responsible for the first thesaurus—published *Persistence of Vision with Regard to Moving Objects*. His findings that each image is held on the retina of the eye for fractions of a second before the next image replaces it led to further study of this phenomenon: the perception of movement occurring when images replace each other rapidly. Think of a flipbook.

Others experimented with this phenomenon. In 1825 John A. Paris of England made a simple optical toy, the **thaumatrope**, which used only two images. In 1832 Joseph Plateau of Belgium invented the phenakistiscope, a cardboard disk with successive images that could be spun on a pivot. The images appear to move as you look through slits that serve as a shutter on a second disk. In France Emile Reynaud built another device with colored strips of paper on the inside surface of a cylinder attached to a pivot, similar to the **zoetrope** toy that had been invented in 1834. Reynaud patented his **praxinoscope** in 1877. About the same time Reynaud was making his experiments, Eadweard Muybridge, a California photographer, was photographing animals in motion. These images, which were shown in France in 1881, could be projected from transparencies so they appeared to move. Reynaud's hand-drawn films, his *pantomimes lumineuses*, were projected onto a screen at the Grévin Museum in 1892.

Early cameras could not shoot frame by frame, but the crank of the camera could be stopped and restarted, so images could be changed while the camera was off. James Stuart Blackton, who was born in Great Britain, made caricatures by using this method in the late 1890s. Another Briton, Arthur Melbourne Cooper, made the first animated film ever using animated matches. By 1909 Emile Cohl of France had made more than forty short films with humor and great style, and he continued making animated films until the early 1920s. In Europe there were many experimental and hybrid films produced during this period using various combinations of stop motion, live action, and animation. Italian artist Arnaldo Ginna

A.D. *2nd century* *17th century*

Chinese are operating the first slide
transparency projection system.

Early books indicate that the Chinese are using the first
magic lanterns, which make objects appear to move.

made animated films in 1910 by painting directly onto the film itself. In the United States, Winsor McCay made his first animated film in 1910 to include in his vaudeville act.

Mainstream Animation in the United States

Winsor McCay had been giving chalk talks, making drawings on stage that changed as he modified them during his presentation. *Little Nemo*, Winsor McCay's first animated short with 4,000 drawings on film, was really the birth of animation in the United States. The film was distributed in theaters at the same time that McCay was using it for his vaudeville act. McCay made other films including his masterpieces *Gertie the Dinosaur* (1914) and *The Sinking of the Lusitania* (1918), a moving dramatic film. He always saw animation as an art form.

After 1910 New York City became an animation center. Animation there was linked to the comics and vaudeville with three main studios: the Bray Studios, Raoul Barré's, and Hearst's International Film Service. Around 1913 John Randolph Bray, a newspaper cartoonist, made what's considered to be the first commercial cartoon. Bray also received a patent for making cartoons on translucent paper so portions of the cartoon that moved could be added separately. Celluloid (cel) was mentioned in his patent, and it later transformed the animation industry. In 1914 Earl Hurd, a former newspaper cartoonist, patented the same techniques that are used in traditional animation today. Raoul Barré, a French Canadian newspaper cartoonist, set up a studio with William C. Nolan in New York. In 1914 Barré introduced the use of standard holes in the drawing paper and the peg system to hold them. It was Nolan who discovered the system of using a background, drawn on a long sheet that could be maneuvered under the drawings, to provide the illusion of character movement. Around 1915 Max Fleischer invented the rotoscope, permitting live-action movement to be hand-traced frame by frame. William Randolph Hearst opened an animation studio in 1916 and brought comics like *Krazy Kat* to the screen. Although Hearst closed his studio after only two years, it was responsible for training a number of important animators. In 1917 Hurd joined forces with Bray. Bray's studio began making cartoons on a production line basis and served as a model for later studios. This studio employed young cartoonists like Max Fleischer, Paul Terry, George Stallings, Shamus Culhane, and Walter Lantz.

In the early days writers were unimportant to the making of animated films. Often the comic strip artist got credit for the film, and sometimes the animators were credited as well. Usually, the artist/animators were responsible for creating stories and gags. Most often the film was split up among a number of animators, each responsible for his own section. Since the gags were so important, plots often were harder to find than the animator at retake time. Some animators did have a natural story sense and wove a simple plot around their gags effortlessly.

The most successful cartoon studios in the 1920s were the three new East Coast–based studios formed by Pat Sullivan (an Australian), Max Fleischer, and Paul Terry. A young animator, Otto Messmer, went to work for Sullivan, and it was Messmer who later made Felix the Cat famous by giving Felix a personality. Max Fleischer created Koko the Clown and went on to animate Popeye and Betty Boop. Paul Terry was the first in 1928 to animate a

Devices like the thaumatrope, phenakistiscope, zoetrope, and praxinoscope, which appear to make things move, are invented.

1824 **1825–1877**

Peter Mark Roget publishes *Persistence of Vision with Regard to Moving Objects*.

short that included sound: *Dinner Time*. Paul Terry and Frank Moser's studio, Terrytoons, later made cartoons with Mighty Mouse, Heckle and Jeckle, and Deputy Dawg. Other early studios included those of Van Beuren, Columbia, and Charles Mintz's Screen Gems. During the 1920s Walter Lantz moved to California and started a studio with Bill Nolan, who had worked with Barré. Walter Lantz and his studio became best known for Woody Woodpecker, Andy Panda, and Chilly Willy.

At that time a Kansas City boy began to make his first cartoons—Walt Disney. In 1922 Disney started his own company in his hometown. His first successful fable was *Alice in Cartoonland*, a series featuring a live child in an animated cartoon world. By the time this cartoon achieved fame, Disney had moved to California and set up shop with his brother, Roy. Ub Iwerks created Disney's Mickey Mouse, debuting in *Plane Crazy* in 1928. But Mickey's first huge success was his third film, the early sound film *Steamboat Willie*.

Disney revolutionized animated films. In 1932 his *Flowers and Trees* was the first animated film to use the Technicolor three-color process. His animated characters became real people with feelings and hopes. After trying and failing, those characters' dreams (and our own) always came true. The groundbreaker was *The Three Little Pigs*, each pig with a distinct personality. The Disney story department made detailed analyses of the main Disney characters. Disney himself had a remarkable story sense. He hired instructors to teach at the Disney studio, and his animators studied live-action film, acting, and comedy in addition to art. In 1934–1935 Disney expanded the studio, and in 1937 *The Old Mill*, a haunting short, introduced Disney's multiplane camera.

Soon Disney set out to do what many said could not be done successfully: animate a full-length feature film. Movies had become very popular during the Great Depression because they were a cheap way to escape the reality of tough times. In 1938 Disney released *Snow White and the Seven Dwarfs*. Disney went on to make many of the best-known animated films in history: *Pinocchio, Fantasia, Dumbo, Bambi, Cinderella, Peter Pan, Lady and the Tramp, Sleeping Beauty, 101 Dalmations, The Little Mermaid, Beauty and the Beast, Aladdin, The Lion King*, and, with Pixar, *Toy Story, Monsters Inc.*, and *Finding Nemo*. These films have been popular because they're great stories with loveable characters. *Who Framed Roger Rabbit* started the toon boom that began in 1988. The Walt Disney name is known worldwide.

Warner Bros. has been another huge influence on animation. In 1929 Hugh Harman and Rudy Ising from Disney produced the first short with a cartoon character that actually had dialogue: *Bosko the Talk-Ink Kid*. Leon Schlesinger pitched the idea of the talking cartoon series to Warners, and the Looney Tunes were born. In 1930 *Sinking in the Bathtub*, the first of the Looney Tunes, was released. Warner Bros. also produced Merrie Melodies, cartoons with titles taken from Warner's songs. Harman and Ising split with Schlesinger over budgets and took Bosko to MGM, but the Looney Tunes and Merrie Melodies remained at Warner Bros. By 1934 a young Friz Freleng was making Merrie Melodies with bigger budgets in color, but the tired formula that Harman and Ising used prevented the cartoons from becoming big hits.

Tex Avery wanted to try something different. Schlesinger gambled on Avery and his crew of Chuck Jones, Bob Clampett, and others, and in 1936 a new Warner Bros. cartoon

15

Arthur Melbourne Cooper makes the first
animated film ever: moving matches.

1881 1899

Eadweard Muybridge projects his transparencies
of animals in motion in France.

style was born with *Gold Diggers of '49*. Frank Tashlin contributed to the Warner Bros. style with his interest in camera angles, **montages**, and other cinematography influences. Soon Bugs Bunny, Porky Pig, Elmer Fudd, Daffy Duck, Tweety, Sylvester, the Road Runner, and Wile E. Coyote became Warner Bros. stars. In the 1960s the studio stopped production of cartoon shorts, and the animation unit shut down. Chuck Jones starred some of the classic characters in TV specials and a feature film in the 1970s. Then the animation studio was resurrected in the 1980s. Warner Bros. experimented with an animated feature division, releasing *The Iron Giant* and several films that combined animation and live-action film. New series and new characters have been developed for television. With the purchase of Hanna-Barbera in the 1990s, Warner Bros. controlled the Hanna-Barbera characters and series library as well. And in television, home video, and merchandise the classic Warner Bros. characters that were developed by animators over the years continue to please children and adults all over the world.

When Harman and Ising left Warner Bros. in 1934, they started an animation division at MGM, taking many of their former staff with them. Once again Harman and Ising made their own version of the Disney Silly Symphonies series, this time naming the series *The Happy Harmonies*. Bosko was soon dropped. The new characters were impressive, but the stories were weak. MGM replaced Harman and Ising with Fred Quimby, who hired new animators from both coasts, including Bill Hanna, Joe Barbera, and Friz Freleng. The new cartoons flopped, and Harman and Ising returned. It was Hanna and Barbera's Tom and Jerry that became the big hits in the early 1940s. About the same time Tex Avery arrived at MGM to round out the classic MGM animation staff. Avery was famous for his timing and his wild gags. The average Tom and Jerry cartoon short took a year and a half from the beginnings of the story to the completed film. By now writers were occasionally getting story credit, but the economics of the big studios were changing. Showing cartoons and newsreels in theaters with a double feature was popular but unnecessary to distributing the films, and in 1957 MGM closed its cartoon studio.

In the early 1940s some of the younger Disney artists were active in the Disney strike, and they eventually left Disney. By 1944 Zack Schwartz, Dave Hilberman, and Stephen Bosustow all had new day jobs, but they were looking for extra work. When the United Auto Workers wanted to sponsor a pro-Roosevelt campaign film, the three formed a company and bid on the film. After these moonlighters and their staff completed their film, the three changed the name of their new company to United Productions of America, later called UPA. The company became known for its satire and its modern, flat, graphic style, and the animation was more limited. Later Schwartz and Hilberman sold out to Bosustow. The studio became associated with Columbia and began to create its own characters, among them Mister Magoo and Gerald McBoing Boing, a concept by Theodore Geisel. UPA went on to make a wide variety of films including *Rooty Toot Toot* and *The Tell-Tale Heart*. John Hubley (known for his independent films), gagman Tedd Pierce, storyman Leo Salkin, Jimmy Teru Murakami (who later opened studios in the United States and Ireland), Bill Melendez (who animated *Charlie Brown*), Gene Deitch (who has claimed he received all his animation training at UPA), and Hungarian Jules Engel (independent animator and teacher for years at Cal Arts School) were just some of the people who worked at UPA. A declining

Raoul Barré invents a peg
system for animation.

1910 1914

Winsor McCay makes his first animated film, *Little
Nemo*, to include in his chalk talk for vaudeville.

UPA was sold to Henry G. Saperstein, who made low-budget television cartoons in the early 1960s before the studio finally closed.

Other studios came and—often—went. More notable companies included Celebrity Productions (Ub Iwerks' cartoons) and Paramount/Famous Studios (*Popeye, Superman*). Later during the 1970s and 1980s Ralph Bakshi made animated films for adults (*Fritz the Cat* and *Heavy Traffic*). Joe Ruby and Ken Spears, former writers for Hanna-Barbera, formed Ruby-Spears and made a string of hit television shows during the 1980s. Ross Bagdasarian produced *Alvin and the Chipmunks*. Art Clokey and Will Vinton were known for their stop-motion or Claymation films.

Television had arrived, but it wasn't until the late 1940s and early 1950s that the average family in the United States could afford to buy one. Color television did not become widespread until the mid-1960s. From the arrival of the first sets, television was tremendously popular. At first people would watch anything that was broadcast. There were only three networks in the United States, so everyone was watching the same shows, and these shows were a major topic of conversation at work or school each day. People tended to think alike, since most had lived in the United States all their lives and consumed the same news and entertainment. Early television cartoons were 1950s shows like Jay Ward's *Crusader Rabbit*, the first made-for-television cartoon and the show that originated limited animation for TV, *Bozo the Clown*, and *Clutch Cargo*.

During the early years of television, the networks produced many of their own shows and sold the reruns both in the United States and internationally. Distribution was a huge source of income for the networks. There were only three places that production companies could sell their ideas in the United States: ABC, CBS, and NBC. Advertising revenues were huge. The networks had tremendous power, and they weren't afraid to use it. All over the world people with access to television eagerly watched U.S.-made programming. U.S. culture through movies and television saturated our planet, and not everyone was happy about that. During the 1970s the U.S. government stepped in to loosen the monopoly of the networks. Financial interest and syndication regulations, called fin-syn rules, went into effect in 1970. Now it was the studios that owned the product; after a run on the networks, the production companies were free to syndicate their own shows and reap the profits. Animation companies, and the syndication companies that sprang up, were now in the business of selling reruns to local stations across the country and around the world. In the 1980s cartoons based on toys were allowed under deregulation. Syndication became a big business. Independent animation companies could prosper.

When MGM closed its doors in 1957, Bill Hanna and Joe Barbera found themselves suddenly unemployed. The market for film shorts looked bad, but television was still new, and Hanna and Barbera felt they could make animated cartoons cheaply enough that they could be sold profitably for television. They developed a production system using limited movement and reusing animation whenever possible. At about that same time advertisers discovered that adults weren't watching TV on Saturday mornings, so the advertisers were eager to use that time to reach an audience of kids. Hanna-Barbera thrived. *The Flintstones* became the first animated, prime-time television show. By the end of the 1970s almost every children's television show in the United States on Saturday morning TV was made by

17

Walt Disney opens
his own studio.

1920s 1922

New York becomes a center for cartoons with the studios
of J. R. Bray, Paul Terry, Max Fleischer, and Pat Sullivan.

Hanna-Barbera Productions. Hanna-Barbera trained animators around the world to help with their vast production needs, and in turn Hanna-Barbera shows were sold to broadcasters around the world.

Other companies like Filmation, DIC, and Marvel sprang up. Filmation did well making *He-Man and the Masters of the Universe* and *Fat Albert*. Both Hanna-Barbera and Filmation experimented with animated feature films during the off-season when they had no television shows to produce. They wanted to keep their artists employed and lessen the financial risk of depending solely on TV to provide revenue. Unfortunately, the films that both Hanna-Barbera and Filmation made during the early 1980s with relatively low budgets and newly trained animators brought in disappointing profits.

Originally, DIC was a French company, but Andy Heyward, an ex-Hanna-Barbera writer, acquired the company and moved it to the United States in the 1980s. Heyward was an excellent businessman who offered to license his new shows for free to U.S. television stations or station groups. In exchange DIC would retain some of the advertising time within these shows to sell for profit. Marvel started up about this same time. Competition from DIC and Marvel, which kept minimum staffs in the United States and sent most of their production work overseas, was part of the reason that Filmation went out of business. Hanna and Barbera, both by now in their seventies, sold out to Ted Turner. Children's cable burst into the picture, first with Nickelodeon and later with Cartoon Network and other children's channels.

In 1990 the U.S. Congress passed the Children's Television Act, mandating educational children's programming. This was later modified to require that stations air at least three hours of core educational programming for children per week. Government regulations had influenced children's programming, for better or worse, throughout the 1970s and 1980s.

Animation once again went through a golden age in the United States during the 1990s. Disney started producing animation for television. DIC sold out to Disney and was bought back by Andy Heyward. Film Roman had started up in the 1980s with service work on *Garfield*, *The Simpsons*, and *King of the Hill*. In the 1990s it branched out into developing its own product and starting up Level 13, a venue for Internet shorts. The future of the Internet looked rosy, and animators and animation developers were courted everywhere. John Kricfalusi's *The Ren and Stimpy Show* brought in a new style of animation. Schools were churning out young animation stars. Cable began to grow while cable costs declined. Cable, the Internet, and even prime-time TV began to feature animation that was targeted at adults after the success of *The Simpsons*. The home video business began to grow. Companies like Saban Entertainment were making and distributing animation worldwide. Nickelodeon, Cartoon Network, and Disney were distributing animation internationally by satellite.

Then the bubble burst. Money spent on the Internet was not reaping profits. The big three television networks were losing advertisers because the advertising dollars were spread too thin. Fox, Warner Bros., and the UPN networks had all started up between 1986 and 1995, the cable stations were growing, and the Internet was also competing for advertising. More children in the United States had two working parents and got shuffled off to sports and other activities or spent quality time with a divorced parent they saw only on weekends. Children spent more of their time with video games or computers, or they watched direct-to-video movies. They weren't watching as much TV.

18

1928 **1929**

Games became a big business worldwide. Ralph H. Baer conceived the idea of interactive games that could be played on a TV set back in 1966. He made a prototype of the first home video game system, The Odyssey, in 1967, and the system was introduced in 1972. Atari founder Nolan Bushnell brought out the first video arcade machine, Computer Space, in 1971. Games became big competition for television.

In the 1990s the fin-syn rules were eliminated, and the television networks were once again allowed to own and sell their own shows. The production studios were not pleased. The U.S. government's reasoning was that there were now so many outlets for news and entertainment, there was no longer the need to regulate the industry so tightly. This and the formation of the European Union led to a big buying spree by the major entertainment companies. The U.S. entertainment industry consolidated into just a few major companies that could make and distribute their own products throughout the world.

Suddenly there was too much product, too many people in the animation business, too few places for small companies to distribute their product, too few children watching any single television show or film on any single day, and too little profit. With children's programming on cable every day all week long, Saturday morning was no longer special. Some U.S. networks outsourced their entire Saturday morning children's programming to another company: CBS to Nelvana and then Nickelodeon, Fox to 4Kids Entertainment, and NBC to Discovery Channel. Teenage and adult males, who had earlier expanded the market for animation, played video games or found other things to do. People outside of the United States wanted to develop their own animated projects, and many companies worldwide felt very capable of developing and producing animation on their own. Not only were the Europeans and the Japanese selling their own programming locally, some of that locally produced programming was selling to the U.S. market as well. A big influence on animation, globally, was Japanese **manga** and **anime**. Both the graphic anime style and the content influenced action cartoons in the United States and some features as well, particularly in the 1990s and into the new century. All of these factors sent profits down, and the U.S. animation industry suffered massive layoffs. Even the companies that survived were not doing well. Many small companies like Porchlight Entertainment began to look for co-productions with companies internationally. Some companies began to tailor programming specifically for localized audiences outside the United States.

Independent Animation in the United States

Worldwide a lot of independent animation has been rooted in art with little or no story. European avant-garde-inspired artists like Maya Deren, painter Mary Ellen Bute, illustrator Douglas Crockwell, painters Dwinell Grant and Jordan Belson, filmmaker Harry Smith, photographer Hy Hirsch, plus Charles Eames and Saul Bass, who made films in the 1930s, 1940s, and 1950s. Some of the best-known, independent animators in the United States were John and Faith Hubley (a writer) who made films like *The Adventures of*, Moonbird, Of Stars and Men, The Hole, Windy Day, Cockaboody, Everybody Rides the Carousel,* and *Second Chance: Sea.* Jules Engel made *Landscape, Accident, Train Landscape, Shapes and Gestures,*

19

Wet Paint, Rumble, and *Play Pen.* James Whitney made outstanding, nonobjective films including *Yantra, Dwija, Wu Ming, Kang Jing Xiang,* and *Li.* His brother, John Whitney, was the father of CGI and made scientific and CGI films including *Film Exercises* (with James Whitney), *Permutations, Matrix* (a series of three films), and *Arabesque.* Other well-known independent filmmakers in the United States include Robert Breer, Ed Emshwiller, Van Der Beek, Larry Jordan, Ken O'Connell, David Ehrlich, Jane Aaron, Ernest Pintoff, John Canemaker, Sally Cruikshank, Michael Sporn, Bill Plympton, Cynthia Wells, and Christine Panuska.

Canadian Animation

Some Canadians who were involved in early animation include Raoul Barré in New York, Walter Swaffield and Harold Peberdy in Toronto, Loucks and Norling in Winnipeg, and Bryant Fryer in Toronto. In 1927 Fryer was working on a film series with silhouettes, *The Shadow-laughs.* Only two of the series were completed, but the films are impressive.

It wasn't until Norman McLaren, a Scotsman, came to Canada in 1941 to become a member of the National Film Board of Canada that Canadian animation really was born. The artists there were encouraged by McLaren to use their own styles as they worked on propaganda films for the war. Film Board artists included George Dunning, Jim McKay, Grant Munro, Jean-Paul Ladouceur, and later Alexandre Alexeïeff and Paul Driessen (a Dutch animator). After the war some of the first artists left the board for greener pastures. The board itself went on to promote Canada and its technical research and to encourage its artists. Canadian animation management talent was nurtured there. Independent animators who worked on the board had the security to make their own films. In 1977 Derek Lamb took over, but the Canadian government cut the budget in 1978, and the quality of the work went down. However, in the 1980s the board's animation was decentralized, opening up new opportunities in Winnipeg, Vancouver, Edmonton, and Moncton. Later Film Board animators included Ryan Larkin, Pierre Hébert, Evelyn Lambart, Richard Condie, Janet Perlman, Joyce Borenstein, and Ellen Besen. In Vancouver there were Al Sens and Marv Newland; in Toronto, Al Guest; in Montreal, Gerald Potterton, Ishu Patel (originally from India), and Caroline Leaf; and in Québec, Frédéric Back (*Crac*), who all made their own independent films.

Ottawa has annually hosted an internationally recognized animated film festival that's focused on independent and student films. Canada's large animation industry has included companies like Nelvana (*Babar, The Magic School Bus, Rolie Polie Olie*), Decode Entertainment, Bardel Animation Ltd., Teletoon, Studio B Prods., CineGroupe, Mainframe Entertainment, and Cinar (*Arthur* and *Paddington Bear*), producing animation that is seen throughout the world. The industry has been able to deliver a high-quality product for a low cost partly because of the financial support given by the Canadian government.

European Animation

In the United Kingdom Arthur Melbourne made the very first animated film *Matches: An Appeal* in 1899. Walter P. Booth filmed *The Hand of the Artist* in 1906, and Samuel Arm-

Tex Avery, Bob Clampett, Friz Freleng, and Chuck
Jones work at Termite Terrace at Warner Bros.

1940 **1940s**

Bill Hanna and Joe Barbera make their
first Tom and Jerry cartoon at MGM.

strong created *The Clown and His Donkey* in 1910. During World War I satirical illustrators and comic strip artists made films lampooning the Kaiser. Ansor Dyer and Dudley Buxton completed their war propaganda films, and after the war they graduated to a series called *Kiddigraphs*. Other English animators were also filming series. Animation studios were starting up, but the films of this era were exhibited almost exclusively in Great Britain and were not seen by animators on the continent. In 1929 Len Lye, a New Zealander trained as an animator in Australia, shot his first film *Tusalava*, funded by the London Film Society. Lye later made other exceptional films painted on film stock and using puppets.

During World War II, advertising, the traditional moneymaker for animation, all but disappeared, but wartime propaganda kept animation alive. Larkins Studio was founded during the 1940s, and it revolutionized style. Halas & Batchelor was founded in 1940 and became one of the most respected animation studios in the world. John Halas was originally from Budapest, and Joy Batchelor was an English animator and writer. The studio completed *Animal Farm* in 1954. George Dunning and John Coates founded TVC in 1957.

England was a center for animation in the 1960s with films, TV series, educational animation, and advertising. In 1965 Richard Taylor founded his own studio. Halas & Batchelor produced the United Kingdom's first TV series in 1960. In the late 1960s the company was one of the first to turn to computer animation. George Dunning completed his *Yellow Submarine* in 1968. Cosgrove Hall (*The BFG, Dangermouse, Duckula*) was founded in 1976 by Brian Cosgrove and Mark Hall, who were college friends. It's been one of the biggest cartoon studios in Europe. *Watership Down*, directed by John Hubley and later Tony Guy, was completed in 1978. In 1972 Peter Lord and David Sproxton founded Aardman Animation in Bristol and produced series for the BBC and Channel 4. The BBC has traditionally been the largest funder of children's programming in England.

Much of the television animation in England in the early 1980s was still purchased from the United States, but that began to change as Channel 4 commissioned British animation, Thames Television financed Cosgrove Hall, and S4C in Wales founded Siriol. By 1987 there were over thirty studios in London alone, with others spread throughout the British Isles. Most of these were small studios that employed freelancers. Telemagination has been TV-Loonland's main production center. Granada Kids produced many children's programs, and Pepper's Ghost Productions made 3D TV series. Other producers have included Hit Entertainment (*Bob the Builder*), Tell-Tale, Entertainment Rights, Tiger Aspect, Spellbound, Contender, Chorion, and Create TV.

Until 2002 British TV producers could receive tax benefits that helped to raise upfront funding. With that help gone and license fees down, animation in the United Kingdom hit a slump. Traditionally, much of British TV animation had been created for the preschool market. More recently, CBeebies and CBBC have launched, and now British kids have two channels of their own.

The United Kingdom has had its share of important individuals in animation. They've included Tony White, who is known for his book on animation as well as his work at his own company: Animus. Canadian Richard Williams has worked mostly in London, but he completed his film *Raggedy Ann & Andy* in the United States. Bob Godfrey, an Australian, has made a number of cartoons in England, mostly for adults. Some have been made in

Artists strike Disney studios.
A union is formed.

1941

World War II disrupts animation in Europe. Animation in the
United States and a few other countries gears up for the war effort.

collaboration with another Australian, writer Stan Hayward. Hayward has also collaborated with Dunning, Williams, and with Halas & Batchelor. Puppet animator Barry Purves has made independent films such as *Next: The Infinite Variety Show* (1989). Animator/Director Nick Park made his Wallace & Gromit films at Aardman Animation Ltd.

Aardman Animation also produced the animated feature *Chicken Run. Dominator* was the United Kingdom's first full-length CGI film, an adult feature. Newer companies like Bazley Films got their start producing Flash animation productions. In 2003 Channel 4 made a large commitment to develop new talent in the United Kingdom by financing animated shorts and specials.

Over in Germany Lotte Reiniger with her striking silhouettes, Hans Richter, Walter Ruttmann, and Viking Eggeling all made early films between 1919 and 1930. During the 1930s and 1940s German animators tried to compete with Disney. Hans Fischerkoesen founded a large studio, and Horst von Möllendorff collaborated with him. Ferdinand Diehl also started a production company with his brothers, making puppet films. His puppet Mecki the hedgehog became famous. Hans Held and Kurt Stordel both founded their own animation studios. Later Stordel headed the animation department at UFA. Hans Fischinger made avant-garde films. Abstract art was prohibited during the Nazi reign, and abstract artists had to hide any animation they wanted to make at that time. Hans Fischerkoesen founded studios both before and after World War II, and Gerhard Fieber founded the EOS studio after the war. The Diehl brothers continued to make films after World War II, and Kurt Stordel made children's films for German TV in the 1960s. In 1962 two German animation producers, Wolfgang Urchs and Boris Von Borresholm, signed the Oberhausen Manifesto, which initiated a new German cinema and opened up new opportunities. During the 1980s Berlin Film and AV developed television series for Iraq. A major festival was started in Stuttgart in 1982. Other important artists included Helmut Herbst, who influenced many animators, and Ulrich König, who made some of his films at Pannonia in Budapest. The brothers Christoph and Wolfgang Lauenstein won an Oscar for their 1989 film *Balance*.

After World War II East German animation had to begin again from scratch. In the 1950s a few animated properties were completed by the Studio für Popularwissenschaftliche Filme. DEFA was officially founded as the national production center for animation in 1955 and produced mainly children's animation, but some political animation was produced for adults as well. East German animators included Bruno Böttge, Klaus and Katja Heinitz Georgi, Kurt Weiler, Günter Rätz, and Otto Sacher. The absorption of East Germany into the German economy in the last part of the twentieth century has been a long-term problem. By 2002 the economy was slow. Giants like KirchMedia and Bertelsmann were having their own troubles, complicated by consolidation, the lack of business in the expanded pay TV market, a huge surplus of content, and problems throughout the European market.

Comedy films for children were produced in Italy as early as 1920. In 1938 Nino Pagot formed his own production company making propaganda films, and in 1946 he made the film *Lalla, piccola Lalla*. In the 1940s films were still made while World War II raged. By the late 1950s RAI-TV decided to permit advertising, and animation exploded, especially in Milan. The first series was *Carosello*. Animators were able to experiment with this series and hone their skills. At the time, one of the largest studios was Gamma Film. More recently,

Yugoslavia animators learn limited animation techniques and win an an award
for *Nestasni robot* (*The Playful Robot*), the first film of the Zagreb School.

1944 **1955-1956**

An election campaign cartoon for Franklin D. Roosevelt is the first completed film of the fledgling
company that becomes UPA, noted for its simple graphic style and its limited animation.

studios like Rainbow Animation S.R.L. and Mondo-TV produced animated series. RAI financially supports Italian projects animated in Italy. In Rome Ezio Gagliardo founded Corona Cinematografica, which made traditional European folktales into shorts. Other film-makers included Bruno Bozzetto, Guido Manuli, Emanuele Luzzati with Giulio Gianini, Osvaldo Cavandoli, Manfredo Manfredi, Cioni Carpi (who also worked at the National Film Board in Canada), and Dario Picciau (*The Egg*).

In Spain in 1905 Segundo de Chomón made *Choque de trenes* (*Train Collision*), a masterful film using models. Caricaturist Fernando Marco made a popular film about a bull in 1917. More films, including some with puppets, were made in the 1930s before the Civil War stopped production. After that war Spanish animation enjoyed a golden age, centered in Barcelona. In the 1940s two companies, Hispano Gráfic Films and Dibsono Film, merged into Dibujos Animados Charmartín, and the new company put out three film series. Also in the 1940s Arturo Moreno made the film *Garbancito de la Mancha*, and about the same time former animators of Charmartín made *Erase una vez*. Spanish production companies like ICA Films, Icon Animation, D'Ocon, Estudios Moro, Estudios Vara, Estudios Castilla, BRB International, Pegbar, Filmax, and Cruz Delgado's company made films and television series. During the first few years of the twenty-first century, television work was slow, and local companies concentrated on making films. Filmax made a number of films, including *Groomer, Nocturna, Don Quiote and Sancho, El Cid, the Legend*, and the co-production of *P3K Pinocchio*. Independents José Antonio Sistiaga and Rafael Ruíz Balerdi made painterly films.

Portuguese animation was probably pioneered as early as the 1920s. Cartoonist Artur Corrêia and Ricardo Neto made folktale films in the 1970s. Democracy returned to Portugal in 1974, and a new attitude was born. The Cinanima Festival was started in 1976. This and government support helped to train a new generation of Portuguese animators. Mario Vasques das Neves, Artur Corrêia, and Ricardo Neto produced animation at their Topefilme company. Other important animators include Abi Feijó, Regina Pessoa, Christina Teixeira, Pedro Serrazina, and José Miguel Ribeiro.

Emile Cohl was making animated films in France before 1910. Robert Collard (Lortac) founded the first animation studio in Montrouge, France, in 1919. Lortac had studied under Emile Cohl. Fernand Léger made *Ballet* in 1924, combining live-action, painting on film, and traditional animation. Marcel Duchamp also made an animated film. Much of French animation during the 1930s was advertising, but some series and a few shorts were produced. In 1932 an Englishman, Anthony Gross, founded the studio Animat in Paris, and in 1936 Paul Grimault and André Sarrut founded Les Gémeaux. Hungarian Jean Image made the first French animated feature, *Jeannot l'intrepidé*, in 1950.

After the war Paul Grimault made several films in France, but the most outstanding was *Le roi et l'oiseau*. Grimault helped the young Jean-François Laguionie make his first film. Laguionie went on to make many films, his best being *La traversée de l'Atlantique à la rame*. Other important French animators included René Laloux, and Polish-born filmmakers, Walerian Borowczyk and Piotr Kamler. In the 1950s the Association Internationale du Film d'Animation (ASIFA) and the Annecy Festival were born. ASIFA has been active worldwide ever since, promoting animation and independent animated films as well as those done

23

The Flintstones becomes the first
prime-time animated series.

1957 **1960**

Hanna and Barbera open their own studio to make
limited animation for the young medium of television.

by the major studios. French television ORTF funded many French animation projects, including those of Laguionie and Jacques Rouxel, who produced one of France's best-known TV series, *Shadoks*. Writer René Goscinny made feature films based on Astérix le Gaulois and founded the studio Idéfix.

Hard times came to animation in France during the early 1980s with unemployment around 70 percent, but the ministry of culture founded OCTET to serve as an intermediary to help the various sectors of the industry. In 1984 France Animation was founded to set standards for production companies. After the mid-1980s animation grew tremendously in France. A tax to French broadcasters by the government, redistributed to producers by the National Center for Cinema (CNC), helped to fund children's programming. Minitreaties with countries like Canada and Australia fostered co-productions.

The main French market has been Western Europe, but there have been some sales to Asia and the United States as well. Companies like AnteFilms, Futurikon, Folimage, Millimages, Kayenta Production, Dargaud-Marina, Marathon, and Toon Factory have been active in television. By 2002 the financial problems at Vivendi Universal added to the general problems throughout the European market.

Robert Réa produced the features *Babar* and *Corto Maltese: La cour secrete des Arcanes* (a Franco-Italian co-production) and for TV *Tintin* and *Blake and Mortimer*. Didier Brunner's Les Armateurs production company produced *Kirikou et la Sorcière* and the features *Princes & Princesses*, *The Boy Who Wanted to Be a Bear* (co-produced in Denmark), and *Les Triplettes de Belleville*. Other features included *Les Enfants de la Pluie, Charley & Mimmo, Loulou and the Other Wolves, T'choupi & Doudou*, and *Totally Spies*. *Kaena la Prophetie* was France's first 3D animated feature.

Belgian animation began in the 1920s with advertising films made by the Houssiaus, a father-son team. In 1932 Ernest Genval, Leo Salkin, A. Brunet, and M. Van Hecke made a couple of adult-themed puppet films. The CBA studio was founded in 1940 during the German occupation, and other films were made in Antwerp before the war was over. In 1948 the Misonne studio released the first Belgian feature, *La crabe aux pinces d'or*. Belvision, makers of *Tintin, Astérix, Lucky Luke*, and the Smurf film *La flute à six Schtroumpfs*, was founded in 1955. TVA Dupuis was founded in 1959 to make a Smurf TV series. Kid Cartoons got its start in 1976, and Atelier Graphoui was established in 1978. One of Belgium's most famous animators, Raoul Servais, made many films between 1960 and the late 1970s, including *Harpya*.

Writer/illustrator/actor Robert Storm-Petersen released animated films made by his own production company in Denmark from about 1916 until 1930. Allan Johnsen produced the film, *Fyrtøjet*, and Bent Barfod made *So Be It Enacted* at his own studio in 1964. In the 1960s Denmark financed art shorts. These were mostly films with cutouts and other low-cost animation. Many of the themes were social. Jannik Hastrup made political and social films, some of them radical. In 1984 Hastrup finished *Samson & Sally*, a feature about whales and pollution, and in 2003 he released *The Boy Who Wanted to Be a Bear* (co-produced in France). Lejf Marcussen, who worked in the TV department of Danmarks Radio, made non-figurative films with images and sound but no plots. Other popular filmmakers included Svend Johansen, Anders Sorensen, and Jorgen Vestergaard.

101 Dalmations is the first feature to solely
use the Xerox process instead of hand inking.

1961

Victor Bergdahl animated his comic strips in Sweden from 1915 to 1930, and several other Swedish animators turned out films during this same time. In 1953 Gunnar Karlsson founded GK Film (*Patrik and Putrik*). Then in 1956 Stig Lasseby started Team Film, which produced many TV series, specials, and films. The first Swedish feature was *I huvet på gammal gubbe* in 1969. Rune Andreasson created a series about a bearcub, Bamse, in the 1960s, and he continued to make occasional new episodes into the 1980s. Filmtecknarna Celzqrec was founded in 1981 by Jonas Odell. In 1982 Jan Gissberg and his brother founded Cinémation. Other prominent animators include Per Åhlin, Lennart Gustafsson, Peter Cohen, Gilbert Elfström, and Karl-Gunnar Holmqvist. More recent Swedish animation has had no particular style, but most of it has been for children and has focused on social themes.

In Moscow Ladislas Starewich experimented with stop-motion animation in 1910. After the revolution he moved to France to continue making his films. Soviet animators made political and satirical films. An animation department was organized within the government-run Sovkino studio in 1928. Important films of the era were Juri Zheljabuzhsky's *The Skating Rink*, in 1927, and *Post Office,* directed by Mikhail Tsekhanovsky, in 1929. In that same year Lunacharsky stepped down as People's Commissar for Culture, sending the arts in Russia in another direction. A congress of Soviet writers, held in 1932, turned away from the avant-garde and spoke for socialist realism. Animation turned to the classics and to films for children, often with political or educational themes. The first director of Sojuzdetmultfilm, the new production center, was Alexander Ptushko.

The earliest Soviet films after World War II were traditional films in the Disney tradition. In 1953 puppet and cutout films were encouraged with the opening of a special section at Sojuzmultfilm. The primary artists during this postwar period were Ivan Ivanov-Vano, the Brumberg sisters (who made mostly education films), and Lev Atamanov. Arguably the most important Russian animator of the 1960s was Fedor Khitruk, who spent twenty-four years animating at Sojuzmultfilm before directing his own films. Others who made films during the period from the 1950s to the 1980s included Anatoly Karanovich, Roman Katsanov, Nikolai Serebriakov, Boris Stepantsev, Vadim Kurchevsky, Eduard Nazarov, Andrei Khrzhanovsky, and Yuri Norstein. In the 1980s a new philosophy of production decentralization crept in. All through the Soviet Federal Republics a wide range of animated films were being made, many of these folktales of the region. Priit Pärn in Estonia won a grand prize at Zagreb with his *Picnic on the Grass.*

Polish animation began in 1917–1918 with films by Feliks Kuckowski. Stanislaw Dobrzynski, Wlodimierz Kowanko, and others made films in the 1920s and 1930s. A puppet animator, Zenon Wasilewski, told tales of the local dragon and other favorites both before and after World War II. A group called Slask made films for state-run Film Polski. In the 1960s the Polish government decided to greatly increase production with as many as 120 animated films released in one year. Many of these Polish School films reflected Polish life at the time, with gray or dark images and themes of the struggle of man. By the new millennium Poland had developed a large television market. Other prominent Polish animators included Jan Lenica, Walerian Borowczyk, Miroslaw Kijowicz, Stefan Schabenbeck, Daniel Szczechura, Jerzy Kucia, Ryzsard Czekala, and Zbig Rybezynski.

25

Astro Boy, Japan's first animated television series, appears and slowly ignites the anime craze of the 1990s and beyond.

The first animated film made in Czechoslovakia, now the Czech Republic, was Karel Dodal's puppet film *The Lantern's Secret* in 1935. The country had a long history of puppet theater that continued over into animation. The heart of the Czech industry was always Prague. Atelier Filmovych Triku (AFIT) was founded in 1935, and the studio made films until shortly before World War II ended.

After the war puppet animation reemerged in Czechoslovakia. Jirí Trnka became internationally recognized as the poet of puppet animation, making *Staré povesti ceské*, *The Hand*, and many other films. In the 1940s Jirí Brdecka (a writer, not an artist), Zdenek Miler, and Eduard Hofman made traditional animated films. Hermína Tyrlová produced creative films with yarn, paper, wood, and other objects. Karel Zeman made films with puppets, traditional animation, and live actors, often mixing these elements. In the 1950s the Czech animation industry grew with younger puppet animators following Trnka. The American animator Gene Deitch came to Prague in 1959 to see about some subcontracting and remained to animate there. He gradually changed the traditional cel animation production model at Bratri v Triku to conform more closely to the U.S. model. The animators in Prague had basically taught themselves animation after World War II by running old Disney features frame by frame. In the 1980s, with fresh inspiration, a new era of Czech animation began. There were five animation centers including the Bratri v Triku and the Jirí Trnka studios in Prague. Unfortunately, in the postcommunist years between 1990 and 1996 animation in the Czech Republic declined again. In 2000 Zdenka Deitch (Gene Deitch's wife) took over as head of Bratri v Triku, continuing their tradition. Other important Czech animators include Bretislav Pojar, who was the actual animator for Trnka's films, Jan Švankmajer, and Jiri Barta.

In Hungary István Kató made his first cutout film in 1914, and he made hundreds of animated films before he retired in 1957. Before World War II, George Pal, John Halas, and other Hungarian animators left Hungary to work elsewhere. After the war Gyula Macskassy and György Varnai made films with adult themes, rejecting the folktales favored by other Eastern European countries. Tibor Csermak made *The Ball with White Dots* in 1961. Hungarian animation saw many changes during the later half of the twentieth century. In the 1960s the state-run Pannonia began producing adult cinema as well as children's fare, making product for TV and the theater. In 1968 economic reforms in Hungary ended the strict planning that had been required under communism. In the 1970s there was a new foray into animated features with the first one, *Janos the Knight*, completed by Marcell Jankovics. In 1981 Ferenc Rofusz won an Oscar for *The Fly*. Other important animators included Sandor Reisenbüchler, György Kovasznai, and Csaba Varga. Important Hungarian studios have included Germany's Loonland Animation and Varga Ltd. in Budapest.

Soviet-trained Serij Tagatz was the first Yugoslavian animator, but animation in Yugoslavia (now Croatia, Montenegro, Bosnia, and Herzegovina) was mostly limited to advertising until after World War II. With government financing Fadil Hadzic founded Duga Film, producing animation during the early 1950s. About 1955 animators from the former Duga Film and a team from Nikola Kostelac discovered the limited animation techniques of UPA. They learned by watching animated segments produced by John Hubley for the American live-action film *The Four Poster*, which Zagreb Film distributed. Early animators of this Zagreb School were Dusan Vukotic, Vatroslav Mimica, and Vlado Kristl. They used

26

More U.S. studios subcontract work overseas. U.S. production shrinks. Production in Korea, China, the Philippines, Australia, India, and Vietnam grows.

1975-2005

a graphic style with the limited animation, often using collages and assemblages. Most of these early films were serious films with deep themes and a dark, comic edge. Vukotic's *Surogat* was an exceptional film and won an Oscar. By 1963 the early Zagreb School animators had moved on. So Zagreb Film promoted those who had worked and learned from the masters. These new animators often wrote, directed, and drew their own films, so the films were more personal. Important Zagreb School animators included Borivoj Dovnikovic, Nedeljko Dragic, Zlatko Grgic, Zdenko Gasparovic, Boris Kolar, the team of Aleksandar Marks and Vladimir Jutrisa, and Josko Marusic. Another important Yugoslavian animator was Borislav Sajtinac, who worked for Neoplanta Film in Serbian Novi Sad in the 1960s and early 1970s.

Japanese Animation

Japanese artists first resolved to experiment with moving images after seeing John Randolph Bray's cartoons around 1910. Seitaro Kitayama made three films in 1917: *Saru kani kassen*, *Cat and Mice*, and *The Naughty Mailbox*. The first Japanese film to be shown outside of Japan was Kitayama's *Momotaro* (1918). Other early Japanese animators included Junichi Kouchi, Oten Shimokawa, Zenjiro "Sanae" Yamamoto, Noburo Ofuji (who made adult films), and Yasuji Murata (who used American-style cels). During the 1930s the government required propaganda films, and Kenzo Masaoka produced many of these as well as other shorts. In 1943 he created his most important film, *Kumo to Chulip*. Mitsuyo Seo made Japan's first feature, *Momotaro-umi noshinpei*, also a propaganda film, in 1944.

After World War II animation consolidated into a more factorylike environment. One large studio set up for a brief period was Shin Nihon Doga. Around 1947 Kenzo Masaoka and "Sanae" Yamamoto set up Nihon Doga, which later became Toei Doga (not to be confused with Toei). Toei Doga turned out some fine feature films, including *Hakuja-den*, directed by Taiji Yabushita. Among animators of the 1950s were Tadahito Mochinaga (puppet films), Ryuichi Yokoyama (founded Otogi in 1955), and Noburo Ofuji (*Shaka no Shoga*). One of the most important animators of that period was Kon Ichikawa, who was famous for his composition. There were many competing studios, including Toho, Otogi, Nihon Eiga, and Kyodo. Yugo Serikawa made animated features as well as many television productions. The studio Gakken, led by Matsue Jinbo, produced educational and puppet films. In 1959 the comic strip artist Osamu Tezuka was hired by Toei to co-direct and write *Saiyuki*. In 1961 Tezuka founded his own company, Mushi, and made the TV series *Tetsuwan Atom* (*Astro Boy*) in 1963. *Astro Boy* was one of the first anime series to air on U.S. television. After Mushi suffered setbacks, Tezuka founded Tezuka Productions, a company more suited to the way he worked. Tezuka continued to make many TV series, shorts, and features, including *Jumping* (1984) and *Onboro Film* (1985).

Starting in the 1960s television became important to Japan. By 1976, 200 animated series had been produced, and that number doubled by 1983. In 1985 Toei alone was completing twenty-six minutes of animation each day with some of that work done in cheaper Asian countries. Many of the Japanese series became very popular in Europe in the 1970s, but it

The TV show *The Simpsons* has its first season.

wasn't until the 1990s that they began to take over children's TV in the United States. By the early part of the twenty-first century the manga and anime influence was felt throughout the international marketplace. Companies like Toei Animation, TMS Entertainment, Nippon Animation, Pierrot Co., and Gonzo-Digimation were producing television series for both the Japanese and international markets. Bandai Visual produced animation for broadband distribution. In 2004 Japan revised laws to allow government financial support to animation companies.

The popularity of television animation led to an increased interest in animation in the theaters in Japan as well. Some TV series were repackaged as features, and animated films for adults gained popularity. Many Japanese films have been financed by a consortium of companies, each company benefiting from a different area of the overall film and marketing profits. Animation directors became stars: These included Isao Takahata (*Celo Hiki no Goshu*, 1980), Tadanari Okamoto (*Hana to Mogura*), Mamoru Oshii (*Ghost in the Shell, Innocence*), Satoshi Kon (*Perfect Blue, Millennium Actress*), and the star of stars, Hayao Miyazaki (*My Neighbor Totoro, Princess Mononoke,* and *Spirited Away*).

The art film thrived in Japan, too, with Tokyo Image Forum helping independent animators. Kihachiro Kawamoto was an important puppet animator who worked briefly in Prague. Yoji Kuri claimed to have made about three thousand films in the 1970s alone. Other animators were Renzo Kinoshita, Shinichi Suzuki, Taku Furukawa, and Koji Yamamura. The Hiroshima Animation Festival, which began in 1985, has been one of the most important animation festivals in the world.

Animation in Other Asian Countries

Dong-Hun Shin was a pioneer of animated shorts in South Korea in the 1960s. Soon South Korea became a haven for animation service companies making television productions for the United States, Japan, and Western Europe. One of the largest was Dong-Seo Animation, and others have included Sunwoo Entertainment, AKOM, Animation Art Center, Anirom Animation Production, Ansan Animation Production, Han Shin, Seoul Animation, Ocon Animation, Dongwoo Animation, and Anitel. KOCCA, the Korean Culture and Content Agency, helped the Korean animation community find distribution for their product inter-nationally. The government assisted in funding Korean animation as well. Korean films, like Lee Sung-gang's *My Beautiful Girl, Mari,* began to find international acceptance.

In 1948, the same year that North Korea became a Communist state, the Pyongyang animation studio was founded. The studio educated North Korean children by making ideological films, many based on tales by Marshal Kim Il Sung. Hundreds of films with drawings, puppets, or cutouts were made since the studio opened, and in the 1980s the studio employed about 600 people. One of the best-known films is Kim Chun Ok's *The Flying Horse* (1986).

Early Chinese and European records seem to indicate that the Chinese made the first zoetrope or magic lantern by the second century and developed the first slide or transparency projection system by the seventeenth century and probably earlier. The Chinese

Who Framed Roger Rabbit spawns a golden age of animation in in the United States in the 1990s.

1988

may well have been the earliest pioneers of cinema. Modern-day animation began in China with the four Wan brothers. From their first film *Uproar in the Art Studio* in 1926 until the war years, they seem to be the only animators. They made a number of films and developed an animation department at the Mingshin studio. When the Japanese invaded Shanghai, the Wans escaped to Wuhan and produced resistance films before returning to Shanghai to establish another animation unit at Shinhwa in the French concession. There they made the first Chinese feature, *The Princess with the Iron Fan* (1941). About this time other artists began to make animated films in China, including Qian Jajun, Fang Ming (who was actually the Japanese animator Tadahito Mochinaga), and a group of Communist party members, who made an animated puppet film.

An animation unit was formed in 1949 in Changchun, which later became the animation unit of the Shanghai Animation Studio (SAS). The unit grew after the animators moved to Shanghai. SAS was officially founded in 1957, and by the 1960s it had close to 400 workers. These films had to be educational and entertaining and retain a national sense. Animation was done with cutouts and puppets and on cels. Hundreds of excellent films were made, including Wan Guchan's *Zhu Baizhe Eats the Watermelon* (1958), Te Wei's and Qian Jajun's *The Tadpoles in Search of Their Mummy* (1960), Wan Laiming's feature *Confusion in the Sky* (1961 and 1964), and Qian Yunda's *The Red Army's Bridge* (1964). As the Communist government changed with the slogans of "One Hundred Flowers" and "The Great Leap Forward," the character of the animation changed as well. SAS closed in 1965, animators were sent away for reeducation, and the studio didn't reopen until 1972. The government-sponsored studio is now Shanghai Fine Arts and Film Factory.

After the Cultural Revolution, most animated films were propaganda films like Yan Dingsian's *The Little Trumpeter* (1972). When the Gang of Four fell from power in 1976, animation production increased. Major animators at this time included Xu "A Da" Jingda, Tang Cheng, and Jin Shi. More recently animators have been able to work at one of the broadcasting companies like China Central Television (CCTV) or at one of the newer studios like the Institute of Digital Media Technology (IDMT), Dalian Animation Studio, Tianjin Animation Studio, Beijing Film Academy, Beijing Scientific and Educational Film Studio, Hosem Animation, Shanghai New Age Art, Jiang Toon Animation, or Hung Ying. Animation service companies like Shenzhen HBB and Color-land Animation Ltd. opened after the Chinese government set up a special economic zone near Hong Kong during the 1980s. Early in the twenty-first century the State Administration of Radio, Film & Television (SARF) drew up plans to develop the film and animation industry and set up requirements for local broadcasters to program at least 300 minutes of animation monthly, with 60 percent of that domestically produced. With China's entrance into the World Trade Organization, new opportunities opened up internationally as well.

James Wang founded Wang Films in Taiwan in 1978, and the animation unit Cuckoo's Nest became one of the top Asian animation studios, thanks in part to a great deal of service work for Hanna-Barbera. In the early 1990s the studio had around 875 employees. Other Taiwan studios have included Green Paddy Animation Studio, Dragon Animation, and Morning Sun Animation.

1989

The U.S. Congress passes the Children's Television Act, mandating educational children's programming.

Southeast Asian Animation

In 1959 the North Vietnam Ministry of Culture sent Le Minh Hien and Truong Qua to Moscow to learn animation and return to train others and start the Hanoi Cartoon Studio. The first film was *What the Fox Deserves* in 1960. During the Vietnamese War about half of the films were propaganda films like *The Kitty* (1966). The others were folktales or satires. The first color film was Truong Qua's *Carved in the Rock* (1967). One of the studio's best films was Qua's *The Legend of the Region* (1970). Like the other countries of Southeast Asia, Vietnam has attracted many animation service companies. The first company was set up by the Japanese in the early 1990s in Long An, but most have been located in Ho Chi Minh City. Studios have included Pixi Vietnam and the Education and Audio Visual Center. In the late 1990s Energee Entertainment of Australia made Hanoi Cartoon Studio its overseas facility.

Malaysian government–owned Filem Negara set up an animation unit in the 1960s. In 1978 the studio made its first short for TV, *Hikayat Sang Kancil*. Malaysian filmmakers have been most concerned with folktales, scenes of daily life, fantasy, and superhero adventures. During the 1980s and 1990s many studios sprang up, including Lensamation, Fat Lizard, Animasion, Fourth Dimension, UAS Animation, and Kharisma Pictures. After privatization of Malaysian broadcasting, new television channels emerged, advertising increased, and the government attempted to counter the influence of foreign cartoons seen on satellite TV. Stories from the popular Malaysian humor magazines and newspapers were adapted for TV. Popular cartoonist Ibrahim Mohd Noor (known as "Ujang") made *Usop Sontorian*. Mohamed Nor Khalid (known as "Lat") created *Kampung Boy*, and Jaafar Taib developed *Jungle Jokes*.

In Singapore K. Subramaniam's Animata Productions produced mainly advertisement, promotional, and educational films. His *Little Pink Elephant* (1988) for the Community Chest was Singapore's first narrative animated cartoon. Subramaniam's best-known film is *The Cage* (1990) about an elderly man who finally releases his pet bird to the freedom he himself can't achieve. Johnny Lau was the creator of Mr. Kiasu, a popular local character that McDonald's restaurant promoted. Mr. Kiasu starred in both a feature film and a TV series. In the 1990s the Singapore government wanted to attract money to Singapore for new media, so they heavily supported schooling in animation, created the Singapore Animation Fiesta, and hosted the Asian MIP in 1998 to give Singapore producers and broadcasters a chance to sell their product. Animasia was founded in 1995 to create product as well as provide animation services. UTV produced the first Singapore-based cartoon, *Jo Kilat*, in 1998.

Early Philippine animation was experimental, special effects, or advertising. Cartoonists Jose Zaballa Santos and Francisco Reyes produced a folktale short, *Juan Tamad*, in 1955. Nonoy Marcelo made two films in the 1970s. The Marcos regime used animation for propaganda and was responsible for bringing in the first animation studio from Australia. That studio was a local branch of Burbank Films, founded in 1982. Other studios, which did mostly service work in the 1980s and 1990s, included Fil-Cartoons (originally founded by Hanna-Barbera) and ImagineAsia. In 1986 Gerardo A. Garcia founded GAGAVEP and made *Ang Panday*, the first local series. Toon City was set up by Disney in the late 1980s to handle

The fin-syn rules in the United States are repealed, allowing television networks to own their own programming. The animation industry in the United States consolidates, and major companies expand worldwide. Cable television expands as well.

1990s

Disney TV production. The Philippine Animation Studio (PASI) was founded in 1990, and it became the largest animation studio in the Philippines. PASI has developed original programming in addition to doing service work, and its original programming has aired locally. Top Draw was founded in 2000. By early in the twenty-first century some of the service work that had been done in the Philippines was going to India and China, where it could be done more cheaply. In the 1990s Tita Rosel, Ellen Ramos, Toger Tibon, and Kris Layug made films dealing with modern issues.

Animation in Australia and New Zealand

Australia's film history goes back to the nineteenth century, but animation came much later to Australia. Harry Julius animated political pieces during World War I, but it was mostly advertising that provided the occasional bit of work until the 1930s. The father of animation in Australia was Eric Porter. Porter worked on advertising spots and began his first film, *Waste Not, Want Not*, featuring Willie the Wombat, in 1937. It wasn't released until after the war. The animator joined Artransa Studios in 1956, organizing an animation department and training other animators. Later he founded his own Eric Porter Productions, making series for U.S. television and original series for Australia like *The Yellow House*. In 1973 Porter made the first Australian animated feature, *March Polo Jr. vs. the Red Dragon*.

Walter and Wendy Hucker founded Air Productions International (API) in 1959 in Sydney. By 1966 the company had made *King Arthur & the Square Knights of the Round Table*, the first series created and produced entirely in Australia. *A Christmas Carol*, produced in 1969, was aired on the U.S. network CBS.

Yoram Gross, born in Poland, made his first animated film *Chansons sans Paroles* in Israel in 1958. He left for Australia in 1968. In 1977 he released his first Dot feature, *Dot and the Kangaroo*, combining 2D animated characters with live-action backgrounds. As Yoram Gross-EM.TV, the company continued to make TV series (*The Adventures of Blinky Bill, Tabaluga*).

Hanna & Barbera Australia was founded in 1972. Animation could be done more cheaply in Australia than it could be done in the United States, and overseas studios could help ease the workload of the U.S. studio during busy seasons. The Australian studio was responsible for around 25 percent of the TV series work produced by the whole Hanna-Barbera company in the 1970s, and it also produced specials for local Australian TV before eventually closing in 1988.

Anne Jolliffe, who specialized in children's animation, founded Jollification Cartoon in 1980. Burbank Films (now Burbank Animation Studios) has made animated versions of the classics since the 1980s. Other companies that were active about that time were Fable Film, Southern Star, Nicholson Cartoon Productions, Second Banana Films, and the ATAM Animation Studios, which produced *Kaboodle* for the Australian Children's Television Foundation.

In the early 1990s Energee Entertainment produced *Crocadoo* and the feature *The Magic Pudding*, Animation Works produced *The Silver Brumby* and *The New Adventures*

31

of Ocean Girl, and Southern Star produced *Kangaroo Creek Gang*. In the 1990s Walt Disney Animation Australia was founded in Sydney. By the late 1990s most studios were working on international co-productions with Germany, France, and Canada. Productions included *John Callahan's QUADS!* (Animation Works/Nelvana), *Old Tom* (Yorum Gross EM-TV/Millimages), *Little Elvis and the Truckstoppers* (ACTF/Viska Toons), and *Yakkity Yak* (Kapow Pictures/Studio B). Newer studios like Light Knights (3D series *The Shapies*) and Freerange Animation (*Leunig*) sprang up, while smaller companies like Square 1 and BigKids Entertainment hoped to move beyond service work and sell their own animated projects.

Highly regarded independent filmmakers include Bruce Petty (*Leisure*), Sarah Watt (*Away with the Birds*), Antoinette Starkiewicz (*Putting on the Ritz, High Fidelity, Pussy Pumps Up*), and Lee Whitmore (*Ned Wethered*). Others are Denis Tupicoff (*Darra Dogs, His Mother's Voice*), Max Bannah (*Bird Brain, The Lone Sailor*), and Adam Elliot (*Harvie Krumpet*).

New Zealand animation began in the 1940s with the New Zealand National Film Unit producing titles and inserts for films. Len Lye had already left New Zealand to learn animation in Australia and make his films in England. Robert Morrow arrived from Great Britain and later founded the first New Zealand independent studio. In 1958 Fred O'Neill made *Plastimania*. He continued to make films, some based on Maori legends, and he made children's television series. Sam Harvey created the well-known sign-off *Good Night*, and in 1978 Murray Freeth produced *The Boy Who Bounced*. In 1976 David Waters founded the Paint Pot Film Studios, which in 1980 released *Rozzo the Goldminer*, the country's first animated series. Murray Ball made the first New Zealand animated feature, *Footrot Flats—The Dog's Tale* (with actual production done in Australia) in 1986. Euan Frizzell made many popular and award-winning films and TV episodes, including *The Great White Man Eating Shark* (short film), *Hairy Maclary Volumes 1 and 2* (home videos), and *Oscar and Friends* (TV series). Other filmmakers included Mark Winter, Murray Reece, Larry Nelson, and Robert Stenhouse (Oscar nominated for *The Frog, The Dog and the Devil*).

Animation in India

Early in the twentieth century Dhundiraj Govind "Dadasaheb" Phalke made the first animated film in India, *Agkadyanchi Mouj*. He had probably seen Emile Cohl's matchstick film. *The Pea Brothers*, directed by Gunamoy Banerjee, was released in theaters in 1934. Then in 1935 Mohan Bhavnani produced *Lafanga Longoor*. Indian Cartoon Pictures produced *Superman Myth* by G. K. Gokhale in 1939, and Gemini Studios produced *Cinema Kadamban*, supervised by N. Thanu in 1947.

In the 1940s the state-financed Films Division started up the Cartoon Film Unit, allowing continuous production of animation. Most of the films were social or educational, but a few art films were produced here as well. G. K. Gokhale and American Clair H. Weeks are credited with the unit's first film, *Banyan Tree*. Gokhale remained at the Cartoon Film Unit for almost twenty years but finally left to freelance and make his own films. The Cartoon

Film Unit produced *Radha and Krishna* in 1956, using miniature paintings of Indian art. Ram Mohan also worked at the Films Division until the late 1960s, when he left to join Prasad Productions as animation head. He founded his own company in 1972. Other important Films Division alumni included V. G. Samant, A. R. Sen (writer, designer, and animator), B. R. Shendge (artist), Shaila Paralkar (animator), G. H. Saraiya (animator), Rani D. Burra (director), Arun Gondale (artist), Bhimsain, Pramod Pati, Satam, and Suresh Naik.

Nina Sabnani and Binita Desai made films at the National Institute of Design. The Children's Film Society of India, set up by the government, produced many animated films. 2NZ produced the first animation series in India. Climb Films, founded by Bhimsain, was the first Indian company to specialize in computer animation. In the late 1990s animation in India grew. Toonz Animation in Trivandrum hosted an international festival. Another festival, the Mumbai International Festival, grew to be one of the largest short film festivals in the world. Studios like JadooWorks, Pentamedia Graphics, 2NZ (a division of Climb Media), Cine Magic, Digikore Studios, Padmalaya Telefilms Ltd., and MUV Technologies provided work for many animators. Some of these studios were also developing projects of their own. The Indian government and the chamber of commerce, in their attempts to expand the high-tech industry in India, have tried to reach out to the U.S. and Canadian animation industries.

Animation in Iran

Jafar Tejaratchi, who was later joined by filmmakers Esphandiar Ahmadieh and Parviz Osanloo, made the first frame-by-frame, animated films in Iran in the late 1950s. The Ministry of Culture and Art sponsored several of their films. Audiences discovered the new animation of the 1960s at the first Teheran Festival in 1966, and in 1969 the Institute for the Intellectual Development of Children and Young Adults opened a film department that specialized in animation. In the 1970s a center for experimental animation was founded, and a graduate program in animation was established at a local university. But animation halted during the fall of the Iranian Shah and didn't start up again until the mid-1980s, when once again it was sponsored by the Institute for the Intellectual Development of Children. Farshid Mesghali was one of the most famous animators, making many films (*Mister Monster, Look Again,* and *A Drop of Blood, a Drop of Oil*) in the 1970s and 1980s. Other important Iranian filmmakers included Ali-Akbar Sadeghi, Vajiholah Fard Moghadam, and Nooreddin Zarrinkelk.

Animation in Israel

In Israel in the 1950s small teams made animated films on commission along with a few experimental films. Yoram Gross made the first Israeli animated feature, *Joseph the Dreamer,* in 1961 before leaving for Australia. Production continued to grow. Animators turned out work for the Hebraic version of *Sesame Street,* for education, and for advertising, as well as for independent films. Animation divisions operated within Educational Television and National Television in the 1960s. Roni Oren's Frame by Frame studio specialized in puppet

films, using Plasticine, and David "Dudu" Shalita's Eyn Gedi Productions made educational films. Other important Israeli animators included Yossi Aboulafia, Arye Mambush, and Ytzhak Yoresh. In 2003 Israel was the first nation in the world to offer a Baby Channel, targeting viewers newborn to age three. Haim Saban, an Israeli composer, emigrated to the United States and later founded Saban Entertainment before moving on to buy out German media interests. Saban also bought a stake in the Baby Channel.

African Animation

One of the first African countries to produce animation was South Africa. *The Artist's Dream*, directed in 1916 by Harold Shaw, was South Africa's first animated film; it told a story about an artist whose drawings came to life. By 1920 I. W. Schlesinger's African Film Productions had produced five animated shorts, including *The Adventures of Ranger Focus* and *Crooks and Christmas*. Animators at Killarney Film Studios produced animated titles for the studio's films during the 1940s. In 1947 Denis Purchase arrived in South Africa and started making animated commercials for Alpha Film Studio. Most of the South African animation studios paid the bills by working in advertising. Alpha Studios and Dave McKey Animation produced thousands of animated commercials a year for many years. South African Broadcasting Corporation commissioned Butch Stoltz and Gerard Smith to make animated programs for them in 1975. They produced *Wolraad Woltemade, Bremenstadtmusikante, An Introduction to Dickens,* and others. In 1978 Gerard Smith and Denis Purchase, who both worked for Rentastudio, became partners. One of the first television series, *Bobby the Cat*, was produced. Unfortunately disinvestment, cultural isolation, and sanctions suppressed the animation industry. Despite these problems, William Kentridge made a series of films (*Pastry, Johannesburg—The Greatest City After Paris, Mine*), Peter Templeton made *My Eye,* and Riccardo Capecchi directed *Walk Tall* about South African miners, as well as other short films. Toward the end of the twentieth century studios like Magic Touch became active in computer animation. Triggerfish Animation (stop-motion and Flash-for-Broadcast) was founded in 1996 by director Jacquie Trowell and Emma Kaye. After the millennium studios such as Anamazing Workshop, AnimMate, Bluehouse, Lovebomb, Skyscraper TV & Web, Art in Motion, and Wicked Pixels (founded in 1997) continued the animation tradition. Although there is still a heavy Disney influence, with the birth of democracy and a new South Africa, many companies, like trendsetter Triggerfish, are returning to a more African aesthetic.

The Frenkel brothers in Egypt made their first film in 1936 after seeing the films of Felix the Cat. They then completed a series of films about Mish-Mish, an Egyptian boy wearing a fez. Politics drove the Jewish brothers out of Egypt, but David Frenkel emigrated to France and transformed Mish-Mish into Mimiche, selling new films for family events. Antoine Selim Ibrahim made animated films in Egypt in the 1930s and 1940s before working in the United States in the 1970s. In 1961 an animation unit was formed for the year-old Egyptian television industry. Hassan Hakem, Mustafa Hussein, and Halim Berguini animated the short *Titi and Rashouane* in 1958; Ali Mohib made *The White Line* for TV; and Alfred Mikhail and Mohamed Hassan created *The Little Magician* in 1963. Ihab Shaker made films in Egypt

Beauty and the Beast, the first animated feature to be
nominated for an Academy Award, is released.

1990

and France. Other noted Egyptian animators were Noshi Iskandar and a woman filmmaker, Mona Abo El Nasr.

Mongi Sancho, Nacer Khemir, and Samir Besbes all made animated films in Tunisia. Mahjoub Zouhair produced films and twelve episodes of the TV series *Les Aventures de Hatem, le courageux cavalier Zlass.* In Algeria, the father of animation there, Mohamed Aram, made his first film in 1963. He taught himself to animate and made his own equipment. In 1964 he formed a team at Centre National du Cinema. He founded his own studio in 1976 and made films like *H'Mimo et les allumettes, L'olivier justicier, Adrar,* and *Sema.* In Niger Moustapha Alassane drew directly on film stock because he lacked equipment. Many of his films were made during the 1960s and 1970s. In Liberia, after television was born, Jefferson Abruzi Zeon led a department of graphic arts at the Liberian Broadcasting System and made several short films. In Ghana Alex Bannerman made *Windfall* and *Don't Waste Water.* The National Film and Television Institute made a handful of animated films during the 1980s. In Zaire (now the Democratic Republic of the Congo), Alexandre Vandenheuvel and Roger Tamar made seven films between 1951 and 1956. They were broadcast for some time on Zaire Television. Jean-Michel Ndjaie Wooto Kibushi and Mohamed Soudani (who lived in Switzerland but was from Zaire) also made films. In 2003 Roger Hawkin's *The Legend of the Sky Kingdom* (Zimbabwe), made with found objects, was shown at Annecy. Animators were working on films or in TV all over Africa—in Senegal, Ivory Coast (for years Ivory Coast artists worked abroad, not in their home country), Togo, Burkina, Mali, Burundi, Zambia, Mozambique, and Mauritius as well.

Animation in South America, Central America, and Mexico

In 1916 producer Federico Valle wanted a one-minute political satire drawn for his newsreel in Argentina, so he hired twenty-year-old Quirino Cristiani, a caricaturist, to do the job. It was so successful that Valle made a full-length political satire *El Apóstol* and released it in 1917. Alfonso de Laferrère wrote the text of this first animated feature made anywhere. Cristiani made more films, including *Peludópolis,* the world's first animated sound feature, released in 1931. Andrés Ducaud made other films for Valle. Both Juan Oliva and Dante Quinterno produced animation with limited success in the 1930s and 1940s. José M. Burone Bruché made films in the 1940s; Victor Iturralde Rúa, José Arcuri, and Rodolfo Julio Bardi made avant-garde films in the 1950s; and Carlos Gonzáles Groppa made puppet films. In the 1960s and 1970s as many as 450 animated advertising minutes were produced a year in Argentina. Then animator Manuel García founded a publishing and TV production empire in the 1960s, producing many animated TV series. In the 1970s Jorge "Catú" Martin directed more than 200 animated shorts. And the Patagonik Film Group in Buenos Aires produced the film *Patoruzito,* distributed in 2004.

In Chile Grafilms was founded in 1978 by Alvaro Arce and Enrique Bustamante. The company made miniseries and commercials and trained a generation of animators until 1984. Cineanimadores produced the first Chilean animated feature film, *Ogu y Mampato en Rapa Nui,* released in 2002. At Arce Studios and EMU Films Alvaro Arce and Ricardo

35

Amunategui released another feature, *Cesante*, in 2003. ChileAnimación, a service studio, produced animation for U.S. TV. Independents Vivienne Barry (*Nostalgias de Dresden*, 1990) and Thomas Wells made shorts. A free trade agreement between Chile and the United States was signed in 2003.

The first Brazilian animated film was *O Kaiser* by caricaturist Seth (Álvaro Marins) in 1916. It was followed by a second film almost right away, but the only animation produced for many years thereafter was advertising. During the 1930s and 1940s several animators made short films. Anélio Latini Filho animated the first Brazilian feature in 1953: *Sinfônia amazônica*. He learned animation by reading manuals and watching North American films. Avant-garde artists Roberto Miller, Rubens Francisco Lucchetti, and Bassano Vaccarini made films influenced by Norman McLaren in the 1950s. Yppe Nakashima produced the TV series *Papa Papo* and some shorts in the 1950s, followed by the animated feature *As avênturas de Piconzé*, made in collaboration with João Luiz Araújo and Sylvio Renoldi in 1972. The young artists of the Cêntro de Estudos do Cinêma de Animação and Fotogramas produced more shorts during the late 1960s. During the 1970s and 1980s Ernesto Stilpen, Antônio Moreno, and Marcos Magalhães won awards with their films. About the same time the comic strip artist Maurício De Sôusa produced animated TV shorts and features about his characters, Mônica, Magali, and their friends. In Brazil the Anima Mundi animation festival brought in animators from around the world.

Cora Film opened an animation department for advertising in Bogotá, Colombia, in the 1960s. Nelson Ramirez at Producciones was a pioneer in Colombian character animation. (Shorts are a Colombian staple.) Cartoonist Ernesto Franco and animator Luis Enrique Castillo made shorts first, and later, in the 1980s, Philip and Magdalena Massonat and Carlos Eduardo Santa also made them. Animator Fernando Laverde made puppet shorts and a feature *La pobre viejecita* in the 1970s and then his most famous film, *Martin Fierro* (1988), made in co-production with animators in Argentina and Cuba. Studios like LEPIXMA and Toonka Films made shorts shown in festivals and created animation for TV. Younger animators like Miguel Alejandro Bohórquez Nates returned to the Colombian staple, making shorts for the Internet.

Cartoonist Manuel Alonso fathered Cuban animation with his short *Napoleón, el faraón de los sinsabores* in 1937. In Santiago de Cuba a group led by César Cruz Barrios was founded, and they made the first Cuban color short *El hijo de la ciencia* (1947). In 1959, after the Cuban revolution, an animation division was founded in the new Instituto Cubano de Arte y Industria Cinematográficos (ICAIC) and led by Jesús de Armas. The films produced were mainly social and political. The mid-1960s saw the output of mostly educational films, but Luis Rogelio Nogueras produced a pacifist film, and Hernán Henríquez adapted a folktale. The ICAIC was restructured in the 1970s to produce films for children, fantasy films with little dialogue for the youngest, and action and adventure for those eight to fourteen. In the 1980s animators began to make films for adults with more experimentation in style. Important Cuban animators include Tulio Raggi, Mario Rivas, and Juan Padrón.

Mexican animation first became popular in the 1940s. Caricolor and Cinemuñecos were founded. Animators like Ernesto Terrazas, Rodolfo Zamora, and Ernesto López worked in the 1950s at a company started by R. K. Thompkins. Later they moved to Gamma Pro-

ducciones. Television provided work for new companies like the Canto brothers' Producciones Kinema, Harvey Siegel's Caleidoscopio, and the companies founded by Daniel Burgos and Dan McManus. Important animators in the 1970s and 1980s include Enrique Escalona (*Tlacuilo*) and Fernando Ruiz, who made *Los tres reyes magos* (1976), the first Mexican feature. *Magos y Gigantes* (2003) from Anima Studios was the first fully digital animated film from Mexico.

Globalization

Some animators worked internationally. Lotte Reiniger continued to make films in Germany, Italy, Great Britain, and Canada into the 1970s. Berthoid Bartosch made films in Vienna, Berlin, and France. George Pal, a Hungarian, worked in Berlin at UFA, in the Netherlands, and in the United States, where he was known for his outstanding *Puppetoons* and his expertise in special effects. Oskar Fischinger made films in Germany and the United States. His films were abstract art linked to music, and it was his work that inspired portions of Disney's *Fantasia*. Born in Russia, Alexandre Alexeïeff made haunting, experimental films with Claire Parker, working in France, Canada, and the United States. Alexeïeff is known especially for his pinscreen films. His masterpiece was *A Night on Bald Mountain*. Norman McLaren was another international animator, and in addition to his work with the National Film Board in Canada, he made nonobjective art films (like *Blinkity Blank*) in Scotland, England, Canada, and the United States. Some of his films were painted directly on film stock. Animators now more than ever go where the work is, or they work in one country on their computer and deliver the work digitally anywhere in the world.

The world seems very small today. The invention of modern forms of transportation changed the way the average person lived and the way he thought. Until the early part of the twentieth century most people never ventured more than a few miles from home. Normal travel was determined by the distance one's feet could walk or one's horse could gallop. During World Wars I and II thousands of average men went around the world to fight and came home with a new perspective on life. Farm boys and girls moved to the big city. For many reasons people all over the world immigrated to new lands, and they're still on the move. The advent of radio and television made us more aware of what others around the world were doing and thinking. It is now very common to vacation in other lands. Phones and the Internet allow us to communicate on a daily basis with anyone, anywhere. Satellites deliver media from around the world. It's impossible for almost anyone to remain unchanged by cultural influences from other lands. Big corporations do business internationally. The products and services of each country must be able to compete with the products and services of companies around the world. Many countries have sponsored animation companies directly; others give incentives or large tax credits for employing workers from their own country. Companies in countries that don't have access to this kind of help from their governments find it hard to compete. When something affects the economy of one country, those changes affect economies around the world. In a very short time the world has seen huge changes because of globalization. For good or for bad, we will never be the same.

Shrek 2 becomes the highest grossing animated film of all time.

 Exercises

1. Pick an individual or studio and do more research in the library or on the Internet.

2. Choose a location or a time period, and do more research in this area. You might want to research some areas that this history was unable to cover.

3. Research the history of animated video games.

4. Watch an old animated cartoon or feature film. How is it different from current animation?

5. How does animation history relate to you? Does it let you understand the animation industry better? Does it inspire you to see some old films? Does it give you any ideas about what you personally want to do?

6. Were writers important to early animated films? Explain. Are they important to most animation today? Why? Discuss this in class.

7. In what ways has technology influenced animation?

8. Who and what do you think are the important influences on animation today? Discuss.

9. Write a short animation script using information from this chapter. Will you stick to the facts and write something educational? Or will you use the facts as a starting place for a fictional story? You may need to do more research before you begin.

10. Can you think of a way to make animated films that wasn't discussed here?

11. Do research that will help you in making a student film.

CHAPTER 3

Finding Ideas

Where Do Ideas Come From?

Ideas can come from anywhere, so be open to all possibilities. Keep a notebook with you to jot down the best ones. Often when you're working on a project, good ideas come to you at night. You might want to keep a notebook, pencil, and flashlight by your bed. I've found that when I'm blocked, if I can put my work away for a day or two, the idea that I'm looking for will surface on its own. Your subconscious keeps working away at the problem until it comes up with an answer.

Think about your own experiences because this is what you *know*. What stands out in your life? How do you feel about the people in your life? Would any of them make good animation characters? What makes you angry? What makes you happy? What's important to you? Are there sounds that frighten you? Think about smells that bring memories. What do you like to touch? Use your emotions and all your senses.

Go back to your childhood. What do you remember most? Why? What problems did you have? What made you cry? What made you proud? What did you love to do? What made you laugh? What bullies did you encounter, and what did they do to you? Who were your best friends? How did you spend your summers? What trouble did you get into and why? The life of a very young child is centered around daily routines. What were the emotions, sights, sounds, and smells of *your* childhood? Do you have any interesting family stories or family myths? What did you care about? What did you wish for? What were your dreams?

Search for a crowd, find a place to sit, and watch the world go by. Choose a park or playground, a shopping mall, the zoo. Or make up stories about the people in line at the grocery store or those in the cars on the freeway. Some places are more charged with opportunity than others: hospitals, police stations, juvenile court, weddings, funerals. Pick any passing person and make up a story about him. Maybe someone reminds you of someone else you know. Give your subject a personality based on what you see. Judge attitude, body language, and dress. How does your subject talk? Whom is she with, and what is their relationship? Why are those people there? What terrible or funny thing just happened? What will happen next?

Photos and Drawings

Look at photos in magazines. What's the story there? Tell a tale. Why are the men huddled on the park bench? What are they discussing? Those boxes stacked in the warehouse . . . where are they going from here? Who's going to pick them up? Where were they previously? Why are they so important? What happened just before that photograph was taken? What will happen afterward? Why does that little girl look so sad? Who just left and why?

If you're an artist, you might want to start the ideas flowing by drawing or doodling. It could be easier for you to think visually. You may prefer to draw funny characters or funny situations and gags. Don't be afraid to combine unrelated things from different drawings. Mix and match.

Research

Save articles from newspapers and magazines that stimulate ideas. What are the current trends? Make a list. What's popular with kids now? Save design styles from photos, drawings, or advertisements. Classified ads provide stories of their own. Why did the previous employee lose this job? Why is that diamond ring for sale? Why is someone moving? Make up alternate endings to news stories. How does it affect others? Place your own characters in those stories, or place yourself there. What if nothing had happened?

Surf the Internet. Let one interesting site lead you to something else of interest. Where's the story here? What kinds of characters would be in this environment? What would they be doing? Research any facts that you might need about something that's new to you. Do you get e-mail jokes? Maybe there's a story to be developed there! Visit artists' websites for styles.

Do you have a library of books at home? Maybe there are ideas there. The Bible is great for plots. Update or put a twist in Bible stories. Insert new characters. Mythology and fairy tales provide some great plots as well.

Go to a local or university library, and find something that interests you. Research a different time period or culture. Make a list of quotations that can be used as themes, idea starters, or gags. Skim through the design and art magazines. Browse the medical or legal libraries.

Haunt the bookstores. Buy a joke book and update or rewrite some of the jokes, using different characters, a different location, or a different theme. Find old magazine cartoons and give them a new twist (the dog in the window becomes a duck on a computer website).

Play in toy stores. Go to museums. Read comic books, science fiction, fantasy, and children's stories. Let those inform you and stimulate your imagination.

Subscribe to magazines about technology and the future. What's new? What do the scientists, planners, and politicians predict? What are the social implications of each new technology and the scientific discoveries of today? How might they be used? How could they be misused? Can you take that technology one step further? Let your imagination go wild. What does government planning predict? Attend expositions and lectures that feature respected scientists and planners. New developments stimulate science fiction and **high-concept** ideas.

Files

Start with a three-ringed notebook binder that uses $6 \times 9\frac{1}{2}$-inch paper. (It's an easy size to keep with you most of the time.) When it gets full, transfer the material to files. You'll need one notebook section or file for characters and another for plots. Keep one for snips of ideas or idea starters. Make another one for themes. You'll need one for people and animals, one for places, and another for props used by your characters. (I keep one for clichés, but if you have a good book on clichés, then you might not need the file). You might want a file for your dreams, and you might want to keep lists of interesting characters from funny real-life occupations, unusual behavior, and interesting or funny real-life details. You could keep a list of funny situations or descriptive or humorous names you've made up. How about a list of funny original titles? You'll want a file for design styles and other artwork. Keep anything that may be of help in a file.

Brainstorm

I found that when I was freelancing, I would run into the same kinds of categories over and over again. Cartoons were focused on the school environment, or there were stories about dogs or cats. There were others about the circus. There were mysteries and westerns. Each time I had to brainstorm ideas about a category again from scratch. So I made lists of things that centered on each concept. Under "school" I listed teacher, student, desk, pencil, eraser, chalkboard, dry erase board, chalk, marker, recess, homework—you get the idea. Pay particular attention to things you can use as props. This will help with the gags. The lists also help with plots and titles. I kept these files in my notebook for the next time I needed them.

Brainstorm ideas about a setting. What's funny about it? What's its history? What happened there? Make up stories about objects. How were these objects used? Did they somehow have a place in history? Did someone else play with that toy long before? What was that glass bottle before it was recycled? And that sheet of paper—where was the tree that provided it? What may it have seen in the forest?

Ask yourself, "What would happen if . . . ?" Make up relationships between two strangers. Give personalities and stories to toys and other inanimate objects. Imagine what could happen if your pets could talk or what would happen if an important event turned out differently? What if two people had never met? What would happen if your hero had made one different choice in his life? Make up a complete fantasy world with fantasy creatures and technology. Lay down rules for how the world operates, and stay true to them.

When you're brainstorming, don't edit. Write down everything as fast as you can, and edit out the unusable stuff later. If you edit as you go, you may destroy the good ideas along with the bad. You're looking for as many ideas or as many different ways of looking at your creative problem as you can find. Include the unique, the impractical, and the silly. Take a new and different approach; look at things from different perspectives. Come up with variations on a theme. Combine ideas. The more ideas you initially produce, the better chances you have of coming up with something unique, personal, and good.

People, Places, and Things

Cartoonists used to make three columns:

- People or animals
- Places
- Things

Then they would often pick one item at random from each column, juxtaposing and combining totally different ideas. You place the unexpected in an unexpected context and the obvious where it's least expected. You create surprising relationships. This is a great way to come up with original plots and write gags. What is that green rabbit doing in the desert with a pound of cheese? You can use other combinations as well. What about two characters, an adverb, and a place, or a theme, three characters, and a verb? Go wild!

PEOPLE	PLACES	THINGS
green rabbit with pink eyes	Africa	merry-go-round horse
Abraham Lincoln	desert	stick of licorice
spotted dog	circus	pound of cheese
old man	downtown	purple balloon
Susie Suckup	in a rabbit hole	jump rope
seven spotted sea lions	at the bottom of the sea	red rose
Petunia Pup	inside a tent	computer
Giles the Giant	Hollywood	pink pointed pincers
Reba the Rebel	behind a potted palm	striped box
Jason the Argonaut	North Pole	Scotsman's kilt
bald baby	floating on a cloud	boomerang
Terrible Teddy	school	jack-in-the-box
police detective	red firehouse	puff of smoke
substitute teacher	inside a book	purple pillow
headless horseman	riding a kite (first class)	kazoo
Sally Forth	Camp Kittywampus	sour pickle
nanny	in the kitchen	CIA file
chess king	deserted swamp	pink poodle skirt
mom	world's largest store	pencil box
fairy princess	amusement park	spy glass
May B. Knott	on top of the Eiffel Tower	zebra striped pajamas
mean landlord	inside a volcano	wet noodle
two-headed orange giraffe	approaching the dog star	ostrich feather
Alien Zorch	in a closet	kaleidoscope
troll	Timbuktu	saddle
Morph the Monster	castle	cell phone
Queen Victoria	in a maze	scroll

PEOPLE	PLACES	THINGS
Santa Claus	at the movies	suit of armor
carjacker	fast food, drive-in window	hammock
Percival the Parrot	inside a motor home	birthday cake
cowboy	on an escalator	boom box
robot chicken plucker	at a space station	player piano
lion tamer	jungle island	hot potato
tooth fairy	atop a flagpole	skateboard
T-Bone Tony	Shape-of-Things Gym	tuft of monkey fur
reality show participant	Australian Outback	tiddlywinks
truffle pig	secret garden	sparkler
Muck Muck Monster	salt mine	oil lamp
bride	playground	magic beans
wizard	inside a seashell	laser sword
Cherie Shipshape	airship hangar	Slinky
soccer player	pirate ship	doll house
unicorn	Planet Doom	necklace of kelp

Plots

Find a list of classic plots. Many experts believe there are only so many basic plots and all stories are based on these few (like the Cinderella plot). Some believe that all plots can be broken down to only three: Man vs. God (or nature), Man vs. Man, and Man vs. Himself. Update old stories. Substitute your own characters. Since stories are usually developed out of a character's personality, new characters make an entirely new story. Each character has unique values, motivations, and relationships and makes decisions accordingly. Place your story in a different time period or place, or put a new twist on it. Spoof a story we all know.

Evaluating Your Ideas

Writing teachers have always advised their students to write what they're passionate about. The theory is that you will write with more conviction and more originality, providing your audience with a very personal and emotional experience—your very best work. This can be excellent advice if you're looking for ideas for a student film, an independent film, or even an original TV series. I would agree that the very best ideas might be those that are interesting to you, those that you want to explore further and spend some time investigating.

Once past the brainstorming process, it's time to evaluate your ideas. Some people climb a mountain "because it's there." Ideas are not mountains, and they should never be used just because they're there. Sometimes an idea hasn't been used before simply because a hundred other people have considered the idea and decided it wasn't a very good one. Ideas must fit the current marketplace. And "pushing the envelope" can be a good thing, but there are envelopes that are better left sealed . . . with superglue. When we get to development, we'll look at ways to evaluate what ideas are best to develop now.

 Exercises

1. After people-watching in a public place, expand the actions of two or more people into a simple story situation with conflict.

2. Using the basic situation you developed in exercise 1, exaggerate the real people that inspired you until you make two original characters reacting as only they would.

3. Now put two entirely different characters into the same story you made in exercise 2. How do the new personalities change the story and the conflict?

4. Make up a funny situation using funny characters.

5. Think about your childhood. Recall a situation or event from back then. What did you see? What did you hear? Was the weather hot or cold? Who was there? What could you smell, and taste, and touch? What were your emotions? How did you feel? Why do you think you still remember this incident?

6. Choose an event that happened recently. Write about it as if you were five years old, or ten, or sixteen.

7. Can you give more suggestions for coming up with new ideas?

8. Create your own idea notebook using some of the suggestions in this chapter. Make the notebook useful for you, personally.

9. Start files with clippings for later use for stories.

10. What makes you angry, sad, or passionate? Write a simple fictional story using those feelings.

11. Read a book or magazine while you're listening to talk radio or TV. Does combining these two sources of information give you any unique ideas?

12. Make up a short story from a quotation or from a sentence of original dialogue.

13. Take the list of people/animals, places, and things and transfer each item to a separate index card. Place the cards in three different bags (one for people/animals, one for places, and one for things). Break up the class into groups of five to seven people each. Someone from each group will draw out one card from each bag. Each group collaborates on a story combining the three ideas on the index cards.

14. Using the list of people/animals, places, and things, make up a story for an original animated short.

15. Begin to think about characters and concrete ideas for a student film.

Human Development

Introduction

This chapter examines some of the basics of human development to help you better know and understand your audience. The audience for animation seems to be constantly increasing in many **demographics**, with a growing acceptance of animation by adults, but the primary audience is still children. Advertisers prefer to target children from ages six to eleven or twelve. Consequently most television cartoon shows have been aimed at these ages as well.

Television programmers look for cartoons that are kid-relatable, with characters and situations that provide an immediate connection for the children who watch. Programmers and advertisers expect a large audience of their target age group. Governments and child development specialists expect media for kids to meet children's developmental needs. Creators and writers want to provide entertainment that kids enjoy. Do you remember what it was like to be a kid?

There are several areas of development to consider:

- Physical development

- Emotional development

- Social development

- Cognitive development (using the brain to acquire information about the world and learning to get through daily life)

- Metacognitive development (thinking about thinking, problem solving)

- Creative and artistic development

- Moral, spiritual, and ethical development.

Get to know children personally to find out what they like and dislike at different ages. Volunteer at Scouts, Little League, soccer, or other children's activities. Watch children at

45

play. Better yet, borrow a young cousin for the day. Talk to him. Listen. Hang out. Children do not all develop at the same rate, and each child is unique, so the following is just a rough guide. In this world of growing global media, children are learning more and experiencing more at an earlier age.

The First Year

Babies start to learn early. Their earliest fears are falling, separation, and strangers. Parents help their babies to face these fears and learn to handle them. By the baby's second month she is already learning through her senses to differentiate between objects. A baby will follow a moving person or look at a light as early as six weeks of age. He'll be soothed by music or a voice by around three to four months. Early on, a baby learns that he can cause things to happen: Mother will feed him when he cries, and with some effort, he may be able to get a pacifier into his mouth. Eyes start to focus in the early months. Babies learn to repeat behavior that brings a good response. And infants who are still unable to sit up by themselves might eagerly watch the changing patterns of light and color on TV. Between the fourth and eighth months babies are able to coordinate vision and grasp. They will play with anything that is in their reach: fingers, toes, mobiles, toys, Mom's hair and nose. They begin to recognize objects, and before they're one year old they begin to recognize that objects can cause effects. Babies prefer the human voice to other sounds, the human face to patterns. They'll play simple peek-a-boo games and enjoy an audience of family, although they may begin to distrust strangers. The psychoanalyst Erik Erickson believed that the key issue in the first six months of life was the development of trust in a child.

Learning is taking place by first noticing a rough "sketch" of a new object, then filling in more details with each additional encounter so that a baby learns "furry thing" first, then "dog," then "my dog Spot." Simple skills of any kind are practiced; then variations are performed: standing, walking, later skipping, hopping, and jumping. By the end of the first year most babies can probably stand and may walk. Babies learn language through listening to others, especially those important to them. They need to hear lots of soothing and nurturing sounds. Researchers have discovered that infants are capable of communication long before they say much. Parents who began to teach their six- to eight-month-old baby simple sign language have been rewarded with infants who can sign words and simple sentences in three to ten weeks. By the end of the first year babies can repeat a simple word or even a few.

Toddlers (Ages One to Three)

Each child is starting to look outward and discover the immediate world (home and family) around him. This is still a very vulnerable and dependent stage, and the child needs to develop a sense of emotional security from Mom and Dad especially. They will help him face his fears, like the second-year fear of the doctor and the shots she gives. A child needs sensory stimulation. He needs to be able to practice newfound skills uninterrupted and within the window of opportunity in which this particular learning process naturally appears and develops. This is a tremendous period of learning. Children learn to solve problems

through trial and error. Everything is brand new, and the toddler likes and needs to explore and touch and taste.

Language develops. A first child will likely learn language primarily from his mother. Later children might have less time with their mothers but will learn language from their older siblings as well, and their early language may reflect these differences. Individual words may be spoken less clearly, but the child could be speaking in distinct sentences earlier.

A toddler needs reassurance and also limits. He needs safety and affection. Both girls and boys like nonthreatening and loving characters on TV and in toys, and they tend to relate to the way these characters look and feel. By the age of two they'll recognize and relate to a stuffed Elmo or Barney.

Around this age come the "terrible twos." The toddler wants to do everything himself (although he may still be incapable of many skills), resulting in out-of-bounds behavior and temper tantrums. Children may pay no attention to what they are asked to do, or they may say "no" to everything. They are learning independence. Tired or hungry toddlers are likely to morph into difficult toddlers—the Tantrum Monsters right out of a mother's nightmares. Children can fear noises, animals, the water swirling down the drain. During the first three years of life a child may not have matured enough to make necessary judgments about right and wrong. The life of a child of this age is centered on himself. There is still much wiggling, laughing, squealing, and crying. The key issue, according to Erickson, is autonomy, asserting independence.

Toddlers are beginning to learn social skills: some sharing, loving, self-control. Some children at this age already attend playgroups, mommy-and-me get-togethers, or classes with simple gymnastics or music. But at this time there is not much cooperative play between children. They will probably play side by side rather than together.

Children at this age are easily distracted, but they may be interested in something for a considerable period of time *if* they are learning things that appeal to them. Experts believe that the critical period for early musical learning is not until around age two and a half, but earlier involvement with music could help with the development of logic and math skills. There appears to be some correlation. Toddlers might enjoy watching TV, especially if there is interactivity (such as singing and dancing) and reassuring characters. They enjoy the simple humor of surprise (the jack-in-the-box, simple slapstick), but they quickly become overexcited and overtired. Because learning takes processing time, and young children have all the time in the world, activities and learning should be paced more slowly and simply.

Preschool (Ages Three to Five)

Thinking is no longer limited to immediate perception and motor activities. A child can play out scenarios in his head. Thinking is still centered on the child herself, but by age three many children can communicate well. Toilet training is complete or almost complete. The "terrible twos" are over, and most children want to do things the correct way. They conform to routines.

The majority of children this age will still play side by side rather than together. There is still much wiggling, shoving, hitting, running, and jumping. Sharing is hard to do. Preschoolers may boss others and tattle to adults. They might show off. They'll probably grumble and whine. They could be pokey and impossible to hurry along. The younger preschoolers may appreciate a slower pace than the older ones.

There is evidence that by age three children can identify their own gender, and studies of this age show that boys and girls already play differently. Male play is more aggressive; female play is centered more on relationships, and it's more nurturing. Male play tends to involve the larger muscles; female play tends to use more of the fine motor skills.

Play is imaginative. Preschoolers may tell stories that aren't true. There is interest in books and learning. Some may learn their ABCs. From age three to seven fantasy and pretend are at their peek. Children build playhouses out of blankets and cushions or forts out of tree branches and cardboard boxes. Toys and media can have nurturing effects (like Barney and Dora the Explorer). Children identify with characters and see them as being like them (the Little Mermaid), or they might want to grow up to *be* like characters (Barbie, Superman), or they could be attracted to the dark side of characters (Darth Vader). Sometimes children like toys or characters that they in turn can nurture (baby dolls) or control (action figures). Transformation is appealing to children because of the fantasy involved and because kids want to believe that they can become anything they choose. Of course even at three children don't really believe that they can literally transform like toys. Physical power for those three to seven has a large appeal because they don't have much power of any kind themselves. This age group needs entertainment and stimulation.

The senses are still important. A strange sound can be frightening, but bells and whistles are great! Preschoolers like primary colors, and they love flash (high-tech and special effects, sparkling makeup and glittering jewelry).

From three through seven most children like slapstick and physical humor, sudden surprise, and action. This age also enjoys putdowns and name calling. Interest is still in the immediate neighborhood and familiar everyday things. Children might be afraid of animals, imagined monsters, or other children who seem different from what they know, such as kids with disabilities. New places and distant time periods are usually of little interest. Preschoolers probably have their own friends. Many go to school, organized sports, or music or dance lessons. They like humor and "pooh-pooh" jokes. Around age four or five children may be so confident in their own opinions that they either love or hate everything. Five-year-olds might have already outgrown the Sesame Street gang.

There's a focus on the development of the right brain from ages three or four through six. This is the area of emotional development, of imagination, of artistic and musical development. The first five or six years the brain establishes a structure to know oneself, and language skills are developed enough to communicate and learn about the world.

A key issue for this age group is initiative, a balance of freedom and responsibility with spontaneity. All children from three to seven need lots of love. They're still bonding with their parents and establishing a foundation of trust. And they need to feel safe; for a few children scary movies can still seem very real. Often between the ages of three and ten, imaginary friends appear to even the most social children. They will disappear again for good at some point.

Age Five

Most five-year-olds are eager to start kindergarten, but some may still be anxious about leaving their parents. Some might still be unable to sit still for long and have trouble following instructions. Some may still have trouble with up and down, right and left, or mirror

image letters, although many will have learned to read before they are six. Most like to learn and to practice, be factual and be accurate. They like to explore what interests them. They're capable of self-criticism. Many still have trouble telling time, tying shoes, putting on a coat, and crossing the street safely. Five-year-olds might still need a nap. Most are calmer than they were at age four, but school may be stressful, resulting in stomachaches.

Kindergartners love games like Duck, Duck, Goose and Ring Around the Rosie. Boys three through seven identify with characters like firefighters, police officers, train engineers, doctors, teachers, kings, knights, sports figures, magicians, soldiers, adventurers, superheroes, funny animal characters (like Bugs Bunny), and male family members. Girls the same ages identify with dancers, ice-skaters, female fashion doll characters (like Barbie), entertainment icons, brides, princesses, good fairies, magicians, horse trainers, teachers, babies, cooks, and female family members. Three- through seven-year-old males are interested in places like the zoo, the jungle, the circus, carnivals and amusement parks, hospitals, fire stations, police stations, farms, beaches, raceways, stores, gas stations, outer space, and prehistoric times. Girls the same ages are interested in home, friends' homes, castles, dollhouses, toy stores, amusement parks, the circus, farms, schools, the stage, elegant balls, and parks.

Age Six

Play is a good indication of what six-year-olds are thinking, although they rarely play freely in front of adults. This is typically a brash and aggressive age. The use of shock words increases. Six-year-olds could be curious about sex; they might play at marriage. Gender becomes important, and girls tend to play with girls and boys with boys. Grade-school-age boys are more antigirl than girls this age are antiboy. Boys begin to test each other. Who can run the fastest or hold their breath the longest? Six-year-olds usually like physical activities. They may fear change, like old stories read and reread. They want the opportunity to choose their own friends, and language is used more in a social context. They probably like imaginative rhythms. Fantasy and a love of magic are still strong. From three to seven children can identify easily with animals. They enjoy anthropomorphism, giving animals and objects human characteristics.

The child of six often sees people and events as either all good or all bad, since kids from three to seven are likely to fix on a single aspect of anyone or anything they encounter. This fixation includes things like a shiny star, a bright red heart on a doll, or big eyes on a favorite TV character. They will choose toys or television shows on the basis of this one attribute. Also, somewhere around ages five to seven, children become very aware of what is "in" or what is "out." A few girls are already beginning to outgrow animation.

Six-year-olds may be defiant about routines and say, "Make me!" They might have trouble choosing what they'll wear or eat. They could look untidy and have a short attention span. Children are likely to be size and shape conscious. Arguing and lying to escape punishment are normal as is breaking a promise. Six-year-olds may steal small items and begin to ask questions about death. They're apt to be insecure and need frequent praise and assurances of love.

Skills may vary a great deal. Most three- to seven-year-olds can't retrace their thinking processes, so logic skills are still absent. The three- to seven-year-old might be impulsive and reactive rather than logical, although the logical left brain is starting to develop in some. A

six-year-old may be expected to develop reading and math skills way beyond what their parents had at this age.

Age Seven

Seven is a more withdrawn age, a time of introversion and calming down. Growth has slowed. Most seven-year-olds are very aware of their own bodies and might dread exposure and public bathrooms. They may want their own bedroom. This is a good age for pets and nature, but it's also an age for complaining, with many worries, tensions, and fears (ghosts, what's under the bed). When life is going badly, the seven-year-old could feel that his teacher hates him, others are cheating at games, and that his parents are unfair with resulting name calling and pouting. Seven-year-olds are still searching for a best friend, but boys and girls get along well together. Children this age are beginning to understand abstract concepts like good and evil. They still tend to accept a view of good and evil that they've learned from someone else (parents, church, superheroes). They begin to take into account someone else's point of view.

This is the peak of dramatic play. The unlimited fantasy of earlier years is being replaced by a more realistic fantasy that is based on logic with more plausible scenarios. Characters like Barbie that were appealing earlier because of their fantasy value are still appealing to the post-seven-year-old because of their more realistic qualities. Big Bird remains behind. The typical seven-year-old probably still likes strenuous physical activity, but he also loves to watch TV, listen to the radio, and read.

Somewhere around age seven the part of the brain that controls autonomic functions (breathing, heartbeat) is almost completely developed. The right brain continues to mature. Other parts of the brain (including the left, logical areas) start developing so that the child can reason and use logic. Serious collecting (as opposed to stockpiling all stuff) usually starts after this age, since it requires more logical thinking ability.

Age Eight

Eight is the beginning of the **tween** stage (eight to twelve or thirteen), a transition between kid and teen. Children are becoming savvy at increasingly younger ages. Girls generally enter the tween stage before boys and leave it sooner as well. Tweens are a force to deal with in films, music, television, and toys. Already kids are identifying with teens. Social development is rapid during this age. The left brain is developing quickly as well. Eight-year-olds are beginning to accept authority and may choose a pretty teacher for their friend. They respect a teacher's knowledge, but they especially like ones who can joke and laugh with them. They enjoy slapstick humor. They like **edgy** and irreverent humor, and they're beginning to appreciate more sophisticated humor forms. They like characters that are realistic or off-the-wall. They appreciate characters with sarcasm and irreverence. And boys, especially, like what is gross and pushes the envelope. They have an attraction to horror, violence, and the taboo.

Children are again more social. Tweens tend to play extensively in pairs and groups. Children this age are interested in relationships and will keep a friend for a longer time, but

in return they expect more from their friends. They want to fit in and do the right thing. Peer pressure becomes increasingly significant. Brand loyalty becomes important during the tweens. Kids have got to be "cool" and wear the right design with the right label. This is the age for organized groups like the Boy Scouts, church groups, and organized sports. Tweens want to learn the rules. Although they might question authority rather than blindly follow rules, they are not eager to go against authority. Their moral sense has developed. They tend to think better in shades of gray.

This is an age of speed, busyness, and activity, a time of curiosity, exploring places, finding new friends, and trying new things. Kids are easier to divert toward constructive play. They might be multitaskers. Nothing is too difficult, no challenge too great. Tweens won't always follow through, but there is also enough time, and tweens use some of this time to learn the use of technology. Tween girls like to work with crafts. Eight-year-olds like to play with real and fake money. They like to collect things; number and quantity are more important than value. They're open to appreciating more detail. They're beginning to have a historic perspective and an interest in faraway places and events. They're interested in the future and in outer space and science fiction. They like personalized items: autographs, logo items, and personal magazine subscriptions. They notice differences and make comparisons. Sex jokes and size comparisons are still in. The typical eight-year-old is also sensitive, and failure is often met with tears. There's still an interest in all-girl and all-boy activities such as makeup and professional sports. There is an interest in strenuous physical activity and competition, in nature, and in animals.

Eight-year-olds attach themselves to role models, sports figures, movie stars, and church leaders. The tweens like action and programming that come at a fast pace (MTV). They like comic books but begin to look for more complex stories. They still like dramatic play: cops and robbers, teacher, doctor and nurse, actors, soldiers. Tweens play with realistic dolls like Barbie and G.I. Joe; they collect things and play games (card games, board games, electronic and computer games).

Age Nine

Nine is another more introverted, quieter age. A child is likely to be wrapped up in herself and overly sensitive, especially about comparisons. There's less self-confidence. Nine-year-olds want to belong to a group or a club, and they get upset when excluded. There's a great desire to be useful and needed. It's difficult to make choices. These kids are apt to resist adult supervision and be critical of others, worry about their own health, and complain. They cry easily when frustrated or when they feel mistreated. They hate anything unfair. They need definiteness, clarity, and standardized rules. They have heroes and might retreat into books or comic books. They like movies and TV, but some boys are now outgrowing animation. Skills are fairly mature. This is a peak of variety in play activities. There are sex differences in play, with boys preferring vigorous play stunts and mechanical devices and girls liking realistic types of dramatization. Girls like to gossip. Nine-year-olds are curious about discoveries, science, and personalities in the news. Self-consciousness and overly high standards could block their best creative work. Puberty can begin as early as nine. Children this age feel they are mature and want to be independent.

Age Ten

A good age for parents and teachers, ten is an age to respect authority and do what is asked. Children are friendly and happy at this age, straightforward and predictable. They accept themselves and others. At ten, children are gaining poise and have fewer fears and nightmares. They are making their own decisions. Both girls and boys will practice to gain skills. Girls are beginning to be aware of boys and show an interest in sex as they approach puberty. Girls worry about breasts. Ten-year-olds will most likely appreciate TV and movies. Girls like to collect things, ride their bikes, play games, draw, write, perform plays, and put on puppet shows. Boys play ball, bike, play games, collect things, draw, and make things. Boys eight through twelve might identify with action heroes, superheroes, (male) sports stars, political figures, knights, soldiers, astronauts and other explorers, western figures, cartoon/TV/movie stars, parents and teachers, coaches, and adolescents. Girls the same ages might identify with cartoon/TV/movie stars, models, dancers, gymnasts, figure skaters, (male and female) sports stars, (male and female) political figures, rescuers (knights, lifeguards), successful women, parents and teachers, and adolescents.

Age Eleven

Eleven is the beginning of adolescence for many. At best children are eager, alert, active, and imaginative. During the worst times they are self-centered, quarrelsome, and overanxious. They might lie and steal. Emotions run wild, with anger and tears following silliness and exuberance. Eleven-year-olds long for independence and tend to be rebellious. They need guidance in setting personal goals, evaluating growth and achievement, and discussing social and personal problems. Standards for others, especially their mother, are higher than for themselves. They're quick to criticize and don't like to help around the house. They are competitive with siblings, gossipy about others. They behave better outside the home than they do around their family. Their peer group is important, and they probably have close relationships. They're interested in the group and work well within one. They have a feeling of team spirit. Social activities are important. They need opportunities for increased leadership and responsibility. They're developing a sense of ethics and justice and can discuss current events.

For one thing, the midbrain, which is involved in emotional development and the imagination, is almost completely evolved by now. Imaginative play decreases. Eleven-year-olds like movies, TV, books about adventure, science, nature, and home life. Studies have shown that television is still popular with kids six to eleven. But boys spend time watching video games in addition to TV, and girls surf the Internet and read magazines along with their television viewing.

Age Twelve

Officially, this is the end of the tween stage. Kids are earning money earlier and making their own decisions younger as well. Friends are important at this age, both as support and socially. The group rules the individual. Boys and girls show noticeable differences in growth pat-

terns, maturity, and interests. They are interested in each other, but girls seek out boys more. Girls worry about their weight and how they look. The right clothes and the right friends are important. Boys are always hungry. They may horse around and look for ways to make money. Both boys and girls are less critical of their parents. Both might have tried drugs, cigarettes, or alcohol. Both have a greater sense of humor with a new use of sarcasm and double meanings. Twelve-year-olds are enthusiastic. Emotions are not always under control. A moral sense is developing. Adolescents look for heroes, especially in comics and on TV. Whom do I want to become? Special abilities and talents in areas like music, athletics, and math are becoming apparent.

Age Thirteen

Age thirteen, the beginning of the teen years, is another age of withdrawal and worry. Hormonal changes make this a moody age. Many girls have already reached puberty. There is less difference between the sexes during ages thirteen to fifteen than there was earlier. Kids may gravitate toward extremes in an attempt to reject the status quo and try the new and different, although some remain conservative and identify with established views. Thirteen-year-olds are collecting their thoughts about many issues. Most brains can now think in abstractions and ponder their own thoughts. Thirteen-year-olds have a sophisticated knowledge of world issues and a good sense of ethics. They want to think for themselves. They tend to be idealists who question what others believe and support. They are more apt to accept blame for their actions. They still need love, acceptance, and success. They are searching for identity.

Many thirteen-year-olds think they are fully mature. Both boys and girls are trying for independence; beginning to dislike authority; and often distancing themselves from parents, teachers, and other authority figures. Many have tried alcohol, cigarettes, drugs, and sex. They enjoy privacy and their own rooms, but their rooms may be a mess. They're very particular about their own grooming and the clothes they wear. Manners improve. Money is spent quickly, and kids are usually broke. Adolescents pay more attention to what their peers think than what their parents think. Boys hang in groups. Girl groups often consist of three, with two frequently close and the third temporarily hanging onto the edge. Thirteen-year-olds seek support from a group that they can identify with, and they spend a great deal of time with peers, far more than any previous age group. Typical groups of teens are very different in what they do, what they think, and what they admire. Both girls and boys are easily embarrassed by their parents. Parents nag, and the teen mumbles, "Okay." Different relationships may be developing with the mother and with the father. Father is more likely to help with homework. Arguments are more likely to occur with Mom. Girls might practice their flirting with Dad.

Adolescents tend to process information extremely quickly, and they seem to need more information, ever faster, in order to remain entertained and interested. Humor is more sardonic, and thirteen-year-olds love to mock teachers, parents, and siblings. They are ready for irony, sarcasm, and innuendo, but they still appreciate slapstick as well. They tend to like entertainment that features other adolescents and young adults and the relationships and issues that they're facing. Action/adventure stories and comedies, particularly sitcoms, are popular. Adolescents prefer characters with more depth, but they'll still watch some of the

more classic cartoon characters with edge like Bugs Bunny, Garfield, and the Simpsons. Most girls have outgrown animation long before thirteen, and many boys have outgrown most cartoons by now as well. Sports figures and actors are popular. Media preferences are based on the entertainment itself, on the performers involved, and on the content as a reflection of what the adolescent wants, needs, and values. Girls, more than boys, tend to appreciate and hold onto things like teddy bears that they have otherwise outgrown, but most toys have been left behind. Comic books start to lose their appeal. Fast food is still definitely in. Thirteen-year-olds continue to take part in sports and play games.

Age Fourteen

Fourteen-year-olds want and expect everything; they take criticism badly. They're largely critical of both parents and feel that neither parent understands, but they might listen a little better to their dad. Girls already look like women. Boys can have their greatest spurt of growth at this age, and they may suddenly develop a deep voice. An overwhelming majority of fourteen-year-olds use alcohol, drugs, or cigarettes. Some fourteen-year-olds find work, but money remains a problem. This is an age of great energy. Both girls and boys might be involved in sports, after-school activities, and various groups. At this point most of the brain is fully developed, but many fourteen-year-olds are still not fully able to appreciate another person's perspective, to be completely empathic, or to love unconditionally. Fourteen-year-olds may get along better with people outside the family group than those within, but friendships are constantly dissolving and being reformed. Boy-girl relationships come and go.

Age Fifteen

The early adolescent years end around age fifteen. There is a continuing drive to become independent, testing the limits of accepted behavior. Quite a few fifteen-year-olds are unhappy. They might rebel against authority. Even good kids may experiment with graffiti and stay out past curfew. Many are sexually active. This age is less energetic, less outwardly emotional and expressive, more reflective and thoughtful. Fifteen-year-olds find it hard to adapt. Friends are still very important. The right hemisphere of the midbrain, which focuses on nonlinear and nonlogical thinking, has been developing from about age four and is pretty much complete by now.

Age Sixteen

Sixteen is a more balanced age because late adolescence begins. Most sixteen-year-olds are more self-sufficient. They could have a part-time job with increased responsibility. They're capable of making the right choices on their own, but like adults they don't always do this. Of course, they still have less experience in making choices. They are more interested and friendly toward others and more sensitive toward others' feelings as well. They think of the future. They daydream. They're more creative and develop deeper interests. By sixteen, most hormonal changes have taken place. Because sixteen-year-olds might have their first driver's

license, they have more opportunity to be independent. They may date often and have regular sex.

Late adolescence is the age when the prefrontal lobe of the cortex of most brains matures. This allows impulses to be controlled. It permits empathy, increased problem solving, planning for the future, and allows for a higher reflective capacity. Not all brains complete this process.

These teens watch sitcoms, reality shows, soap operas, and game shows in addition to MTV. They may be interested in news shows, educational material, and social and political issues. They like action/adventure, teen humor and slapstick, romantic comedies, and social drama. The late adolescent's sense of humor is probably mature. Television cartoon watching has dropped off. Thirteen- to nineteen-year-olds are the largest demographic for motion pictures. Electronic games (especially role-playing games and sports games) and some classic games (chess and poker) remain popular. Sports activities also remain of interest.

Ages Seventeen to Twenty-One

The transition into adulthood starts here. Adolescents leave their parents and venture into the adult world. Most healthy brains have matured by late adolescence. Men, especially, might still be immature. Women may be vulnerable. Both find their own values, their own sexual identities. A vocation becomes important. This age group is searching for a temporary or life mate. Intimacy becomes important: If I give myself, will I lose myself? A shift away from the old rules allows this age group to be unusually receptive to new people, new ideas, and new ways of doing things. Studies have found that males eighteen to thirty-four want surprises. With the brain capable of advanced abstract reasoning, many in the transition stage especially appreciate sci-fi and stories with a distant and exotic locale. By seventeen some teens have already shifted away from teen music and have more adult or mature tastes.

Young Adulthood (Ages Eighteen to Forty-Five)

Young adults are establishing new life patterns. They might make peace with their parents and accept advice. Young adults begin to see their parents' lives in all their complexity. They may move back home until they're financially able to make it on their own. They begin to have a strong confidence in making their own decisions and doing things their own way. They're apt to feel that there are no limits on the future. They're still experimenting with lifestyles and finding new friends. There is a great interest in careers, and young adults may enthusiastically put in long hours at a job. They could establish a family, adding new responsibility and a change in focus and relationships. Major changes are made in this period: leaving home, establishing a career, marriage, having children, establishing a new home and a lifestyle. During this period life experience grows. Relationships change as a marriage matures and children get older. This is the greatest point of financial responsibility for most. Home and career stresses can be great. Somewhere between age thirty and forty-five there may be a midlife crisis, spinning events and lifestyles around. The catalyst can include a career crisis, a divorce, children leaving the home, and so on. Am I fulfilling my potential? How successful have I been in parenting, in my career, in my relationships?

Midlife (Ages Forty-Five to Sixty-Five)

If life is going well, this is a period of increased confidence, stability, and affluence. There might be periods of crisis in any life. Men might enjoy more responsibility and more prestige at work, or they might get bored. Women could have similar work experiences, or they might go back to work during this period as children get more independent and leave home. The ability to nurture others provides a sense of satisfaction and helps adults to be less self-absorbed. There could be a need to care for aging parents. Both men and women probably have increasing spare time and more disposable income during this period. Around age sixty to sixty-five there is a reassessment of life and a preparation for retirement. Both men and women might feel a push out the door in the workplace and strive to hold onto their careers.

Late Adulthood (Ages Sixty-Five to Eighty)

This is an age of reassessment of the life lived and either a decision to enjoy the remaining years or one to make some use of the time that is left to give worth and meaning. How did I do? What is life? Did mine have meaning? Did I measure up? This is a time of wisdom. Illness and loss become more frequent.

Old Age (Ages Eighty and Up)

Chronic illness becomes more of a problem. The scope of life grows smaller. Involvement with self becomes more complete.

Other Developmental Issues

Studies have also found that more than half of all children multitask as they watch TV. They talk and eat primarily, but they also play and do homework. A few rarely look at the screen at all. Of course, adults multitask as well, but children seem to be the multitask masters and do more things at the same time.

Television program developers have discovered that children are growing out of specific television programming earlier than they did in the past. *Sesame Street*, for instance, has an ever-younger audience. Children want to move on. Part of growing up and growing older is rejecting what was prized in the past. Toys and programming suddenly, almost overnight, become something for "babies." Adolescents reject the ideas and advice they previously welcomed. Even adults may move suddenly into another stage of development.

The age of decision making has lowered increasingly as well. Children with working parents become independent earlier and are probably making more decisions on their own earlier.

Increased population in cities and multicultural influences around the world from migrating people also change the way we think, as does our exposure to an international community through the Internet. Children coming into a new culture must adjust, although their parents might cling to the old. Each family member may adjust at a different rate.

Parents might try to isolate their children from new and unwanted influences. Children in the host culture learn new values from the immigrants. The cultures could clash. All of this affects development in ways that it did not in earlier times.

Today much controversy remains about differences between the sexes. Certainly there seem to be some basic genetic, biological, and psychological differences, especially in activity, social behavior, and the amount of aggressiveness. There have been many studies done, but results are not conclusive. My own feeling is that biological differences are greatly strengthened by the way we raise our children and what we expect from them, and that much of the testing is biased with prior expectations being confirmed. Regardless of the reasons, there are great differences in most boys and girls as they grow up, and I don't see that changing in the near future.

There are also developmental influences within each family. Cultural expectations affect development. Order of birth affects the way children are treated and the way they develop. Makeup of the family (large, small, single parent, multigenerational) affects development. Deaths or divorce in the family, whether a child is adopted, whether there are disabilities in the family, family lifestyle, age of the parents, illness or mental illness within the family, child-rearing style, all of these and more might affect development.

A child is not an adult, and each child and each adult is different. As you write and develop your own projects, try to see the world from different points of view. Consider what you've learned, keep your sense of humor, and be creative.

 Exercises

1. Check out a child development book from the library and skim the material. Focus on the differences between age groups. What new things have you learned?

2. Write a fact sheet about a specific child you know or can borrow for an afternoon. What does the child like and dislike? Does he seem to be typical of his age and gender?

3. Go to a school or playground and watch the children at play. What does this specific age group like? How do they play? Summarize what you've seen.

4. Develop characters and a basic animated TV concept for a specific age group based on child development principals. Be creative.

5. Compare how a television show, developed for one age group, would be different from a similar show for a different age group. Discuss.

6. Develop characters and a concept for a film that might appeal to a wide range of ages from preschool through adults. What things did you consider? How did you successfully bridge the age gap?

7. Conduct your own research. Invite a small group of children to watch a video. Prepare a list of questions for the children about the video in advance. After you've shown the video, interview each child separately to get the answers to your questions. What did you learn about their preferences? Were they age specific? Do you think you got honest answers, or were the children telling you what they thought you wanted to hear? Could you improve your questions the next time so that you might get more accurate answers?

8. Interview a child about her favorite animated television show or film. What does he like? Dislike? What characters does he like best? What was his favorite episode? Why? What does he think about the villain?

9. What was your favorite animated television show or film when you were young? Why did you like that one best? Was there some reason why you could especially identify with that particular one? What didn't you like?

10. Was there a film that frightened you when you were young? Why? If not, why do you think you were so fearless?

11. Pick an age when you were young that you can remember really well. Try to recreate the feelings you had then. What did you feel? What do you remember seeing? Tasting? Hearing? Touching? Smelling? What did you like and dislike then? Who were your friends? What did you do together? What secrets did you have? How did you feel about your parents and your teachers then? What were your disappointments? Your successes? Save the information in your notebook of ideas.

12. How do human development concepts apply to your student film?

Developing Characters

How to Begin

Put in as much time as it takes to develop characters that are really original and interesting! You'll want each of them to be as different from the others as possible. Those differences allow your characters to conflict and to relate to each other in funny ways. You'll probably want to start by writing a biography or fact sheet for each of your main characters. If you're an artist, you may prefer to start by drawing the characters. Often writers choose to script scenes between characters to see how they'll react. And actors sometimes prefer to improvise scenes out loud to develop their characters. Whatever works best for you is fine. Think of your characters as real actors. Get to know them so you know what they'll do. Lucky for you, your actors won't indulge in gourmet lunches and then demand a trainer to get in shape for the big battle scene or insist on a stunt double to fight the fifty-foot, flying monster with two robotic heads!

Types of People

People have been characterized by types and traits for eons. In the Middle Ages there was black bile (melancholic, sentimental, thoughtful), blood (sanguine, amorous, joyful), yellow bile (easily angered, obstinate), and phlegmatic (calm and cool). Another method divides the body into centers: head (soul, link to God), pituitary (integrated mental, emotional, and physical), throat (conscious creativity, intellect), heart (greater love, brotherhood of man, self-sacrifice), solar plexus (aspiration, group power, personal power), sacral (sex, money, fear), and root center (survival). Carl Jung classified types as the introvert or the extrovert, and then further into those who experience life mainly through sensing, thinking, feeling, or intuition. People have been characterized as being dependent, independent, or interdependent. Whether or not you believe in these kinds of classifications, any of these methods might help you to develop your characters. Of course, there's also astrology.

Consider these other norms. Real people are often in conflict with their character opposite. However, some people seek out others that complement their strongest traits. Usually, people are a combination of two or more types.

Classic Comedy Character Types

From its beginnings comedy has often been based on a character type. It's a stereotype in that it's an exaggerated model we recognize and understand. This kind of character is valuable in comedy shorts like cartoons because we already know that character and what to expect. It saves time. We don't have to set up a new character for the audience, but we can go immediately into the story and the gags. We laugh when the character does the funny thing that we have come to expect, and we laugh when he does something off-the-wall that we don't expect. Inflexible types are great for comedy. These character types have a comic defect. You can set up a character type and bounce the world off him, using conflict and contrast. Think of Homer Simpson, Donald Duck, and the Grinch.

Comedy stemming from character allows for sustained humor, and it's remembered long after the gags and the situations. A good gag builds characterization, and characterization builds gags.

Classic Roman comedy types are still used in cartoons:

- *The Blockhead*—We're smarter than he. He's defeated before he even begins.

 Fred Flintstone (*The Flintstones*)

- *The Nave*—The kid who's always in trouble.

 Bart Simpson (*The Simpsons*)

Other typical comedy types include the following:

- *The Fish Out of Water*—The misfit. (Try developing a whole series around this type!)

 Shrek (*Shrek*)

- *The Naïve*—Forever innocent.

 Winnie the Pooh (*Winnie the Pooh*)

- *The Conniver*—Not innocent, but *really* guilty.

 Wile E. Coyote (*Road Runner*)

- *The Zany*—Wild and crazy.

 Aladdin (Disney's *Aladdin*)

- *The Poor Soul*—The underdog. This character works best today when he's a child or an animal. Be careful about adult characters that appear to be victims. If the adult is a victim, then he must constantly be struggling to get out of that situation for us to identify with him. Also, this kind of character must retain his cool

and remain likeable no matter what injustices are done to him. Charlie Chaplin fought for his dignity.

Tweety Pie (*Tweety Pie*)

- *The Coward*—Always the chicken.

Scooby-Doo (*Scooby-Doo*)

Classic Comedy Types vs. Negative Stereotypes

For a short cartoon, you may choose to use a classic comedy type that we already know, but take care to avoid negative stereotypes. Commercial broadcast television, especially, is a mass-market medium. Networks have censors that ensure that their comedy is politically correct, especially if the comedy is targeted at children. Some networks are more careful than others. In commercial TV advertisers will refuse to buy advertising in programming that offends. In a global marketplace where the audience is very diverse, a certain amount of political correctness is just common sense. You simply cannot afford to lose a segment of your audience . . . even if the gag is the funniest ever!

When you're writing about someone of the opposite sex, someone older or younger, someone with disabilities, someone from another culture or lifestyle than the one you know well, consider what you write. Be aware of nuances. Think of people in terms of multi-dimensions. What do these characters do in their spare time? What are their relationships socially at play, at school, or at work?

Whether you're developing characters or just writing a scene, consider who would normally be in that location in real life. Who would be there in New York or Detroit? Who would be there in New Delhi or Beijing? What races, nationalities, social/economic classes, occupations, sexes, and ages would be there? Develop different characters into your series and films in places where you would normally find them and in places where they could be.

Value diversity! Prize differing beliefs and cultural values besides the traditional ones you know. Make minorities active, not passive. Avoid casting minorities as victims, or if they must be the victims, let them overcome this by themselves. Both bad guys and good guys come in many diverse types. You might want to create characters and then add a gender or race afterward. The key is in not isolating minority characters. One child in a wheelchair is a role model, but it's hard to make role models interesting and unique. If you have two or three characters with disabilities in the same script, then each can be unique and interesting, good guys and bad.

Do your research before you develop and write characters and scripts that are different from what you know best. Read the latest scientific studies. Get to know people who are not like you. This is a part of your job! Understand people's thought processes and really care about others. Try to get someone from another culture, lifestyle, age group, or sex to give you feedback about characters and scripts that are different from what you know so that you get it right.

Don't be afraid of a point of view! Let characters stand up for their culture and experiences and provide the rest of us with new insights.

Recent studies on gender differences are compelling: Most, but not all, women are more relational, better at reading emotions, nuances, and social cues. They're apt to be more sensitive to touch, pain, and sound. Their body movements may use more of the small muscle

groups. They might score better in verbal skills and short-term memory. Men generally score better in mathematical, mechanical, and spatial skills. Assertiveness is likely to be higher in males. Males tend to do more exploring and may be more creative. Women often overcome problems with support from their friends. Men tend to deal with problems more on their own. Remember, however, that not all males or all females are the same. Today there are plenty of stay-at-home men and plenty of women who are CEOs. Try seeing sexuality in broader terms with warmth and love for all ages. Instead of describing people by their attractiveness, try describing them by intelligence, style, or uniqueness. Try giving your characters traits that are opposite from the norm.

Everyman vs. One-of-a-Kind

As human beings, there are qualities that we all possess. A character who is everyman is someone who represents us all, and we'll always be able to identify with that character. Real people are a combination of the qualities that we all possess and specific, unique traits. Characters should also be a combination of those global qualities and the unique characteristics that make them one-of-a-kind.

Complex and Original Characters

If you want to develop characters for a feature or a series that you hope will become a classic, then you probably want to develop more complex characters than the character types just listed. Classic characters who will be loved and remain on the toy shelves for decades are usually unique characters that we can all relate to and like. You want to give those characters a complete personality and an attitude toward each other. The more personality and individuality your characters have, the better your stories will be.

Starting a Profile

Not every question that follows will be applicable or necessary for each character you develop. The most important information is what will help you delve into the thoughts, feelings, and emotions of your characters. Feelings and emotions are key to good writing! You might even want to write down your own character profile and delve more deeply into the things that make *you* tick. Tapping into your own emotions, often buried deep inside you, may help you hit pay dirt in understanding the complexity of your characters and getting inside their skins. Some people feel that it's better to write a character profile in the first person, as if it were an autobiography, so you really get inside the soul of each character. Your characters should be allowed some room to grow as you write more about them. The more you know about your characters, the better.

Character Profile
- Name (name may give us a clue: Precious, Cowboy, U.R. Steel, or Ted D. Bear)
- Sex

- Age

- Appearance (height; weight; hair color; eye color; physique; size; posture/poise/carriage; outstanding physical characteristics, such as dimples; dress—taste, neatness)

- Movement

 — Does he move like a dancer or someone who's sleepwalking? How does he walk?

 — Does he use expansive gestures when he talks?

- Mannerisms

- Voice (diction, vocabulary, power, pitch, unusual attributes)

 — What docs the character say, and how?

 — Give your character a **dialogue tag** (Fred Flintstone's "Yabba dabba doo!").

 — Make your character's voice distinctively his or hers.

- I.Q., abilities, talents, qualities (imagination, judgment)

- Personality/attitudes/temperament. Attitudes are key to comedy and situation drama.

 — Is your character ambitious, loyal, sensitive? Inferior, optimistic? Shy? Sloppy? Eager?

 — Character flaws, bad habits, weaknesses

 What is your character's biggest secret? What will happen if someone finds out?

 What is your character's biggest fear? Why? What caused this?

 What was your character's biggest disappointment?

 What was his most embarrassing moment?

 What was the worst thing that ever happened to him?

 How does this affect your character today?

 What makes your character angry? Frustrated? Ashamed?

 Does he have self-esteem?

 — Is your character a loner? Does he belong to lots of groups? Which ones?

 How does he connect with the other characters during your story?

 — What makes your character laugh?

 — How does he relax?

 — **Motivations**, goals, ambitions. What does your character want?

 — What is your character's **spine**? What's his unchanging driving force throughout life?

 — Does your character put his own self-interest first or that of the group and its survival?

— What are the shifting allegiances in your character's life?

— Does he feel pressured by other people or circumstances?

What are your character's hard choices? Crises? Urgent decisions? How does he react differently from the norm?

— Values. What's important to your character?

— How does he feel about the past? What in past situations have specifically affected the important choices he is making in this story?

— What are your character's current circumstances (rich/poor, good luck/bad luck)?

What effect do these things have?

What current threats exist in your character's life?

What opportunities does he have?

— How does your character feel about the future?

- Situation

 — How did your character get involved in this situation?

 — What about his background or personality made him get involved?

 — What kinds of changes has your character been going through?

 Birth of a child? New brother or sister?

 Marriage? New stepmother or stepfather?

 Death in the family?

 A major move?

 A major school or job change?

 — What external or internal stresses is your character facing?

- Birthplace

- Ethnic background (when needed, research for authenticity) and any cultural baggage?

- Social/economic/political/cultural background and current status (research)

- Education

- Occupation—research well if he has one. Values derived from the work (an accountant vs. an actress)

 — Pace, stress factors, other characteristics of the job

- Lifestyle

- Family

— Siblings? Parents? Husband or wife? Extended, adopted, or alternative family?

— How do these relationships now or in the past affect your character?

— How did he grow up? With love? Closeness? Neglect? Abuse?

— How did your character's family affect his self-image?

- Hobbies, amusements

— What does your character read, watch on TV/in the movies/on the Internet?

— What sports, exercise, or hobbies does your character engage in?

— What does he do on Saturdays? Sundays? Tuesday evenings?

- What makes him funny?

- Give your character one dominant trait, with a couple of other less important traits.

- Era—if this is historical, research well.

- Setting or place

— What kind of people would be in this setting?

— How would your character react to this setting? Would he be happy here?

— Why or why not?

— Where was your character before this? Why?

— Is he likely to leave soon? Why or why not?

— Does this setting or where he was before give your character a different outlook or attitude? A different rhythm?

— What sounds, smells, and tastes are in your character's surroundings?

You don't need to answer every single one of these questions, but do take the time to get to know your character. Use the Character Profile to help you explore personality.

Types of Characters

Different kinds of stories have different kinds of characters. Realistic characters are often found in modern stories and in dramas and are multidimensional. These characters have feelings and attitudes just like real people. We can see what motivates them. They act like people we know.

The classic hero is found in classic tales, often oral histories. The story is meant to teach us some important truth. The classic hero had some realistic traits and some that were more symbolic that made him bigger than life. He's an adventurer, a person of action, a warrior. Often the hero goes on a quest with much demanded of him along the way. He may find a mentor, undergo tests, and win a final battle to attain his goal and save the day for all. His journey makes him stronger and wiser. Classic heroes and heroines are found in myths, westerns, crime and war stories, science fiction, comics, and many children's stories.

Fantasy characters are romantic. Often they live in a magical world with powers that can be used for good or evil. They're more realistic and less exaggerated. They usually have a limited number of traits. They may look different, and these physical characteristics might extend to their personalities. Much of the fun of these characters is the fish-out-of-water conflicts they have. This world could be a nightmare world or a world of our fondest dreams. Stories can be funny or tales of good and evil. It's possible for humans to enter into these fantasy worlds and for fantasy characters to suddenly find themselves in a world that is real.

Nonhuman characters often personify certain human traits. Pooh is always hungry; Scooby is always scared. Usually, only a few traits are given to the character, and the audience can identify with those traits. These qualities may stem from the properties or physical appearance of the animal or object itself. A cat uses its eyes like a soldier with a night vision weapon, or a stick of gum clings.

Symbolic characters are meant to represent a trait or idea. They're one-dimensional and stand for qualities like love or evil, justice or fear. We find these characters in myths, comic book stories, fairy tales, and other fantasy. The Ancient Greeks and Romans used these characters, and they appeared in the morality plays of the Middle Ages and in the Punch and Judy shows later. There are no gray areas in these personalities.

Everyman represents the ordinary man or woman or every kid. This character is less specific and more symbolic. He has more than one trait, but he is generalized and we should always be able to see ourselves in this character.

Taking Your Character Further

Consider other ways to develop characters. Is your character like anyone you know? Who? Does the character resemble an actor or actress or one of the characters they play? In what way? Stay away from characters that have been overdone. Does thinking about this real or fantasy person give you any ideas to make your character funnier or more realistic? Is this character a combination of people? Juxtaposing traits gives you something we wouldn't expect. You might want to take this real or fantasy character, and then give his personality a new twist.

Observe people and use your observations. Try taking some real traits that you've observed, and add a funny trait to make your character unique.

Quality characters are often more complex. This may explain why they tend to have more lasting appeal. Make a list of inconsistencies in your character: He's this, but he's also that! What's illogical, surprising, and unpredictable about him? What makes him interesting? Different? Fascinating? Compelling? Never too bland? Always larger than life? Use "what ifs" to dig deeper into your characters. Once you've decided on these inconsistencies, they should remain constant. They do not change on whim or in keeping with the current episode's story.

What makes your character funny? A comic character needs to have a flaw that makes him funny. What are his funny attributes? What very human mistakes does he make that would make us laugh? Recognize ourselves? Be typical and recognizable to kids of a specific age category? We tend to like comedians who let us feel superior (like Charlie Chaplin). We know that we're much smarter, more resourceful, and luckier than they. For animation comedy we often want to create loveable and larger-than-life characters to whom slapstick

things are almost certain to happen. It's human nature to like to see slapstick things happen to people with power or authority, especially if they're pompous or misusing that authority (the mean boss, the overbearing substitute teacher, the bully who's a hall guard). Most of us humans struggle to be normal, to be perfect children or parents, to be the ideal student or employee, and fail at these things every step of the way. Much current television is based on these failings.

Do you really understand this character and what makes him tick? How is this character similar or different from you? Let his feelings and emotions show. Do you like him (even if he's the villain)? Accept the shadow side of yourself so you can accept those flaws in your characters. If you truly understand and like your characters, others probably will, too. If you still don't quite "get" your character, do more research. Delve more deeply into yourself. Write or act out scenes that won't be in your script to learn more about him. Make your character real to you.

Then exaggerate! Make your characters larger than life. Think James Bond or Superman! When the average person is the main character, he or she often walks taller than in real life. The character becomes a model of all average people. Make your slob a superslob, the bore a superbore. Exaggerate! Exaggerate! Exaggerate!

More realistic characters are harder to animate convincingly. You can't squash and stretch a real person. The less realistic ones lend themselves more to the medium and to the gags, especially if it's a comedy.

What **behavioral tags** does this character have? These are repeated actions that are specific to that character. Does he go into a one-armed handstand when overjoyed? Does she shake her hips from side to side or tug on her ear?

Set up relationships. One way to create a series is to start with a character type or one really strong character and let all the remaining characters bounce off. How does your character feel about each of the other characters, and how do they feel about him? Why are these characters friends or enemies? Contrast characters (a smart guy with a dumb guy). How does this character affect each of the others by the strength of his personality, by his actions? How do they affect him? Does he team up well or conflict with the others? Each of your characters should be as different as possible from each other. You might want to make a list of characters and then itemize the traits of each to make them as different as you can.

There may be two stars. What brings your characters together and keeps them together? What pushes them apart and provides the sparks? Is life better for others around this team or worse? Is life sweet or bitter when they're together? Are there enough believable reasons that this team will stay together, or is the conflict intense enough that they must eventually split up and end your series? Too much attraction and the show is boring; too much conflict and the characters may become unlikable. Roadblocks may come from the situation rather than the characters themselves to avoid this problem.

Avoid using too many characters. Keep economy in mind. Also, it becomes much harder to identify with characters who don't receive a lot of screen time. If there's too many, we don't care about any of them.

Can we identify with this character? Bond? Does the audience have real recognition of that character? We need enough information about a character to empathize. What are the real-life, down-to-earth traits that we immediately recognize? What are the character's little eccentricities, small compulsions, and very human characteristics? Or you may want the audi-

ence to feel superior to (rather than identify with) a character. Think of Scooby-Doo. You could let your character be the scapegoat, the butt of her own or someone else's jokes. It's okay to let your character appear foolish and find life difficult. The audience sympathizes.

Do we really respond strongly for (or against) this character as a person? We need to feel that this character is family. What makes us root for her or hate her? How can we strengthen this? It's been said that it's hard to sympathize with someone who is too naive or dumb, but one moving relationship with another person may save an otherwise unsympathetic character. If you must have an unsympathetic character who's not a villain, then start by showing what happened to make her that way. Avoid showing your **protagonist** as a complete misfit in the beginning. Your audience must like her and admire her enough to want her to recognize character flaws and try to change. We like characters with positive goals and dislike characters who are evil or selfish and have negative goals. If something is important to your likeable character, then it will probably be important to your audience as well.

Buyers like a cartoon character with an edge, someone you love to hate. Think of bad Bart Simpson. The audience will identify with someone who's not sickening sweet but has tastes, dreams, and weaknesses.

Is your villain *really* bad? Your hero or heroine is only as strong and as good as your villain is evil. A truly great villain can add inches to the stature of a hero. Is your villain a life-and-death threat? A monstrous **antagonist** requires a stronger hero to beat him. But you may want to add those shades of gray, a wisp of human kindness where you least expect it. Give your villain emotions and feelings to make him vulnerable. Motivations keep any villain from becoming cardboard. In a very short story you may require a fairly cardboard villain due to the lack of time to develop anything else. Why does this villain want what he wants? Is he aware of how evil he seems to others? How does he convince himself that this is right or at least justified? A funny villain isn't very frightening. Watch out for bumbling antagonists. They need to be at least as strong as the hero to make it a fair fight. A bumbler might work in a comedy, especially for younger children. If you want a funny villain, try making him the secondary antagonist, with a stronger and more evil villain as the main foe. The antagonist doesn't always have to be a villain and be evil, but the antagonist *usually* is evil in animation.

More to Think About

Today's characters should be able to extend across media. Think in terms of film, TV, home video and DVD, the Internet, wireless, books, games, toys, and other merchandise.

Layer details, gestures, speech, imperfections, behaviors, original reactions, and approaches to action. Layering makes your character more interesting and attracts different demographic groups for different reasons.

If this character is for a series or a game, is your character interesting and unique enough to not eventually become boring? Is there some mystery there, a feeling that there's more to find out, more we want to know? Can your character grow? How? Is she strong enough to sustain conflict and be funny week after week? Characters must have enough history to allow the audience to continually be discovering something fresh. Two or more characters who have known each other in the past can keep tapping into this history.

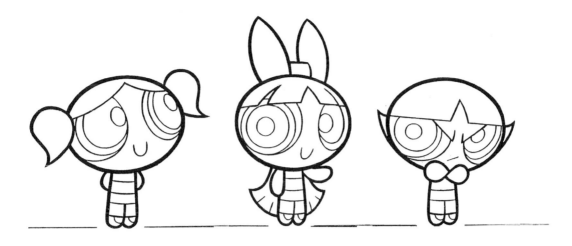

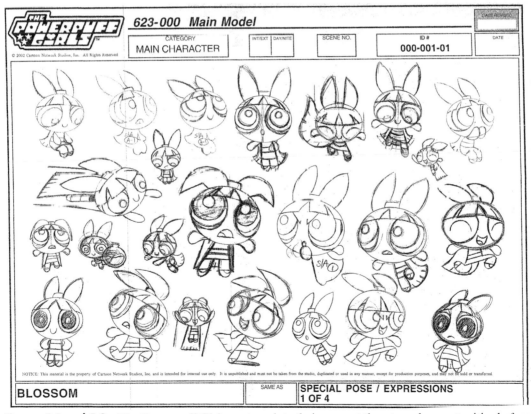

Figures 5.1 and 5.2 The Powerpuff Girls contemplate their current threats and opportunities before filling out their own Character Profile! Notice the basic shapes and the over all simplicity of design. *The Powerpuff Girls* and all related characters and elements are trademarks of Cartoon Network © 2004. A Time Warner Company. All rights reserved.

In a series characters probably change a little over the course of each story, but if they change too much, then their relationships have changed, and you no longer have that same series. You have to watch out for that.

For television keep your characters simple, something you can establish (without detail) in a speech or a half page of script. Your characters should have only two or three major attributes. Keep them visually simple as well (see figures 5.1 and 5.2). A simple character makes a better stuffed toy. The character animates more easily and ends up looking nicer in a TV series because the artists can draw or model him better and quicker. Every detail and extra color adds pencil time or modeling time during the animation process, adding up to increased animation expenses. When designing, think three-dimensionally for toys and for animation because the character must be drawn or modeled and seen from every angle as she moves.

As you're designing these characters, you'll want to show what they look like from all angles (front, back, and side, and possibly from a low angle and a high angle as well). You'll want them drawn in action and flaunting an attitude, showcasing their personality. You'll want them posed so that we can see easily what they're doing if we can only see a silhouette. We want to also see them in relationships with one or more of the other characters, preferably in typical backgrounds of the series or film.

Okay—now you've developed your characters. Is a character missing . . . someone to set off the other characters, set sparks flying, take the **plot** off in another direction? Try creating a situation in which your characters have to react. The way they react is the way you get to know them and test their relationships.

Any character who is similar to another character shouldn't be there. Remember that characters should be as different from each other as possible to keep interest, provide conflict, and comment on the theme. Their traits and visual appearances should be different; they should contrast in values, attitudes, lifestyles, and experience. A comedy, especially, requires that each character contrast sharply with each other character to provide the humor.

Let your characters evolve as you work with them. Changing one part of the puzzle usually means adjusting others. This is a process; do some research of your own. Try out your characters on your own kids, on your nieces and nephews, on a youth group. You might test them at children's wards in hospitals or as mascots. Make up a story about them to tell your kids at bedtime. Watch reactions, ask questions, and make developmental changes accordingly.

Keep your characters consistent. They must remain true to their core traits and to what has made them who they are. Keep their choices consistent with their values.

Put your best character in the right concept for him. The concept and the character should be a tight fit. Stories should stem from the personalities of the main characters.

Your Character in a Story

If you're creating characters for a feature or a short as opposed to a series, then you want to develop your characters to best tell your specific story. Characters have conflicts in dramas and do funny things in comedy because they are so different. So their values in life must be different. Your characters must be created with personalities that best express a conflict in

their values. Values indicate a **theme**. The theme centers on the core values that are expressed in a story, the basic message, or lesson that the protagonist learns. You may want your main character to reveal something about the theme to us but probably not in words. Maybe he represents one point of view about your theme and the villain who opposes him represents the opposing view. Maybe the other characters all represent differing points of view. One character could even express the point of view of the audience. But each character should have his own good motivations for feeling the way he does.

Your audience needs to be able to identify right away who the major characters are and be able to tell them apart easily by name, sight, and personality. We should recognize, too, which characters are minor and unimportant. Use height, weight, ethnic type, voice, hairstyle, clothing style and color, attitudes, and movement to help identify characters.

The hero or heroine must be the most interesting character in the story. If he's not, then you might want to consider centering the story around the colorful character instead, making him the protagonist. Supporting characters don't have the burden of driving the story forward, and so they may become more interesting and colorful. Don't let them take over! If your characters get too pushy, stand up to them, and threaten to erase them from your hard drive!

You may want your less important characters to help in defining the role of the hero. Is your hero a leader, a father figure, the class clown? Minor characters can help us to understand the star's role in his peer group and in the story.

All characters need a story function, or they shouldn't be there. What's the essence of this character—the core or nub? What is the one dominant characteristic that most affects the plot? If a character doesn't affect the plot, then remove him. A character should always be motivated by this essential characteristic, and every other trait should ideally come out of this one or support it. What event or circumstance or decision in the past made him this way?

Character information is sprinkled throughout the script, not crammed into the beginning. Use only the essence, and be concise. Use conflicts, contrasts, reactions, gags, or visual symbols to convey information and define character.

Consider your protagonist or hero. What plans does he make, and what does he do to attain this goal? What decisions does she make along the way? How do they affect her? How do they affect others? What terrible thing is at stake if our hero doesn't reach this goal? Animation protagonists invariably do reach their goals at the end.

What are each character's goals? What do they want? Do we care? What are their hidden agendas? What do they *really* want? (If this is animation for kids, what drove you personally as a kid?) What does each character promise? You should only set up traits and circumstances that apply to this story and the goal. But if a character is playing with matches, we need to see the inferno, the payoff. Don't cheat your audience out of the juiciest parts of your story.

Think in terms of scenes. What are your characters' goals in each scene? Which character is driving each scene? What are your characters' feelings in each scene?

Is there a broad range of emotions throughout your story? What are the conflicts your characters go through to reach their goals? The goals of different characters should conflict to set off sparks. We need to see the effects of conflict on the main characters. Characters should confront difficult choices, and they must make those choices themselves. The more difficult the choice, the more interesting the story. Because of difficult choices we get to know

the characters better, and we come to admire them more. What's hidden along the way from your characters or from the audience? What things do some characters hide from themselves? As all this information comes to light, the choices become ever more difficult, leading to the most difficult choice of all, the **critical choice**, near the end of the story. These choices make your characters drop their masks. They react instinctively, revealing what's been hidden. What do we learn about a character then? What does that character learn about himself? How does he change because of it? Characters change each other. Does your character always stay in character, acting and reacting in ways that only he would do?

In the end, this is what's important: What event/circumstance/decision in the past is still affecting your hero today, making him who he is and driving the plot of the story you're writing today? Anything that you discovered about your character in developing him that doesn't relate to this is unimportant and doesn't belong in your story.

Animated Characters Live

The technology exists to control animation and lip-sync of characters in real-time. What this means is that kids can call into a show and speak to their favorite character on the air live as an actor/animator controls the animation and lip-syncs in a booth. Interactive games can become a part of a live show with callers using telephone keypad game controllers. Actor/animators could develop their own characters for this kind of production. Or writers could provide a cast of actor/animators with detailed bios, backstories, and guidelines for the characters they portray.

Animated Characters as Icons

Internet providers are just one source of supply for animated character icons with personality. These characters have built-in animated behaviors that respond to real-time input. They can accompany instant messages, responding to the text with motion, sound, color, and humor. File size for these characters must be small, and many of the character expressions are exaggerated to give them more visual impact in the limited space. There appears to be a great future for characters like these in cell phones, sales pitches, and so many other areas. Changing technology will continue to open up new opportunities for animated characters.

Market Research

Studies seem to show that kids like characters that they can identify with, characters that appear to be like them in one or more ways. The youngest children like characters that are safe and nurturing or that they can nurture in return. They like characters that they can emulate: heroes and heroines, teen or adult role models, sports figures, entertainment figures. Children, too, are fascinated by the dark side of life and are entertained by villains. Perhaps it's a way of learning to deal with life on a more adult level. Children generally prefer characters who are older than they are, or at least that's what they want other kids to think. Boys often prefer male characters, although girls apparently have no preference. Boys are more

apt to be attracted to power and control, to defending the right, to the gross and silly. Girls still seem to be more romantic in the broadest sense and more nurturing. Animal characters often are nonage and nongender specific, making them less likely to be rejected for those reasons.

We all like characters that satisfy our basic emotional needs and values while still appearing fresh and "in." Children and adults alike seek love, acceptance, belonging, and security. We all strive for independence and control. Parents want to instill the very best of all qualities in their children.

Popularity usually starts with the oldest and drops down in age. When characters become too popular, then the fad subsides. Part of being a fad means being the first. By the time a character is beloved around the world, it has started to lose its appeal.

Protecting Your Rights to Your Characters

If you hire an artist to design your characters for you, then that artist needs to sign a simple "Work for Hire" agreement *before he sets pencil to paper*. It's recommended that you obtain the services of an entertainment attorney to draw this agreement up for you. If you don't have an agreement signed *before* pencil is set to paper, then you don't own the character—the artist does.

You must protect the characters you've created, but if your project includes a **bible** or a script, then it's best to file for protection and copyright when the project is completed. You may wish to file for trademark protection then as well. In the meantime, place the following information on each piece of completed artwork, title page of script, and bible: © (copyright symbol) 2005 (year of completion) Jean Ann Wright (your name). Your work is not protected without that information.

 Exercises

1. Think back to when you were a child. Who were the people that you liked the best? Who frightened you? Why? Can you use any of these people as the basis of a character? Exaggerate!

2. Use kids you know for the following: Listen to kid dialogue. Write it down. Make a list of hobbies and activities, especially noting anything that is interesting and out of the ordinary. Ask the kids about places they especially remember and like. What places made them afraid? What do they hate? What hurts their feelings? What embarrasses them? What makes girls scream? What makes them laugh or cry? What does their sister or brother do that they hate the most? Save the lists.

3. Go to a mall or park and watch people. How are they different? How do they walk? What funny mannerisms do they have? How do they change their behavior when interacting with different people? Do they react to their environment? Now create two opposing characters from those that you've seen. Add new traits. Give them motivations. What's the conflict? How can you make them funnier?

4. Observe half a dozen animals or everyday objects. What stands out about each one? Pick an "essence" that you can develop into character traits: the happy-go-luck dog, the sly cat waiting to pounce, or an elegant tapestry pillow. Develop them into characters first as the animals or objects that they are and then into animated people.

5. Choose a classmate to work with. You'll each think like a character, any character. Ask each other these three questions:

 A. What do you want?

 B. How do you move (your walk, things you do with your hands, etc.)?

 C. What do you enjoy doing?

 It's okay to make up wild and funny answers. Now change partners and ask each other three different questions:

 A. What's your biggest fear?

 B. What do you sound like?

 C. Who or what are you (male, female, person, animal, object . . . like a banana)?

 Individually, develop a unique, new character using most of these attributes. Discuss your characters in class.

6. Think of the funniest thing that ever happened to you or a friend. If you can't think of anything, make something up. What kind of character would make that situation even funnier? You may improve the details, if you wish. Discuss.

7. Develop three to six characters that you can use in a TV series, a short, an animated feature, or a game. You may work any way that is most comfortable for you, filling out a fact sheet, scripting short scenes, doodling and drawing, or improvising monologues or scenes between characters.

8. Grab a piece of paper and list at the top each of the three to six characters you're developing for your project. Underneath list the opposing attributes and traits of each, making sure that each character is as different from each of the others as possible. Will these characters conflict or rub against each other in a funny way?

9. Write out a detailed biography of each of your characters and give them a name.

10. Design your characters or work with an artist who can.

Development and the Animation Bible

Getting Started

How can you turn your characters and your ideas into a project? Development is starting with a kernel of an idea and growing that **concept** into something that will sell. In this chapter we focus mainly on how to develop ideas into a marketable form. However, you'll find many suggestions that will help you in developing material for a student film or a short as well. We also discuss briefly the **presentation** for selling a feature. To pitch a TV project you normally need to develop the series idea, design characters, and a couple of major settings, put it all into a bible (the presentation tool), and prepare your pitch. Developing games is discussed more specifically later.

We're looking here at the generally accepted rules for development. They've become the rules because they've worked best over time. If you can break the rules and come up with something that works better, do it! Just remember that companies must find an audience and make money to stay in business.

Follow these steps to develop your own project:

- Take a great character and develop your project around her. Put her in the right concept for that character. Bounce the world off of her.

- You might want to create your project around a central issue, a kind of struggle, or a general theme. Some central conflict ensures that there will always be action. A really funny, off-the-wall, central predicament or fish-out-of-water situation for your project ensures plenty of humor.

- Try a design style that is completely fresh and unique.

- To develop a television show you might want to use a unique **format** (*The Flintstones* was the first animated prime-time sitcom; *Archie* was the first Saturday morning soap opera).

- For a TV show or a feature you might consider obtaining the rights to something with marquee value and develop your project around that. Concepts with marquee value are those that are already well known: concepts from films, toys, books, comic books, games, commercial products, sports or entertainment figures, or any other source (like prime-time television programming).

- Look for the void. What's missing in the marketplace that today's kids want? What will interest tomorrow's kids?

Developing a Marketable Idea

Before you develop an idea too far, stop to evaluate its marketability.

- *Medium.* Are you developing this idea mainly for TV, a film, a game, a book, the Internet, a toy? Companies want ideas that will easily cross over from one medium to another. What medium does your idea best suit?

- *Core concept.* What's the principal idea? Boil it down to a **logline**—the statement of your entire idea in twenty-five words or fewer. Is this core idea going to be of utmost interest to your target audience? What else will the target audience like about your concept?

- *Theme.* Does it have a message or educational concept?

- *Characters.* Will they appeal to your specific audience? Can the audience identify with your characters? Is your children's concept "kid-relatable"? Are your characters archetypes? Set up relationships. Contrast characters.

- *Design.* The visual style. What's the look? Is it fresh?

- *Setting and time period.* Is this especially appealing? Why?

- *Competition.* What other ideas will be competing?

- *Accessibility.* Can your audience identify personally with your core concept? Can they interact with it in any way? How does it involve them? Can kids sing along, collect trading cards, play a game, or waddle like a dotty duck?

- *Temperature reading.* Is this idea "cool" enough for today? Is this tomorrow's sizzler? Some ideas may be good, but this may not be the time to pitch them.

- *Legginess.* Will this still be appealing down the road? Is this a classic?

- *Freshness.* Is this different enough from what's already out there?

- *Promise.* Will this live up to what your audience will expect?

- *Hypeability.* Does it have a **hook** that makes it easy to sell?

- *Demographics.* Will it appeal to a large enough audience? How can you make it appeal to an even wider demographic range? The six to eleven or six to twelve age range is the target age for U.S. advertisers for children's TV. Be sure you know who your target audience is. In evaluating ideas for children, keep in mind that the ideas

must also appeal to their parents, because they're the ones who usually lay out the money.

- *Appeal*. Does it appeal to the needs, hopes, and dreams of your audience?

- *Quality*. Do you have a good tale to tell? Great designs?

- *Profitability*. Is the buyer going to be able to make money on your idea?

More Things to Keep in Mind

- Off-the-wall ideas are good. Start wide. Then bring your idea down a bit.

- A catchy title shows creativity and attracts buyers and an audience as well.

- Good stories are usually simple. The children's classics aren't too complicated. Take your ideas and give them twists, reversals, and surprises to make them original. Stories need to connect with the core emotions in us all.

- Describe characters in a way that gives readers an instant handle on their personalities ("a relationship like Fred and Barney"). Don't mention a character's age, specifically, unless it's important to the concept.

- When you talk to anyone in the development department of a company, remember to be friendly. Being friendly doesn't mean taking up their time; I've never met a development person who isn't extremely busy. Often people find it more convenient to respond to a short e-mail than to take a call. Or make friends with the assistant. An assistant who likes you can provide a wealth of information and help you schedule a pitch meeting. Relationships are everything in the animation business. Assistants are also very busy.

- Do your homework. Don't develop and pitch what a network has on the air today or what they had on the air that didn't work last season.

- Leave enough variety and openness in your basic situation, **arena**, and characters for room to develop in future seasons. Can these characters undergo change? Can they go to a new locale? Can new characters be brought in . . . all without destroying the fun of the show?

- Is this a good idea for animation? Is it practical to produce?

- Can this idea be produced at a cost that will make a profit?

- Many buyers look for CGI shows that can be made on a television budget. Some feel that CGI works better in preschool television than in shows for older kids. Sometimes unrealistic CGI facial expressions, modeled on a cartoon budget, can drive away older kids because there's a lack of emotional depth.

- You want your characters to be easily seen against the backgrounds, or the action will be confusing and the audience won't "get" the gags. Backgrounds that are a little busy, however, can sometimes make low-cost animation appear to have more movement because the characters travel across the busyness.

- If this is a children's show, think of the kids! Stretch their imaginations. Develop programming **content** that's active, not passive. Give them good role models. Let them laugh and forget all the stress of modern life. Provide them with content that is entertaining, healthy for them, or educational . . . or all three. Programming that sends negative signals to parents in any way will be more difficult to sell. And yes, kids do have a right to enjoy pure entertainment, too!

- Develop what you personally have a passion for and what is going to sell. Many buyers will have a new budget to work with each January. Most companies today are looking for new concepts all year around, but they don't buy many!

Generally Accepted Rules of the Selling Game

You can **option** your idea to a production company and get a **development deal** to develop the concept further. The production company will tailor your idea to the needs of that company and to what they think will sell. Generally speaking, a small, independent production company might take higher risks and be more creative. A mainstream, large production company is likely to takes fewer risks, and they could be less creative. If the company is a major international player, they may have the means to distribute your project as well, but they'll probably have to sell the project to another department or division. If not, they'll have to find financing, possibly by finding a co-producer, and then they'll have to sell the project to a broadcaster or other distributor themselves.

Buyers of television programming look first for concepts with marquee value. Many buyers, particularly those in the United States, will not buy anything without it. To create new characters or a new series that's based on something with marquee value, you must obtain the option rights from the existing rights holder. Cartoons like *Muppet Babies, The Flintstone Kids, The Disney Babies*, and so forth were based on known characters. If you hold the rights, you can spin off a minor character from a well-liked television series as many prime-time shows have done in the past. If you're developing something with marquee value, be sure you don't lose whatever made the original a success. Keep the feel of the original and the look of the characters and environment. But make it practical for animation. For a concept with marquee value, you'll want to license something you can afford, something so new that the big companies are not yet bidding on it, something more obscure but really worthwhile, or something old and forgotten but well loved.

Projects with financing, partial financing, or merchandising already in place will probably be easier to sell. Many companies don't really expect a writer/developer to explore these areas first, but including additional incentives might help you get your project off the ground.

Better production values usually mean a longer life for a film or a television show, but not always. Generally, kids have become more sophisticated in film and programming tastes and in artwork as well. They're more design conscious than they once were. Certainly fads play a large part in longevity as well.

The general mythology of television programming has been that boys (especially after age six) won't watch "girl's shows" but that girls will watch "boy's shows." About the time that children start grade school, gender tends to become an issue. Some hits have been less gender specific. And, in fact, action shows with strong, rough-and-tough girl heroines have

done well. But programs with a girl in the lead are still often a tougher sell. If you feel that girls need good, strong role models, give it a try anyway.

Time slots for programming are important for kids just as they are for adults. Research has shown that boys watch animation more consistently on weekdays than do girls. The popularity of games may be changing that. Preschoolers watch their own shows when older kids aren't around, early mornings before others wake up, and during school. The older child usually has control of the remote. The audience late on Saturday mornings has traditionally consisted of many adults. Of course, the late evenings are primarily for adult viewing, but there are a few kids who watch TV at all hours.

As a developer, you may want to layer your concept with elements for younger kids, older kids, and adults. Some buyers prefer that you not limit your audience to a target age, allowing for as wide a viewing audience as possible. Other buyers want a program that's targeted specifically at only one age group or gender. Attitude and point of view are all-important in connecting with different age groups. Preschoolers like to be nurtured, young children like things that are silly, and older kids like wit and sarcasm. Tweens are more particular in what they watch than the younger audience and teens generally want programs that are edgy.

Programmers are finding that kids are outgrowing programming for their age groups earlier and earlier each year. Recent studies have shown that *some* older kids will continue to watch a favorite show even though they've outgrown that age group and that older siblings may come back to a show and watch it with a younger brother or sister, especially if a parent controls the remote. Kids will watch shows with older characters, but they won't "watch down" (watch shows with younger heroes or heroines), at least not when they're with their peers. Tougher censorship at some networks may tend to limit older audiences that cable and satellite networks with looser standards may pick up.

Animation isn't necessarily just for kids, and the adult audience seems to be growing, especially in prime time. Japan has had a large adult animation audience for many years and develops programming accordingly. Individual broadcasters are constantly realigning their audience as new channels start up and old ones change and find a new target audience.

Buyers look for ideas that stand out. Many concepts were sold because they're fresh and didn't follow the rules. Watch for hot concepts. Read magazines. Clip from newspapers and trade magazines stories about what's hot. Study commercials for concepts and characters that are getting the most exposure and marketing push. You have to be at the start of a trend or ahead of it. Forget the trend that's on its way out. Make your own trends. Remember that for a series to stay on the air or a feature to remain in the theaters, it has to have an audience and make money.

Market Testing

If you wish to develop a television project yourself, research the program idea. Use books and magazines at the library, research on the Internet, watch other animated programming and films, and talk to people in the target audience. If this is a kids' concept, immerse yourself in kid culture. Talk to kids in the target age group. What makes them laugh? Check out their interest in a **genre** or type of animation as well as in specific concepts. Study levels of enthusiasm. Watch kids at play. If you don't have children of your own, borrow a child!

(That's *borrow*, not kidnap!) Get nieces and nephews involved. Ask a soccer group or church group what they think. Do they like your idea? Do they have any good suggestions?

Television networks do market testing, often by bringing in **focus groups** of around ten to twelve children to test concepts or pilots of possible future shows. This testing can be very valuable. It works best when the network is looking for specific information from the child viewers. One U.S. network tests its projects about four times during the course of development. Testing also has its dangers. It's possible for a focus group to kill a pretty good concept. Testing isn't always impartial, and information obtained from testing can be flawed. The expectations of those testing, the kinds of questions asked, the general unreliability of children's responses, and many other things can skew results. One opinionated child can sway a whole focus group. The report on the testing may not reflect accurately what really happened. Often in testing, a DVD or video of the artwork is shown to the kids with narration about the concept. It will probably run about one minute. Kids may be asked to rate each concept with a happy face, sad face, an indifferent face, and so on. A longer cartoon may not test as well as a shorter cartoon, because there's not enough time to get into the longer concept with a one-minute test. A concept that doesn't appeal to both boys and girls won't rate as high.

Check out the details. Are the rights to the idea available? Is this a visual idea, suitable and expansive enough for the large screen or intimate enough for the small screen? Are production resources, talent, and budget available to do the idea well? Is the concept timely? Will it involve the audience? Is the concept too broad or too narrow? Can this concept be presented properly in the amount of time you'll have (film or program length)? Work from personal strengths. Drop an idea that doesn't seem promising at this time.

What Are Buyers Looking For?

Each production company, each network, and each development head is different, and each looks for different things. Do your homework. Watch the cartoons of the company you plan to pitch. Read the major trade magazines regularly: *Animation Magazine* (U.S.), *Animation World Network* (*AWN* online), *KidScreen* (Canada), *Worldscreen*, *The Hollywood Reporter* (U.S.), and *Variety* (U.S.). If you can go to one of the major markets like MIPCOM and MIPCOM Jr. or NATPE, do it. All of these help you to know what is selling and who is buying it.

Picture yourself in the position of the buyer. Most buy on instinct and because of trends. Buyers generally prefer something with an edge rather than anything too **soft**. Some executives you pitch, some toy manufacturers, and some programming executives may not be familiar with animation or even the film or television medium. Television sponsors normally have no input on programming, but anything that could scare away sponsors from advertising on a specific program is a definite factor in buying. Network decisions are made by committee, and all buyers have to justify their jobs. Sometimes what is most likely to sell is the "least objectionable programming." What is your program going to do for the development person or network that you're going to pitch? Know your buyer.

Generally the feeling is that multilayering, unpredictability, and diversity are good things, in moderation. In either a big budget animated film or in TV, something slightly different will probably sell easier than something entirely new. There's less risk. Usually, net-

works are looking for something that's similar to something else that's currently successful. What's hot and what's not is constantly cycling.

Some of the large corporations are interested in branding. That means that they want programs that viewers will associate with their company and its values and reputation—what the company stands for and promises. At least one multinational corporation is interested in attracting loyal child viewers who will want to search out their company's programming as adults. A few networks are looking for projects where the creator's voice is prominent. Many development people have told me that they look for a project that the writer/ developer is passionate about. I think this is true, but the project must also attract viewers!

Most children's networks have core values they want to include in all their children's programming. These values change frequently as the networks rebalance their programming for government mandates and for the viewers they currently want to attract. Here are some examples:

Core values of Kids WB! (U.S.)

- Heart

- Humor

- High adventure

- Heroism

Dr. Renee Cherow-O'Leary's Whole Child Curriculum Used by Playhouse Disney (U.S.) Do you recognize these from the human development chapter?

- Physical development

- Emotional development

- Social development

- Cognitive development (acquiring facts and information about the world)

- Metacognitive awareness/development (thinking about thinking, problem solving)

- Creative/artistic development

- Moral, ethical, spiritual development

Those are only examples and may have changed by the time you're ready to pitch to these companies. If you're developing a children's project with a certain company in mind, you might want to learn what the company specifically needs and tailor a project especially for them. However, because it's so difficult to sell any project, you'll probably want to pitch your project at a number of places.

The truth of the matter is that if you have a great project and someone is interested, the development people at that company will rework it extensively anyway. Any necessary values can be worked into the project at that time. What's important is that you're aware of this ongoing development process for most television projects. Any original project for chil-

dren's TV is likely to be changed substantially during development after it's optioned. So be flexible and open to any changes if you want to be involved. On the other hand, if you are involved during development, don't be afraid to stand up for what you believe to be really important to the vision and success of the show. It can easily take a year or longer to develop a series. Broadcasters are likely to have contractual approval over the cast, theme music, writers, characterization of the main characters, premises, outlines, scripts, storyboards, rough cuts, and final delivered show.

You're selling to the buyer, not to the audience. Most large networks look for a marketing hook, for something that can be sold internationally, and for something that has licensing possibilities. They may also be looking for a concept that can be made later into a feature or home video. Remember that these concepts must be financed somehow. They look for a good ensemble cast and strong leads. They look for something with a good story, for "cartooniness."

What do you need for your pitch? For an original project for television you'll want a presentation bible and probably, but not necessarily, some artwork. Some developers also provide a script or a short one- to five-minute pilot. Most buyers feel that a script is a waste of time at this point because the concept will change during development. A well-done pilot is helpful but expensive and unnecessary. A pilot or short produced on a budget with low production values actually makes a sale more difficult. Usually, developers don't attach stars or composers to their television development package. Although it could help in certain instances, it can also raise the budget too high or interfere with the development changes that a major company wishes to make. Although if you have major names interested, you might want to give it a try. Believe in your project, and find a buyer who does, too! Passion and confidence sell.

Artwork

Many writers hire an artist to design artwork for the series or film they're developing. If you don't know any artists who can do a professional job, you can hire a good artist from an art school. Be sure that any artist you employ signs a "Work for Hire" agreement *before* he puts pencil to paper. Artwork is not necessary to pitch an original concept to many production companies because these companies are interested primarily in strong concepts and good stories. They will find the correct artist to fit your concept. However, really outstanding, professional-quality artwork can help sell your show. Many development people are not artists and have a hard time visualizing what you have in mind. Unprofessional or mediocre artwork is probably worse than no artwork at all.

If you do include artwork, you need full-color designs of the main characters and at least one or two drawings of the characters in action in the locale of the film or series. Buyers like to see the characters in relationships, characters with an attitude, types of conflicts, and types of situations. If this is a comedy, make the drawings fun. A visual gag or two won't hurt. The drawings should be big enough to be displayed at the presentation. They will usually be viewed from about two to three feet away. A few developers, like Cartoon Network, have traditionally preferred a series pitched in storyboard form, but this is not a requirement. Any designs that are a part of your presentation should also be printed in the presentation bible that will be left behind. If you're selling a feature, you'll want more designs and you'll want them to be more elaborate.

The Television Presentation Bible

A presentation bible contains the following (often in this order):

- Title page with the series name and logo if there is one, plus the names of the writer/developers, copyright, and trademark information (if you have a trademark).

- One-page description of the show or concept including any myths or legends that are absolutely necessary to explain your cartoon world and how it came into being. If necessary, include a brief description to explain the time period and the rules of your project's universe. You may want to begin by telling the basic concept in a logline, twenty-five words or fewer.

- Brief description of the arena (setting) and any important props, especially unique and interesting ones that can be made into toys.

- Thumbnail description of the four to six main characters, relationships between characters and with the villains. Devote no more than a half page to each character, listing only a few traits (the essence). The character is this, but he's also that (a meek man but a devil behind the wheel of a car). If you do include minor characters, each should be limited to a sentence or two.

- Three to thirteen great **storylines** showing the kind of conflict, humor, and jeopardy. The best format for these is a logline summary of each followed by an expanded one-paragraph version. Usually, one of these stories will be the pilot episode. Six really great storylines are better than thirteen that aren't so good.

- **Context**. Context is the makeup of the show. Is this traditional animation, 3-D, or some other form, like Claymation? Is this fantasy or is it realistic? Comedy or action/adventure? Is there special music? How long is each episode and each segment? What's your target demographic age?

Approach the whole series. Think of yourself as the producer and director. Skip the nuances and sell in broad strokes. Style is important in writing the bible. You should capture the tone of the show. Let the executives know where the fun is and why it will continue. You should know how the series would evolve. Everything should be clear and easy to read. Leave nothing to the imagination. The buyer wants the facts, not just a sales job. Be specific. Write concisely. Be descriptive. Misspellings and poor grammar are bad salesmanship. A presentation bible usually has some artwork included. The main purpose of the bible is to get a development deal and ultimately sell the project. It's a tool for the buyer after you've left the presentation or pitch. Most executives will have to pitch a series to their boss.

The shorter the bible, the better! Be precise. Three pages are good, five pages are okay, and fifteen pages are normally too many! If a busy development executive has to read fifteen pages, the bible is likely to sit there until she has the time, which may be never! Also, longer bibles give the executive more to think about and more to dislike. The bible is a tease.

The Preschool Curriculum

A preschool series in the United States normally requires a separate curriculum in addition to the bible. This must be prepared in depth by a qualified expert in the field—a doctor in child development or in the specific subject covered by your series. The curriculum includes issues covered and goals for each episode. This can run anywhere from twenty to seventy-five pages in length.

It's harder to finance preschool programming, so it is usually harder to sell. Your concept must be very special!

The Feature Presentation

If you're developing a feature film, you'll want presentation material similar to the television bible plus a fifteen- to twenty-page treatment. If you're new to screenwriting, I'd recommend a well-written script as well. Writers who are well known in the business do not need a script for the pitch. For your feature pitch you'll want to include casting suggestions with names of stars who might be interested. You'll probably want to include some musical components, maybe with some sample orchestrations. Artwork will be of higher quality as well. Unfortunately, original animated features are difficult to sell. Direct-to-video or DVD features, which require less financing, sell a little easier.

Independent Shorts

Independent films are about creativity and expressing yourself. In an independent short you want to develop a concept or theme with variations, twists, and surprises. The film may or may not have a story. Without a story you might have no script, and you could have no need for a presentation to sell your idea. You may choose instead to develop your film by listing your ideas. From there you might want to outline your concept before going to storyboard.

Shorts are made for many different reasons. Why are you making this film? What is the content? Is this meant to be educational? Does it sell an idea or product?

Who is your audience? A teacher? Fellow students? Festival judges? Schoolchildren? An independent film normally does not have to please a mass audience, but it can afford to delight or even horrify a small one. The film will be remembered by the payoff at the end.

Is this film meant to be shown on a large screen where we can appreciate nuances, or is it meant for the Internet where subtleties are lost? How long will it be? Some independent animators advise that a short be no more than five minutes long.

Student films can be entered in festivals and compete for awards at places like the Academy of Television Arts & Sciences or the Academy of Motion Picture Arts and Sciences in the United States. Some cable networks show student films. In order to air your film, you need to get clearances on all rights like music, brands mentioned in the script, and so on. Be sure to check out all legal issues.

A short that can serve as a pilot for a series of **interstitials** might be easier to sell than a series itself. Broadcasters need to spend less money to air a series of shorts than they would

to air an entire series, and the interstitials can build up audience support for a series later. So consider pitching your short to a broadcaster as a pilot for interstitials.

If your film is meant to be a calling card to getting a job in the animation industry, then it should have the characteristics of commercial projects. It should show quality and good craftsmanship. Recruiters and agents appreciate a film with great characters and good storytelling skills. They're looking for freshness and originality. They aren't likely to appreciate a film that is too gross, consists of "in" jokes, or seems overly serious in theme. If you make an independent film that centers on loveable or cutting-edge characters, is suitable for mass audiences, has humor, and tells a good story, then you have an excellent project for your portfolio. It may open doors for you.

International Considerations

With today's global marketplace, shows are often financed through co-productions. Sometimes a co-producer helps only with financing or distribution. Sometimes one company does most of the pre-production and another provides production services or perhaps post-production services. Co-productions may mean additional tax credits and government financing. For instance, in Canada productions get a tax credit if they use Canadian writers.

In some European countries writers and artists have moral rights. That can mean that the writer or artist there must approve everything. So getting the work done can translate into additional time and additional headaches.

Certainly, preferences for local culture and other cultural and political views must be considered in projects that will be financed or viewed internationally. This takes research and sensitivity to people everywhere. But U.S. buyers are finding that many projects will work anywhere, as people around the world are becoming more alike in their tastes for children's programming. A program that is geared to only one country must be much cheaper to produce to make a return on the investment.

All programming trends cycle, so find out what's hot internationally today. Quality is more important in selling a concept in many countries than marquee value. There's often interest in softer projects as well as action/adventure. But some countries have regulations against developing shows from toys. Preschool projects may be harder to sell. Comedy sells well in Europe, not as well in the Middle East or Asia. I believe that over time satellite-delivered programming, beamed to wide areas of the globe, will change some of the traditional international attitudes about programming likes and dislikes.

Remember that puns and wordplay don't translate well internationally. Physical comedy works best. Action doesn't require translation.

Around the globe buyers are looking for cutting-edge art. Avoid written signs for an international audience. Avoid flags or anything else that might seem out of place to audiences around the world.

Protecting Your Work

Protect your work as well as possible. For example, © 2005 Jean Ann Wright on the title page of the bible and on each piece of artwork would theoretically protect my bible and

artwork. It would be protected more thoroughly if I actually registered that work with the U.S. government by paying a fee and filling out the paperwork to obtain a copyright. Obtaining a trademark would protect my work even better. There are those who feel that a copyright notice on a script title page looks unprofessional. It is true that top writers don't bother with copyright notices on their scripts, but top writers are represented by top agents who look out for their work. Use your own judgment; legally your work is not protected without the notice. Major studios always place a copyright or trademark notice on their artwork. If possible, hire a lawyer to give you good advice, and read everything you can about legal issues. The Writers Guild of America also allows you to register your work there. Get more information by going to www.wga.org.

Other Legal Issues

In the United States if you don't have an agent or an entertainment lawyer who can submit your project, then you'll probably have to sign a release form to get anyone to look at it. These forms protect the studio and require you to sign away some of your rights. Do this only if you have no other choice and are willing to risk losing some of the rewards of this project if it means making contacts and getting a start in the industry. I wouldn't recommend it. It's better to take more time, start relationships with people in the industry, and find a way to submit without signing away your firstborn.

After you've protected your original work as well as possible, get it out there and stop worrying about someone stealing it. Development people have offices stacked with presentation bibles and scripts. Chances are your original idea isn't original anyway but has already been submitted in a similar form. What buyers are buying is your original *take* on an idea. If they like how you handle your idea, chances are they'll want you to be involved in developing it. Good ideas are everywhere. Media companies don't want to risk lawsuits any more than you do.

If you're able to find an agent who will represent you, that's great, but in animation an agent is not a requirement. Either way you're the one who will be doing most of the legwork. In case you're offered a contract and you have no agent to negotiate it, be sure to get an entertainment lawyer to look it over first. Negotiate a price for his services before you hire him, or put an upper limit on what you're able to spend. A good attorney knows what is possible for a newcomer to negotiate and what is not. And he can save you money in the long run.

A bible from the animated series *How To Care For Your Monster* follows (figure 6.1).

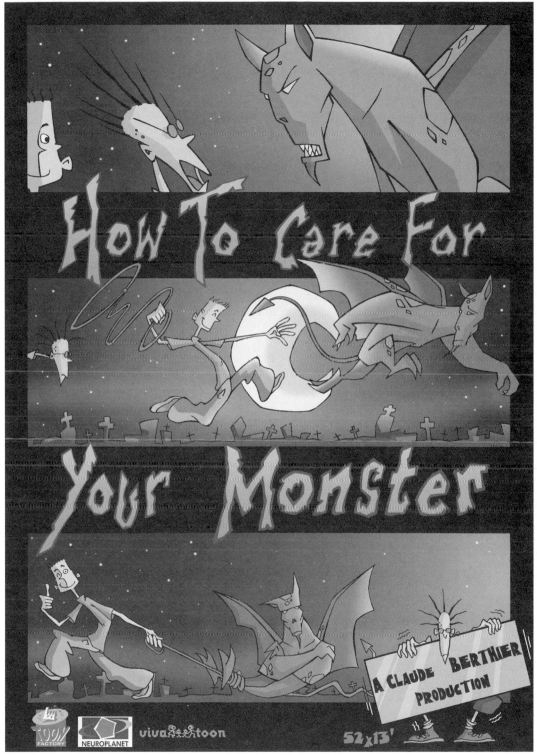

Figure 6.1 Bible for *How To Care For Your Monster*, Toon Factory (France). Based on the book *How To Care For Your Monster*, written by Norman Bridwell, published by Scholastic Inc. Series created and developed by Tom Tataranowicz and Greg Johnson.

TABLE OF CONTENTS

SERIES GUIDE

Figure 6.1 *Continued*

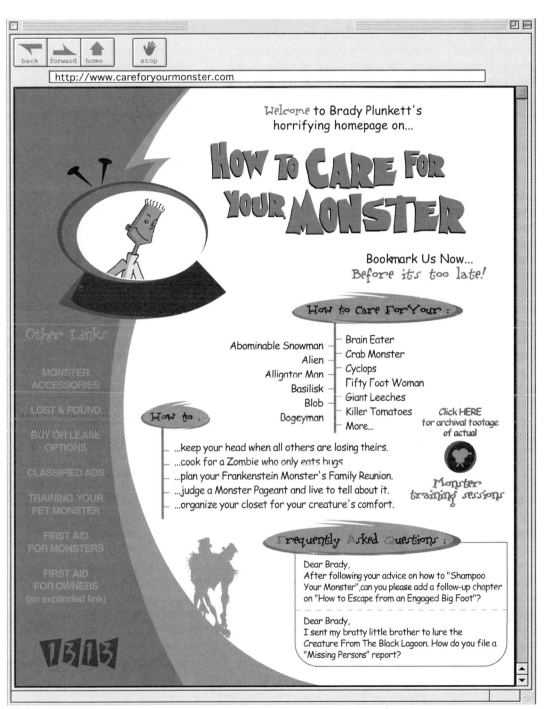

Figure 6.1 *Continued*

THE CREEPY CONCEPT

What would it be like to live in a world where kids are clamoring to replace their adorable little household pets... with MONSTERS ?

Frightening, unpredictable, often carnivorous Monsters ?

Well, twelve-year-old Brady Plunkett lives in that world. In fact, he was first on his block to con his folks into owning a pet monster. After all, goldfish and gerbils are passé. Hideous Monsters are the rage of the new millennium.

And though Monsters of all shapes, sizes, and appetites are slowly being accepted into society as sort of semi-domesticated pets, this shift in lifestyles doesn't necessarily come easily. In fact the adults are still downright terrified !

Family values will never be the same !

And, as a tireless crusader for 'Monsters' Rights', Brady Plunkett's self-appointed role is to help mainstream these frightening brutes into quiet suburban life with a few helpful "Do's, Don'ts, and Do at Your Own Risks".

To that end, Brady eagerly canvases the neighborhood "haunts" with camcorder in hand to document new chapters for his "How To" Website. Shaky footage and blurry zooms are de rigueur as he captures friends and neighbors in their comedic attempts to tame these wild, bloodsucking, moon howling, half-stitched beasts of lore.

And, being sort of the guru in this "Monster Obedience Course", Brady has justifiably earned the reputation as local expert on :

"HOW TO CARE FOR YOUR MONSTER"

Figure 6.1 *Continued*

THE TONE OF THE SERIES

No cuteness allowed... **"Verboten"** *(as the sign on the Old Castle says).* Though this is a comedy, you won't find any monsters forming rock bands here, or a hippie van of Mystery Chasers and their clumsy dog.

This is a quirky, unpredictable comedy , where the humor is driven by the unique dilemma of mainstreaming genuinely frightening Monsters into our "normal" society – despite their lack of social skills.

THE PREVAILING ATTITUDE

Though the acceptance and domestication of Monsters is recognized by kids the world over, it is not accepted by adults. Kids aren't scared of the Monsters, but the adults usually are! That's why kids are always calling Brady Plunkett, to help ease the potentially perilous adoption process.

BRADY'S TOWN

RAVENVILLE. We definitely recognize this picturesque burg. It's got the manicured suburban neighborhoods, the cheerful park, a big mall, a steep snob hill, and a stuffy business district. You'd expect Beaver Cleaver to coast up on his bike at any moment.

And then there's the neglected Old Cemetery, the Castle Ruins on the cliff, the Misty Woods, Haunted House Hill, Devil's Caverns, and the Foggy Bog just outside of town.

Oh, not to mention the Pet Store owned by the creepy one-eyed Igor who keeps Monsters in the dark underground chambers of what is confidentially known to all kids as the Monster Shoppe.

Figure 6.1 *Continued*

The Old Cemetery

The Woods

The Monster Shoppe

Figure 6.1 *Continued*

BRADY PLUNKETT

This outspoken twelve-year-old video virtuoso has a passion for misunderstood Monsters everywhere. It all started during a lightning storm when he was barely four. Arlene, his ornery older sister, convinced Brady that the scratching outside the window was not a branch, but a Monster wanting to come in... and eat Brady. Well, it turned out it actually was a Monster, and it actually did want to eat Brady. So, feeling sorry for the hungry beast, Brady tossed that night's leftovers out the window. The Monster scarfed it, gave a final sniff toward Brady, who had sought refuge under his covers, and then vanished into the cluttered depths of Brady's closet.

And though he didn't know it at the time, the spark of Brady Plunkett's noble cause was ignited. Like kids everywhere, Brady had come to love and fear his monster for the fright it was... an undeniable part of every childhood. In the years to come, he'd take the "Monster by the Horns", and attempt to introduce these eerie creatures to domesticated life.

And now, with a wholesome intent that would rival "Opie Taylor", yet with an "Eddie Munster-ish" delight in the macabre, Brady has a unique way of reaching the inner feelings of most any monster. A real "Doctor Ghoulittle". But he's also a somewhat hapless boy with misguided confidence, determined to maintain his ideals for a perfect world in which man and Monster can live together in harmony.

In the not-too-distant past, he was simply one kid among many, but Brady is now the B.M.M.O.C. ("Big Monster Maven On Campus") at his local school. At home, though, he's a slightly flawed diamond in the rough, where his comically dysfunctional family is, according to Brady's perspective, out to make his life as rotten as a zombie's fart. (Okay, so we can't say fart, but you get the idea.)

THE GRUESOME CAST OF CHARACTERS

Figure 6.1 *Continued*

Brady's House

Hallway

Brady's Room

Figure 6.1 *Continued*

VIRGIL ARP

Brady's twelve-year-old best buddy. The handsome star in many of Brady's video productions, young Virgil is determined to shine on screen despite his one little shortcoming. He's frightened to death of Monsters, having never forgiven them for no doubt hiding beneath his bed when he was a toddler. Not the sharpest tack in the junk drawer, and with a hambone tendency to overact that would make Vincent Price proud, Virgil finds himself in many a "hairy" predicament with Monsters as his costars.

Virgil's Basement

EMBER TOMBS

This thirteen-year-old friend of Brady's is a beauty with a ghoulish fascination for the morbid side of life... or death. She sleeps with a voodoo doll, designs her own line of "bone" jewelry, and gushes enthusiastically when Monster training sessions go terribly awry. However, Ember's weird talents often prove handy in tight situations.

As far as owning a Monster herself, Ember is a bit fickle - taking uncanny pleasure in testing a continuing procession of assorted creatures to welcome the unwary visitor to her house. Every time Brady and Virgil visit, the goosey Virgil must always brace himself for the unexpected.

MAXWELL PLUNKETT

He's Brady's long-suffering, barely tolerant, monumentally miserly father, who is more concerned with running a tight ship than enjoying the unpredictability of family life. And Monsters do not belong on a tight ship! Kids probably don't either, but hey, what are you gonna do? Things happen. But Max Plunkett is also quick to seize the profitable opportunities that some Monsters present – like free check-ups from "Dr. Jekyll!"

Figure 6.1 *Continued*

POLLYANNA PLUNKETT

Brady's mother – an easily flimflammed Edith Bunker-ish type of home-maker whose domestic creativity leans more to the oddball side. But to her credit, being virtually fright-proof, she actually likes having Monsters around as pets, and treats them like "such cute little critters," much to their dismay. The problem is, some of the more clever monsters actually take advantage of her naiveté, and manipulate her into furthering their selfish needs.

ARLENE PLUNKETT

Brady's seventeen-year-old boy-crazy, brother-torturing older sister (think a more PG rated "Kelly Bundy"). She's outgrown the need to have pets, especially of the Monster variety. But even she sometimes still finds them a "useful" means to an end, as in dealing with old boyfriends; filling the occasional gap in a double date, etc. Brady now and then finds himself reluctantly going to Arlene for advice. Not always good advice, and often geared to serve her own motives. But hey, what does Brady know? He's just a young kid untutored in the devious machinations of a teenaged sister.

Though Brady has designated his room off-limits to his pillaging sister, Arlene totally disregards the signs, barricades, and alarms to rummage through his stuff looking for things to sell.

MARVIN and GAYE PLUNKETT

Brady's eerie and pathologically quiet twin brother and sister, who seem to communicate telepathically... and only with each other. Though merely five years old, these eerie siblings take great pleasure in startling and frightening Monsters every chance they get. Brady is halfway convinced that there was some sort of baby mix-up with the "Addams Family" twins in the maternity ward.

MR. IGOR

Igor is the owner of the Ravenville Pet Shoppe, an establishment that has been in his family for generations. The main store distinguishes itself by the special extension built deep into the cellar of the Monster Shoppe! Igor himself is a short, one-eyed, hunch-backed, creepy little toad of a man who never seems to leave the Shoppe and get any sun, making his skin a pasty grey colour. He gives the impression of being unhealthy; wheez-ing, coughing, sniffling and sneezing as if balancing precariously on death's door. Igor is always trying to rip off his clients. Half his monsters are high-end, top of the line creatures, but the other half are damaged by at least one major flaw – but if you don't ask, Igor won't tell!

Figure 6.1 *Continued*

THE GHASTLY GANG OF MONSTERS

Monsters are unpredictable, untamed, and yes, uncouth!

You can take the Frankenstein out of the Rotting Windmill but you can't take... well, you get the idea. They are simply not looking for ways to win friends and influence people. It's no secret. Monsters are beastly, that's why they're called "Monsters!"

Vampires are also a challenge. Aside from keeping you up nights, feeding time requires a large and... "understanding" family. And Zombies? Face it, they're "rotten" pets when it comes to recreation. In a game of Zombie Football, hearing *"hand off at the fifty-yard line"* is nothing to cheer about.

But things are fine as long as kids can keep their Monsters somewhat under control – no Creatures from the Netherworld chewing up the furniture, Ogres chasing down the mail carrier, or smelly Sasquatches sneaking into Mom and Dad's bed during a stormy night.

You see, even though the hours are good, and the fright work comes naturally, it is sometimes hard for Monsters to shake those latent, time-honored inclinations to rampage a village. And frankly, they don't really try. **We'll be meeting a wide variety of these Monsters**, some who speak, some who can't, and some who grunt convincingly. The various episodes will occasionally focus on a few select Monsters like :

Figure 6.1 *Continued*

THE FRANKENSTEIN MONSTER

Or "Stitch" as he prefers to be called, which means in Karloff-ese, "man of many pieces." Unable to communicate much beyond grunting the occasional hostile word, this Monster is a towering mass of menace. However, Brady manages to sometimes touch a nerve with the big guy, getting an insight that few others live to see.

What Brady learns is that Stitch, patched together from any number of unique and generally reluctant "donors", suffers from the ultimate of identity crises. Really a sensitive Monster, Stitch is suspicious there might be a "female part" somewhere in his anatomy, since he occasionally "tends that way."

When he's not out on a senseless rampage, Stitch is sentimentally driven to construct a virtual forest of family trees in hopes of tracking down any and all lost family members, where he hopes to introduce himself. But he's annoyed at popular myth that has the outstretched arms of Frankenstein Monsters interpreted only as a gesture of hostility. Sometimes it really means they just want a hug. But then again, sometimes it means they're trying to throttle you. People should just be able to tell the difference!

THE VAMPIRE

"Vlad"... an aristocrat of ancient royalty who expects to be treated as such. But keep an eye on this guy. He thinks with his teeth. Though it's not his fault. He is, by nature, a vampire. This means that he... well... face it, he sucks! However, to his credit he is trying to kick the guzzle-blood habit, sometimes going as far as committing himself to a blood-treatment program. Just don't fall for his "look over there!" trick.

THE MUMMY

Just called "the Mummy" because, with Egyptian burial rites being well known for giving literal meaning to the phrase: "cat got your tongue", this swaddled fellow can't even enunciate his name. This very lack of communication skill so easily frustrates him that he'll start swatting at you if you don't understand his mumbled laments.

And this guy wants a lot! Very materialistic (he was buried with all his earthly possessions, after all), he refuses to throw anything away, and he can't pass a dumpster or a landfill without stopping to browse for unique "treasures" to fill his tomb.

Figure 6.1 *Continued*

THE WEREWOLF

"Harry." When the moon is full, he wants to eat garbage, sniff the neighbors, and chase cats, joggers, cars, and trains. Forget using a leash, you'll be skinned alive. And, after he's been out for the night, hope he doesn't come home picking his teeth with a bone. But when the moon isn't full, he's just a bald-headed, needy man without a job who is good for little else than sitting around your house complaining, watching the tube, and eating pork rinds. With his monotone "Steven Wright" laconic comments, complaints and criticisms, the human Harry is "The Wolf-Man Who Came To Dinner" and who never intends to leave.

BRADY'S MISSING MONSTER

Not too long ago, Brady had a great Monster, a real absolute bane of creation. It was truly a standout ghoul.

But then, one stormy evening, Brady nervously peeked inside his dark closet expecting the usual fright, but got nothing. No gasp, no jolt, no lunge, no imminent demise... not even a tingle. Nothing. Then the true horror began to sink in.

Brady's bedroom had been invaded... cleaned up by his mother! And his Monster had fled.

So the search is on for Brady's Monster...

...a personal if slightly obsessive quest that will motivate Brady through the entire series. But until he finds his runaway fiend, he'll be trying out a string of potential replacements - despite the exasperation of his family.

The identity and appearance of this creature are kept a mouth-watering mystery... but we do get tantalizing, comedic bits of insight as to what this thing might look like through Brady's attempts to describe it to potential witnesses. And the perpetually unseen picture he passes around gets consistently alarmed responses. It's a running gag which is perhaps best paid off in the imaginations of our viewers.

Figure 6.1 *Continued*

GARGOYLE

DRAGON

EVEN MORE MONSTERS

is as long as Stitch's father's day card list or as varied as Vlad's blood type, all ripe for a quirky personality or two. Aside from the traditional Monsters one would expect, you'll also find a surplus of the uncommon variety. Everything from Gargoyles, Gremlins and Golems, to Leviathans, Lepus', and Lunar Fungi. Not to forget Minotaurs, Chupacabras, Hobgoblins, Trolls, and fire-belching Dragons, just to name a few.

SKELETON GUY

HOBGOBLIN

MINOTAUR

Figure 6.1 *Continued*

THE 3 FRIGHTENING FORMATS

Since we're looking to produce 52 X 11-minute episodes, we're going to need a variety of ways to tell these stories. We've identified THREE formats or ways to get into each of the stories.

1 BRADY ON THE JOB

In these stories, Brady offers his "professional advice" to all who need help with their monster. The story will be about Brady helping another kid with their monster. These stories might start with a kid knocking on Brady's door. Or Brady might run an ad announcing his advice for hire.

In this format, Brady enthusiastically imparts his sage and occasionally misguided wisdom on such topics as "How To Find A Monster Perfect For You". And he will gladly demonstrate the finer points of setting a snare for a creature from the wild, cutting a deal on a previously owned model, or purchasing one from an arcane backroom at the Pet Store.

Above all, Brady is determined to educate kids and parents alike about Monster Care. Say your Sea Serpent refuses to come out of the toilet - call Brady! Your pair of Cyclops' don't see eye to eye - call Brady! Your neurotic Mummy comes unraveled at the drop of a cat - call Brady! Quality service, reasonable rates, all Trading Cards accepted.

This format could also make use of Brady's Website. We'd start the episode with a full frame "web page" and "click" on a "department" on the site as a way to introduce the story.

A story example in the "On the Job" format:

Figure 6.1 *Continued*

Virgil goes to Brady with a problem. He wants to get a girl at school to notice him, but the problem is, she likes Monsters, and Virgil is frightened to death of them. The answer is obvious – Brady's got to get Virgil a monster. The worried Virgil reluctantly agrees, but on the condition that it's of the easy, quiet, and non-hostile variety. Something mature, worldly and easy to store, something like... a Mummy! Preferably a polite female. So, after a few dead ends, Brady finally secures a female mummy about to be discarded from the museum. Unfortunately, the new owner of any mummy also inherits its Curse – and life becomes one hazardous accident after another for Virgil – with Brady doing his expert best to keep his friend safe. Though Virgil does succeed in getting the girl to like him, the mummy likes him even more, and stalks the poor kid in a monstrous "fatal attraction." Now it's up to Brady to answer the question: "How To Get Rid Of A Jealous Mummy."

For additional episodes, this unique Website format is handy when other Monster Owners are in search of guidance, hoping to answer questions like, "How to deal with my Frankenstein Monster's identity crisis." Or "What to do with a Fad Monster once it's no longer in vogue."

2. BRADY AT HOME:

In this format, the stories center around Brady and his family. Whether it's his easily manipulated MOTHER, long-suffering and penny-wise FATHER, self-indulgent teenage SISTER, or the telepathically malevolent YOUNG TWINS – they all provide frustrating obstacles in Brady's mission to help the monsters and their kid owners. And his family doesn't make it any easier on Brady as he consistently parades a succession of Monsters to replace his missing one.

At least Brady can count on the faithful, though somewhat hapless, support of his best friends - the oft-distraught VIRGIL ARP, and the ghoulishly pretty EMBER TOMBS.

A story example in the "Brady At Home" format:

Figure 6.1 *Continued*

"How To Handle A Part-Time Monster"

Every red-blooded boy needs his very own Monster, so when a heavy-hearted Brady decides it's long past time to replace the one that ran away, he must then go to the "Bank of Dad" and convince his Father to let him. But ol' thrifty Dad's got an eye on the bottom line, and only agrees to a bargain rate, part-time Monster. So with visions of free medical care, Maxwell Plunkett allows his son to bring home a "Dr. Jekyll / Mr. Hyde" Monster, who was found holding a cardboard sign on a freeway on-ramp "Will Perform Medical Treatments For Food". But it turns out that this Doc is just a whacked-out chemist practicing "horror-istic" medicine while trying to find "the cure" to his transforming ails. To that end, he experiments on Brady and his family, tricking them into taking a little sip of this or a little nibble of that, until the Plunkett household literally become Monsters themselves. Everyone, that is, except for Brady's teenage sister Arlene, who, to get spending cash, sells the whole slathering bunch to a gypsy Monster Trader passing through town.

3 BRADY'S FAR-FLUNG SEARCH:

These stories would be about Brady trying to find his long lost pet Monster. Brady will follow ectoplasmic evidence, slimy leads, and dripping clues in search of his pet, only to always come up empty-handed. These stories would feel a bit like a "detective story" as he hunts down clues.

A story example in the "Brady's Search" format:

"How To Find Your Missing Monster"

Brady, feeling like he has exhausted all options after his latest search, posts a reward on his Website for anyone who might have crossed paths with his missing Monster (and lived to tell about it). Unfortunately, this instantly brings out every flimflam artist in town, all presenting Brady with a string of broken down monsters and outright fakes, until the house is literally overrun. Brady's father comes home to this absolute chaos, and kicks everybody out in short order, no one realizing he's just slammed the door in the face of a newcomer, who actually is Brady's long lost Monster.

Figure 6.1 *Continued*

SAMPLE STORIES

"How To Throw A Monster Bash"

With Halloween fast approaching, Brady seizes this perfect opportunity to organize a P.R. blitz for the Monster Movement. He decides to stage a high profile event - the first annual Ravenville Monster Pageant – and kids all over town are entering their reluctant Monsters. But competition is quite stiff *(and stiffness is a category)* with points awarded for sharpest fangs, best shriek, and worst aroma. And with all the time Brady Plunkett has devoted to "grooming his creature for success" his frightening fiend is the odds-on favorite to win.

Unfortunately, only days before the pageant, his Monster hits the high road, fleeing the Plunkett home thanks to an uncommonly energetic and thorough house cleaning by Brady's mother. And though Brady searches high and low *(and sometimes lower)*, he comes up empty. Duty calls, however, and ever the budding professional, Brady grabs his camcorder to document the eager preparations of Monster Owners everywhere.

The Pageant is a hit, with every Ogre, Ghoul, and Dripping Entity attempting to act on their best behavior (a subjective call, if anything, given their ghastly *predilections)*, all shining examples of good Monster guardianship, thanks to Brady's tutelage.

And to Brady's absolute joy, his own *(unseen)* Monster makes an appearance to the gaping wonder of the others. But the monstrous competitiveness of the owners is what really gets nasty, and by the final shredded curtain, Brady's Monster has fled once again – no doubt disgusted with the absolute beastly human behavior.

Brady resumes his search for his beloved creature while preparing his next Web installment – "How To Train A Monster Owner."

Figure 6.1 *Continued*

The Foggy Bog

"How To Get Rid Of An Undesirable Monster"

When a young city boy goes on a country outing, he finds himself exploring the Black Lagoon, collecting the usual treasures – rocks, reeds, pine cones, and a cute little pollywog, which he lovingly puts in a water-filled jar.

But once the boy gets his new pet home to the family brownstone in the city, the little pollywog has already outgrown the jar. And it's not so cute anymore. Within days, this "Creature's" appetite has progressed from bugs to pigeons to Mail Carriers, and it has flooded the cellar and taken up residence in it – turning most of the house into a swampy, humid, moss-dripping lair. In a reversal of roles, the boy and his family have become the Creature's pets, and to forestall becoming entrées on the menu themselves, they keep it fed by sending a series of hapless Neighbors and Salesmen into the depths of the house as "offerings". In the meantime, the boy locates the only Monster Expert he can find on the net - Brady Plunkett, who arrives to professionally handle the situation.

It's a creepy adventure as Brady and Virgil set a series of traps, lures, and oddball strategies - all of which fail. It looks hopeless until Brady sends the reluctant Virgil to the dark and frightening Black Lagoon with a cellphone, hoping to transmit the sounds of other creatures at play. What he gets, though, is the creature's mother laying a monster-sized guilt trip on it. "You *don't write, you don't call...*" That, of course, doesn't work, but luckily Virgil does find a cute young girl Creature to lure him back into the Black Lagoon *(via a subway, two bus transfers, and one unlucky cabby).*

Figure 6.1 *Continued*

"How To Train Your Monster in Home Protection"

With a rash of burglaries in Ravenville, Max Plunkett decides to let Brady bring home a monster that can also stand guard over the house. Unfortunately, the monster takes its job too seriously when the Twins convince it that Max perfectly fits the profile of a hardened criminal type.

"How To Haunt A House"

A family moves out of the old house on Haunted Hill, taking the ghost with them. Not good news for the kids of the new tenants, who were looking forward to living in a "haunted house." So they look to Brady to find them a suitable ghost to make their home complete. But the only poltergeist Brady and Ember find is new on the job and needs a little help getting into the "spirit".

"How To Sneak Your Monster on Vacation With You"

Brady has been e-mailing out "Internet feelers" about his missing Monster, and one finally pays off. Someone claims to have it, though he won't give it up without a suitable replacement. Brady cleverly reroutes his family's vacation, while trying to keep his stowaway, Stitch, aboard the motor home in order to make the trade.

The Haunted House

"How To Build Your Own Monster..."

From his home, Brady prepares an instructional video to show kids everywhere how easy it is to generate your own monster... complete with recipes for growing parts in your mother's Crock-Pot. However, thanks to Virgil's inept assistance, the directions are difficult to follow at best, and Brady is faced with a long line of disgruntled customers and their mixed up, troublesome monsters. To top things off, the Twins meddling with Brady's own concoction for "Home Grown Ghoul" causes it to come to life in disastrous fashion.

Figure 6.1 *Continued*

 Exercises

1. What genre of stories do you have a passion for now? Which stories did you like as a child? Why did you love those stories?

2. What themes interest you or move you? Why?

3. Find a design style that you particularly like. Bring in pictures that the class can see, or draw something in a style that is uniquely your own. Discuss.

4. Using the characters you developed earlier, start development on a television series and a presentation bible.

5. If you're an artist, design the primary locations for your series, put your characters in action within the settings, add the character drawings you finished earlier, and include the artwork with your bible.

6. Start development on a concept for a feature film, using the characters you developed earlier. First see the section on feature films.

7. Work on the basic idea for a short film using your own original characters.

8. Develop the concept for an Internet short. See the section on the Internet.

9. Create a video game or wireless concept, and work on the concept proposal. See the section on games or wireless first.

10. Go to a legal library and research copyrights and trademarks.

11. Research contracts.

Basic Animation Writing Structure

Differences in Story Structure

Structure exists to help you write a better story, but differences in the length of your story make a difference in the complexity of your structure. Differences in type (feature, kid's cartoon, Internet short) or genre (action/adventure, comedy, preschool) can also make a difference in complexity and style. A feature script is longer and requires more structure to hold our interest. An Internet short or one-minute TV cartoon requires very little plot. In fact, structure may get in the way of the gags. Generally action/adventure shows require more plot than gag-driven comedy shows. Prime-time animated shows generally use a sitcom structure with more clever dialogue and less action.

Basic Structure

All stories must have a beginning, middle, and end. A short series script (for TV or the Internet) must be about the stars of that series and be centered on them. The star or hero of each episode must have a goal or motive, and someone or something must oppose that goal. These are the basic story musts, and the same applies to a film. Of course, there are also independent animated films that are more abstract and make no attempt at telling a tale.

Normally scripts use a three-act structure:

- *Act I* This ends after the problem has been set up. (The girl is on top of a flagpole.)

- *Act II* This ends before the **climax**. (Someone is pelting her with squishy tomatoes and rotten oranges.)

- *Act III* **Resolution**. (She finds a way to get down.) Wrap up with a **tag**.

Occasionally a TV animation script will be written in just two **acts**, but even with only two acts, the basic three-act structure will be spread out over the length of those two acts. The three acts of a typical television script may be about the same length, although the last act will probably be the shortest. Sometimes the first act is shorter. Television act breaks normally come at commercial breaks, so suspense should be built up to help keep the audience in their seats through the commercials. There may be an opening teaser.

A three-act feature script will probably have acts that are apportioned: 25 percent for Act I, 50 percent for Act II, and 25 percent for Act III. The rules are not carved in stone.

Creating the Story

First Method

This is a simple step-by-step method for creating a story for an established series or for your own characters. Here you're writing a story for characters you know.

- Who is your protagonist, star, or hero for this episode? We will use the terms *protagonist*, *star*, and *hero/heroine* interchangeably in this book because the protagonist, or the person who drives the story, is normally the star or the hero/heroine in an animation story. What is the star's character flaw, fault, or weakness? How does this flaw hurt or annoy others?

- Go to the end of your story. What does this character learn about himself and how to treat others by the end of this episode? What was the lesson that the story taught him—the theme of your story? A series star may have to repeat some of these same lessons time after time, since series characters don't undergo much change. For instance, Scooby-Doo remains a coward.

- Back to the beginning. What does your protagonist want? This goal should start low and snowball throughout the story until it's almost an obsession by the end.

- Who (what villain or opponent) can best attack the star's character flaw, oppose his values, and try to stop him from reaching his goal? This villain should ideally want the same thing as the star. (It could be something specific like a treasure chest of gold, or the characters might be fighting over something general like control or a way of life.)

- What's the **catalyst** or inciting incident, the person or thing from the outside, that causes the protagonist to come up with his goal and start the story moving? It may be the villain that puts the story into action, especially in a mystery. (The villain appears as a ghost at the old house.)

- Make sure that all story points are related and tied together so that you're telling only one story.

- The star or hero develops a **game plan** to reach his goal. The villain attacks over and over. There is usually a major reversal or **turning point** in the way that the action is

going at the end of Act I, spinning the action around in another direction. Now there's no turning back for the hero.

- In Act II new information is coming out. Our hero keeps revising his plan because it's not working. A high point is likely about halfway through the script. Everything looks good for the hero, and it appears that he'll attain his goal. But the hero has a defeat or apparent defeat, giving the villain or antagonist an advantage. This starts the downward slide for the hero.

- There's another turning point toward the end of Act II, spinning the action around again.

- The **major crisis** is the lowest point in the story for the hero. It's the reverse of what the hero wants. Often it's here that he's faced with his critical choice (whether to go after the gold in the chest that's nearing the edge of the falls or to save his best friend). This crisis might be the turning point at the end of Act II (more likely in a feature), but it can't come too soon or the third act will drag. If the major crisis is at the end of Act II, it requires a short third act.

- In Act III the hero comes back and tries harder. This is the biggest battle. It's best when it's a physical battle and a battle of values. The hero wins! This is the climax! Everything must build to this point.

- Resolution. Wrap up quickly.

This method works best for longer material: a feature or an hour or at least a half-hour story. It works best when you want more character, more plot, and less belly laughs. The steps are general, a structure to work toward. Your story may be slightly different.

Second Method

This method is the same as the first method, but if you don't yet know your characters, the steps will be in a different order. Here you may want to start with the theme or lesson that your protagonist is going to learn—what the story is really about, the second bullet in the first method. Then go to back to the first bullet: Create a protagonist or hero that can best benefit and learn from that theme and an antagonist that is best suited to fight or oppose that theme and that hero.

Third Method

Some longer stories have all the elements of the previous, but they have more than one plot: an **A-plot** and a **B-plot**, and sometimes even a C-plot. The B-plot is a subplot that complicates the main plot or places an obstacle in its way. One plot may be an action plot and the other a character-driven plot. The character plot may revolve around the hero, and the action plot may revolve around the villain. Both plots must advance the story. The subplot must

add to the story, giving it more dimension. The subplot should start after the main plot, interweave, and wrap up close to the main plot. It should remain less important. Getting the two plots to come together into only one story with nothing extraneous can be the hard part. Stories with A- and B-plots are too complicated for shorter stories under the half-hour length. Even some half-hour stories do not deal with subplots. If you're working with a story editor on a series, ask if he wants a subplot.

Fourth Method

Prime-time animated shows are written like sitcoms. A sitcom is a comedy based around a situation. A protagonist still has a goal, develops a game plan that's opposed, and battles someone or something for the outcome. But sitcoms have less action. They're not as visual and lend themselves less to classic animation techniques. The comedy is centered on the characters, who may be more realistic. Sitcoms stand out for their clever dialogue and multitude of jokes, one or more on each page. One or two writers may write an initial script, but somewhere in the process, a whole group of staff writers sits around a table and works together, punching up the humor and polishing the script. These scripts usually have a subplot.

Fifth Method

A few animation writers work very differently. They feel that plot tends to get in the way of the gags and the laughs. Preferring to keep it simple, they work with a basic idea for the star's goal and opposition (Coyote wants to catch the Roadrunner, but Roadrunner doesn't want to be caught). They add an arena, the necessary characters, and some props. Then they build the gags toward a big climax, placing the best, wildest, and funniest gag there. The story is simple with a beginning, middle, and end. Create one escalating conflict with at least one reversal. Stories over five minutes need multiple obstacles or complications. But funny is what it's all about! This style tends to work best in shorter cartoons: thirty seconds to twelve minutes max. The classic animators worked this way. They worked together often in one room, developing stories by topping each other with gags. They developed ideas and animated the stories themselves. Characters developed gradually through gags, dialogue, and bits over a period of time. They knew and loved their characters, sometimes becoming their characters as they worked. Imagination, surprise, and exaggeration are very important in this style. There is not enough plot here to keep the audience's interest for a longer story or feature film.

And More!

There are many variations and combinations of these styles. Each feature, each series, and each story editor is different. One other suggested structure method leapfrogs a plot-developing or story scene with a gag scene throughout. So you have story scene, gag scene, story, gag, story . . . until the end! You can find more details to help you in developing your structure in the checklist found in the chapter on editing and rewriting.

Story Theme

The theme is the lesson that the protagonist learns, the central message or values of the story. We just touched briefly on theme when we talked about what the main character learns about himself. Not all animation stories have themes, but many of the best stories do. A theme is something for the audience to think about later. It gives the story some substance. It helps us understand each other and the world around us. It's an observation about life and the people in our world. It helps us to identify with the characters. We recognize our own problems and root for the character to work through those problems, flaws, and needs in order to survive and grow.

Think of a theme as one value coming into conflict with another and winning out. Forgiveness is better than revenge. Living for the present can make life fuller than constant worrying about the future. Pestering your older brother is more fun than playing by yourself . . . at least until you get caught. These are the basic everyday values of life, and they have been the subjects of stories from the beginnings of time. Oral tales of old; myths; legends; the Bible; Greek, Roman, and Shakespearean plays; novels; films; and even games have all been centered around these conflicts in values.

Remember your audience. Because male teens are the biggest ticket buyers, many films center on the theme of childishness losing out to adulthood (coming of age or identity). If your audience is primarily children, then you may want to consider what is appropriate. Universal and timeless themes that touch us all are usually the best themes for films.

Character, plot, and theme are all connected. Your hero may have a character flaw that is getting in the way of his happiness. What he goes through during the course of the story changes the way he looks at life and alters the way he'll live in the future. That's his **character arc**. Ideally, he will become a better person, or at least come to know himself and the world a little better. Will reaching his goal make life better for your hero and for others? Will the values of the hero or the values of the villain win out, and why? It's possible to have more than one theme, but if this is the case, the themes must be interrelated.

A theme is felt, not indoctrinated or preached. No one wants a sermon. Instead we want characters that by their actions show what they value in life and fight for what is good in the world. Values are expressed mostly through action, but they might come out briefly during the course of a verbal conflict as well. Conflict and opposing values are at the heart of any story.

 Exercises

1. Make a diagram of basic animation structure so that you can see it and better understand it. Be sure your diagram shows how it's all interconnected.

2. Copy one of the structure diagrams on the board and discuss it in class.

3. What was your favorite gag-based cartoon of all time? Why? Discuss the structure of one of the classics.

4. Watch *Shrek*. List and discuss the basic structure points (hero and goal, villain, catalyst, game plan, turning points, major crisis, critical choice, battle, climax, and theme).

5. Discuss the subplot of *Shrek*. How does it weave in and out of the main plot and make the story richer?

6. List ten possible themes for an animated feature.

7. If a short cartoon has less structure, what keeps our interest? Discuss.

8. What keeps our interest in a short film with no story? Discuss in class.

9. How much structure will your project need? Which structure method will you use, or do you plan to use another kind of framework? If you're using a structure that was not discussed, how will it hold your story together and make it interesting for the audience? Explain.

10. Who is your protagonist in your project? What's his problem or goal? What terrible thing will happen if he doesn't get what he wants? Who or what opposes him? Does your protagonist learn something by the end of the story and if so what?

CHAPTER 8

The Premise

Getting Started

Whether you're writing a premise or treatment for your own work or trying to sell a premise to the story editor of a television cartoon in production, the process of developing a story idea is roughly the same. You think of a good idea and write it down in a generally accepted form. Since most of the work in animation writing consists of writing for established cartoon shows, we're going to focus here on the process of developing an idea and selling a script for an animated television series that's in production.

Writing a Television Animation Script

If you want to sell a script for a specific series, then you have to pitch a really good idea to the story editor of that series. He's the one in charge of assigning the scripts for the current season. The story editor will usually expect to see your idea in the form of a short premise, written as a narrative. Unfortunately, there's no pay for writing a premise. If the story editor likes your premise and thinks that you can write well, then he may give you the go-ahead to write an outline. If he likes the outline, then he'll give you an assignment for the script as well. But before he'll even consider your ideas, the story editor judges your writing ability by reading a **sample script**. See Chapter 20 on agents, networking, and finding work for more information on the sample script.

Preparation

Before you meet with a story editor, watch as many episodes as you can of the show you're pitching. Analyze the episodes. How long is each? What makes this show popular? How is it different? What's the level of reality? What are the rules of that cartoon universe? What makes it funny? Who are the main characters, and what makes them funny? Make notes.

How many characters are in a typical episode? How many locations are used in each? Analyze the structure. Who wants what? Time exactly where each **plot point** comes in. Is there a lesson, and how is it handled? Be sure you are thoroughly familiar with the main characters and their attitudes! The more you know about the show, the better chance you have of getting a shot at writing an episode. If this episode is new, write down the names of the story editor and the producers. That information might come in handy when you're trying to find a current story editor.

Meeting with the Story Editor

So the story editor likes your sample script, and you've set up a face-to-face meeting or a meeting by phone or e-mail. Come prepared with several imaginative, twenty-five-word-or-less ideas for episodes, **springboards** that you can pitch verbally if asked. These ideas can start from anything: the characters themselves, a theme, a situation, a place, or a visual image of some kind. What appeals to you? What ideas do you have that are fresh and original? Just remember that you're pitching a story, so ideally the ideas should have a beginning, a middle, and an end.

Listen carefully to everything the story editor tells you, and make notes. Request a bible of the show, a script, and a copy of several other premises that you can use as samples. The writer's bible contains information about the show and the show's characters. Ask questions. Does this show have an A-plot and a B-plot? Short cartoons do not; longer cartoons often do. Does the show have a joke ratio per page? Can you include any new characters? What are the demographics or target ages of this show? Is the target specific, or are the executives hoping for a wide range of viewers? What length does the story editor want your premises to be? The usual length is about one page, but each story editor has his own preference. How many premises does the editor want you to write before submitting the batch . . . three, four? When do you need to submit your first premises? Animation writing deadlines are usually very short, and you'll want to submit your ideas quickly. As a new writer, you would be lucky to have one idea selected, and you may have to submit premises many times before any are accepted.

Planning the Premise

Now you're sitting at home, staring at a blank page. Find a different way of looking at things. Come up with something new or a different twist on an old idea. Don't limit your imagination. Think broader, wilder! For a comedy be sure the main situation is funny. Go for the color; situations are a dime a dozen. The basic idea must be visual. Animators must have something to animate. You're writing for the story editor and any executives that have to approve your idea. Also, remember that networks have censors. Can your audience identify with these characters in this story? In a kids' show, the writing should be kid-relatable; it should talk both to and with the kids.

The story should be so simple in concept that it could be told in a few sentences. Be sure you're telling only one complete story, one single main incident going directly from A to B to C—nothing extraneous. One problem! One solution! Know the beginning, middle,

and end. Center the story on the star. (Sometimes it's okay to center the story around one of the other major characters instead.) Your story should grow out of the star's character. It's the star's weakness, his goal, his story. He should move the action ahead by what he says and does. He must solve the problem. He shouldn't be off stage for more than a couple of pages, or maybe not at all. Show him off. Normally, the villain in a cartoon is *really* bad, but preschool shows may contain only funny villains. Remember that your hero is only as strong as your villain. It takes a superhero to vanquish a strong villain. Every character you include should be absolutely necessary. Be sure that you have enough props available in your arena for your gags. Consider the budget; use few characters, fewer special effects, and a minimum of expensive action unless you're writing for a big budget show.

You may want to start your planning at the climax of your story and work backward. Many writers feel that it's easier to plan a story after you know where it's going. If there's a twist at the end, you need to plant the seeds of it in the beginning without giving away the twist. As your story goes along, increase the jeopardy. Add a dire threat. For greater tension include a time factor (the raft that's about to slip over the falls). There should be no easy solutions to the problems. If the story isn't working, it's probably because there's not enough conflict. Solve one problem, and the solution leads to another. In comedy the harder the star struggles to get out of his predicament, the deeper he digs himself in. A six- to twelve-minute cartoon will have a simple plot. A shorter cartoon might have only a situation and attempts to overcome it, which all fail until the very end. A longer cartoon will need more structure.

Network Television Censors

Television censors (Broadcast Standards and Practices, or Program Practices) have to approve each premise, outline, and script. You'll want to consider this when you're writing your premises. Of course, each network has slightly different standards. Requirements are sometimes much stricter in one country than another, or at least the concerns are different. If the material is created for children, then the standards are generally stricter than if it's scheduled for airing late at night. Standards in the United States address the mass audience and what the networks see as the standards of viewers and parents in their particular audience. Cable networks are generally less restrictive than the broadcast networks. Although writers often have an adversarial relationship with the censors, I can assure you that without censors watching over them some writers tend to push the envelope, and anything and everything would soon go out over the airwaves.

Violence is a big concern. Is this something kids can imitate? A finger stuck into a nuclear reactor is okay because a child will never come into contact with one. A wire pushed into an electrical plug is not okay. Writers should exaggerate and blow up gags until they are no longer imitable. There is anxiety about killing real people and using realistic weapons or firearms (including baseball bats or cue sticks). Laser guns and other fantasy weapons are more acceptable. There is worry about real children flying. Superheroes are okay, but young kids could jump off a roof, believing that an umbrella would actually keep them in the air. There are concerns about showing kids or animals inside a washer, dryer, or oven. Some broadcasters require that seatbelts be worn in vehicles and helmets be used for biking.

Characters may have to repair property damages. There are worries about substance abuse, and occasionally there are concerns about the occult and hypnotism.

There is anxiety about anxiety! Watch for excessive or prolonged anxiety, gratuitous psychological pain, or hopelessness. Characters should be shown ways to overcome their problems. There should be positive role models, no negative stereotypes. Language must be acceptable. Commercial names should be avoided (to avoid lawsuits). Program content and commercial messages must be clearly separate. It should be clear at all times that stories are fiction and not real news reports. In the United States a rating system is used for television, motion pictures, and games.

Writing the Premise

Hook the story editor immediately. Make your title catchy. Sparks should fly with the first sentence. Joe Barbera used to say, "Get aboard a moving train!" Set up the star, villain, problem/conflict, and where it takes place immediately in the first narrative paragraph. What's the dreadful alternative if the problem isn't solved? Use common emotions. Why are your characters doing what they're doing? Include examples of characters reacting in character. Introduce attitude. Put your own personality into the premise. Add a gag or two. Omit dialogue. Write in the present tense. Use strong verbs. Check spelling and grammar. Keep your premise as short as possible, and emphasize the best parts, downplaying the rest. As a new writer, it's best to include a fairly complete structure, but if that structure doesn't help sell the premise, keep it sparse. Make your premise fun to read. Scare, tease, tantalize! Write. Then put each premise away for a day or two, and rewrite. Be sure that you're clear, specific, and precise. Check that your premise is written in the same format as the sample premises that the story editor gave you. Remember that the purpose of a premise is to sell your idea!

Submitting Your Premises

Working quickly and meeting deadlines are essential. Be sure that you finish your premises right away. Drop them off. Don't bother the story editor personally unless he's asked to meet with you. It might take him a couple of days to get back to you. More likely it will take a couple of weeks. You can write more premises while you wait. You may have to submit a number of premises before the story editor finds one that is just right. It's likely that the story editor will give you notes and ask for a rewrite (or a couple of rewrites) before he feels that your premise is ready to send on. Once he approves a premise, the story editor will probably need approvals from the producer, from anyone who may hold a license to the characters, and finally from the network (programming and censors). Each person who has approval rights may have notes for you. If the premise is approved, then the story editor will call you and give you notes for changes at the next step: the outline. Sometimes the competition is tough and none of your premises is approved. The story editor knows his show well, and he understands what will work for those characters and what won't. He knows what has been written and aired before. And he's aware of what's already been approved for the current season. Your idea must complement the other stories that will be airing; it must be workable and right for the series.

Premise Checklist

- The title—is it catchy? ("Sir Barks Alot Ruffs It Up" works better than "The School Guard Dog.")

- Is your idea original or at least an original twist on an old idea?

- Did your main story idea develop directly from the personality of your main hero (or out of the personality of one of the other lead characters)?

- If this series contains a theme, did this character learn something from what happened?

- In the first paragraph of your premise did you set up your hero, your villain, your hero's problem/goal, and what will happen if the goal isn't reached? Did you hook your reader (the story editor and the other executives) right away?

- Is there exciting action right away? Conflict all the way through the story?

- If this is a story idea for children, is it kid-relatable?

- Do we care what happens to the hero?

- Are your characters true to what they are—"in character"? Is your story true to the show that you're pitching?

- Is your basic idea visual?

- Is it funny, with a few gags included in the premise? (Even most action shows contain a few gags.)

- Have you given us enough motivations so that the story seems believable?

- Is the basic structure there: the catalyst, a game plan, major twist/turning point, new information, another major twist, a major crisis, a critical choice for the hero, the big battle, a build to a climax, resolution of the problem, and hopefully a surprising twist at the end? Is it short enough?

- Did you make your premise fun to read? Does it have style? Is it clear?

- Did you use strong verbs? Colorful language?

- Is everything spelled correctly? Is language usage correct? Is it typo-free?

What follows is a premise from Sony's *Jackie Chan Adventures*. (*Premises are normally double spaced so that editors can add notes.* Most companies do not expect entire words to be capitalized in the premise as Sony does.)

Jackie Chan Adventures © 2003 Sony Pictures Television Inc. Written by David Slack. Story Editor: Duane Capizzi.

JACKIE CHAN ADVENTURES

"Queen of the Shadowkhan"

(Premise #206)

When JADE's friend/rival MAYNARD shows up at school sporting a cool new TATTOO, Jade deals with the peer pressure by resolving to get a cooler tattoo than HIS. So what if she's gonna "fake" it: they'll never know. She picks a GNARLY-LOOKING CHINESE SYMBOL out of one of Uncle's magic books (e.g., a DRAGON SKULL with crossbones—something real "Harley" looking), and carefully "inks" it onto some rice paper before wetting and pressing it to her arm herself. While Jade thinks her method will create a temporary tattoo, we, however, see that the ink magically "etches" into her skin.

But the kids at school aren't too impressed, and Maynard reveals his own was a FAKE. Jade storms away, but is a little disturbed to find that she can't wash it off. Knowing she'd be in trouble, Jade goes through ridiculous pains to hide it from Jackie and Uncle. But that night, Jackie discovers Jade's tattoo and freaks out. Uncle steps in to calm things down, telling Jackie that "in many cultures, tattoos are—AIYAAA!" Uncle sees the SYMBOL that is Jade's tattoo and freaks worse than Jackie. This is a symbol of great

evil; who knows what catastrophic effects this tattoo could bring?

These "catastrophic effects" quickly become apparent when Jade is endangered in a SET PIECE BATTLE with the DARK HAND, and the SHADOWKHAN rush to her aid! Afterwards, she tries to tell Jackie about her "rescue," but he doesn't believe her.

As Jade gradually figures out, the tattoo has given her control over the Shadowkhan (much to Shendu's frustration when he attempts to summon them and finds that they're "busy"). Under her command, they seem innocent enough: i.e., when Jade accidentally summons ninjas at various times, they might follow her to school like lost puppies, in the pure and charming interest of protecting her. But she decides to keep this to herself as well, knowing full well that Uncle and Jackie would freak (Uncle, in the meantime, is still trying to find a potion that will remove the tattoo from Jade's arm).

Besides, Jade's using her control over the ninjas for the cause of good; the Enforcers are annoyed/panicked when Jade

sends the ninjas in to kick Enforcer butt. They criticize Shendu/Valmont for losing control over his private army: what will they do now that the Shadowkhan are their enemy? Shendu/Valmont knowingly, mysteriously, and obtusely suggests that they should simply "let things take course. . . ."

When Jackie finds out the truth, he indeed freaks; Jade tries to convince him the ninjas are harmless—clearly, it all depends on the nature of who's controlling them. But before long, Jade seems to get carried away with being "Queen of the Shadowkhan" as she has them comically waiting on her hand and foot, attending to her comfort. Ultimately, at about the time Uncle devises an "antidote" that should wipe the tattoo from her arm, it becomes clear that Jade is beginning to undergo an odd transformation: she has taken to wearing black, and hisses at Uncle and summons Shadowkhan to prevent him from applying the antidote.

Before long, Jade begins to *physically* resemble the Shadowkhan—skin turning ninja blue! Jade and her "army of ninjas" run all the agents out of Section 13 and take over the facility as her "palace" (Captain Black tries to prove to his superiors in Washington that "dark forces" have taken control

of Section 13, indicating their surveillance monitors; but Shadowkhan, like vampires, do not photograph). Shendu/Valmont (having learned the location of S13 in ep. #113) comes to pay his respects to the "queen" and persuade her into joining his dark fight: it is good to have a strong ally for one's cause (Valmont's presence in Section 13 gives us some Shendu/Valmont character comedy, as Valmont keeps trying to persuade Shendu to "swing by the talisman vault" on the way out; Shendu himself, of course, is focused on his new quest and no longer desires the talismans).

While Shendu makes his pitch, Jackie has to figure out a way to get close enough to Jade to splash Uncle's antidote/potion on her, and with an army of Shadowkhan guarding her, that ain't gonna be easy. So Jackie has to go undercover—as a Shadowkhan. After some fun comedy beats as nice-guy Jackie tries to blend in with the sinister Shadowkhan, our hero gets within splashing distance of Queen Jade. But Shendu spots him at the last moment, alerts Jade, and now, things look grim for Jackie: the Shadowkhan grab him, the potion gets spilled. But as Shendu encourages Jade to destroy Jackie, our hero makes a final plea . . . and it gets past all that evil to the goodness that is still in Jade's heart.

The Shadowkhan release Jackie and attack Shendu/Valmont, who tries to counter-control the ninjas in a battle of wills with Jade; but he loses and flees, just as Tohru comes up and splashes the potion on Jade's tattoo, which melts it away. Turns out, Uncle gave Jackie a PLACEBO, knowing he'd never make it through the throng successfully. Jade and Jackie have a happy reunion; she gets down on herself about having succumbed to dumb peer pressure at school; Jackie gives her more credit than that, though—if only she had seen herself NOT succumbing to Shendu's peer pressure.

################

 Exercises

1. Watch at least five episodes of an animated series that you would like to use for your sample script. Take notes on characters, kinds of stories, gags, and so on. Try to find a script from that series on the Internet or from a bookstore that sells scripts. Then write a premise for the series.

2. If you live outside the United States, discuss in class how animated series and the writing process in your country may differ from what is described here.

3. Create a premise for your favorite gag-oriented cartoon.

4. Think of a premise for your favorite on-air action/adventure series.

5. Develop a premise for your favorite animated sitcom.

6. Using the characters and basic idea you developed, write a detailed premise for your student film or Internet short.

7. As a class, create a concept for a group project.

8. Taking those characters that you developed earlier, write one complete premise and several springboards (a short paragraph each). Use these for your original television series bible.

9. Write a logline for your project.

10. Continue work on the concept proposal for your wireless or video game.

11. From your original characters and a theme, take the feature concept you were developing earlier and write a detailed premise.

The Outline

What Is an Animation Outline?

It's a plan. The premise is expanded so that the structure will be complete. It's tempting to skip this stage, but don't! The outline is important to ensure a good story. Sometimes to save money in television, a very short cartoon goes directly from premise into script or storyboard because less structure is needed when it's short. Approvals for an outline must often come from producers, programming executives, censors, and sometimes from licensing or toy executives, as well as the story editor. Each cartoon is different, so what follows is general information.

An outline is a narrative description of the action—a blueprint. You'll indicate scenes and pace your story. You reveal through action, character, and a little dialogue. Write in the present tense. You may suggest an occasional camera **angle**, working it into the sentence structure: We push in, dissolve to, see inside, and so on. You might sprinkle in a little good dialogue, but not too much. Emphasize action rather than description. You'll be paid for writing the outline.

Meeting with the Television Story Editor

When your story editor notifies you that your idea has been approved for outline, you'll want to set up another meeting. Today most writers are freelancers, writing at home, occasionally continents away. If a meeting is impossible, conduct your business by e-mail, snail mail, or phone. Ask for a sample outline. Not all outlines look the same. Is this an outline with (1) numbered **beats** (a **beat outline**), with (2) **master scenes** (each beginning with a slug line as in a script), or in the form of (3) narrative prose? Ask about length. Do you understand all the notes that the story editor has given you? Can you decipher the handwriting? You'll need to follow the notes exactly. Ask questions. Know when your finished outline is due. Typically, you might have only a week to finish. *Never* miss a deadline!

Structure Planning

What are the main points needed to tell your story, the skeleton? What **scenes** are absolutely necessary? Look at your premise. You may want to start at the climax and work back from there. The specific personality traits of your star/hero cause this story to happen. What were the characters' motivations to get them to the climax? After you have the skeleton, you fill in the blanks with the minor points.

- What does that star/hero/heroine want?

- Who opposes the star? Who's the villain or antagonist? His motivation?

- What's the catalyst? What incident starts the story moving?

- Your hero needs a plan. His goals should be in direct conflict with the villain's goals. The villain tries to foil the hero's plans.

- Each turning point requires a decision by the hero, who solves the story problem. There are no unseen forces, no easy solutions or clues. The hero/star leads the action throughout the story.

- The hero continues to oppose the villain as new information comes out.

- Everything looks very bad, and the hero risks losing it all. What's the major crisis, the worst thing that can happen to the hero to keep him from attaining his goals?

- The hero is faced with his most difficult decision, his critical choice. The decision leads toward the climax of your story with the biggest battle. The hero wins and attains his goal.

- Did your hero learn something? If so, that's the theme. Not all cartoons have a theme.

- Now wrap everything up quickly in the resolution.

Look at the series sample script to see the length of each act. The acts for your TV sample script are probably roughly equal in length, leaving your hero in trouble before each act break. Remember that features usually have a structure of Act I, 25 percent; Act II, 50 percent; and Act III, 25 percent of the overall length of the story. Every scene should be visual with action and conflict.

More to Think About

It's okay to restructure your plot somewhat at this point if the restructuring makes for a better script. You may want to add more plot. You could change motivations if you wish. Is your story true to the elements and characters of that series? Don't change the location or the villain. The story editor is balancing locations and villains for an entire season. If adding more characters is absolutely necessary, get permission from the story editor first. Remember to stage action for the budget, using cuts, camera shakes, and trucks to avoid expensive animation where it's not needed. Save the expense for the important story points and the important gags. Don't leave out whatever it was that sold your premise in the first place. You may surprise your story editor with a few new twists.

There should be no surprises left for the final script! Include the structure, what happens, the major jokes. Show your characters revealing themselves. Think in terms of scenes (one action in one time and one place) and sequences of scenes. Are your scenes in the right order, or would it be better to rearrange them? Can you combine some scenes? Do you need any scenes to fill a gap? This is a puzzle. Use multiple open windows on your computer or separate index cards for each scene to help your planning.

Breaking up Your Story into Beats

What scenes or story beats do you need to tell this story? You'll add what you need to the basic framework you already have in your premise. Let's work from the *Jackie Chan Adventures* premise we have so you can see how it's done.

Basic structure of *Jackie Chan Adventures*: "Queen of the Shadowkhan" premise:

- Jade, as one of the main characters, is the star of this episode. Her character flaw is her need for peer acceptance/respect. This flaw motivates a whole chain of problems for everyone around her.

- We go to the end to see what, if anything, she learned. She learns not to succumb to peer pressure, and she realizes that indeed she did not succumb to Shendu's pressure. (Theme: Respect earned from someone you admire is better than respect from all others!)

- Jade's initial goal is to be cool (have a tattoo) and gain respect. That snowballs as she begins to abuse the respect she gets from the ninjas.

- Shendu is the villain who uses Jade in an attempt to destroy Jackie Chan, Jade's hero. Shendu also wants respect.

- The catalyst that started the story moving in the premise was Maynard's tattoo. The catalyst was changed in the outline.

- You can see how all these story points are related.

- The first turning point, plot turn, or gateway is when Jade calls for help and the Shadowkhan fight *for* Jade instead of against her. Jade has unknowingly crossed over onto the wrong side of the fight for justice.

- Jade's game plan includes getting a temporary tattoo and so on.

- About halfway through the script, she realizes that she has real power over the ninjas and convinces herself that she'll use the Shadowkhan in the fight for justice. But she's on a downward spiral, deceiving Jackie and her uncle, undergoing a transformation.

- The second turning point or twist is when Uncle tries to apply an antidote on Jade's tattoo to save her. Jade hisses at him and summons the Shadowkhan. She has taken to wearing black. The tattoo has Jade under its power. She has passed through another gate.

- Jade's skin is turning ninja blue. It looks like Jade will come under the influence of Shendu and end up destroying Jackie, who has been captured. This is the worst thing that could happen—the major crisis.

- The conflict or battle continues as Jade makes a critical choice and responds to Jackie's pleas. The Shadowkhan release Jackie. Jade and Shendu have a battle of wills over control of the ninjas.

- We have come to the climax as Jade wins. The tattoo is melted away.

- In the resolution Jade and Jackie have a reunion. Jackie tells Jade she has his respect.

Look at the premise along with these basic structure points to plan what scenes you'll need. A rough estimate of scenes needed in a half-hour television episode (actually about twenty-two minutes of story in the United States) is around fifteen to twenty-five scenes. You don't want so many scenes that you have no time to develop any of them. And comedy scenes will probably take more time than action scenes. List the scenes you must have in order to tell this story, numbering them as you go. What you're looking for are scenes that are necessary to advancing the plot.

We'll need a scene where Maynard shows off his new tattoo at school and makes Jade jealous of the attention and respect it gets. What about a scene where Jade finds a symbol on one of Uncle's magic books and inks it onto paper before pressing it onto her arm? Here we'll see that the ink etches into her skin. We'll need a scene where Jade shows off her new tattoo to the other kids, and Maynard confesses that his tattoo is a fake. Another scene is needed to show Jade as she hides the tattoo from Jackie and Uncle. We'll need a scene where Jackie discovers the tattoo, and Uncle freaks out because it's a symbol of evil. Continue to list in a sentence or two each of the scenes that you need to tell your story.

How many scenes did you list? If you have too many, combine some or find a different way. If you don't have enough, then you need more complications.

Have you considered any changes that might make the story stronger? What new information can come out in Act II to complicate the plot? What twists can you add? See the more detailed information in Chapter 15 for more story structure tips. When you read the Jackie Chan outline near the end of this chapter, you'll notice that there is a B plot with Shendu trying to retrieve his book. There is an opening teaser as well.

Taking Pencil to Paper

- Get into the action right away, and use plenty of action throughout.

- The thread of the story, reflected in all gags and dialogue, should be immediately apparent and weave through to the end.

- Principal characters must appear early.

- Reveal character through action, reaction, and universal emotions. Show relationships. Show that you know the series characters. All action should be motivated and believable for those characters and within that series.

- The plot must be logical. Later developments need a seed planted early in the script. Use unresolved questions and action throughout to hook your audience into watching until the end. All structure points must be there.

- If the story isn't working in the middle, add more conflict. New information spins the hero and/or villain off in a new direction. This information may be new to the hero or the villain, or the audience.

- Include the major gags, showing how you get in and out. Think broadly. Comedy scenes usually go out on a laugh, so set them up that way. Build your gags, top them, and pay them off. Save the best gag for the climax.

- Watch pacing and timing.

- Know your location, where each door is. What's the closing shot?

- Build your story, your chases, and your gags to a climax.

- If the outline is too hard to write, perhaps the main situation isn't funny enough, you don't have enough props, the structure is wrong, or there's not enough conflict between characters.

- Have you told a good story in an original way?

- Is it funny? Keep your outline light and fun to read. Make it snappy.

Alternate Outline Formats

The sample Jackie Chan outline is written in narrative form. There are no numbers on the scenes because the format you see is the format that Sony uses. You'll notice that character names, places, props, effects, and other points that the writer wanted to emphasize for production are written in capital letters. Frequently, outlines do not use caps in this way. Follow the format of each individual series.

Many outlines are instead written in master scenes like the one that follows. It's often a good idea to number your scenes so that the story editor can easily refer to them as he gives you notes. The average animation script uses caps for character names only on their first appearance in the script. How is your sample written?

1. ANCIENT GOTHIC LIBRARY—DAY

Inside this medieval looking library JACKIE makes a treacherous three-story climb up a ladder to the top shelf where he finds . . . not a talisman or a demon portal, but an important book for Uncle's library: an unearthly tome with. . . .

Revisions

- Do you need to add more action and peril, a life-threatening time factor (the **ticking clock** or ticking bomb)?

- Does everything move the story ahead with nothing extraneous?

- Is everything clear, specific, concise?

- Does your writing flow? Are there transitions between scenes?

- Did you write toward a big ending? Is there a twist at the end?

- Check your grammar and spelling.

Usually, you'll get two sets of notes on the outline from the network (1. programming, 2. censors). Your story editor will also give notes and may require a rewrite. Make all the changes requested in the notes. This is a script for hire, not a script negotiation! Ask questions if you don't understand.

Once (and if) the outline is approved, you'll go on to write the script. You might be paid separately for the outline, or you may receive payment for both script and outline at once after you've completed your script.

Here is an outline from Sony's *Jackie Chan Adventures*.

Jackie Chan Adventures © 2003 Sony Pictures Television Inc. Written by David Slack. Story Editor: Duane Capizzi.

JACKIE CHAN ADVENTURES

"Queen of the Shadowkhan"
(Outline #206)

TEASER

Inside an ANCIENT GOTHIC LIBRARY (something real medieval-

like), JACKIE makes a treacherous 3-STORY CLIMB up a LADDER

to the top shelf where he finds...not a talisman or a

demon portal, but an important BOOK for Uncle's library:

an unearthly tome with a foreboding picture of a DRAGON

SKULL AND CROSSBONES on the cover (think: an ancient

Chinese version of the legendary *Necronomicon*). But no

sooner has Jackie grabbed the book than an ARMY OF SHADOWKHAN "melt" out from the darkness and attack! CUT TO MAIN TITLE.

ACT ONE

A quick-but-thrilling exchange of KUNG-FU ACTION ensues between Jackie and the Shadowkhan atop the ladder. Meanwhile, HAK FOO, FINN, and CHOW (no Ratso) show up below and decide to help out by trying to "shake Jackie out of the tree" by giving the ladder a big PUSH across the room. Jackie freaks as he rides the SLIDING ladder—then improvises his exit (e.g., by executing a stunning LEAP onto the heavy drape covering the room's only window, using it as cover as he crashes through, then further using the drape to parachute down the castle wall into a waiting car, boat, whatever). Jackie escapes with the mysterious book as the Enforcers "oops," and the Shadowkhan melt back into the shadows, disappearing. DISSOLVE TO . . .

JADE'S SCHOOL: where JADE's friend MAYNARD (the gentle ex-bully, see #107) is showing off his gnarly new TATTOO. As the other kids gape in awe, Jade plays it cool, claiming she

might get one, too. But class-skeptic DREW calls her bluff:
there's NO WAY her "wimpy-dig-in-the-dirt-with-tiny-little-
brushes-archaeologist" Uncle would let her. Challenged, Jade
immediately vows to come to school tomorrow with the coolest
tattoo EVER.

That afternoon, Jackie arrives at UNCLE'S SHOP and presents
the mysterious book to UNCLE, who explains why he sent Jackie
for it. Known as THE ARCHIVE OF DEMON MAGIC, it is a book
of powerful spells written by the DEMON SORCERERS themselves.
The Shadowkhan's appearance at the library proved Uncle's
hunch that it was only a matter of time before Shendu tried
to retrieve it. Although Uncle would *never* USE such dark
magic, the book may give our heroes valuable information on
each Demon and clues about how to defeat them. What's more,
satisfied Uncle says he's finally gotten "even" with Shendu,
tit for tat: the villain took one of Uncle's books (in
#201), and now Uncle has one of HIS!

Uncle drags Jackie and TOHRU into the library to "clear a
space" for this new research project; and the Archive is
left unattended as Jade shows up and asks Jackie if she can
get a tattoo—fibbing that "all the kids at school are getting

them." Jackie of course answers with a flat "no," and Jade emerges into the main shop room, grousing. But when she spots that SUPER-GNARLY DRAGON SKULL SYMBOL on the cover of Uncle's ominous new book, she gets a sly look: her tattoo doesn't have to be REAL, it just has to be GNARLY! So (while Jackie et al. are in the library) she grabs the book and "inks" the pattern, then presses it to a piece of notebook paper. In Uncle's kitchen, she wets the paper and presses it to her arm, leaving an impressive but *temporary* TATTOO— or so she thinks: we see the ink MAGICALLY "etch" into her skin. . . .

At the new DARK HAND LAIR, Shendu (in Valmont's body) now wears a ceremonial CHINESE ROBE which he feels befits him— while Valmont "breaks through" to complain about the change in wardrobe, how ridiculous it looks, etc. RATSO sits in the corner with the PAN KU BOX, trying to "solve the puzzle" to get them to the next demon portal. He's having a really tough time with this one.

HAK FOO, FINN, and CHOW arrive, and Shendu berates them for losing the Archive. The Enforcers try to shift the

blame onto the Shadowkhan; but Shendu crossly reminds them that the Shadowkhan are merely "drones" in Shendu's command: are they suggesting this is SHENDU'S fault?! As the Enforcers timidly back down, Shendu deduces that the Archive is in Uncle's shop, and orders them to retrieve it. FINN, RATSO, and CHOW are hesitant: every time they go there, they get their butts kicked. But cocky HAK FOO boasts, "That is because you have never been there . . . with ME."

During RECESS at SCHOOL, an amazed crowd gathers as Maynard and Jade compare tattoos. But the glory ends when Maynard's tattoo starts to PEEL OFF—it's temporary: a fake! Drew accuses Jade of being "a big faker," too (they don't buy that she really did it). Jade makes lame attempts to deny it, then thinks she's found out as the kids grab her and DREW tries to rub it off. But all are stunned: it won't COME off! Drew and the kids are impressed: Jade really did it! Jade meekly plays along, confused. A MOMENT LATER, in the bathroom, we see Jade wildly trying to SCRUB the tattoo off, soap suds everywhere—"Off, OFF, OFF"—but to no avail.

That evening at UNCLE'S SHOP, Jackie studies the Archives with Uncle and Tohru while Jade (who's doing her homework) goes through ridiculous pains to hide her un-temporary tattoo—but her arm gets exposed in a TBD way, and Jackie spots the tattoo and freaks out. Jade tries to explain she *meant* it to be temporary, as Uncle steps in to calm things down, telling Jackie that "in many cultures, tattoos are—AIYAAA!" Uncle sees the SYMBOL that is Jade's tattoo and freaks worse than Jackie. The icon on the cover of the Archives is a symbol of great evil; who knows what "catastrophe" this tattoo could bring?

Uncle and Tohru start searching for a way to remove the tattoo; but they don't get far before the Enforcers bust in, demanding the book. While Jackie and Tohru take on Finn, Ratso, and Chow (with some help from Uncle), Hak Foo makes a grab for the book, but Jade snatches it away and takes off running. A brief CHASE ensues as Jade uses all of her Jackie-training to get away from the agile Hak. But ultimately, he corners her in a DARK ALLEY. But as if THAT weren't enough, the eerie SHADOWKHAN emerge from the darkness BEHIND her: she's surrounded! Scared, Jade ducks into a crevice (or dumpster) with the book—not watching as the

NINJAS start kicking Hak's butt! The Shadowkhan send a con-
fused Hak Foo running, then vanish back into the shadows.
A beat later, Jade—wondering why no one's grabbed her yet—
peers out to see all her attackers have gone. As she takes
in bewilderment, we push in to see that her tattoo is GLOWING
OMINOUSLY.

END ACT ONE

ACT TWO

Back at the DARK HAND LAIR, embarrassed Hak Foo tells Shendu
and the other Enforcers what happened, but nobody believes
HIM either until . . . Shendu attempts to summon the Shadowkhan
and CAN'T! Shendu figures that possession of the Archive has
ALREADY given the Chans an advantage and rages at the thugs
to redouble their efforts: if brute force won't work, then
they must rely on cunning. As the Enforcers start schem-
ing, DISSOLVE TO . . .

The next MORNING at SECTION 13, Jackie wakes Jade up on his
way out—she's going to be late for school! Unfortunately,
"slow and steady" Uncle has not yet found a "tattoo remover"
spell. As Jade's rushing to get ready and wishing she had

time for breakfast, a SHADOWKHAN steps out of a mirror and scares the heck out of her. But when the docile (and SILENT) ninja offers her various FOOD ITEMS, Jade notices her GLOWING TATTOO in the mirror and (after giving the Shadowkhan a few "Simon Says" style orders: "Stand on your head," "Hop on one foot," etc.) she realizes that THEY were the ones who saved her from Hak Foo! Clearly, the tattoo has given her control over these mysterious warriors. . . . If THIS is the "catastrophe" Uncle was talking about, this "RULES!" All the same, she decides to keep her power a secret: "If Jackie won't let me have a tattoo, there's no WAY he'd let me have my own ninja!"

So . . . Jade gets ready in a flash with the help of several SHADOWKHAN: one brushes her teeth, while another combs her hair, and another picks out her clothes (all black, of course); another packs her a nutritious lunch. But the whole gang is startled when Jackie comes back ("Forgot my wallet") and finds . . . Jade, all by herself, ready in record time (though Jackie double-takes, almost not recognizing her in her black clothes). As Jade nonchalantly trots off to class, bewildered Jackie doesn't notice the Shadowkhan clinging to the ceiling above him.

At SCHOOL, Jade prepares to prove to her classmates once and for all that the "magic ninjas" she's talked about are "real." But Drew cracks wise: getting a "real" tattoo is one thing, but magic ninjas? As Drew keeps laughing, Jade FUMES—and sinister Shadowkhan emerge from shadows, closing in on the unsuspecting Drew until...the <BELL> rings, causing Jade to shake it off at the last second, and the Shadowkhan <POOF> disappear without anyone seeing them.

At UNCLE'S SHOP, FINN shows up IN A COMICAL (but *extremely convincing*) DISGUISE, pretending to be a wealthy customer interested in Uncle's most EXPENSIVE items. While the "customer" keeps Uncle, Tohru, and Jackie busy in the store, the FLOORBOARDS in the library lift up and reveal, Hak, Ratso, and Chow sporting SHOVELS and MINER'S HATS—they've tunneled in! The plan works like a charm: the Enforcers swipe the book and "customer" Finn suddenly decides he's "just browsing."

But as the Enforcers regroup around the corner and celebrate their victory, Jade (who's still grumbling about Drew on her way home from school) spots the Enforcers and unleashes

her Shadowkhan fury on them in a quick ACTION SET PIECE. As the Enforcers get a sound beating and the Shadowkhan retrieve the book, Jackie, Uncle, and Tohru (having discovered the tunnel) show up in time to see a starting-to-look-eerie (and VERY PALE—think of the girl from *Beetlejuice*) Jade standing at the center of the melee, controlling the Shadowkhan like a puppeteer (think: *Firestarter* but with ninjas).

Jackie interrupts, stunned at the sight; Jade's concentration is again broken, allowing the Enforcers to escape. As the frightened thugs race away, Jackie starts giving Jade an earful—causing the Shadowkhan to close in on HIM. But Jade stops them, explaining that Jackie is a "friend." Off Jackie, Uncle, and Tohru's "wary" looks . . .

Back at the DARK HAND LAIR, the Enforcers storm in and rail at Shendu for a change: What will they do now that the Shadowkhan are their enemy? How could he lose control of his private army . . . to a LITTLE GIRL? On hearing that JADE is the one with the power, Shendu cuts his losses—controlling the Shadowkhan are a luxury he no longer *requires*

because, like himself, they cannot touch the Pan Ku Box (for that task, he is stuck with the Enforcers). But as for "the girl," Shendu cryptically suggests that "matters will take their course. . . ."

Back at UNCLE'S, Jade "practices" ninja maneuvers with a silent Shadowkhan (i.e., he is "training" her in ninja moves, the way Jackie teaches her Kung Fu). As she does, she casually tries to convince Jackie that the ninjas are harmless—clearly, it all depends on who's controlling them; and Jade's using them only for good. After all, they HELPED JACKIE—*twice*! She even points out that they gave *Tohru* a fair shake, why not the ninjas? But despite her casual demeanor, it's obvious to Jackie, Uncle, and Tohru (who "play along," while wide-eyed at the weirdness) that Jade is undergoing an odd transformation: her skin has turned a Shadowkhany shade of BLUE (Jackie has her look in a mirror, but Jade shrugs, "So? Blue's my favorite color"). Jackie won't have it; he orders her not to summon the ninjas again until Uncle has found a way to remove the tattoo.

Before Jade can retort, Uncle cries, "Hot Cha!" He has discovered an "ANTIDOTE POTION" that should wipe the tattoo

from her arm. Uncle quickly mixes the potion; but when Jackie drags the protesting Jade over to remove the tattoo, she hisses and summons several more Shadowkhan: she is their "Queen" and that is how things shall remain. As the ninjas close in on Jackie, Uncle, and Tohru, we . . .

END ACT TWO

ACT THREE

Jade grabs the mysterious Archive and runs off into the night. Then the Shadowkhan disappear into the shadows. Concerned, Jackie, Uncle, and Tohru are left trying to figure out where Jade went to.

At SECTION 13, black-garbed, blue-faced, Jade bursts in with her "dark minions" and claims the facility as her own, because "all Queens need a palace." Captain Black first perceives this as some kind of weird "prank" by Jade; but it soon becomes clear that it's something serious as Shadowkhan begin to subdue his agents—Jade herself helping out with a particularly *Matrix*-y kinda move.

Jackie (perhaps searching the streets) gets a call from CAPT. BLACK on his cell phone, informing him of developments [Black has dodged the Shadowkhan for the moment, calls covertly]. A comic moment as Jackie fervently apologizes to Black for this "inconvenience," but Black's seeing the bright side: he can FINALLY prove to his superiors that the Shadowkhan actually exist! Black hangs up and places a cocky cell phone call to Washington and tells his boss to "check their surveillance monitors" of the Section 13 facility; but, in that one-sided call running gag, we garner that his superior checks the monitors and sees nothing. Stupefied, Black looks at his own BANK OF MONITORS to see that there are indeed NO NINJAS TO BE SEEN. Black sees himself on the last monitor, as a NINJA ENTERS FRAME and subdues him—the action only a seeming *pantomime* by Black on the security monitor (creepy!).

Meanwhile, Jackie, Uncle, and Tohru know they have to come up with a plan: they've got to figure out a way to get close enough to Jade to splash Uncle's potion on her, and with an army of Shadowkhan guarding her, that ain't gonna be easy. Tohru cites Finn's earlier disguise, inspiring Jackie to

realize that the only way to get close to Jade, is under-
cover . . .

Meanwhile inside Section 13, we see Capt. Black and the
agents have been locked in the cell block. In the main
room, Jade—having found a suitable makeshift throne—is poring
over the book of dark magic, looking for spells that will
increase her power. But she's FLUSTERED because the book
is written in ANCIENT TEXT, which she cannot read. She knows
of one who can help her, and summons the Shadowkhan to fetch
him. . . .

At the Dark Hand Lair, the Shadowkhan arrive to take Shendu
prisoner. But the villain goes willingly, to "pay his
respects" to the new Queen. We can tell by his sly demeanor
he has something in mind. . . .

At Section 13, the Shadowkhan return with SHENDU/Valmont
[NOTE: he is "sans" Enforcers]. We get a quick Shendu/Valmont
character comedy moment as Valmont suddenly "comes to," real-
izes where he is and tries to persuade Shendu to "swing by
the talisman vault" on the way out—"These new robes I'm
wearing have plenty of pockets." Jade tells him he is welcome

to the talismans, but Shendu tells her that he no longer desires them. Jade protectively guards the book: he cannot have THIS, yet she requires his aid.

While Shendu tries to persuade Jade to let him hold the book so he might better "translate" some choice ancient spells for her, we see Jackie—DRESSED AS A SHADOWKHAN—carefully making his way through the facility. After some fun comedy beats as nice-guy Jackie tries to blend in with the sinister Shadowkhan, our hero gets within splashing distance of Queen Jade, Shendu spots him at the last moment and alerts her (only so he can divert her and grab the book).

Our FINALE SET PIECE unfolds as Jackie jumps, dodges, swings, climbs, and fights for his life against Jade's ARMY OF SHADOWKHAN—all the while trying NOT to spill the potion. Ultimately though, the Shadowkhan capture Jackie and his vial of potion <SHATTERS> on the floor. Shendu encourages Jade to destroy Jackie (if he can't have the book, he can at least destroy his nemesis who would USE the book against him and all demons), but our hero makes a final plea to Jade . . . and a TEAR wells in the Queen's eye as his words gets

past all that evil to the goodness that is still in Jade's heart.

Fast as lightning, the Shadowkha+n release Jackie and attack Shendu. Shendu makes a grab for the Archive as he tries to counter-control the ninjas in a quick battle of wills (somewhat comedically, like remote-control puppets); but an ENORMOUS SHADOWKHAN steps out of the darkness and SPLASHES a vial of POTION on Jade's tattoo. As the tattoo melts away and Jade's skin begins to turn back to normal, Jade calls out her final command to the Shadowkhan—to DESTROY THE BOOK. Shendu tries to renege the command, but the Shadowkhan magically "torch" it just before they vanish with a <POOF> — except the big one who reveals himself to be . . . Tohru! Shendu curses our heroes as he makes his exit, promising that his Demon brethren will have their revenge on them for destroying the book.

As Jade and Jackie hug, Uncle steps out of hiding and explains that he had Tohru bring a little "extra" potion, just in case. They are glad to have Jade back, and Uncle even admits she did the right thing by sacrificing the book lest Shendu acquire it.

As things return to normal at Section 13 (except for the fact that Black's on "disciplinary probation"), Jade gets down on herself. None of this would have happened if she hadn't succumbed to dumb peer pressure at school. But Jackie gives her more credit than that, though—if only she had seen herself NOT succumbing to *Shendu's* "peer pressure."

THE END

 Exercises

1. Go through the Premise of *Jackie Chan Adventures* to number and list all the beats (or scenes) that will be needed. Keep it concise. Add or combine scenes as necessary. Change the order of the scenes if that seems to make a better story. Now look at the sample outline and compare. Would you have written the outline differently? Why do you think that the writer wrote his outline as he did? You might want to discuss this in class.

2. Watch a half-hour cartoon on tape or DVD. What's the basic structure: hero and goal, villain, catalyst, game plan, turning points, major crisis, critical choice, battle, climax, and resolution? Watch it again, and break it into story beats.

3. As you're watching TV, break up the narrative into beats. Any program with a story will do. This is only practice. Don't try to write it down.

4. Take a short story or joke from a joke book and break it up into story beats. Use the master scene format, numbering each scene and starting it with a slug line.

5. Using the story in exercise 4, add transitions between scenes.

6. Break the project premise that you wrote earlier into beats and write a TV episode outline or a treatment for your film.

7. Develop your game concept proposal into a **walkthrough**, and start collecting your assets.

8. How can you create anticipation and suspense in each of your story beats so that the audience must watch to find out what will happen next? Use examples from animated films to discuss this in class.

9. What are some of the ways that you can make your outline or treatment an exciting or funny read?

CHAPTER 10

Storyboard for Writers

The Way It Was

For many years in animation there were no scripts. U.S. artists took a general idea and developed the story visually. These artists were storymen or story sketch artists. Often storymen had been animators who had a special talent for developing stories. When television arrived, the artists continued to work in the same manner as they had worked in features or shorts. But since TV budgets were even slimmer, any savings that could be made in time and work were incorporated into the production process. The storymen began to work out their stories visually on a template that was the storyboard. They were called storyboard men.

Feature Visual Development

The treatment or script for a feature is merely the springboard for months of development. Major changes are made to the story by the story sketch or visual development people.

Viewers can see much more detail on the big screen. Something that is boarded for a theatrical feature may use subtleties in facial expression and emotion that would never be picked up on a small-screen TV or computer. Features demand more scope.

Direct-to-video or DVD is a hybrid of feature animation and television animation. Studios like Disney might go into production without any script. In cases like that, the storyboard artists may even write some of the dialogue. The process again varies from studio to studio.

Television and Other Small-Screen Storyboarding

Today the longer television stories in the United States start with scripts, but some of the shorter, more gag-driven cartoons still skip a script entirely. A creator or writer/artist may board the episode essentially as it's being created. She might start with a kernel of an idea

153

and get the basic story beat out onto cards that can be thumbtacked to a wall. Next the creator or a writer may write a detailed outline and revise it, maybe several times. Then thumbnail sketches might flesh out the outline before it's boarded, perhaps with the help of storyboard assistants. After the board is done, the creator might make more revisions, punching up dialogue and making cuts before the board is sent to the network for final approval. There might be many meetings along the way. The creator could do the work herself or farm it out to other writers or artists. If she outsources some of the work, she'll have to approve each step. A writer/artist going directly to storyboard can save money. If the board is a team effort, the finished work may be better and require fewer retakes at a later date. Many say that gag-driven cartoons of twelve minutes or less are so visual that boarding a cartoon directly makes for a funnier cartoon. Traditionally, Cartoon Network and Nickelodeon have been more likely to go directly to board than studios like Warner Bros.

My own experience is that writers may create scripted stories with better, tighter plots; artists might create cartoons that are visual with more and funnier gags. Of course, it all depends on the strengths of the individual who is telling the story.

An animated cartoon is always a team effort, and the storyboard person looks forward to **plussing** the story, contributing his talent to making the finished product better. When there's an initial script, most producer/directors still allow the board artist to add gags and sometimes substantially change scenes and even dialogue if the changes improve the show. Exactly how much the board artist contributes to a scripted show depends on the studio, the producer/director in charge, the amount of time that the board man has to finish his work, and so forth.

Unfortunately, much can go wrong to sabotage the ideal story situation. Writer and artist may be in different locations. Even with a complete script, a whole team of storyboard artists and revisionists might be working on one board. Writers and artists may be struggling to meet the deadlines and much too busy to communicate with each other. And inexperience can make any situation more difficult. Writers sometimes complain that artists add things that are extraneous to the plot or change dialogue that has been carefully constructed to sound just right. But writers must learn the animation process so that the stories are practical for television animation: no crowds, lots of visual action that actually works, and so forth. Writers must also be very clear on the page to avoid miscommunication. And they should avoid situations that make the storyboard person's job more difficult, like missed deadlines, overwriting, and rewriting after the board has been started. Sometimes even in the best of situations, one man's improvement is another man's disaster; but the producer/director is the person that's responsible for making the final call.

Of course, the cheapest, most efficient way to end up with a good visual story is to do each step once, getting it right before progressing on to the next. A finished script goes to one experienced board artist, who completes the project. Or a writer/artist does a detailed outline and boards it himself with perhaps one assistant cleaning it up for production.

Storyboarding for a small-screen TV or computer requires broader strokes. Subtleties in expression will be lost. The viewing room is probably not dark, and viewers are less likely to be as focused on the story as they are in a theater. In fact, viewers may well be reading, working, playing, or talking as they watch. So clarity is very important for instant recognition and understanding.

Television Storyboard Considerations

The storyboard artist is the visual director. It's his job to tell the story as creatively as possible, to be clear and maintain continuity, to increase emotion with dynamic visual storytelling, to add humor, and to set the stage for all that follow, especially the layout and background people, but also the timing director and animators. All the information must be shown; no viewer has a script. If the storyboard person is not the writer, he won't see the script in exactly the same way that the writer sees it in his head. Sometimes (and ideally) what the board person sees is better than the writer can imagine! The storyboard artist has the authority to change any visual direction that the writer has in the script. I've found that things normally *do* need better **staging**. Even if you as the writer have storyboarded professionally, you will already have so many other concerns as you're writing your script, that obvious things can get left out and other things are better staged in another way. As the first visualization of the script, the television storyboard must be approved by the producer/director and executives involved, such as TV network people.

In television today some companies request that their writers provide a script that's written in master scenes like a live-action script, as opposed to a script with each camera shot included like a traditional animation script. In this case the board artist does all the detailed visualization and acts as the visual director. Other studios still ask for the traditional animation script with each (or most) shot written directly into the script.

Length of the script can be a major problem for a storyboard artist. If the story editor, director, or producer has not monitored the length well enough, then an overlong script must be cut at the board stage or later. This wastes time and money. Scripts and boards should be exactly the correct length.

The storyboard artist considers the audience (the kids or other viewers, the executives that grant approval, the production people that use the board), the needs of the script and the production, the medium, the budget, and the time available to complete the job. In daytime television time is usually very short.

Boarding a Script

The artist reads the script to familiarize himself with plot and characters and their personalities. He asks to see previous boards to get the feel and style of an existing show. Then he looks at model sheets, available backgrounds, and any stock animation. He determines size and scale of characters to backgrounds and props and to each other. A large character like a giant in the same scene with small characters causes special problems. Characters should be drawn correctly on model. All effects and cycled animation must be discussed with the producer/director and indicated properly for that show. If the sound track has already been recorded, the board artist listens to the track and matches the visual acting to it. Any questions or suggestions are covered in a phone call or meeting with the producer/director. Whenever possible the storyboard person works with the character model artists, the prop artists, and the background artists to give them what they need to do their jobs well. All the information must be on the board for the overseas artists who might be enlarging the panels for their layouts.

Locations should be researched or planned carefully before the board is started. What locations are already in stock? Can the number of new locations be cut down without hurting the story to save money? Many board artists keep an extensive home library of clippings of people, places, and things. They stockpile magazines, catalogues, and books. Some visual research can be done on the Internet. Artists may go to the library. Maps, rough blueprints, or floor plans should be drawn for each new location. The storyboard artist places doors, windows, furniture, and props in each room, and plans the placement of characters and the camera.

Next the board artist considers what's important in each scene and how it fits overall into the show. He blocks the scene just as a live-action director would do, so that he's sure there's enough room for the action and he can visualize the scene well. For really complicated action, the board man may write out a shot list first. He emphasizes what's important in the story and downplays the rest, making only one point at a time. The board artist will exaggerate and isolate to make that point, giving no more information to the audience than is necessary. A confused audience won't laugh or empathize with the characters, so staging gags requires basic, no frills camerawork and action. Simplicity is very important! The idea should be communicated instantly. Often it's the obvious staging that communicates the best. The board artist might draw thumbnail sketches first. When he roughs out a scene on the storyboard template, he may draw it first in blue, because light blue pencil doesn't photocopy. All the relationships, perspective, props, and other details are spelled out and made clear for the executives and production people that follow. Some studios require detailed boards that can be blown up and used as layouts. Others use boards that are rough. Extra pencil mileage is avoided where possible, but the board artist does put in as many notes and details as possible to make the board clear for the production staff that follows.

The board person will carefully build the gags. Timing and pace are suggested in the way that gags, action, and scenes are set up. Budgets can be stretched by staging unimportant action off-screen. A reaction after the action might be funnier and more important than the action itself. Viewer emotions can be influenced by point of view, direction (left to right, or right to left), and composition. Walking, involved fights, and other extraneous action may be cut or restaged to cut expense. The board person probably has access to lists of stock backgrounds and stock animation and will sometimes change unimportant action or locations to accommodate these. He also watches continuity and transitions between scenes. Clarity and continuity are very important.

Characters

Visual creativity and freshness assist in developing character and telling an interesting story. The right character dominates each frame. Who is this character, and what does he represent in the story? Mannerisms, body language, attitude/pose, stage business, and reaction shots all help define character. The essence is distilled. Characters on a storyboard show off their acting ability. The faces on the characters reveal real emotions, not just blank stares. In a comedy the board artist might think caricature. He considers what the character is thinking and feeling and expresses that in the body language. He considers what pose will help the audience to identify with that character. Many artists act out the story, using a mirror. A board artist that can get inside a character will draw a character that the audience can

better identify as being real. The storyboard poses are the best poses possible to reveal and show off each character.

Characters in storyboards are posed in extremes. That means the poses are the most exaggerated poses in that scene with an imaginary and dynamic line of action shooting through each one. They are bold! They make a statement! All key poses are drawn, showing the starting and stopping poses of each action. Distinct changes are made between each pose. That way the layout people will draw strong, exaggerated poses, giving animators and assistants strong action to animate. Otherwise scenes would be boring, and not much would happen. Poses are drawn "in silhouette." If all you could see of a character was a silhouette, you could still make out the action. Silhouetting makes the action clearer and quickly recognizable. Figures 10.1 through 10.5 show examples of silhouetting.

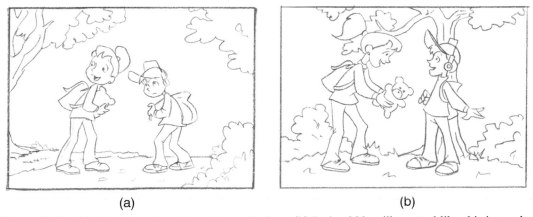

(a) (b)

Figure 10.1 (a) The action here is not instantly clear. (b) It should be silhouetted like this instead.

(a) (b)

Figure 10.2 (a) The action is silhouetted against the sky. (b) Effective down shot on characters silhouettes their action.
Artwork by Alvaro A. Arce.

Figure 10.3 (a) The girl is silhouetted. The action is a bit boring. (b) This shot is better. The girl's action and emotions give the animators more to work with. There's more energy.

Figure 10.4 The characters are drawn in silhouette. The buildings are in a contrasting color, allowing the children's action to stand out.

Figure 10.5 The boy's gesture, the teddy bear, the cap, and the ponytail are all silhouetted. Artwork by Alvaro A. Arce.

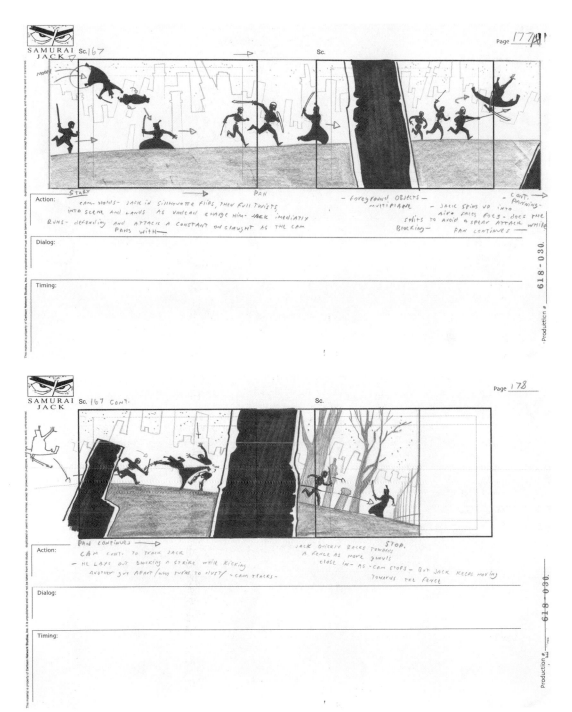

Figure 10.6 *Samurai Jack* is noted for its beautiful design and Japanese-influenced style. This Emmy ® winning series is boarded in the normal horizontal storyboard format. You can see the use of multiple planes, upshots, and down shots. The action is beautifully choreographed.

Story and board by Bryan Andrews. *Samurai Jack* and all related characters and elements are trademarks of Cartoon Network © 2004. A Time Warner Company. All rights reserved.

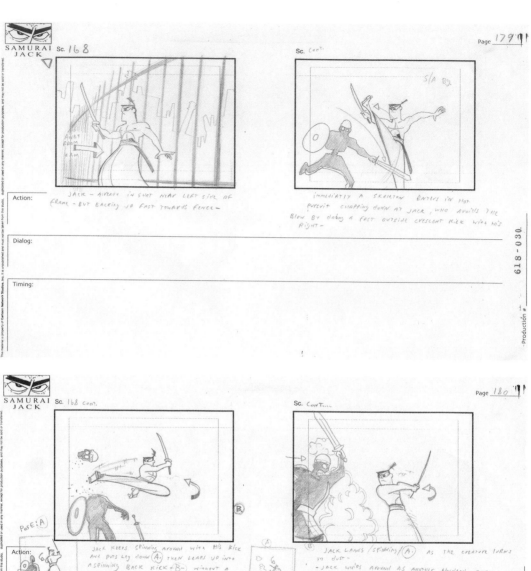

Figure 10.6 *Continued*

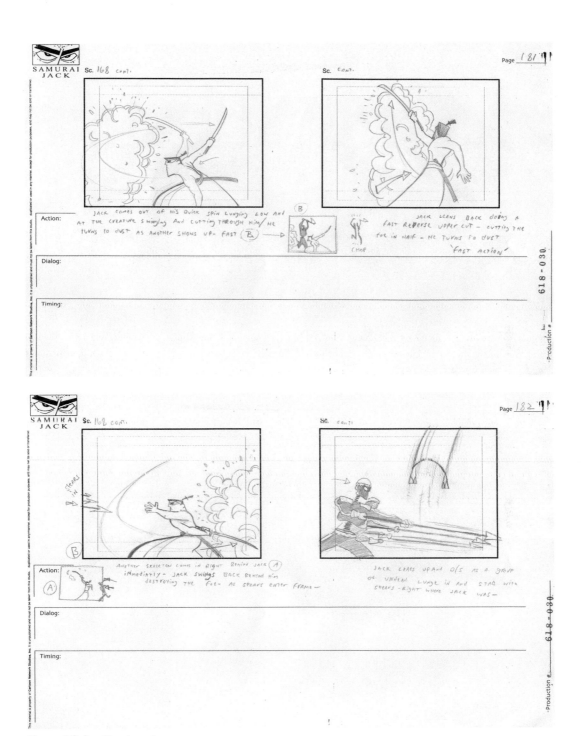

Figure 10.6 *Continued*

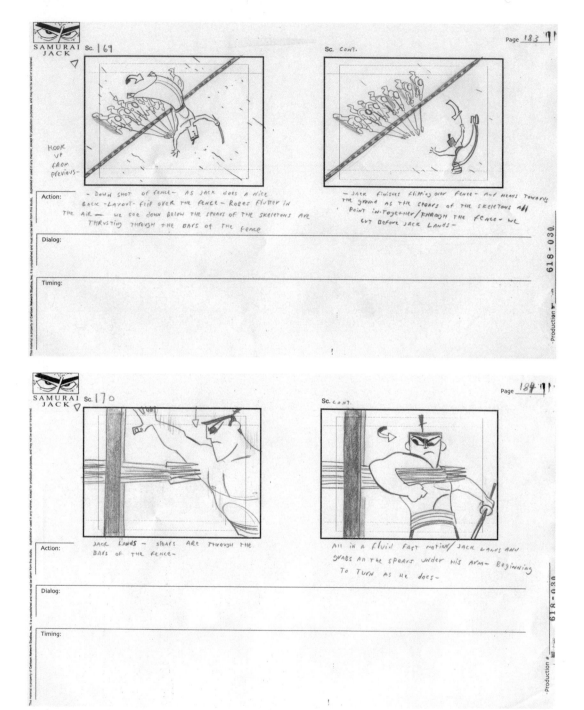

Figure 10.6 *Continued*

Locations

The background is kept simple so we can focus on the action. Board artists watch backgrounds for tangents and other details that close in on the character. There's air between the action and the detail in the background. Board artists avoid flowerpots growing out of a character's head!

Composition and Drawing

An artist uses good art and design techniques and composition contrasting shapes, lines, textures, size, values, and color. He utilizes negative space and asymmetrical compositions. He uses balance and suggests scale, size, weight, movement, view, and perspective. Normally each panel shows at least three planes (for example, two walls and the floor). Usually in animation, artists want to give the illusion of life by making a two-dimensional surface seem less flat. If there is a slight incline in the direction of movement, there is less chance for strobing or flickering. An occasional break in vertical parallel lines can also prevent strobing. Two people standing at the same height next to each other is boring. It's better to stage one closer to the camera and use perspective to make the more distant character's head lower. If the characters are parallel to the sides of the frame and in action so that they're not static, this is even better. Characters and props that are posed at a one-quarter turn seem to have depth. So do buildings in the background. The use of perspective shows depth. Perspective might be forced. An overlay of a partial tree or bush in the foreground frames the action and gives more depth. Underlays also give dimension. If we're looking slightly up or down on the characters, there's more interest. Shots with a low horizon often seem to work best.

A good use of design principals gives more emotion and focus to the shots. For instance, a tiny lost dog isolated and alone in the center of a huge park (trees on the sides, nothing by the dog) makes us feel more sorry for him. The eye should flow around the composition.

The board artist draws with confidence and arrogance. Heavy lines in the foreground and thinner lines behind make the background recede. Too many lines signal uncertainty. The most is made of light and shadow, especially when the scene is dramatic rather than comedic (see Figure 10.6).

Time and Space

Normally in animation for children, there are no flashbacks because experts feel that flashbacks are too confusing for most children. However, time can be expanded, compressed, cut, or frozen to make the story more interesting.

In using space a filmic formula with a logical pattern of movement is used for clarity. The train will always go from left to right or right to left, but it shouldn't change directions. If it's traveling from Chicago to Los Angeles, it travels right to left as if we were looking at a map. In western nations we're conditioned to moving our eyes left to right when reading, so the punch line would appear on the right side of the frame. In Asia the conditioning is different. If a character is coming home from school, he should continue to travel in the same direction unless he forgets his books and goes back for them. Then he would reverse direction to return to school. Horizontal movement is restful. Diagonal movement is dis-

turbing. The audience must frequently be oriented to where they are with establishing shots and long shots (unless you want to deliberately add confusion in a mystery). Rounding up a suspect or wrapping up a story, the action may narrow in a series of scenes that increasingly confine time and space.

To indicate a time lapse, writers should cut to another scene in another location and then cut back again. "A moment later" or "five minutes earlier" is almost impossible to indicate without subtitles. These subtitles have no place in animation. Cutting away gives a clear indication that time has elapsed.

Thinking Like a Camera Sees

Board artists consider what's most important in any scene, and they focus on that. Is a location or room being established? Do we need to see a prop in close-up because the prop is an important story point? Do we need to see how someone reacts? Reactions are often funnier in comedy than the gag itself. Shots often come in a series of three. A long shot of character A may move in to a **medium shot**. Then the board might cut to a **close-up** of B replying, then cut again to another close-up of A reacting. The shots vary between close-ups, medium shots, and **long shots**. A few over-the-shoulder shots may be thrown in. An artist might force perspective. He may show us the villain towering above from a **worm's-eye view**. It makes the villain more menacing. We could see the mother looking down on her child as if we were looking from her point of view. The artist avoids strange angles that are hard to animate. A good board person keeps returning to **full shots** to reorient the audience. Motion is indicated clearly in each shot. Only the inbetweens will probably be missing from the board.

Good animation writers and artists think like a camera sees. Slow **truck-ins** with **cross dissolves** give the impression of multiplane moves. The imaginary camera never crosses an imaginary action axis by turning more than ninety degrees. That disorients the audience. Even close-ups of two people talking are staged with less than a ninety-degree cross between the two matched close-ups (see Figure 10.7).

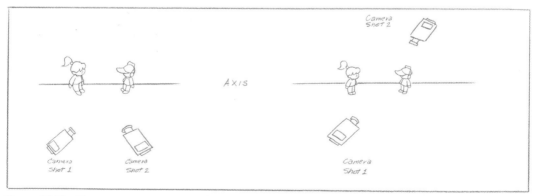

Figure 10.7 The camera setup on the left of the page is correct. The camera setup on the right would disorient us as we cut back and forth between shots. Images should be drawn as if the cameras stay on the same side of the axis.
Artwork by Alvaro A. Arce.

The best board artists will consider the point of the story and whether the mood requires a camera move. They won't overuse **pan shots**, truck-ins, or truck-outs. When trucks and pans are used, they keep them simple, especially for television. Wide **field** background shots are expensive and those of more than two or two-and-a-half panels are normally avoided for traditional television. Panels that involve a pan move are connected. Most storyboard panels are now formatted in proportion to a twelve-field. One quarter of that panel is the size of a six-field. Traditional animation production doesn't allow technically for truck-ins to closer than a six-field. However, most productions can now accommodate computer trucks that can go from a one-field to a one-thousand-field. And producers of CG animation usually encourage sweeping camera moves. In either traditional or CG animation overlays give the impression of multiplanes.

Courage the Cowardly Dog deliberately avoided pans, **wipes**, **dissolves**, and other transitions other than the **cut**. According to Bob Miller, who was storyboard supervisor the first season, the director felt that camera moves would remind the audience that they were watching a cartoon.

Transitions and Hookups

Scenes must hook up to the scene preceding and the one following. Transitions must be made. We can cut from a girl looking at her reflection in a river in the final shot of scene A to the next scene, B, where we cross dissolve to the liquid reflection of a witch. Then when we pull back, we see that the witch is stirring a caldron of soup. If we end with a close-up of a character, the following scene of that character in a long shot has to match in background, props, action of the pose, and direction of gaze of the character. The relationship of all characters must be the same.

Artists will avoid cutting from a character in one scene to the same character at a similar size in the next scene. Otherwise it will look like the character animated or jumped from one spot to another in the space of a single frame. Board people watch out for the same problem with similar backgrounds in two adjoining scenes.

Shots are motivated. If a character turns to look at something important, then the audience sees what she was looking at in the next shot. And we see it from that character's point of view.

Storyboard artists avoid cutting on an actor's line if they can help it. And they listen to the voice track to be sure there's enough space to cut if a new cut is added.

Before each transition board artists write one of the following:

- *FADE IN* (or *FADE OUT*)
- CUT TO:
- WIPE TO:
- DISSOLVE TO:

Visual Storytelling

As a writer, visualizing your story will help the board artist. Consider this: We establish Jefferson High. School is in session. We cut to a close shot of a poster: "Halloween Party,

Jefferson High Gym, Tonight." We truck back to an establishing shot of the gym's interior already decorated for the party. Three guys are playing ball. Jason dribbles the ball down the court to the basket. Angle on Steve as he grabs a jack-o'-lantern from a courtside table and continues after Jason. Angle on Jason, still dribbling. Mike enters the shot and smoothly steals Jason's ball on a dribble. Instantly, Steve enters the shot and just as smoothly places the pumpkin in Jason's hands. Closer on Jason. Unaware of the switch, Jason turns to the basket and shoots the pumpkin. We pan with the pumpkin as it arcs into the hoop, a perfect shot. SPLAT! We cut to a close shot of Mike, the jack-o'-lantern apparently still in one piece for an instant as it drops over his head. The pumpkin splinters and runs down Mike's face. Cut to Jason doing a **take**. Cut to Steve doubled over in laughter. No dialogue. The narrative was told entirely with visual action.

Gags and action must read visually because internationally the joke may be lost in translation. We must understand what's happening from what we *see*.

Good storyboards open in an exciting way, and they keep moving throughout. They have a variety of shots, and the lengths of scenes vary. Tension is built with mood and atmosphere, with composition, or with shots that show what the characters don't see (the villain lurking in the shadows, the waterfall dead ahead). The board looks and feels exciting. Cuts are motivated by the action. For CG animation, where more camera movement is not only possible but also expected, watch video games to get a feel of that movement.

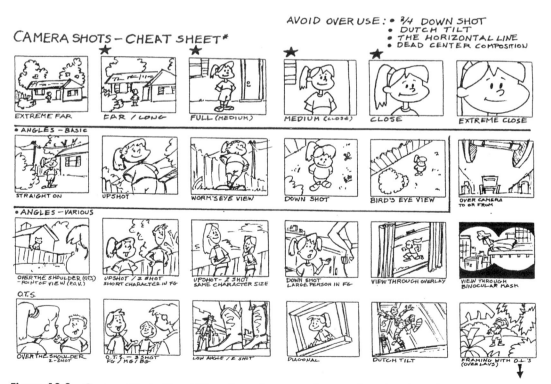

Figure 10.8 Camera Shots-Cheat Sheet brought to you by storyboard artists Llyn Hunter and Jill Colbert. Llyn and Jill encourage you to photocopy this Cheat Sheet and use it as you work.

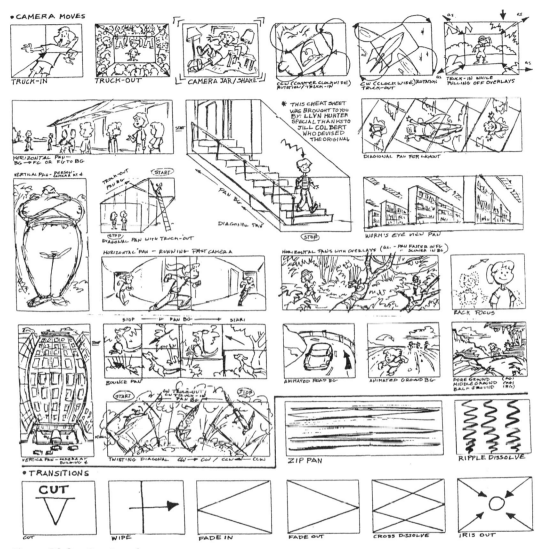

Figure 10.8 *Continued*

Some of the best cartoon design uses the fantastic inventions of the imagination. Nothing can top the wild inspirations of a talented writer or storyboard artist! But don't forget to use common sense and consider the laws of nature.

Dialogue

The more acting the characters are allowed to do, the more the audience can identify with them. Sometimes a gag can be inserted with props to add action to the dialogue. Dialogue scenes that are overlong can be broken up with personality acting, different angles, close-ups, or reactions. Subtleties will probably be missed on TV. A good board person will usually keep the visual acting broad. One phrase per pose in close-up is fairly standard.

The character's mouth should be kept shut when there's no dialogue. Overseas, information can get lost in translation, and the animator may animate the wrong character talking if there's more than one mouth open.

The storyboard artist adds any deviations or additions to the board between the script and the dialogue track. These are often things like "mmms" or "aahs." During storyboard revisions, if a dialogue track that was not available earlier is suddenly available, the board artist changes any drawings that don't match the track.

Using the Medium

The board goes in tight on important information. Signs are usually avoided, but if they absolutely must be used, the lettering had better be professional looking and spelled correctly. Shading is used only to convey atmosphere. Left-to-right staging lacks depth and is usually avoided if there's enough in the budget to stage in a more interesting way. Television shows animated on a computer can use characters walking toward or away from the camera, growing or shrinking in size. But this is usually too expensive for traditionally animated children's television cartoons because repeat cycles cannot be used. Use of complicated perspective may be feasible on a computer, but it's more difficult and expensive by hand. Complicated camera movements and effects easily done in live-action can be done in animation only on big-budget features or on CGI shows that use a lot of computer compositing, never on traditionally animated TV shows.

A good board artist thinks like an animator, letting the characters act and show off their personalities. An artist can introduce a character by letting him walk on stage. Anticipation will catch the audience's attention before important action or camera moves. The audience wants to see the characters react to what's going on around them. A moment of reflection can be more dramatic, seem more natural, and actually save money. Each scene demands at least a start pose and an end pose. Any changes in action will normally be drawn as well. The more poses that are shown, the more control there is over the action.

The Opening

First off, the board orients the audience to the story. Where are we? If this is a whole new world that's established in a long shot, then we set up the rules of that world. In any case, the audience is oriented as to where they are and what's happening there. We give the viewers a good look at the characters and their faces, let them see the characters' personalities, and learn any other important visual information. Establishing shots often include pans, or they may truck in.

Timing

Pace is varied throughout. Shots normally get shorter, cuts faster for action sequences and as the climax nears. Comedy usually zips along at a faster pace than drama or mystery. Dia-

logue is paced, unnecessary action skipped. A rhythm will be evident with the timing, but the board includes surprises to break the pace. Establishing shots are held long enough for the audience to take in the information. Viewers need time to absorb any important point. Comedy is totally dependent on timing. Good board artists feel it with their gut. They set the gag up and then . . . whack!

Pacing is important! Sometimes an artist draws on a paper with sixteen panels on it so he can get a feel of the pacing and the use of shots as he's boarding. Then he cuts out the panels afterward and pastes them into the standard format that he uses. If the board is done before the dialogue track is recorded, the artist may want to act out the action and read the dialogue out loud to time it for a more accurate board.

Format

Many different formats are used for storyboards today. The size of the panels is standardized to fit the size of the screen that will be used. For films that will be shown in cinemascope this aspect ratio is 2.35:1. For feature films or direct-to-video with a limited theatrical release the aspect ratio is 1.85:1. For normal direct-to-video release and for television the ratio is 1.33:1. And the ratio aspect for widescreen digital television is 1.78:1. In the United States there are two standard TV production storyboard formats: the normal horizontal format and a vertical Asian format (*Jackie Chan Adventures* and *LowBrow*). Some studios use two panels per page, especially on direct-to-videos; some use three, four, or even more. Two or three seems to be the most common. Regardless of the format used, a show formatted one way may also be seen another. Shots must work well whether seen in either conventional or HDTV. DVDs may be seen on a TV or on a computer. If the DVD is a feature, it may have started life on a wider screen.

Once sent overseas the storyboard panels are usually enlarged as they're photocopied so they can be used as the basis for the layout. Board artists never write or draw in the slug areas of the board. The area in the storyboard panel itself is the area that is within the **TV cutoff** line, the area that will be seen on TV. Actual layouts will extend beyond that.

Rough or Tight?

Just how sketchy and rough or tight and detailed the board is depends on the show and who is doing the boards. Producer/directors or writers doing their own boards may draw more loosely than staff board artists. Experience has shown that especially on shows that go overseas, the tighter the board and the more detail included, the better the finished product. Lack of easy communication, especially when any communication must be done through a translator, can take a toll.

Labeling for Boards

The pages of a board are numbered at the bottom right corner in light blue or nonphotocopy blue when the first draft is turned in. An approved board gets numbered in graphite

pencil in the top right corner. Each scene will be numbered in the upper left-hand corner with (**CONT**) next to the scene number if it's continued. Panels in continued scenes get labeled A, B, C, and so on in the lower right-hand corner.

Each panel contains a letter or number so a storyboard supervisor can refer easily to a specific panel that he may want changed. All **EXT** (exterior) and **INT** (interior) shots are labeled at the beginning of each sequence. Time of day is indicated and circled. All CUTs are indicated. Cuts, dissolves, or wipes to a new scene on a new page are labeled at the last panel of the page before. Boards may have to be translated for overseas animators, so colloquialisms are avoided. The descriptions must match the panel.

All camera moves are included in the action area of the board, and they must be clear. All pans and trucks are labeled with START and STOP. Pans are indicated as the audience sees them, not as the actual background moves under the camera. **BG** (background) pans are indicated wherever the background is moving in relation to the character. Animate BG is indicated where the building, trees, clouds, and so on are moving in perspective. OL is indicated for **overlays** and UL for underlays. The direction of the move is indicated. Screen shakes and dramatic shadows, usually considered to be too heavy for comedy, are labeled. Camera directions and effects, as used on that particular show, are labeled in a standardized way. It can be helpful to indicate the direction of the light source for shadows to keep any shadowing consistent.

In dialogue INH (inhale) or EXH (exhale) is used when it's heard on the voice track. VO is indicated if the character is talking in **voice-over**. **OS** is used instead if the character is speaking off-screen. All scripted acting instructions like (loudly) or (with a catch in her voice) are written in. Pauses are indicated as (a beat) or (pause).

Everything must be written legibly, or typed and pasted. Room must be left for last-minute additions. It's okay for board artists to draw and write bigger and then reduce their work to the proper size. Everything must be very clear to avoid errors and retakes.

Wrapping Up

Overall, a storyboard must be done in a simple, clear way, especially when the finished product is for children. It should also be done in a way that adds to a good story without complicating it! After the board is finished, the artist should flip through it without reading dialogue or description. If you can't follow the story from the pictures, then the board needs more work.

What Makes an Outstanding Board?

Certainly, different groups of experts will have somewhat different opinions and individual preferences about what makes a storyboard outstanding to them. But those who judge awards generally look for excellence above what is expected at the journeyman level in the following categories:

- *Ideas.* Boards that do an outstanding job of setting up the mood, tone, and pace for the project. Boards with creativity and freshness.

- *Visual directing.* Projects that have been visualized well, with each sequence attracting and holding audience attention and flowing seamlessly into the next. Excellence in cinematography.

- *Technique.* A good, practical blueprint for production of the project.

- *Execution.* Outstanding drawing skills and draftsmanship. Nuances.

- *Characterization.* Excellence in acting.

- *Background.* Excellence in design while still allowing for space for the characters to star.

Never be afraid to enter your work in competition for awards if you feel that yours is better than the norm. Whether it's a student award or the highest professional accolade, often the most superior boards are not entered, so you may very well win. By entering, more people in the industry will get to know your work. So go ahead, visualize yourself tripping up those long stairs to accept your award!

Checklist

- Did you start with a good, solid story in outline or script form?

- Have you done your research? Do you know what those locations look like? What has been done before and is already available for this series? Have you listened to the sound track? Looked at any available model sheets? Talked to the director or producer?

- What's the purpose of each scene? What is the visual focus? Keep reviewing your scenes to be sure that you're making your point clearly and that you don't lose it somewhere along the way.

- Whose scene is this? Which character is driving the action? What does he want in this scene? Be sure that the right character dominates each scene.

- What is the emotion?

- Did you do thumbnails of each scene to plan the action, reveal character, and discover the best composition for each shot? Did you do floor plans, maps, and so forth so you know your location well?

- Are you remembering the budget? Are you staging with that in mind . . . not too much action or too many poses for lower budgets? Have you made the best use of stock backgrounds and animation to save expense where you could? Did you avoid crowds and stage action in a way that considers the expense of animation?

- Is each shot staged in the best way to tell the story?

- Is the location and time always clear?

- Did you make good use of time and space? Are both clear?

- Do your compositions vary? Do you use up shots and down shots? Make good use of perspective? Add depth to each scene?

- Do you avoid placing your characters parallel to each other and parallel to the sides of the picture frame?

- Can we see what your silhouetted characters are doing quickly and easily? Is the action framed by the background and foreground? Is the background around the characters as clear or as simple as possible? Are you avoiding tangents that close in on your characters (horns or halos on heads)? Is there contrast? Is the shot design simple enough to keep the emphasis on the characters and the action?

- Do your characters have enough room to move around and do whatever they need to do in this environment?

- What about composition? Does the posing of your characters and the overall composition charge the scene with emotion?

- Do your characters reveal character personality? Are your characters really showing off their acting ability and revealing emotion?

- Do the characters relate to each other?

- Are your poses as strong and exaggerated as possible with characters drawn in silhouette and with a dynamic line of action?

- Do you have enough extreme poses for the animators?

- Have you made the most of anticipation to draw attention to the action?

- Are the gags staged in the funniest way? Are the characters posed and acting in funny ways? Are you making the best use of your props for visual humor?

- Do you use reaction shots?

- Are your characters drawn on model and in the right perspective to each other and to the rest of the scene?

- Will the action work?

- Have you made good use of camera movement?

- Do your shots have a good rhythm to their sequence?

- Did you avoid crossing the ninety-degree axis with the camera?

- Have you restaged sequences to avoid too many talking heads?

- Did you suggest timing in the way you boarded your scenes?

- Is there a variety of shots and scene lengths?

- Did you think creatively?

- Does the action flow easily from one scene to another? Do you have good transitions between scenes?

- Do the hookups match? No problems with continuity?
- Are the mechanics of the camera moves correct?
- Did you use the correct effects for this show or project?
- Did you label everything clearly, consistently, and correctly?
- Is the board exactly the right length?

 Exercises

1. Research a location for your outline. If this is a fantasy, research styles and influences that might help stimulate your imagination. Use the library, books you might have, magazines, design books, catalogues, encyclopedias, the Internet, and so on.

2. Study cinematography. Two good books are *The Five C's of Cinematography* by Joseph V. Mascelli (may be hard to find) and *Shot by Shot* by Steven D. Katz.

3. In class, take the narrative gag about the Halloween pumpkin in the school gym and write it in script form. Feel free to change it and improve on the story.

4. Try to draw from memory something you've seen or read. Stage it in the most dramatic way. Now stage it as a comedy. Compare the two.

5. Using your outline, board an important sequence from your project, or team up with an artist and work on the sequence together.

6. Put some of the sequences up on a large board so the class can critique them. What did you learn from the critique?

7. Rework your sequence after listening to the critiques. Has it improved?

8. Board your entire project.

9. Practice pitching your story to the class by tacking up your storyboard and telling your tale. Act it out and really "sell" your story as you do.

10. Try to get more information about storyboarding and visual development on the Internet. Check out www.AWN.com, www.mpsc839.org (The Animation Guild), and other animation websites. Share some of the information and where to find it with other students.

The Scene

What Is a Scene?

A scene is a single event or conversation between characters that takes place during one period of time and in one single place and moves the story forward toward a climax and resolution. Some of the best scenes that you've seen will linger in your mind for the rest of your life. Remember that sweeping scene of African splendor in the opening of *The Lion King,* where all the animals arrive from near and far to pay homage to the new royal cub? One event, one period of time, one place!

Scene-Planning Checklist

It's time to take those basic beats from your outline and write each scene with focus and polish. Consider these:

- What will this scene accomplish? Scenes may have a main point and a couple of minor points. Each really important plot point in your script probably requires a separate scene.

- Where does it take place and when?

- Who's in this scene? Which character is driving the scene?

- What do the characters want here? What's their attitude? What's at stake?

- Who's putting up obstacles? Why? What does this person want?

- Is there subtext, an underlying meaning with people talking around a problem or hiding it? Are people being direct or indirect in what they want?

- Where is the tension or conflict? Tension can also be created by conflict already established earlier or what we anticipate might happen next. Perhaps the audience knows something that the hero or the villain doesn't know.

- Can you create curiosity? Ask a question and keep the answer for later.

- How does the scene move the story forward and add to the audience's understanding? Each scene should change the status quo. The hero should be closer or farther away from his goal than he was at the beginning of the scene.

- Are you revealing character and motivation through each character's behavior?

- What makes us have empathy for the hero?

- Does the scene have a catalyst at the beginning? Usually scenes do.

- New information might come out in the middle, spinning the scene off in another direction.

- Does the scene build to a climax?

- How are you going to make it funnier or more dramatic?

Stay away from the clichés and easy solutions. Do the unexpected. Add a twist. Scenes normally depend on action rather than dialogue. Use complications, obstacles, and sudden reversals. Use character relationships, subtext. What's happening under the mask? Remember, however, that subtext will probably go over the heads of the preschool gang.

Your Scene: Where to Start and Where to End

Individual scenes can be as long or as short as necessary to tell the story and fit into the pacing of the whole. Young children have a short attention span. Short scenes with lots of action, gags, and kid-relatable characters help to keep your script on track. Although scenes usually have a beginning, a middle, and an end, you can choose to cut off any one or two of these to make your scene more effective. The beginning or ending of a scene is often unnecessary. Your scene may be better without it! You want only the essence. And in comedy you need the gags! Once you've made your main point, the scene is over. Nothing should be extraneous!

The Opening Scene

Grab the audience in the opening scene, or they won't stay around for the rest of the story. A teaser or action opening keeps the audience glued to their seats. *Jackie Chan Adventures* has action before the opening credits. Get into the story right away. You can fill in any missing pieces later. Often your opening scene is a gag scene in a comedy, a scary action scene in a mystery, or a character-developing scene in a feature. Usually beginnings and endings of scripts have some relationship to each other. For cartoons it's best if this opening scene can advance the plot—with the star—on the very first page. In a shorter cartoon we want to know what the star wants, who opposes her, and what terrible thing will happen if the star doesn't obtain her goal—and we want to know it right away. In a feature you have more time to develop character and set mood in the opening scene. We must like your characters well enough to take this journey with them and root for them to win.

Each Scene

Each scene should be visually interesting and never talky (unless this is specifically a talky animation series). Keep descriptions to a line or two. Plot points should be made visually. Cut anything that won't keep the kids rolling on the floor with laughter, sobbing into their tissues, or sitting on the edge of their seats with their mouths agape like a farm boy at his first sighting of alien crop circles. Cartoons should be funny all the way through; even the adventure stories usually have funny scenes and a general sense of humor. Add plenty of conflict and action. Scenes should have surprises. Actions do not produce expected results. What is known (the villain is just around the next corner) and what is unknown produce tension. Add powerful imagery and symbols where you can. Where a scene takes place can affect mood.

Put in the motivations. What's the motivation of the story? What are the motivations of the star and the villains? Why? Add complications. Why does the witch need her brew right now? How does the ghost appear? Inquiring minds want to know! Give your hero difficult choices.

The viewers and others who work with the script (executives, production crew, etc.) should be able to easily understand each scene. Avoid complicated visual ideas, subtleties, or unknown actions where explanation is necessary. Adding complications to the plot doesn't mean confusing the viewer. Be clear.

Fitting the Scenes Together

Every scene fits into the rhythm of the whole. For overall pacing action scenes may need to be broken up with a quiet character-building scene or a comedy scene, especially early in the script. Vary your scenes and your sequences. Vary locations. Vary shots. Cut between action and character insight, comedy and action, the negative and the positive. Vary scene lengths. Vary pace. Look at your scenes. Would they be more effective rearranged in another order, or would it be better to combine some of them? Use your best storytelling instincts to make your story compelling, moving, action filled, and funny! Normally one scene should lead us smoothly into the next. An action in one scene can lead to a reaction in the next. An image or sound at the beginning of a scene can remind us of an image or sound from the one we just saw. At the end of the scene you want your audience eager to find out what will happen next. Build to a big climax. Then tie up the loose ends quickly. And leave them giggling with a gag!

Checklist

- Does your scene accomplish everything you think it should?

- Does it stay focused on the plot and characters?

- Is the scene clear? Is it easy to understand? Will the audience believe it?

- Be sure the scene is visual. Is there enough to animate?

- Each scene should flow! Does it transition easily from the last scene and into the next? Will it fit neatly into the whole?

- Consider length. Is it too long? Does it repeat information that we already have? Once in a while you may want to repeat important information that you think the audience might have missed.

- Is there enough conflict and action? Cut **exposition**. Show; don't tell.

- Is the scene unpredictable with twists, turns, and reversals? Does it build to a climax? Is there freshness in the way that the scene is portrayed?

- Does the scene make us want to know what happens next?

- Is it entertaining, funny, emotional, or tension filled? Can you heighten these?

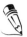 **Exercises**

1. Think about the funniest, most frightening, or worst moment of your life. Write a scene about it. Now change it to make it even funnier or more dramatic.

2. Recall a scene from a well-known animated movie, one that almost everyone in class can remember. Discuss the scene. What made it effective? Why do you still remember it? Can you think of ways to make it even better?

3. Watch the opening scenes of three television cartoons. How did the writer set up the important information: the hero, the villain, the problem and goal, the terrible thing that is going to happen if the hero doesn't achieve his goal? What was the catalyst? What made you want to root for the hero? How many minutes did it take for you to get that basic information? What happened in the very first scene?

4. See an animated feature. Look for the same information as in exercise 3. Notice the additional time that you have to get the same information. Did the action start any slower? Did you learn more about the characters?

5. Write a scene opening that will leave us sitting on the edges of our seats.

6. Script a short scene that's either action-packed or emotional. Be sure it furthers plot, reveals character, contains some humor, changes the status quo, and leaves unanswered questions, whetting our appetite for more.

7. Write the scene for a video game. How did you keep the story effective (funny, action-packed, moving the plot ahead, defining character) while still providing a good gameplay experience?

8. Work on the scenes for your own original script.

CHAPTER 12

Animation Comedy and Gag Writing

What Makes *You* Laugh?

What makes you laugh? Or, more importantly, what makes your audience laugh? "Why does Brutus the Brave refuse to cross the road?" "Because he's no chicken!" Humor varies from culture to culture and from age to age. In comedy we set up a situation, increase the tension, and suddenly we're stopped dead by something unexpected. Emotion gushes out, tension is relieved and exploded into laughter. At least that's the way it's supposed to work. And it *will* work if you set up the gag right. Comedy is a contrast between two individually consistent but forever incongruous frames of reference linked in an unexpected and sudden way. A stereotype is twisted. You lead the audience down the garden path (the setup) and then—zap! Surprise is very important. Generally the bigger the surprise, the bigger the belly laughs. Two classic baby jokes, peek-a-boo and the jack-in-the-box, demonstrate at an early age what makes us laugh. There's the buildup, the expectation, then the pop or shock.

Some forms of comedy, like satire, don't rely on a single effect but a series of minor explosions or a continuous state of mild amusement. A running gag gets funnier with each repetition. Think of *the Road Runner* series, one long running gag.

Experts believe that all comedy contains an impulse of aggression or fear. The fear may be combined with affection, as it is when we tease. It's this fear or aggression that's released when we laugh. Shock works well. Repression can contribute to a bigger laugh. Repression is the reason that gross-out and bathroom humor get belly laughs. The energy of the comedy is important. Whether a situation is tragic or funny depends on the audience's attitude, whether that attitude is dominated by pity or animosity. Who is slipping on the ice? Is it the sweet, little old lady or the school bully? If it's the little old lady, the two frames of reference remain juxtaposed. We're apt to feel sorry for her. But if it's the bully, the two frames of reference collide, and we laugh. The experts claim that kids naturally laugh at cruelty and boasting. They laugh when a hoax is played or when others are in some way made uncomfortable. A witty remark may go over their heads. Of course, in children's media we need to

consider good taste and good role models as well and use common sense in what we want children to see. Humor for kids is politically correct, but that does not mean it's boring!

Animation Comedy

How is animation comedy different? It's above all visual with plenty of sight gags. The very basis of your idea must be visual. Animation uses motion and misuses the laws of physics. Timing is important. The comedy is exaggerated, often taking reality one step beyond. It may be illogical. There might be a use of fantasy, occasionally with musical numbers and dances. Dialogue may be "smart" with comebacks, put-downs, puns, rhymes, or alliteration. Titles are funny. Names of people, places, and things are funny. Most executives that buy or approve stories prefer material that will make both the kids and the adults that could be watching with them laugh. Of course, this means higher ratings and higher box office receipts. However, a few executives prefer the comedy material to be specific to a single age group. So you must find out what the executives who are going to approve your material want. Never write down to the kids!

Comedy Out of a Character's Personality

The funniest comedy develops out of a character's personality. Take a classic character type and twist it. What makes your unique character naturally funny? Use a character's attitude, mannerisms, and dialogue to increase the comedy. Reactions and comedy takes can often be funnier than the gag that has gone before. You might also play against character type or expectation for your humor: a rough and tough dog that cringes at the sight of a bug. Exaggerate appearance, diction, behavior, and attitude. Act out your scenes as you write. How would that action really happen? How would you feel if you were that character? How can you exaggerate and make it funnier? Spend some time developing comedy and gags from the personalities of your characters. Good characters and the comedy that their relationships can provide is the best recipe for a classic script. Characters with a comic defect and fish-out-of-water characters are types that work well for comedy. Use characters as different from each other as possible so that these conflicting personalities can bounce off of each other in a funny way.

Writing a Funny Television Script

Start by putting yourself in the mood to *think* funny! Then begin to analyze. Where does the humor of this series originate? Is it belly laughs, giggles, or smiles? Is there visual humor or funny, smart dialogue? What's funny about the star's personality? Be consistent to the kind and amount of humor of that show.

Combine people, places, and props, juxtaposing one idea with a totally different one (an angry man and an office cooler in the middle of the desert). Place the unexpected in a surprising context. Place the obvious where the viewer would least expect it. Place incongruous words or things in juxtaposition to create surprising relationships. Make sure that your

script is sprinkled with spot gags throughout. Come up with a script that's funny and fresh, or at least put a new twist onto a classic idea.

Try creating an episode around a funny situation: perhaps the fish-out-of-water or an unresolved predicament (like a lie or a secret). You can give your star a tough choice between two good things or two that are bad. Often there's a catalyst that rocks the boat. The star may make a plan, but it turns into a textbook case of Murphy's Law, and everything that can go wrong does. Complicate the predicament your star finds herself in by adding additional layers of problems. Escalate the trouble so that she digs herself in deeper and deeper. Maybe there's a race against time with your star in really big trouble if her parents come home early or if she doesn't get something fixed before they find out what she did. Or maybe your star is trapped somewhere embarrassing.

Be sure you have plenty of props available because these are necessary for the gags. Misuse your props. Make up your own wild gadgets.

Set up your gags with the basic information of the joke. You might intentionally mislead your audience in the setup with false clues. A beat or two of complications or incongruity adds tension, but keep the setup short. Exaggerate everything. Build your gags, **milk** them, and top them. Add a **capper**. Comedy is a process of setup and **payoff**, and this is often done in a rhythm of three . . . dum, dum, de-dum! Setup, setup, payoff! Sometimes you can set up now and pay off later with the **punch line**. You may have multiple punch lines, each one funnier than the one before. Friz Freleng often timed his animation to the beat of a metronome. He'd get a rhythm going and then break it for the surprise. Get a feel for the timing, and work on your gag until it feels right.

Getting the laugh often depends on using the right words in exactly the right order. If something isn't funny enough, try adding C's and K's to the dialogue. These sounds are funnier!

Use timing, tension, and hints, letting your audience bring a little to the whole and bridging the gap. Use simplification and selection. Give the audience A, B, C and F, G. The audience should have to supply D and E. Use implicit, not explicit, punch lines. Instead of saying, "Miss Petunia eats like a pig!" you want to say, "Miss Petunia is invited to lunch. Should I get out our best trough?" Don't tip off the surprise—the punch line—but save it for the end. Save the biggest, wildest, and best gag for the climax. Scenes usually go out on a laugh line, a **stinger**, or a **button**. End your script with a twist!

Get feedback on your gags from story editors or trusted friends. Listen with an open mind, and don't get defensive. Try to put the script away for a couple of days; then look at it with a fresh point of view, consider the suggestions carefully, and do your rewrite. If something bothers you even a little, then it's not right. Fix it! Turn in your very best work.

Putting Together Comedy Scripts

Established writers have several theories for putting together comedy scripts. Some believe that comedy plots need to be simple to have the room to make the story funny. They like to focus on doing comedy riffs around a basic subject. This works best on short cartoons, where a complicated plot isn't necessary to hold the viewer's interest. Some writers like to use the leapfrog method (a story-developing scene, then a comedy scene, then a story-developing scene . . . all the way through). Even action scripts in cartoons usually have

some comedy scenes. These scenes are used to break up the tension from the intense action. After all, this method was good enough for Shakespeare. In a longer story with more depth, consider the effect of tension and when you want it released. Tension built up in a mystery can be released in a good comedy scene. But if you want the tension built up for the climax, perhaps you don't want a comedy scene immediately prior to that climax. Most writers just use their judgment on what will work best for the length and depth of the story they're writing.

Comedy Devices

Cartoon gags have an old history with roots in vaudeville and magazine cartoons, as well as comic books and silent films. Here are a few comedy devices that you can use in writing gags:

- *Old Gags*

 Don't be afraid to take an old gag and update it with a twist.

- *Impersonation/Disguise*

 A character in costume or drag. This is great for kids' cartoons. Children like this best when the character is embarrassed by the disguise.

- *Multiple Personalities or Role Reversal*

 These devices allow characters to do things that they wouldn't normally do.

 o For multiple personalities: A witch places a spell over a rabbit, and the rabbit changes into a flamboyant frog, then an unlikely looking prince, then a meek but gigantic lion.

 o In role reversal: A normally responsible girl pretends to be flighty in order to attract the attention of the football captain.

- *Anthropomorphism*

 Like impersonation and role reversal, you have two forms of reference, and you oscillate between them. *Scooby-Doo*

- *Multiple Reference*

 Two or more frames of reference in one gag or joke. "His mom repaired the microwave with extra parts from an old jet. Now when she opens the oven, the bagel circles the table twice before coming in for a blue-plate landing."

- *Pretense and Exposure*

 Pretending to be someone the character is not, hypocrisy unmasked. Pretense usually involves character mannerisms and business, perhaps a change in voice. *The Emperor's New Clothes*

- *Reactions and Takes*

 These are usually used in an ending to a gag, rather than as gags themselves. They rely on funny expressions, reactions, or a funny take, even a double take. The character is often left in a funny pose, perhaps with something on top of his head.

- *Pull Back and Reveal*

 The basic gag element is at first hidden from the audience. We see a tic-tac-toe game in progress. We pull back to see that the game is being played by two very dignified scientists in the middle of a dry erase board covered with complicated, mathematical formulas.

- *Hidden Element*

 The gag element is hidden from one of the characters.

- *Twist Around*

 Things are the opposite of what we expect. *Alice in Wonderland/Through the Looking Glass.* The twist might be in the dialogue: "That teacher's so mean that when a pit bull sees her, he runs for his blankie." Or the gag could be visual: At a spa snooty pigs, dressed to kill, are taking a tour. They turn up their noses as they watch people wallow in mud baths.

- *Misunderstanding*

 Old is mistaken for young, man for woman, and so on. Sitcoms use this technique often. The teacher says to the principal, "I won't put up with those pests!" In the next scene we see a classroom of kids waiting for their teacher. Instead . . . in walks the pest control man!

- *Twisted Clichés*

 Take a cliché and twist it.

 - Twisted—a visual twist is part of the cliché gag. "They're playing our song!" We see performing birds ringing bells as they peck out a once-romantic ballad.

 - Turnabout cliché—one important word is changed. Two kids at recess are fighting. One says, "She called me a dirty number."

 - Literal cliché—The gag centers o[r] [w]ord in the cliché that has more than one meaning. We use the wrong one. [pi]cher is worth a thousand words."

 - Cliché visual—A new gag is mac[e] cliché picture. Uncle Sam is pointing his finger. We pull back to see Uncl[e] [Sam], looking defiant. Uncle Sam says, "You pick up your toys before you wa[nt] [fi]reworks!"

- *Customs*

 The juxtaposition of references fr[om] [d]ifferent occupations, ethnic customs, or time periods. *The Flintstones, The* [...]

- *Pop-Culture References*

 Shared cultural experiences. *Shrek*

- *Topical Humor*

 Jokes based on the news of the day or time period. You can use any old joke and bring it up to date. Topical humor is harder to use in animation because of the extensive lead-in time until the television show or film is shown. Also, topical humor may be dated by the time a show is rerun or released on video or DVD. *The Simpsons, South Park*

- *The "In" Joke*

 "In" and upscale. "In Beverly Hills 911 is unlisted."

- *The Dumb Joke* (usually a belly laugh)

 Blonde jokes, women driver jokes

- *Kid's Mistakes*

 Not always funny to kids. This is hard to use in kids' cartoons unless the joke involves a younger brother, sister, tagalong, or (in the same vein) a pet. *Bill Cosby's Kids Say the Darnedest Things*

- *The True Story*

 Usually this is a real belly laugh. Often it's something embarrassing that has actually happened to you.

- *The Ridiculous Situation*

 The opposite from The True Story. The gag is exaggerated so far that it couldn't possibly be true, but the sheer ridiculousness of it is funny. The cowboy riding the nuclear bomb.

- *Understatement*

 Chaos may be all around, or something very unusual is happening. The main character ignores it or says something very understated. A huge crowd is watching the take off of the first flight to leave our solar system. The spaceship rockets toward the sky, then explodes like a firecracker. Cool Surfer Dude: "Looks like a dud, dude."

- *The Excuse*

 We've all made them, and we recognize ourselves. Usually there's a lie involved. The character tends to keep digging himself in deeper and deeper.

- *Insult and Name-Calling (often a belly laugh)*

 These are some of the easiest to write. You have to be careful in children's television, but it can be done. *Teenage Mutant Ninja Turtles* used this frequently.

- *Comebacks and Put-Downs*

 Modern cartoon staples

- *Malapropism*

 The wrong word. Dr. Seuss's holiday dinner of "roast beast"

- *Literal Use of Words*

 Take a slang word and use it literally.

- *Whimsy*

 "I feel like burying myself in a box of jelly beans and committing spearmint!"

- *Definition*

 "A lie is like a watering can. It usually has holes in it."

- *Pun, Witticism, Poetry with Rhymes and Alliteration* (all a snicker to a chuckle, not a belly laugh)

 These should be used along with (and not in place of) sight gags. They don't work internationally because they can't be translated properly. Association based on pure sound. Kids love the sound of words: "The monster mumbled through a mouthful of still-morphing marshmallows." Also, a play on words and ideas where two different reference scales meet. Think cliché, then twist: "Eager beagle."

- *Caricature, Satire (verbal caricature), Irony*

 We see ourselves and yet something else. Fun-house mirrors. Irony appears to take seriously what it really does not. This might be over the heads of kids.

- *Parody*

 A funny put on of someone or something. Often these are twists on books, movies, or television shows.

- *Funny Sounds*

 Anything with a C or K. Some sounds and letters are funnier than others. Sound effects. Accents. For children's media accents should not be demeaning.

- *Misplaced Emphasis*

 This can be a child's lack of understanding or a ditsy adult. But something is not right in the sentence context.

- *Transition, Digression, or Non Sequitur*

 A mood or mental picture is broken by a complete transition of thought or inflection in the punch line. The punch line isn't logical and doesn't fit the setup.

- *False Logic*

 "How do you get milk from a kernel of corn?" "You use a low stool!"

- *Say One Thing and Show Another*

 What is said is the setup. What is shown is the punch line.

- *Metamorphosis*

 In animation someone or something can totally change physically into someone or something entirely different.

- *Shell Game*

 People, props, or animals shuffle, hide, and pop up where they're least expected.

- *Funny Chase*

 Chases right out of the Keystone Cops.

- *Food Is Fun*

 Characters can have food fights. Food can be gross or crazy like fried bugs or purple ice cream with green spots.

- *Rube Goldberg Inventions*

 Kids love fantastic machines, devices, and contraptions—the more complex and sillier, the better.

- *Try-Fails*

 Kids love a character who keeps trying and goofing up. They can relate. Build this series of failures so that each failure is bigger than the one before.

- *Action Gag*

 Based on action rather than a funny situation. Action gags are very visual and depend on timing and the funny way in which the action is performed.

- *The Running Gag*

 Keeps repeating during the course of the story or series. It's funnier as it goes along. Often has a twist each time it repeats. Bugs Bunny's "What's up, Doc?"

- *Gag Series*

 All based on a single situation or prop. This series builds and gets funnier and wilder with each new gag topping the one before. Here you're milking one basic idea for all it's worth: A cat watches a goldfish in a bowl. The fish peeks out, and you see two huge, cat eyes magnified by the bowl. The goldfish dives and flips a piece of seaweed onto the cat's nose. The cat reacts and leaps for the bowl. In the next shot we see the bowl on top of the cat's head. The fish blows a huge bubble. It lands on the cat's tail. The cat turns around and bats at the bowl, flipping the goldfish up into the air. By the end of the gag series, the whole room is in a shambles, with the fish playing a victory song on its own scales.

- *Artist Gags*

 The artists devise these. They involve funny drawings, the use of funny staging, design, animation, effects, and color. The writer may try to describe them, but it's really up to the artists to make them funny.

- *Playing with the Medium*

 These gags surprise the audience by going against expectations in timing, cinematography, design, animation, and filmmaking.

- *Speeded-Up/Slow Motion Action*

 Use a change in normal speed for your gag.

- *Laws of Physics*

 Animation often rewrites the laws of physics. Wile E. Coyote runs in the air before falling to the bottom of the canyon and flattening, but he always reappears in the next scene unhurt.

- *Proportion*

 Play tricks with big and little, fat and skinny—perspective.

- *Motion Gags*

 Any gag that uses motion is especially suited to animation. A treadmill becomes an escalator.

- *Death*

 This is a hard one, but it can be done! The point is that anything can be made funny.

- *The Surprise Ending*

 A scene or an entire show may be fairly standard and cliché. But the ending has a comedy twist and saves it. Often this twist is heightened if what goes just before is especially everyday and normal. This doubles the surprise.

More Comedy Techniques to Try

To build a gag, try taking a situation, building it, exaggerating it, and then making a sudden reverse. Or use Gene Perret's "Uh-oh Technique": Everything is going all right, then something happens and the audience says, "Uh-oh!" Or the character doesn't realize just how grave the crisis is, but the audience does (see Figure 12.1). Use switching techniques, taking one basic situation and then making a funny variation on the situation. Make lists of words, phrases, events, places, people, facts, things, and symbols that relate or are opposite to the main topic. Conjure up surprising and ridiculous images from your list. Write about what makes you passionate or angry. Attack authority. Look at a problem from all angles and home in on what's illogical. Verbal humor works well when the budget is small and animation is limited. Visual humor works better internationally, as any word play can get lost in translation. And it's okay to be silly! Have fun!

Global Comedy

Comedy can be culture-specific. Certainly, a people's history influences their comedy. If you're writing comedy for a specific country, you should be aware of their preferences in

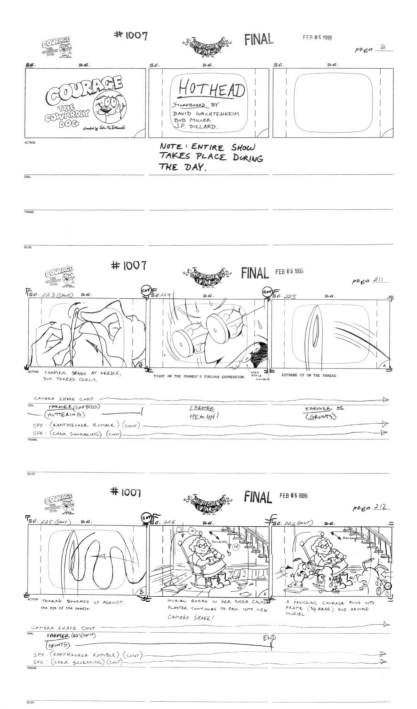

Figure 12.1 Who knew that one little needle was capable of bringing down the house?
Courage the Cowardly Dog, "Hothead," written by David S. Cohen; this section boarded by Bob Miller. *Courage the Cowardly Dog* and all related characters and elements are trademarks of Cartoon Network © 2004. A Time Warner Company. All rights reserved.

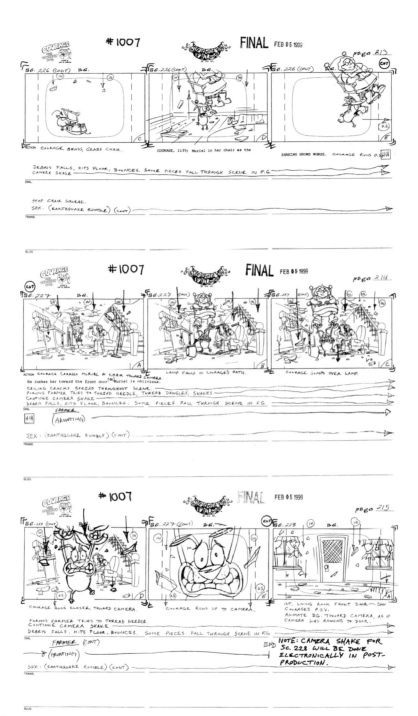

Figure 12.1 *Continued*

humor. Study what films and television shows are successful in that country and which ones fail. Visual humor is almost universal.

Comedy in Your Original Project

If you're developing an original project, rather than writing comedy for someone else, you want your comedy to be particularly fresh. One thing you might want to consider is character point of view. If you give one of your main characters a point of view that's totally unique and off-center, that view of reality will change the entire world around him, and you'll have a funny script. Another way to develop fresh material is to create a new storytelling style that's uniquely suited to this one project. Or you might want to develop a style that's especially suited to you! You can brand yourself with an original style as some stand-up comics do. This will make you stand out from the pack, but it will also limit you. Developing a unique style can take time. It may develop naturally over the course of several projects if you let it. Then try to write what you know well and what you feel strongly about. If you're honest, the details will ring true. We'll laugh at what we recognize in ourselves and the others we know.

Reference

Watch the old silent films. Charlie Chaplin and Laurel and Hardy are especially good for learning animation comedy. Watch the Our Gang comedies and The Three Stooges early sound films. You can learn from clowns as well. All of these are visual.

Checklist

- Is the very premise of your script a funny one?

- Are the majority of your gags visual? Did you use the types of gags that work best in animation, motion gags, gags that defy the laws of physics?

- Does all of the comedy relate directly to the story and characters with nothing extraneous?

- Is much of your humor based on your characters' personalities? Have you used these attitudes and reactions to the best effect?

- Are all your gags in character, true to the established personalities in that script?

- Can your star dig herself in deeper and deeper for funnier and funnier results?

- If you're writing for a current series, is your humor similar to the humor already established for that series, and do you have about the same ratio of gags per page?

- If this is an original script, are all of your characters as different from each other as possible in order to heighten the comedy?

- Have you exaggerated as much as you can for the level of humor of that series?

- Do all of the gags have a setup, increased tension, and a sudden surprise at the end (the payoff)?

- Does the timing feel right, or is there a way to make your gag funnier?

- Have you twisted at least some of the running gags so that they remain funny and don't get monotonous?

- Do your gags build throughout so that the funniest gags are near the climax of your cartoon? This is especially important for short cartoons with little plot.

- Will your gags be appropriate for your audience? If this is a kid's series, are the gags those that you'd want your kids to see and appreciate? If you're writing for a series, who is your audience? Are you writing for kids of a certain age only or for both kids and adults? What do the executives who approve your script expect? Will an international audience understand the gags?

- Are you using a variety of types of humor?

- Have you refrained from spelling out the joke so that the audience can bring something to the party? Is the joke still clear?

- Focus on the dialogue, making it wittier with funnier comebacks. Remember to keep up the conflict to heighten the repartee.

- Have you used the funniest words (some with C's and K's), placing them in the funniest juxtaposition and the funniest order?

- Is your script sprinkled with gags throughout?

- Now forget the rules. Are your gags funny?

 Exercises

1. Watch a classic cartoon. List as many of the gags as you can. Rewrite five of the gags by updating them, giving them a new twist, or switching the personality of some of the characters.

2. How many different gag techniques can you list that haven't already been listed here?

3. Take a book of jokes that you like and analyze the sentence structure of five of them. Are the sentences long or short? Did the writer use lots of adjectives and adverbs, or is the structure lean? What kinds of verbs are used? What's the imagery like? How is the joke set up? How is the punch line delivered? What about timing?

4. Develop five funny premises, each using funny situations. Be sure that your star digs himself in deeper and deeper.

5. Write five funny premises based on character.

6. Make a list of props around a specific subject (such as mysteries, dogs, magic). Write ten gags using many of these props.

7. Write ten sight gags. Then rewrite these gags, pushing them up a notch by exaggerating even more.

8. Dash off ten gags using at least ten different comedy devices.

9. Take five of your gags and rewrite them several ways. Set them up differently. Change the character reactions. Experiment with the wording and the timing.

10. If you can draw, board a gag sequence. Concentrate on funny staging, funny drawings, and funny movement. Explore several ways of doing the same sequence.

11. Can you think of other ways besides those listed to make your humor fresh and unique? Discuss these in class.

12. If you're developing a project of your own, try increasing the humor and uniqueness of one or more of your characters by making their point of view a little more off-center.

13. Develop a unique and humorous storytelling style for an original project you're working on. Be sure that this style is right for this particular project.

Dialogue

The Purpose of Dialogue

You want to show your story, not tell it! At its best, animation is all about action and movement; it's not about words. Animation explores space. It experiments with time. When Jackie Chan is making his moves, he doesn't need a lot of words to dish out disaster to the evildoers. There are cartoons with no dialogue at all! The norm in television cartoons is three **dialogue blocks** at once with no more than three short sentences per block. Action cartoons will probably use less dialogue than prime-time cartoons. Once again follow the general dialogue ratio of the sample script for that series. In a feature where you're delving deeper into character, a little more dialogue might be necessary, but even there you don't want too much.

Dialogue does have its place in animation storytelling. It's used to reveal the characters. It provides direction, moving the story along and advancing the plot. It discloses information. It provides conflict. And it sets the spirit or mood of the story, whether it's a comedy or drama.

Basically in animation, words should be used only after you've tried all other methods of communication. Silence might accompany discoveries, revelations, and deep emotions. The absence of dialogue can give the audience time to assimilate what has just happened.

Revealing Character

Sometimes only dialogue can expose the real motivations and secrets of a character in all their complexity. It's especially effective when it exposes the character in an entirely new way from what we as an audience expect. We use dialogue to establish relationships. Dialogue reflects feelings and attitudes. Be sure you know your characters. Each character has her own agenda, sometimes hidden. There may be subtext. What is really being said? Which character is driving each scene? Your characters can be driving the action directly or indirectly. Direct dialogue drives people apart: "You're *always* late!" Indirect dialogue draws people together: "I know you had to help your sister before you could come." Characters

might talk around a problem as we often do in real life, but because younger kids probably won't understand subtlety, writing targeted at preschoolers should say what it means. Writing will also be more direct in shorter cartoons because there simply is not time for many shadings. A longer story digs deeper. To get beneath the surface, try using questions.

Make your dialogue unique to each character. It should never be interchangeable. Each character should have a different rhythm, perhaps a different sentence length. Dialogue reveals education, age, and cultural and ethnic background. Use wording and colorful expressions that are individual to that one character. Unique phrases and pet words can serve as a character signature. Each character should have his own speech fingerprint.

Moving the Story Along with Dialogue

Dialogue should serve the plot. A good animation story has to keep moving. Don't let the words slow it down. Words are one way to tell the story, but conversation should always disclose tidbits that the characters must tell each other, not just information that you as a writer want the audience to know. Characters make discoveries about what's happening and unearth secrets about each other. But characters don't always listen to each other—just like people in real life.

Conflict Can Reveal Information

Conflict in dialogue or tension between views is a good way to get information out and keep it interesting. Conflict allows the audience to choose sides. Characters in scenes often have a personal agenda that comes out in conflict during the course of the scene. Who has control? Who has the most status? Who is telling the truth? All the exposition doesn't have to come out right away. We want to know what happened before the story started that's motivating our characters now. But information can leak out throughout the story. Do be clear enough so that your young viewers understand, but don't say everything. Leave enough unsaid that the audience becomes involved and wants to watch the story to learn more.

The Mood of the Story

The type of dialogue must be appropriate for the genre of that specific series, film, or game. Set the tone and style of the story right away. This is especially important in comedy, so that we know that it's all right to laugh.

Characteristics of Dialogue

Dialogue is the essence of real talk with thematic content and an ongoing exchange of power. Good dialogue has a beat, a rhythm, and a melody. It's affected by time, place, the weather, and so much more. It's intangible like mist, and it depends on your characters and who they are, their relationships, the situation, the genre, the world of that series, the target age of your audience, the length of the script, and who you are as you're writing the dialogue. Dia-

logue sounds like real talk, but it isn't. It's the essence. In real dialogue we tend to interrupt each other, repeat the last phrase, use jargon and colloquialisms. We might speak differently to different people (teacher, peers, an enemy). Women may be more supportive in dialogue, and men may be more competitive. Different cultures have their own general characteristics. Emotions change dialogue. Keep it simple; less is more. The words must always be easily understandable and clear to everyone. You might want to repeat important story points, especially for preschoolers, but repeat with a twist.

Comedy Dialogue

The best comedy stems from character. Be sure you have funny, exaggerated characters reacting to a funny situation and speaking in a funny way. Try to avoid straight lines wherever you can. Use dialogue that plays off the characters and the situation. If there's a fire, "Let's hotfoot it out of here!" Then play the next line off that. A straight man might serve as a foil for the one-liners. Insults can be funny. Sometimes a character misses the joke, and only the audience gets it. Sometimes the humor is in the contrast between what is said and how it is said. Reactions are significant in comedy. Timing is important! The dialogue may be delivered with a rhythm, often in a series of three. Comedy dialogue develops with a setup and then a surprise punch line that comes at the end. Comedy scenes usually go out on a laugh line, a button.

Writing the Dialogue

If you can listen to tapes of your established characters in advance, do it. Your story should be set up in the first few words of dialogue. From the start, keep in mind your final end point, and build the dialogue toward the climax. Write less than you think you need. See and hear it as you write. Act it out in character. You'll want to add a new dimension with your dialogue, but don't make it so different that it doesn't sound like the established characters. Write the words so that the actor can contribute something with his voice (a gulp, an excited squeal, a drawl). Think of Homer Simpson's "Doh!" Give your actors attitude, emotion, special phrasing. Character sneezes and sighs should be written with the dialogue so they're not missed during the recording session. If you're writing only one line for an incidental character, make that one line a jewel . . . something really memorable. Keep your language appropriate for that series. If you're writing an original script, decide ahead of time whether you want your language up to date and fresh or classic for a longer shelf life for that show. Dialogue for children can be whimsical and full of contradictions and nonsense. Be original and clever!

Common Problems with Dialogue

- Too much dialogue! Tests show that cartoons are primarily seen, not heard.

- Not enough conflict, or the dialogue doesn't grab us emotionally.

- Talking heads. Be sure there's something to animate.

- Filler dialogue and repetition. Make every word count! Don't tell the audience what they've just seen or what they're going to see.

- Unnecessary dialogue. Would the action or gag be better with no dialogue?

- Preaching! Don't verbalize the story's moral content (if it has any) in a line of dialogue.

- Feeding information to the audience. Does the dialogue have another reason?

- Dialogue that's difficult for the actors to say. Make it colloquial. Write in between breath spaces.

- Bad dialect. Don't write in dialect, misspelling the words and making them hard to read. It's too difficult for the actors. Let the actors add their own dialect. But do give the lines appropriate phrasing with the flavor of the language and the place.

- Overdone puns, alliteration. Puns don't translate well internationally.

- Clichés. Keep away from them unless you can give them a twist.

- No variation in tone and pace. Dialogue should not be too predictable.

- Dialogue that writes down to kids.

The Rewrite

Polish up your dialogue last. Go through the script and read only the dialogue. Better yet, read each character's dialogue separately. How does it sound? Does it need more conflict? Is it as clever as it can be? Can it be funnier? You'll feel great when you overhear some kid quoting the lines that you wrote!

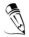 **Exercises**

1. Who was your best friend when you were a child? Recall a childhood disagreement or misunderstanding. It helps to recall your feelings, the sights, the sounds, and the smells of that day. Write dialogue for the fight.

2. Write dialogue for after the fight when you wanted to make up. Remember to include those awkward pauses and those attempts to apologize that weren't really apologies at all.

3. Explore the characters you created and the relationships between characters by placing two or more of them in an awkward situation. Write their dialogue.

4. Now write dialogue for the same situation between different characters. How does the dialogue change?

5. Improvise scenes from your project using other class members or friends, or play all the characters yourself. Often acting out the scenes improves the dialogue, develops deeper characterization, and gives you better scenes overall.

6. Write dialogue between characters that are from a different country, different section of the country, or different time period. In other words, write in dialect without the misspellings. Use the natural phrasing and flavor of the dialect only.

7. Create a scene between two characters, focusing on smart, witty comedy and funny comebacks.

8. Script a scene in your project that uses conflict. Who has the power or control? Does the same person have the power at the end, or has the power switched?

The Script

The Animation Writer as Visual Director

Writing an animation script is somewhat like directing a film. But there are some differences! Even in the era of big-budget contract players, Coyote and Roadrunner never once phoned in sick until their contract was renegotiated. More recent cartoon celebrities, like Marge and Homer Simpson, wouldn't think of holding up a production schedule while their lawyers fought out a messy divorce in court. Animation writers never need to cater to a stack of drawings!

In a live-action project it's the director who decides what to film. Then just to be safe he shoots a great deal of extra footage. Later he edits that footage, and much of it ends up on the cutting room floor. There is no need for that kind of expensive editing process in animation. No extraneous footage should be produced. So animation scripts have traditionally included the camera shots, as if the writer was directing the story. A finished animation script is still a work in progress with the storyboard artist who follows, improving upon the look of the story. But it's the writer who initially visualizes each shot in his head.

Working with a Television Story Editor

Before you begin to write, carefully read the story notes that you've been given by the story editor, and get ready to follow them exactly. These notes could change your story substantially from the outline. Perhaps network executives required changes, other subsequent stories have made these changes necessary, or your story editor has thought of something better. If you've had a fantastic idea that will improve your story, discuss it with the editor first. He wants the best story you can write, but you already have approvals for *this* story. If you're writing a script for a game, technical aspects have already been worked out. The story editor will have to weigh the improvement with the practicalities of a change.

Prepare! Be sure you have a sample script (an average script from the series) to follow. Get a page count for your completed script. Ask for a deadline, and stick to it! You may have as little as a week to write your script.

Format

Discuss formatting with the story editor. You may be able to download a script template. In any case you must know technical requirements: whether your script needs to be submitted on a disk or if you must use a specific word processing program like Microsoft Word. Follow the format of the sample script exactly. No story editor has the time to make formatting changes.

Suggested general format guidelines follow. All scripts should be written on $8^1/_2 \times$ 11-inch white, three-hole-punched paper. Use Courier 12-point font, the script standard. The normal number of lines per page is around fifty-two. If you follow standards, story editors can correctly estimate the length of your script. For those of you who don't have screenwriting software, here are some suggested settings: Adjust the top and bottom margins to one inch. Set the left margin at one and a half inches and the right at three-quarters of an inch. The body of the script runs from space fifteen to space seventy-five. (The body includes FADE IN and FADE OUT, scene headings, and scene descriptions.) Dialogue extends from space twenty-five to space sixty. Dialogue cues run from space thirty-one to space fifty-four. Character names start at space thirty-seven. Scene transition cues (except for FADE IN and FADE OUT) begin at space sixty. A few spaces or lines off one way or the other is all right. Number your pages in the upper right corner.

A title page should start all scripts. It contains the title (about a third of the way down and centered in all capitals, and either in bold or underlined), and the episode title if there is one (two spaces below the main title, centered in upper and lower case, enclosed by quotations). Four spaces below that is the phrase "by (centered and lower case) [your name]." Contact information is located in a single-spaced block (upper and lower case) in the lower right corner of the page, typed flush left within the block. Registration notice (copyright or WGA registration information) is in the lower left block, typed flush left within the block. Registration notice is for original rather than episodic scripts. Some people feel that a registration notice makes the work look unprofessional, but your work is not legally protected without a copyright notice. Use your own judgment. If the script is a script-for-hire, then the date instead of the contact information is typed in the lower right corner.

Some studios want a cast list or list of speaking characters for recording with brief one-sentence descriptions about each character on the second page. Check with your story editor.

Not all animation scripts are alike. Feature animation scripts and CGI series resemble live-action scripts. They're written in master scenes: INT. THE CASTLE—DAY, just as you'd write a live-action script without specific camera shots. Prime-time animated TV scripts resemble their live-action sitcom counterparts.

Animated daytime TV scripts are normally written differently. They average roughly one and a half pages of script per minute. Ask your story editor exactly how many pages he wants. Many camera shots are normally included (CLOSE SHOT OF BATMAN or LOW-ANGLE ON SCOOBY), as if you were directing the episode. A sample TV animation script follows. It's reasonably typical, but different studios and different shows at the same studios have slightly different needs in the use of camera shots, format, pages per minute, scene numbering, and so forth. Ask your story editor for a sample script of the show you're writing, and follow that format exactly.

Here are some more suggestions: Do not break actor dialogue blocks, starting the block on one page and finishing it on the next. Skip the few lines and start the block fresh on the

next page if it won't fit. You'll notice that most scripts have each character typed in caps the first time that they appear. Most scripts also have camera directions and sound effects typed in caps. A few have props typed in caps. Sounds that the actor makes (like sneezes, snorts, etc.) are best placed in with the dialogue so that they're not missed during recording. You do not have to type CUT or CUT TO after each scene. If you write no specific instructions for scene transitions (like DISSOLVE TO), then we assume that it's a cut. Traditionally, scripts are started with FADE IN (flush left) and end with FADE OUT (either flush left or at the far right tab setting). Many scripts today skip those obvious directions.

The camera directions following are written in the traditional daytime animation script format:

CLOSE SHOT ON JADE

Jade smiles.

WIDER—TO INCLUDE JACKIE AND THE SHADOWKHAN

As Jackie does a flying kick into the Shadowkhan, Jade flips out of the way as a chair comes hurling into the shot.

See how each camera direction is typed in caps on a separate line with spaces before and after? This is the traditional animation script format. I would suggest that you use this format for your own sample script because it's more widely accepted. Now look at the sample script at the end of the chapter. Rather than typing the shots separately and skipping a line for the action, these scripts are written with shot and action on the same line. Some scripts today are written like this. It reads better. It's less standard.

Break up your dialogue with action. A standard animated script has no more than three blocks of dialogue at once. An average of two or three lines of dialogue per block is about normal. But each show is different. When you can, model your script format on a script for the specific show you have in mind.

The First Draft

You'll want to write your first draft or version straight through. Think about length as you write, estimating page count by the ratio of script to outline. It's better to write a little too long and cut to tighten than not to write enough. Save the script editing until the end.

The first page has to hook your audience! Even descriptions should be interesting. The first scene must be strong, funny, or high action—never exposition.

Every scene should have a grabber opening. Each scene will have a purpose that's accomplished as simply and economically as possible, advancing the plot, furthering suspense with unresolved questions or action, adding to the pacing, telling your story in a way that's entertaining and unique, contributing something that's fresh and unexpected.

Write with magic and wonder. Set a mood. Write with passion! Provide an emotional experience putting the senses into play. Establish attitude, using dialogue, mannerisms, body language, and stage business. Give your viewers a few moments that they'll remember . . .

and they'd better belong to your star! Be sure to be clear to the executive readers and the artists that follow, explaining even the things that are to be a surprise for the audience later. Design your set with style, using an economy of words. Add camera directions picturing what the camera sees. Choreograph your action and your camera movement, but do it simply without breaking the budget. Know what can be done economically in a traditional 2D show and what can be done in a CGI show. Is there stock animation or stock backgrounds that the producer wants used? Can complicated action happen offstage and still be effective?

To stage for the budget:

CLOSE ON MOUNTAIN PETE

> MOUNTAIN PETE
> Look out! It's an avalanche!

CLOSE ON FALLING ROCKS

A few rocks fall into the shot.

CLOSE ON CLUELESS CHUCK

One rock hits Clueless Chuck on the head.

In this low-budget version of an avalanche little animation is needed. But our imaginations supply what we don't see.

Be Practical!

The action must work for the production people as well as the audience. Set the stage well first. Know the room. Make the most of your props. Add sound effects, special wipes, special music, and so on as needed. Try to add only the kind of effects that show uses. Ask! If there's a sign, be sure that one of the characters reads it out loud or the accompanying picture tells the story. Young kids can't read, and international viewers may not be able to understand English. Not all cartoons get dialogue rerecorded in the language of the country where it is shown.

Keep Up the Pace!

Use the essence! Break up the action and increase the pace with cuts. Cuts keep the story moving. Individual scenes should be very short, especially for TV. Action. Reaction. This is your first big use of dialogue. Every line should work to build the story. Keep sentences short. Use strong verbs. Make it flow, but don't make your sentences so smooth that they lull you to sleep. Follow the gag ratio of that series, or ask if you can write more. Exaggerate! Visual, not audio, gags work best in animation, especially in an international marketplace. Is this a series with lots of smart dialogue? Build your gags, milk them, and top them. Did you set up expectations and then spring a surprise? Repeat a gag only if you can do a twist. Timing is everything! End with a bang and a gag!

Checklist

- Did you make all the changes indicated from the notes the story editor gave you?

- Is the structure all there: a protagonist with motivations and a goal, an antagonist with the same goal and his own good reasons for stopping the protagonist, a protagonist with a character flaw that he learns to conquer because of this story, a catalyst that starts the story moving, a game plan for the protagonist, new information in the middle, a crisis, a critical choice, the big battle, a climax, and a resolution? Are there two major turning points in the three-act story, one at the end of Act I and another near the end of Act II? Is there a twist at the end?

- Do you start with action? Is there plenty of action and suspense throughout?

- Will this script work well for storyboard artists, designers, animators, and so on through the production process? Will it be crystal clear to everyone, even those who may not be familiar with local slang?

- Cartoons are funny! Is yours?

- Are your characters acting and speaking "in character"? Are they true to who they are? Can we relate to them? Are they likeable?

- Is your villain *really* bad?

- Are the relationships true to the series?

- Is the dialogue as funny and clever as it can be?

- Smooth the transitions.

- Be sure that nothing is too subtle to animate or see on a small television screen (unless this will be shown primarily on a large screen).

- If something bothers you, even a little bit, respect your instincts and cut it. Cut the extraneous. Cut the philosophy. Then if your script is too long, cut the adjectives. Tighten. If you still have too much, try cutting off the beginning or the end of a scene.

- Can you find anything there that the network censors will cut?

- Is your script format correct and consistent?

- Check spelling and grammar.

- Make sure there are no typos.

- Your job is to please the story editor of that series. Did you?

- See Chapter 15 on rewriting and editing for a more detailed checklist.

Script following: *Jackie Chan Adventures* © 2003 Sony Pictures Television Inc. Written by David Slack. Story Editor: Duane Capizzi.

Jackie Chan Adventures

"QUEEN OF THE SHADOWKHAN"
(Script #206)

TEASER

EXT. MEDIEVAL CASTLE—SOMEWHERE IN EUROPE—NIGHT
An eerie-looking castle on a hill. Dark skies.

INT. ANCIENT LIBRARY—CASTLE—CONT.
REVEAL—The cavernous, gothic, shadowy interior of a VAST LIBRARY,
every wall lined with ANCIENT BOOKS. The room must be several stories
high. We hear a <SQUEAK>, and a LADDER "wheels" into FRAME in f.g.

ANGLE ON LADDER BASE—PAN UP, AND UP, AND UP, following the ladder,
slowly at first and then speeding up to a BLUR until we STOP on . . .
JACKIE, <WHEELING> himself along the wall at the TOP of the ladder
near the ceiling, as he searches the shelves—looking exhausted.
 1
 JACKIE
 <exhausted sigh> Finally.

Jackie stops the ladder and pulls a MYSTERIOUS BOOK from the shelves.

ECU ON THE BOOK—A very large UNEARTHLY TOME with a foreboding picture
of a DRAGON SKULL AND CROSSBONES on the cover (think: an ancient
Chinese version of the legendary *Necronomicon*).
 2
 JACKIE (OS)
 Uncle said this book could help put an end
 to all of this "Demon Portal" business.

JACKIE—begins to put the ominous book in his BACKPACK . . .
 3
 JACKIE (CONT)
 I hope Uncle is right.

ON EMPTY SLOT—. . . where the book was; a black-cloaked BLUE SHAD-
OWKHAN HAND thrusts out of its darkness, <SHING!> . . .

. . . and grabs Jackie's arm (the one shoving the book in the bag).
His eyes BUG.
 4
 JACKIE
 <bwaaa!> <struggles>

The Shadowkhan hand tries to pull the book back, via Jackie's arm
[it will retain its GRIP on Jackie's arm until noted]. Jackie strug-
gles, then looks around in horrified surprise to see . . .

DOWN SHOT—several Shadowkhan, climbing up the shelves toward him.

UPSHOT—several more Shadowkhan crawling upside down along the ceiling toward him, spiderlike (creepy!).

BACK TO JACKIE—he realizes:

 5
 JACKIE
 Shadowkhan!

CUT TO BLACK AND ROLL MAIN TITLE.

ACT ONE

INT. ANCIENT LIBRARY—CASTLE—NIGHT, CONT.

REESTABLISH—the various Shadowkhan creeping toward Jackie (who still stands atop the high ladder). The ninja hand from behind the books still hangs onto his arm. Struggling:

 6
 JACKIE
 Let go! Leggo leggo!

Jackie gets a sudden idea, quickly grabs ANOTHER book off the shelf, hands it to the hand.

 7
 JACKIE
 Here.

The hand frees Jackie to take the wrong book, allowing Jackie to fully shove the ARCHIVE fully into his bag—just as . . . the other Shadowkhan ATTACK!

 8
 JACKIE (CONT)
 <BAA!>

QUICK SHOTS—Jackie (bag with book now slung over his back) TWISTS back and forth on the ladder, trading BLOCKS and BLOWS with the ninjas who attack him.

 9
 JACKIE
 <fighting efforts>

JACKIE—grabs an ANCIENT BOOK in each hand from the shelves and uses them as blocking shields—but the moment they are struck, they <POOF-POOF> crumble to dust in his hands and he mugs in panic.

ANGLE—Jackie (now turned completely around so his back is to the ladder) sends TWO more attacking Shadowkhan FLYING with RAPID-FIRE KUNG-FU, and then he momentarily forgets himself and LEAPS off the ladder and SPLIT KICKS the last TWO SHADOWKHAN o.s. Jackie flails in mid-air panic as he DROPS o.s.

 10
 JACKIE
 <AAAAH!>

TRACK JACKIE—Falling down beside the ladder, Jackie SPINS around, CLAMPS his feet <SCREECH> onto the sides of the ladder and <TH-TH-TH-TH-THUMP> tries to grab the rungs to slow himself down, but they're moving by too fast, and . . .

 11
 JACKIE
 <Ow-Ow-Ow-Ow-Ow-Ow-Ow!>

LOW ANGLE—. . . as Jackie slides down the tall ladder, the ENFORCERS (FINN, RATSO, and CHOW) enter frame near the base of the ladder, grinning smugly.

 12
 FINN
 Chan at 12 o'clock!

UPSHOT—JACKIE GRABS a rung, stopping himself; above, several ninjas slink spider-like down the shelves.

DOWN SHOT, PAST JACKIE—(who is still more than halfway up the ladder's great height), at the leering Enforcers.

THE ENFORCERS—grab the ladder with a mischievous nod . . .
 13 A/13B/13C
 FINN/CHOW/RATSO
 Heave . . . HO!!!

. . . and SHOVE the ladder, which <SQUEAKS> o.s.

UPSHOT—the ninjas miss Jackie as the ladder ZOOMS o.s.
 14
 JACKIE
 <WAAA!, Gasp!>

TRACK JACKIE—clinging to the ladder as it STREAKS along the wall. He mugs in panic, then reacts to o.s.

QUICK CUTS:
 > Jackie LEAPS from the ladder . . .
 > . . . catches himself on an ANCIENT CHANDELIER and SWINGS across the room . . .
 > ON A HUGE WINDOW—Jackie lets go of the chandelier, tucks into a ball as he <RIP!> hits the window's VELVET DRAPES and . . .

EXT. MEDIEVAL CASTLE—NIGHT, CONT.
WIDE . . . sails through the glassless window of the CASTLE, wrapped in the drapes.
 15
 JACKIE
 <WAAAAAAH!>

The drape-wrapped BLOB drops like a stone until suddenly . . . <FOOMP> it UNFURLS into a MAKESHIFT-DRAPE PARACHUTE, with Jackie hanging safely from the bottom.

TRACK JACKIE—floating, relieved. He wryly quips:
 16
 JACKIE
 <phew> I guess it's curtains for me.

INT. LIBRARY—CASTLE—CONT.
ON ENFORCERS—The ninjas "glare" at them.
 17 A/17B/17C
 FINN / RATSO / CHOW
 Uhh . . . / Oopsy? / Heh.

 DISSOLVE TO:

EXT. JADE'S SCHOOL—PLAYGROUND—DAY
CLOSE—A FLAMING PIRATE-SKULL WITH AN EYE-PATCH . . .

PULL BACK TO REVEAL—. . . is TATTOOED on the bicep of DREW, who smiles proudly as he shows off to a small group of impressed (REUSE) KIDS at recess, JADE among them.

 18
 KIDS (PARTIAL OS)
 No WAY! / DREW got a TATTOO?!!

JADE—tries to grab some attention by playing it cool.
 19
 JADE
 Yeah, been thinkin' I might
 get one o' those.

All the KIDS <WHIP> turn to Jade in excitement.

 [OMIT]

ANGLE—class-skeptic DREW calls Jade's bluff.
 20
 DREW
 SURRRE, Jade! Like your dig-in-the-
 dirt-with-tiny-brushes-uncle JACKIE
 would ever LET you get a tattoo!

CLOSER—Challenged, Jade steps closer to Drew, boasting.
 21
 JADE
 He would SO let me, Drew! By tomor-
 row, I'm gonna have the GNARLIEST
 tattoo in the HISTORY of GNARL!

EXT. ESTAB. / INT. UNCLE'S SHOP—THAT AFTERNOON
CLOSE ON COVER OF THE BOOK—with the Dragon Skull and Crossbones,
as Uncle's hand opens it and turns the pages, revealing page after
page of CRYPTIC WRITING and PICTURES OF SINISTER MAGICAL OBJECTS.
 22
 UNCLE (OS)
 "The ARCHIVE of DEMON MAGIC" is an
 ENCYCLOPEDIA of powerful spells, writ-
 ten by the DEMON SORCERERS themselves.

REVEAL—Jackie and Tohru looking over Uncle's shoulder.
 23
 JACKIE
 So we will use Shendu's own spells
 against him— <Ow!>

But Uncle gives him a two-fingered <THWAP!> on the forehead.
 24
 UNCLE
 Do not be foolish! Using such dark
 magic would be VERY DANGEROUS!!

Uncle CLOSES the book and leads Jackie and Tohru into the LIBRARY
as he continues to explain, calmer now:
 25
 UNCLE
 But it may hold CLUES which will HELP
 defeat the Demons who created it.

INT. UNCLE'S LIBRARY—CONT.
UNCLE—leads Jackie and Tohru inside.

26
 UNCLE (CONT)
 Besides, Shendu took one of MY books,
 now I have one of HIS!

He gestures to the main desk/table, stacked with books.
 27
 UNCLE (CONT)
 Both of you, clear room for my new
 research project!
 28 A/28B
 JACKIE / TOHRU
 Yes, Uncle.

ANGLE—Jackie and Tohru move HEAVY STACKS OF BOOKS as Uncle straight-
ens his desk. <JINGLE>, Jade enters from the main room with her
SCHOOL BACKPACK on and nonchalantly tries to slip one past Jackie.
 29
 JADE
 Hey, Jackie, how was your trip? Have
 you lost weight? Can I get a tattoo?

JACKIE—starts to answer and then DROPS his books in shock.
 30
 JACKIE
 My trip was—A TATTOO?!

ANGLE—Jade pleads her case as Jackie picks up his books.
 31
 JADE
 PLEASE, Jackie! All the kids at
 school are—
 32
 JACKIE
 No.

 33 A/33B
 JADE / JACKIE
 But— / No. / But— / No. / But—

Jackie turns to her, firm and serious.
 34
 JACKIE
 No. Tattoos. For Jade. Period.

Jade turns and marches out, thwarted.
 35
 JADE

 AWWWW!

INT. UNCLE'S SHOP—MAIN ROOM—CONT.
JADE—HOPS onto the COUNTER beside the mysterious ARCHIVE and folds
her arms, grousing.
 36
 JADE
 <Oh!> Drew was RIGHT! What am I
 gonna— Whoa!

Jade stops in her mental tracks as she sees . . .

ECU—THE DRAGON SKULL SYMBOL on the cover of the ARCHIVE.

JADE—grins a sly grin as she starts scheming.

 37
 JADE (CONT)
 My tattoo doesn't have to be REAL . .
 . it just has to be GNARLY!

CLOSE—Jade pulls a piece of NOTEBOOK PAPER from her BACKPACK, flat-
tens it over the ARCHIVES, and quickly TRACES the pattern with a
MARKER.

 38
 JADE
 A little ink . . .

Finished, she holds up the paper to look at it. The EERIE SYMBOL
fills the frame and we . . .

 MATCH DISSOLVE TO:

INT. JADE'S SCHOOL—HALLWAY—MORNING
THE SYMBOL—gets drenched with WATER as . . .
 39
 JADE (OS)
 . . . a little water . . .

REVEAL—. . . Jade runs the paper under the WATER FOUNTAIN, looks
around to make sure no one's watching, and then PRESSES the paper to
her ANKLE.

 40
 JADE (CONT)
 . . . a little squeeze AND . . .

CLOSE—Jade pulls the paper away, revealing the GNARLY SYMBOL embla-
zoned on her ankle.

 41
 JADE (CONT, OS)
 I'm bad to the bone.

WIDE—As Jade tosses the paper in the wastebasket and picks up her back-
pack . . .

ECU—. . . WE SEE the INK in her tattoo MAGICALLY "ETCH" into her skin!

INT. FISH CANNERY (DARK HAND LAIR)—DAY—LATER
CLOSE—VALMONT looks in a MIRROR, unhappily. SHENDU's SPIRIT face
is superimposed over his.

 42
 VALMONT
 I will put up with a lot, Shendu . . .

PULL BACK TO REVEAL—Valmont wears an ostentatious CHINESE CEREMO-
NIAL ROBE.

 43
 VALMONT (CONT)
 . . . but I DRAW THE LINE at wearing a
 DRESS!

VALMONT—turns away from the mirror, his eyes GLOWING BRIGHT RED as he "argues with himself."

 44
 SHENDU
 THIS is a SORCERER'S ROBE!

Just then, the three Enforcers sheepishly enter in b.g.

CLOSER ON THEM—as they REACT, then awkwardly backpedal.

 45 A/45B/45C
 FINN / RATSO / CHOW
 Whoa, Shendu-dette. / Uhh...pretty
 dress! / Very becoming.

The Enforcers lean back in fear as Valmont ENTERS frame and stares them down, RED EYES bulging with rage.

 46
 SHENDU
 <ANIMAL GROWL> WHERE is my Archive?!

Fearful and defensive, they are quick to answer:

 47
 RATSO
 Uhh, Chan's got it?

 48
 CHOW
 But it wasn't our fault!

 49
 FINN
 That's right, the SHADOWKHAN were
 there, too!

CLOSER—Finn cringes as Valmont gets in his face.

 50
 SHENDU
 The Shadowkhan are puppets in my
 command: are you
 suggesting this is MY fault?!

Terrified Finn violently shakes his head.

 51
 FINN
 <pathetic "huhn-uh!">

 52
 SHENDU
 Then redeem yourselves! No doubt Chan
 has brought my book to his Uncle's
 shop.

Finn and Chow look worried as Ratso complains.

 53
 RATSO
 But every time we go there...we get
 our butts kicked!

They react to an o.s. door opening.

DRAMATIC ANGLE—HAK FOO ominously enters, boasting.

54
HAK FOO
You have never been there . . . with ME.

EXT. JADE'S SCHOOL—PLAYGROUND—DAY—SHORT WHILE LATER
At RECESS, JADE proudly/casually shows off the TATTOO on her ankle
to the same amazed group of KIDS (and DREW).

55
KIDS
<Awesome!, Cool!, It's even gnarlier
than DREW'S tattoo!>

56
JADE
And I didn't scream once while they
were doing it.

DREW—leans in close to scrutinize Jade's tattoo . . .

57
DREW
<tsk>, that looks about as real as
those "magic ninjas" Jade's always
talking about.

INCLUDE JADE—overly defensive, outraged:

58
JADE
The ninjas ARE real, and so's my
tattoo!
(notices o.s.)
Unlike YOURS.

FAVOR DREW—looking defensive as the kids suddenly look at his arm—
where there is no longer a tattoo.

59
KIDS
<Hey, where's YOUR tattoo? / Where'd
it go? / etc.>

Drew, sheepish at first, deflects the attention toward Jade.

60
DREW
Uhh . . . I thought you knew. They peel
right off—like *this*!

JADE—reacts as Drew lunges and grabs her foot, starts vigorously
RUBBING her ankle. STRUGGLING:

61
JADE
Hey! Whatchit, Drew! Cut it out!

FAVOR DREW—looking on in surprise as:

62
DREW
Whoa . . .

FAVOR ANKLE—the tattoo remains.

JADE—surprised, covers—though clearly concerned.

 63
 JADE
 Uhhh, TOLD you it was real.

INT. JADE'S SCHOOL—BATHROOM—SECONDS LATER
JADE—vigourously <SCRUBS> her ankle, with her BARE FOOT in a sink full
of SUDS.
 64
 JADE
 C'mon, off! Off! OFF!!

CLOSE—Jade's HAND wipes away the SUDS . . . and her DRAGON SKULL tattoo
is still there, staring at CAMERA.

ANGLE—Jade, looking worried. Flat:
 65
 JADE
 I'm in trouble.

EXT. ESTAB. / INT. UNCLE'S SHOP—LIBRARY—EVENING
ON THE DOORWAY—As Jackie, Uncle, and Tohru quietly research the
ARCHIVE, we hear the <JINGLE> of the front door and Jade <CLUMP,
CLUMPS> by the doorway, wearing BIG OVERSIZED SKI BOOTS.
 66
 JADE
 Hey.

Jackie looks up in confusion as the <CLUMPING> continues.

INT. UNCLE'S SHOP—CONT.
ANGLE—Jackie steps out of library to find Jade sitting in an ANTIQUE
CHAIR doing her HOMEWORK, still wearing the SKI BOOTS. He mugs at
her in bewilderment.
 67
 JACKIE
 Jaaaade, why are you wearing ski
 boots?

Jade shrugs, trying to play it casual.
 68
 JADE
 Heard it might snow?

CLOSER—Jackie crouches beside Jade and pulls off the boots, and Jade
mugs in panic and points o.s.
 69
 JACKIE
 It's 72 degrees out—
 70
 JADE
 Avalanche!

Jackie turns to look and Jade quickly THRUSTS her tattooed foot
inside her BACKPACK. When Jackie turns back to face her, Jade
smiles hopefully.
 71
 JADE (CONT)
 <heh> False alarm . . .

But Jackie leers at her in suspicion, pulls away the backpack, and mugs in horror as he sees her ankle.

 72
 JACKIE
 <GASP!> (sternly) Jade, wash this
 off, *right now.*
 73
 JADE
 (sheepish)
 Err, tried that.
 74
 JACKIE
 WHAT?! It's a REAL tattoo??!!
 75
 JADE
 By accident!

As Jackie FREAKS, Uncle emerges from the library, interest piqued.

 76
 UNCLE
 How can you get a tattoo by
 accid—<GASP!>

Uncle DOUBLE-TAKES at . . .

SMASH ZOOM—. . . Jade's DRAGON SKULL tattoo and . . .

UNCLE—rears back with a HORRIFIED TAKE, holding his hand before himself in protective stance (see #106).

 77
 UNCLE
 <horror gasp>

INT. UNCLE'S SHOP—LIBRARY—MOMENTS LATER
CLOSE ON—Jade's ANKLE and the ARCHIVE, side by side and bearing the same EERIE SYMBOL.

 78
 UNCLE (OS)
 This is a symbol of GREAT EVIL!!

PULL BACK TO REVEAL—Jackie and Tohru looking on with concern as Uncle explains and Jade winces sheepishly.

 79
 JACKIE
 I *thought* it looked familiar.
 80
 UNCLE
 We must find a SPELL to remove it IMME-
 DIATELY! Who KNOWS what CATASTROPHE
 such a tattoo will bring?!

They REACT to the o.s. <JINGLE> of the door.

INT. UNCLE'S SHOP—MAIN ROOM—CONT.
UNCLE AND JACKIE—look out of the library door to see . . .

FINN, RATSO, AND CHOW—standing in the front door, tough.
<div align="center">

81

RATSO
</div>

 Hand over the—

But before Ratso can finish, HAK FOO LEAPS over their shoulders and
SAILS past CAMERA.
<div align="center">

82

HAK FOO
</div>

 <crazed kung-fu scream>

The Enforcers exchange impressed shrugs and run after him.
<div align="center">

83 A/83B/83C

FINN / RATSO / CHOW
</div>

 <battle yells>

QUICK SHOTS:
 > INT. LIBRARY, OTS ARCHIVE—Hak Foo LUNGES for the ARCHIVE,
but it is WHISKED out of frame before he can grab it. Enraged,
Hak Foo turns to see . . .
 > JACKIE—holding the ARCHIVE. As Hak Foo LEAPS into frame
ATTACKING, Jackie yanks a METAL TRAY out from under a NEARBY ANTIQUE
TEA SET (which stays in place) and uses it as a SHIELD to fend off
Hak's KUNG-FU FURY while keeping the ARCHIVE safe in his other hand.
But with each blow <GONG!, GONG!, GONG!>, the tray BENDS a little
more.
<div align="center">

84

HAK FOO
</div>

 MAD MONKEY KUNG FU!!
 MANTIS BOXING STYLE!!
 RABBIT PUNCH!!

JADE—watches with concern as . . .

TOHRU—moves to grab Hak, but Finn and Chow LEAP onto Tohru's massive
frame and try to bring him down with WRESTLING HOLDS.
<div align="center">

85 A/85B/85C

FINN / CHOW / TOHRU
</div>

 <battle cries, strain>

And then Uncle rushes into frame and comedically <WHACKS>
them with his BROOM.
<div align="center">

86

UNCLE
</div>

 <kung-fu screams>

ON JACKIE—With another BLOW from Hak Foo, the TRAY is bent com-
pletely around Jackie's arm. Hak Foo goes to HEAD BUTT
Jackie, who reflexively/defensive raises his "metal arm" . . .
<div align="center">

87

HAK FOO
</div>

 RHINO CHARGE—<GUH!>

. . .Hak accidently smacking his own forehead, <KLANG>. As Hak goes
down, Ratso KICKS Jackie from behind and the ARCHIVE goes flying.

88
JACKIE
<OOF!>

JADE—catches the comparatively oversized book, almost knocking her over.

89
JADE
I got it! <oof!> <BAA!>

But an ANGRY HAK FOO lands on all fours beside her. As he LUNGES at her, Jade FREAKS and DASHES o.s.

EXT. UNCLE'S SHOP—NIGHT—CONT.
LOW ANGLE—JADE runs out of the shop carrying the book, Hak Foo FLIES out the door after her.

90
HAK FOO
LION STALKS ITS PREY!

EXT. CHINATOWN STREETS—NIGHT, CONT.
TRACK JADE—running down the sidewalk as Hak Foo uses a series of ACROBATIC MOVES to catch up to her.

91
HAK FOO
RUN LIKE CHEETAH...LEAP LIKE GAZELLE!!

ANGLE—But just as Hak DIVES to catch her, Jade ducks through a narrow opening in a stucco wall, winding up in...

EXT. DARK ALLEY—CONT.
JADE—squeezes through, barely getting the book through, and takes in panic.

92
JADE
Uh-oh...

REVEAL—She's in a dead end alley: nowhere to run. She turns to see...

ANGLE—Hak Foo KICKS THROUGH the too-narrow opening, shattering the stucco. Sinister:

93
HAK FOO
Black Tiger Enters Warren.

HAK FOO stalks toward CAMERA, grinning ominously.

TRACK JADE—backing away in fear; she calls out for...

94
JADE
HELP! Jackie?! *Anybody*?!

SMASH ZOOM—...her ankle tattoo <GLOWS OMINOUSLY> and...

ON JADE—...COUNTLESS SHADOWKHAN step out of the darkness all around her. Jade sees them and FREEZES in fear.

95
JADE
<terrified gasp> *Shadowkhan*.

Then as Hak Foo and the Shadowkhan close in, she DUCKS into a ball, covers her head with the ARCHIVE, and closes her eyes.

 96
 JADE
 <quivers with terror> Oh no . . .

ANGLE—but just as Hak Foo antics to attack . . .

 97
 HAK FOO
 <kung-fu scream>—<huh?!>

. . . the SHADOWKHAN attack HIM instead!

VARIOUS QUICK SHOTS—As the Shadowkhan attack a bewildered Hak Foo.

 98
 HAK FOO
 <OOF!, UGH!, REE!, GAK!>

HIGH ANGLE—A tattered and terrified Hak Foo flees scene . . .

 99
 HAK FOO
 <kung-fu fleeing scream>

PUSH IN SLOW—The SHADOWKHAN melt back into the darkness, leaving only . . . JADE, still curled into a ball with her eyes closed. As the last Shadowkhan disappears, the <OMINOUS GLOW> of Jade's tattoo FADES away. Jade cautiously opens her eyes, and then looks around in bewilderment . . .

 100
 JADE
 I'm . . . still alive?

. . . then down at the book still in her hands. With a shiver:

 101
 JADE
 Weirrrrrd.

ECU ON TATTOO—PUSH IN, until the black of the figure FILLS CAMERA, wiping screen TO BLACK.

 END ACT ONE

ACT TWO

<u>INT. FISH CANNERY—NIGHT—A SHORT WHILE LATER</u>
HAK FOO—is wrapped in a comical number of BANDAGES, QUIVERING with
enraged embarrassment as he insists:
<div align="center">102</div>
<div align="center">HAK FOO</div>
> I am TELLING you: it was the SHADOWKHAN
> who did this to me!

VALMONT—looks on as FINN and CHOW smirk at Foo.
<div align="center">103</div>
<div align="center">FINN</div>
> Chan kicked OUR butts, too.
<div align="center">104</div>
<div align="center">CHOW</div>
> Yeah, you don't hear US lying about
> it.

VALMONT—scowls, his eyes GLOWING RED.
<div align="center">105</div>
<div align="center">SHENDU</div>
> Need I remind you: the Shadowkhan do
> ONLY what I command. Come, minions.
> . .

With that, Shendu spreads his arms with flourish as if to summon the
Shadowkhan. But nothing happens. He looks from side to side, dis-
concerted, and then tries his gesture again.
<div align="center">106</div>
<div align="center">SHENDU (CONT)</div>
> *Minions*?

Valmont waits for a beat . . . but nothing happens.

THE ENFORCERS—mug in shock.

VALMONT—the red eyes fade off revealing a SMIRKING
Valmont:
<div align="center">107</div>
<div align="center">VALMONT</div>
> It would seem you have lost
> your touch, Shendu.

The eyes GO RED again, and SHENDU rails at the Enforcers.
<div align="center">108</div>
<div align="center">SHENDU</div>
> I have NOT lost my touch! Chan
> is OBVIOUSLY using the POWER of
> my ARCHIVE against me!

CLOSE—On Valmont's RED GLOWING EYES, smoldering with rage.
<div align="center">109</div>
<div align="center">SHENDU (CONT)</div>
> So I don't care HOW you do it, but
> GET! MY! BOOK!

THE ENFORCERS—nod and raise eyebrows as their collective mental
wheels start turning.

INT. SECTION 13—JACKIE'S KWOON—MORNING
JADE'S POV—BLACKNESS.

110
JACKIE (OS)
Jade . . .!? Jade!

The blackness SPLITS HORIZONTALLY as Jade opens her eyelids, reveal-
ing Jackie looking down at her.

111
JACKIE (CONT)
Wake up, you're going to be late!

JADE—wearing PAJAMAS and sporting a comical case of BEDHEAD, sits
up in BED, stretching and yawning in a groggy fog as Jackie exits
in b.g.

112
JADE <B-TRACK>
<yawns, sleep smacks>

113
JACKIE
I am going to Uncle's to help him find
a "tattoo-removing" spell, so I will
see you there after school. And don't
forget to eat breakfast.

As Jackie walks out the FRONT DOOR, sleepy Jade glances at the CLOCK
beside her bed and mugs in sudden panic.

114
JADE
<gasp!> I WAY overslept!

INT. SECTION 13—JACKIE'S KWOON—BATHROOM—MOMENTS LATER.
A FULL-LENGTH MIRROR—is mounted on the wall beside the BATHROOM
SINK. JADE'S IMAGE is reflected in the mirror as she RUSHES to the
sink in panic and quickly puts TOOTHPASTE on her HAIRBRUSH.
She sarcastically rolls her eyes:

115
JADE
(sarcastic)
I WISH I had time for breakfast.

Jade is just about to run the toothpasty brush through her hair
when she DOUBLE-TAKES at it. And as she does, her image in the
mirror TRANSFORMS into a SHADOWKHAN. Jade sees the ninja and DOUBLE-
TAKES again, FREAKING OUT.

116
JADE
<BAAAAH!>

JADE—stumbles backwards against the wall and holds the brush out
like a weapon.

117
JADE (CONT)
GET OUTTA MY—

OTS JADE—The Shadowkhan steps THROUGH THE MIRROR carrying a FOOD
TRAY filled with BREAKFAST FOODS, clearly offering it to her.

JADE—stands frozen in total bewilderment, until she spots something
o.s and takes in amazement.

<div align="center">118

JADE (CONT)</div>

 —breakfast?! <gasp!>

IN THE MIRROR—Jade sees that her TATTOO is GLOWING with <OMINOUS
ENERGY>.

<div align="center">119

JADE (CONT)</div>

 The tattoo...

ANGLE—Jade steps closer, eyeing the ninja suspiciously.

<div align="center">120

JADE</div>

 Stand on one foot.

And the tray-toting Shadowkhan obediently lifts a foot off the
ground. Jade suspiciously tries another command.

<div align="center">121

JADE (CONT)</div>

 Hop up and down.

<CLINK, CLINK, CLINK> The dishes on the tray bounce as the Shad-
owkhan complies.

CLOSE—Jade turns away, wheels turning with wide-eyed realization as
the Shadowkhan <CLINK, CLINK> continues hopping in b.g. behind her,
then turns back to the ninja—still <CLINK> hopping.

<div align="center">122

JADE</div>

 THAT'S what happened last night. I
 called for help...and YOU guys came!

INT. SECTION 13—JACKIE'S KWOON—SECONDS LATER
JADE—sits at a TABLE happily eating her breakfast, surrounded by
SHADOWKHAN servants: brushing her hair, loading her BACKPACK with
BOOKS for school, refilling her ORANGE JUICE, etc.

<div align="center">123

JADE</div>

 <smacks> Now this has to be our
 secret: if Jackie won't let me have a
 tattoo, there's no WAY he'd let me
 have my own ninjas. <gulp, AHHHH>

Jade takes a final bite of breakfast and as soon as she swallows, a
Shadowkhan starts brushing her teeth while two more clear the dishes.

ANGLE—With her hair and teeth still being brushed by two ninjas,
Jade walks over to her DRESSER where another Shadowkhan picks out
her CLOTHES (all BLACK, of course).

<div align="center">124

JADE

(mouthful of tooth-
paste)</div>

 Mm, tres chique. <GASP!>

Jade TAKES and the Shadowkhan eyes WIDEN as...

THE FRONT DOOR—opens and JACKIE steps into the room and grabs his wallet off his DESK.

<div align="center">125
JACKIE</div>

Forgot my wallet. Are you ready for?

But he mugs in surprise as he sees . . .

JADE—fully dressed (in BLACK) with her BACKPACK on and a SACK LUNCH in hand, smiling: there is not a NINJA in sight.

<div align="center">126
JADE</div>

Under control.

JACKIE—looks at Jade in confusion.

<div align="center">127
JACKIE</div>

Why are you wearing black?

<div align="center">128
JADE</div>

<div align="center">(shrugs)</div>

In a dark mood.

JACKIE—shrugs. As he turns and EXITS, PAN UP TO REVEAL the Shadowkhan, clinging to the ceiling above.

JADE—looks up at the ninjas on her ceiling, WINKS.

EXT. JADE'S SCHOOL—PLAYGROUND—MORNING, LATER
ANGLE—DREW and the same GROUP OF KIDS from before sit on the BLEACHERS. JADE struts confidently up to them.

<div align="center">129
JADE</div>

Get ready, guys. Time to PROVE my "magic ninjas" are for real.

But DREW cracks wise and the kids all burst into laughter.

<div align="center">130
DREW</div>

Oh yeah? Being dumb enough to get a real TATTOO is one thing, but NINJAS?!

<div align="center">131
KIDS</div>

<laughter>

PUSH IN—Jade SCOWLS with sudden rage.

<div align="center">132
JADE</div>

Let me *show* you . . .

JADE'S POV, TUNNEL VISION—As DREW keeps laughing, sinister Shadowkhan EYES AND FACES appear in the darkness under the BLEACHERS behind him. As they approach, BLUE HANDS reaching out from underneath to grab him . . .

<div align="center">133 A/133B
DREW / KIDS (ECHO FX)</div>

ON JADE—. . . the <BELL> rings, and Jade snaps out it.

 134
 JADE
 <woozy moan>

ANGLE—The Shadowkhan quickly sink back under the bleachers, disappearing into the shadows without anyone seeing them. The gang disburses, and Drew heads for class, still chuckling as he passes Jade.

 135
 DREW
 <heh, heh> Later, Ninja Girl!

EXT. UNCLE'S SHOP—THAT AFTERNOON
ON UNCLE'S SHOP—Finn steps into frame in extreme f.g. and speaks into a VID-PHONE.

 136
 FINN
 Finn to Ratso: I'm in position . . .

Then he pinches a MONOCLE in his eye and puts on a BIG FAKE BEARD.

INT. UNCLE'S SHOP—CONT.
ON THE FRONT DOOR—<JINGLE> Finn steps through the door in a fairly convincing "RICH GUY" DISGUISE (the aforementioned BEARD and MONOCLE, along with a FAT PAD, TUXEDO and TOP HAT).

 137
 UNCLE (OS)
 Too busy! Come back later!
 138
 FINN
 (bad, fake accent)
 But I am a WEALTHY ART COLLECTOR.

ANGLE—Uncle's head pokes out of the library as in f.g., RACK FOCUS to a WAD OF BILLS which Finn fans in his hand. Uncle ZIPS out, very attentive and all smiles.

 139
 UNCLE
 Welcome to Uncle's Rare Finds!
 (screams o.s.)
 Jackie! Tohru! TEA!!!

Jackie and Tohru EXIT the library into the main room as Uncle continues, sweetly:

 140
 UNCLE
 Were you looking for something in particular?

INT. UNCLE'S SHOP—LIBRARY—CONT.
POV LOOKING OUT THROUGH THE LIBRARY DOORWAY—Uncle leads "Rich Guy" Finn o.s. into the main room; Jackie and Tohru hurry towards them with a TEAPOT and CUPS, passing thru FRAME and o.s.

141

FINN (PARTIAL OS)
(fake accent)
Just some PRICELESS ARTIFACTS for the
MANY, MANY MUSEUMS I own . . .

REVERSE—The FLOORBOARDS of the library floor lift up . . . and HAK FOO, RATSO, and CHOW cautiously emerge from a TUNNEL in the foundation, wearing MINER'S HATS and carrying SHOVELS.

THE ARCHIVE—sits among COUNTLESS OPEN BOOKS and NOTEPADS on Uncle's DESK. Chow's HANDS enter frame and grab it.

PREVIOUS—Chow descends into the tunnel with the ARCHIVE as Hak Foo lowers the FLOORBOARDS and Ratso gives a big "A-OK" sign and OVER-EMPHATIC WINK o.s. to . . .

INT. UNCLE'S SHOP—CONT.
DISGUISED FINN—who has inched his way back within eyeshot of the library. He WINKS in return and <PLING!> pinches his MONOCLE out of his eye like a flipped coin. Finn mugs in a split-second of panic . . .

142
UNCLE (PARTIAL OS)
. . . this one dates back to the Han
Dynasty. It is a VERY GOOD piece—

ANGLE—. . . but he quickly SNATCHES the SPINNING MONOCLE from the air and plants it back on his eye as Uncle continues a sales pitch about a VASE and Jackie and Tohru stand by.

143
FINN
(fake accent)
Er— I'll let you know!

And he hurries out the door, leaving Uncle, Jackie and Tohru bewildered. Uncle turns <THWAPS> Jackie and Tohru.

144 A/144B
JACKIE / TOHRU

<Ow!>

145
UNCLE
You are both very bad salesmen!!

EXT. CITY STREET—CONT.
TRACK JADE—walking down the street with her BACKPACK on [looking a bit on the PALE side now].

146
JADE
Having ninja tutors is gonna make
homework WAY more fun.

Just then, she passes an ALLEY where Hak Foo, Ratso, and Chow climb out of a HOLE IN THE GROUND with the ARCHIVE before disguised Finn and their SEDAN. Jade stops in her tracks.

INT. ALLEY—CONT.
FINN—sheds his disguise.

 147
 FINN
 Can you BELIEVE they bought my disguise!?
 148 A/148B
 RATSO / CHOW
 <laughing> What a plan! / We're
 GENIUSES!

But the Enforcers freeze as they spot o.s. Jade and see...

ZOOM TO JADE—scowling at them in rage, flanked by ninjas.
 149
 JADE
 Give 'em a spanking!

An ARMY OF SHADOWKHAN RACES past her.

ANGLE—The Enforcers try to run...
 150
 ENFORCERS
 Uh-oh. / <AAAH!> / No!!

...but the dark army of ninjas SPRINGS in, ATTACKING.

INT. UNCLE'S SHOP—LIBRARY—CONT.
ANGLE—Uncle leads Jackie and Tohru back into the library, still com-
plaining.
 151
 UNCLE
 You were TOO SLOW with the TEA! Good
 salesmen must always—<AAIYAA!>

Uncle mugs in horror as he POINTS at his EMPTY DESK.
 152
 UNCLE (CONT)
 WHERE IS THE ARCHIVE?!

Just then, <CRACK> the FLOORBOARDS give way under TOHRU'S weight
and he drops into the TUNNEL, up to his waist.
 153
 TOHRU
 <whoa!> <oomph!>

Tohru mugs in surprise while Jackie and Uncle take in shock.
 154 A/154B
 JACKIE / UNCLE
 <gasp!>

EXT. ALLEY—CONT.
VARIOUS QUICK SHOTS—As the ENFORCERS get a KUNG-FU BUTT-WHUPPING
from the ruthless SHADOWKHAN and the ninjas take back the ARCHIVE.
 155 A/155B/155C
 FINN / RATSO / HAK FOO
 <Oof!> / <Ugh!> / <AAA!!>

<div align="center">156</div>
<div align="center">CHOW</div>

The BOOK!!

ON THE TUNNEL—Jackie and Uncle emerge from the tunnel and take in shock as they see . . .

<div align="center">157</div>
<div align="center">JACKIE</div>

Jade . . .?!

At the center of the ATTACKING SHADOWKHAN—JADE stands with her arms outstretched, clearly controlling them like a puppeteer. <GHOSTLY WIND> blows through her hair (think *Firestarter*) and her skin has turned even MORE PALE.

CLOSER—stunned JACKIE rushes into frame and GRABS Jade, once again snapping her out of her trance.

<div align="center">158 A/158B</div>
<div align="center">JACKIE / JADE</div>

JADE!! / <huh?>

FOUR-WAY SPLIT-SCREEN—The SHADOWKHAN suddenly PAUSE in mid-attack, allowing the four Enforcers to SCRAMBLE o.s.

<div align="center">159 A/159B</div>
<div align="center">FINN / RATSO</div>

RUN!!

ANGLE—As the frightened thugs PILE into their SEDAN and <SCREECH> away in b.g., a stern Jackie grills Jade.

<div align="center">160</div>
<div align="center">JACKIE</div>

JADE?! What in the WORLD is going—

But as he starts to lecture, the menacing Shadowkhan close in around him. Jade holds up a hand, and the ninjas stop.

<div align="center">161</div>
<div align="center">JADE</div>

It's okay . . . he's one of us.

Jackie looks at the Shadowkhan around him in apprehension, then exchanges a worried glance with a VERY SHOCKED Uncle.

INT. FISH CANNERY—NIGHT—SHORT WHILE LATER
CLOSE—Valmont widens his GLOWING RED EYES in surprise as the TATTERED ENFORCERS rail at him for a change.

<div align="center">162</div>
<div align="center">CHOW</div>

You want the book?! GET IT YOURSELF!!

<div align="center">163</div>
<div align="center">RATSO</div>

No WAY are we fightin' those NINJAS again!!

<div align="center">164</div>
<div align="center">FINN</div>

Yeah, how could you lose the SHADOWKHAN—to a LITTLE GIRL?!!

Hearing this, Valmont raises an eyebrow, intrigued.

 165
 SHENDU
The CHILD controls my army?

ANGLE—Valmont turns away from the Enforcers, grinning with cryptic anticipation.

 166
 SHENDU (CONT)
In that case: we need only wait, and
allow matters to take their course...
 DISSOLVE TO:

<u>EXT. ESTAB. / INT. UNCLE'S SHOP—LIBRARY—MOMENTS LATER</u>
UNCLE—shaking his head with dread, urgently scours the ARCHIVE and other MAGIC BOOKS with Tohru. We hear the sounds of "sparring" footsteps coming from the main room.

 167
 UNCLE
This is verrry bad...

<u>INT. UNCLE'S SHOP—MAIN ROOM—CONT.</u>
TWO SHADOWKHAN—spar inside the shop...

PULL BACK TO OTS JADE—she practices controlling them like a puppeteer, with HAND MOVEMENTS that mimic their moves, as Jackie watches, warily (i.e., we don't see Jade's face).

 168
 JADE
Aaand...BACK FLIP!

The ninjas perform a perfectly executed backflip.

 169
 JADE
See, Jackie? *Total control*! They do
what I tell 'em, and I only tell 'em
to do good!

ON JACKIE—looking on in disbelief as...

 170
 JADE (OS)
So can I keep 'em?
 171
 JACKIE
No, Jade.

REVEAL JADE—lounging in a BIG ORNATE ANTIQUE CHAIR as if it were a throne—her face now colored SHADOWKHAN BLUE!

 172
 JADE
Awww, why not?

WIDEN as Jackie enters, flustered.

 173
 JACKIE (CONT)
Because YOU'RE turning BLUE.

```
                        174
                        JADE
                     (shrugs)
          Blue's my favorite color.  Besides, we
          gave TOHRU a chance.
                        175
                       JACKIE
          Tohru is HUMAN.
```

ANGLE—Jackie sternly gives scowling Jade an order as he gestures to
the two ninjas in b.g.

```
                        176
                    JACKIE (CONT)
          Now I want you to make them go away
          until Uncle can find a—
                        177
                     UNCLE (OS)
          Hot Cha!
```

UNCLE—emerges from the library waving an OPEN ANCIENT BOOK in the
air, pointing at the PAGES.

```
                        178
                    UNCLE (CONT)
          I have found a POTION that will make
          Jade's tattoo vanish!
```

ANGLE—Jackie turns to the protesting Jade as Uncle and Tohru quickly
pour LIQUIDS and POWDERS from different VIALS into a POT in b.g.

```
                        179
                        JADE
          But I LIKE my TATTOO!!  You can't DO
          THIS to me!!
                        180
                       JACKIE
          It's for your own safety, Jade.
```

OTS JADE'S TATTOO—Uncle pulls a BRUSH from the POT, dripping with
PURPLE POTION. As he moves the dripping brush toward her BLUE-
SKINNED ankle with its EVIL TATTOO . . .

```
                        181
                       UNCLE
          Now sit still and—
```

JADE—hisses like an angry cat and . . .

```
                        182
                        JADE
            <hiss>
```

PREVIOUS—. . . <SHWING!> a SWORD BLADE flashes through frame and cuts
off the end of the brush as Uncle takes in shock.

```
                        183
                       UNCLE
            <GASP!>
```

JADE—speaks in an UNEARTHLY VOICE as the Shadowkhan beside her bran-
dishes his SWORD.

184
JADE (UNEARTHLY FX)
Do not touch me! I AM, and shall
remain, QUEEN of the SHADOWKHAN!

ANGLE—Jackie, Uncle, and Tohru look around in fear as SHADOWKHAN
step menacingly out of the shadows all around them, and surround
them with menace.

END ACT TWO

ACT THREE

INT. UNCLE'S SHOP—NIGHT—CONT.
REESTABLISH—As the Shadowkhan close in around them, panicked Jackie
makes a last ditch effort to control Jade.

185
JACKIE
Jade! <sputters> You're GROUNDED!

OTS HEROES—BLACK-GARBED, BLUE-SKINNED SHADOWQUEEN JADE backs away,
flanked by several SHADOWKHAN GUARDS.

186
JADE (UNEARTHLY FX)
<T'ch!> YOU'RE not giving me orders
anymore!

With a HAND MOTION from Jade, the Shadowkhan UNFURL their "batwing"
CAPES and close in around her.

CROSS-CUT—with Jackie, Uncle and Tohru's REACTIONS as . . .

. . . Jade and the Shadowkhan disappear into the shadows!

ON JADE'S ANTIQUE CHAIR "THRONE"—TWO SHADOWKHAN grab the chair,
throw down SMOKEBOMBS, and disappear with it.

INT. UNCLE'S SHOP—LIBRARY—CONT.
ON THE ARCHIVE—Jackie, Uncle, and Tohru watch through the doorway
as a SHADOWKHAN grabs the book and disappears.

INT. UNCLE'S SHOP—CONT.
JACKIE—galvanizes, quickly pours the POTION into a GLASS VIAL.

187
JACKIE
I must find her!

WIDE—Jackie dashes out the front door, urgent and worried.

INT. SECTION 13—MAIN AREA—MOMENTS LATER
EST. the vast interior of the top-secret underground agency.

CAPTAIN BLACK—reviews data on COMPUTER SCREENS with a few of his
AGENTS when suddenly . . . PULL BACK FAST TO OTS JADE as <STING!> she
STARTLES Black and the agents.

188
BLACK
Run a background check and— <Whoa!>
Jade, you—

JACKIE CHAN ADVENTURES

EPS 206 ACT 3

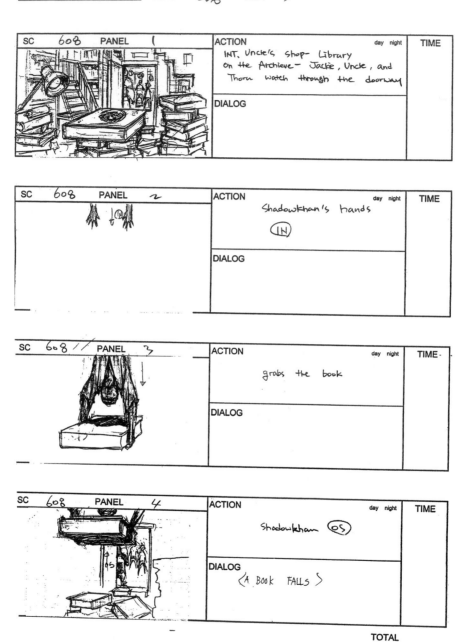

SC 608 PANEL 1	ACTION	day night	TIME
	INT. Uncle's shop- Library On the Atchieve- Jackie, Uncle, and Thorn watch through the doorway		
	DIALOG		

SC 608 PANEL 2	ACTION	day night	TIME
	Shadowkhan's hands (IN)		
	DIALOG		

SC 608 // PANEL 3	ACTION	day night	TIME
	grabs the book		
	DIALOG		

SC 608 PANEL 4	ACTION	day night	TIME
	Shadowkhan (OS)		
	DIALOG <A BOOK FALLS>		

TOTAL

Figure 14.1 *Jackie Chan Adventures*, "Queen of the Shadowkhan," written by David Slack, storyboard by Seung Eun Kim. *Jackie Chan Adventures* © 2003 Sony Pictures Television Inc.

JACKIE CHAN ADVENTURES EPS 206 ACT 3

SC 608 PANEL 5	ACTION	day night	TIME
	DIALOG		

SC 609 PANEL 1	ACTION Jackie galvanizes	day night	TIME
	DIALOG		

SC 609 PANEL 2	ACTION	day night	TIME

TART → PAN

SC 609 PANEL 3	ACTION	day night	TIME

TART — STOP (187) JACKIE "I MUST···" TOTAL

©2001 ADELAIDE PRODUCTIONS, INC.

Figure 14.1 *Continued*

Black DOUBLE-TAKES at Jade in disbelief.
 189
 BLACK (CONT)
 What happened to YOU?!

SHADOWQUEEN JADE—smiles at Black, sinister, as SHADOWKHAN appear all
around her.
 190
 JADE (UNEARTHLY FX)
 I've become Queen . . .

BLACK AND THE AGENTS—take in shock as the SHADOWKHAN engulf them.
 191 A/191B
 BLACK / AGENTS
 <GASP!>

 192
 JADE (UNEARTHLY FX)
 . . .and every Queen needs a PALACE.

EXT. CITY STREETS—NIGHT, MOMENTS LATER
ANGLE—Jackie runs toward CAMERA, searching the streets . . .
 193
 JACKIE
 Jade! Jaaaaade!

. . .as he reaches f.g., his <CELL PHONE RINGS> and he stops to
answer. Hopefully:
 194
 JACKIE
 Jade?
 195
 BLACK <OS,PHONE FILTER>
 Black. Jade's gone ninja . . .

INT. SECTION 13—PRISON CELL (REUSE #113)—CONT.
ON CELL—BLACK is locked behind bars with many agents.
 196
 BLACK (CONT)
 . . .and they've taken Section 13.

EXT. CITY STREET—CONT.
CLOSE ON JACKIE—with sober determination, into his cell:
 197
 JACKIE
 I am on my way.
 198
 BLACK <OS PHONE FILTER>
 Proceed with caution, Jackie: the
 place is CRAWLING with 'em.

This gives Jackie pause; a thoughtful look crosses his face.

JACKIE CHAN ADVENTURES EPS 206 ACT 3

SC 615 PANEL 1	ACTION	day night	TIME
	DIALOG		

SC 616 PANEL 1	ACTION day night	TIME
	Black and the agents — take in shock as the Shadowkhan engulf them	
	DIALOG (191.A) (191.B) BLACK / AGENTS <GASP!>	

SC 617 PANEL 1	ACTION day night	TIME
	DIALOG (192) JADE "...AND EVERY QUEEN NEEDS A PALACE."	

T.I.

SC PANEL	ACTION day night	TIME
	DIALOG	
		TOTAL

Figure 14.2 *Jackie Chan Adventures*, "Queen of the Shadowkhan," written by David Slack, storyboard by Seung Eun Kim. *Jackie Chan Adventures* © 2003 Sony Pictures Television Inc.

 EPS 206 ACT 3

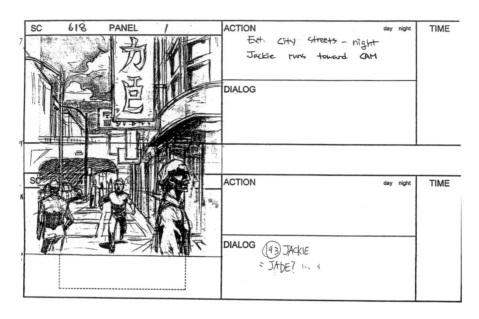

SC 618 PANEL 1	ACTION	day night	TIME
	Ext. City Streets – night Jackie runs toward CAM		
	DIALOG		

SC	ACTION	day night	TIME
	DIALOG (193) JACKIE = JADE?		

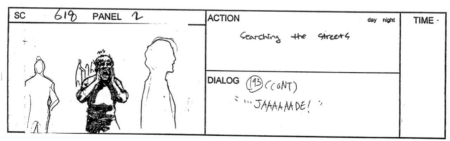

SC 619 PANEL 2	ACTION	day night	TIME
	Searching the streets		
	DIALOG (193)(CONT) = "...JAAAAAADE!"		

SC 618 PANEL 3	ACTION	day night	TIME
	DIALOG <CELPHON RINGS>		

TOTAL

Figure 14.2 *Continued*

 EPS 206 ACT 3

SC 618 PANEL 4	ACTION day night	TIME
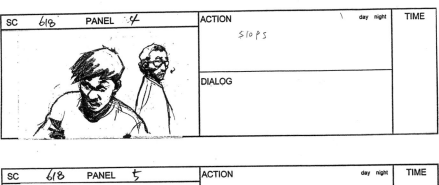	SIOPS	
	DIALOG	

SC 618 PANEL 5	ACTION day night	TIME
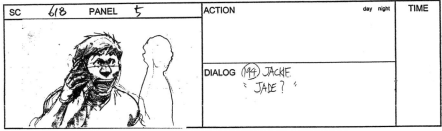	DIALOG (194) JACKIE "JADE?"	

SC 618 PANEL 6	ACTION day night	TIME
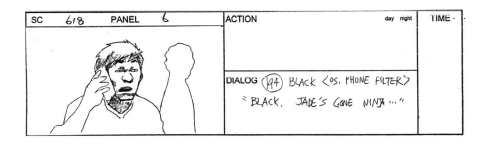	DIALOG (194) BLACK <OS. PHONE FILTER> "BLACK. JADE'S GONE NINJA..."	

SC 619 PANEL 1	ACTION day night	TIME
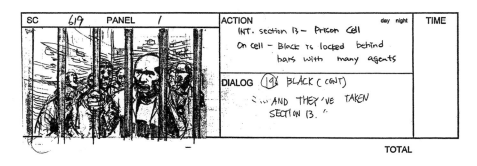	INT. Section 13 - Prison Cell On cell - Black is locked behind bars with many agents	
	DIALOG (194) BLACK (CONT) "...AND THEY'VE TAKEN SECTION 13."	
		TOTAL

Figure 14.2 *Continued*

EPS 206 ACT 3

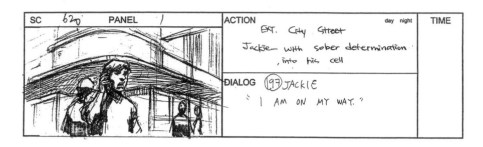

SC 620 PANEL 1	ACTION day night	TIME
	EXT. City Street Jackie with sober determination , into his cell	
	DIALOG ⑲7 JACKIE " I AM ON MY WAY. "	

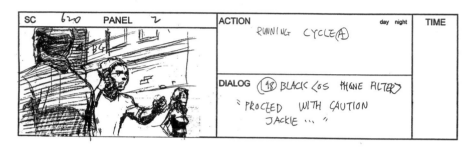

SC 620 PANEL 2	ACTION day night	TIME
	RUNNING CYCLE Ⓐ	
	DIALOG ⑲8 BLACK ‹OS PHONE FILTER› " PROCEED WITH CAUTION JACKIE ... "	

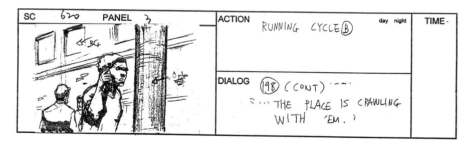

SC 620 PANEL 3	ACTION day night	TIME
	RUNNING CYCLE Ⓑ	
	DIALOG ⑲8 (CONT) THE PLACE IS CRAWLING WITH 'EM. "	

SC 620 PANEL 4	ACTION ① SLOW DOWN TO STOP day night	TIME
	SLOWER BG	
	DIALOG	
		TOTAL

©2001 ADELAIDE PRODUCTIONS. INC.

Figure 14.2 *Continued*

INT. SECTION 13—MAIN AREA—CONT.

EST. the NOW-DARKENED interior of Section 13, as Shadowkhan "redecorate" it with RED CURTAINS and HIDEOUS SCULPTURES.

CLOSER—In the center, Jade sits on her ORNATE "THRONE" from Uncle's, surrounded by SHADOWKHAN SERVANTS. She is reading from the Archive, which rests open on a GILDED PODIUM before her.

 199
 JADE (UNEARTHLY FX)
 (labored pronunciation)
 "Fo . . . Shee . . . Kwong . . . Shoo . . . Wee
 . . ."

CLOSER YET—Jade mugs in frustration which quickly escalates to rage.

 200
 JADE (UNEARTHLY FX)
 <grrr!> How can I know the secrets
 of the Archive if I CAN'T UNDERSTAND
 A SINGLE, STUPID WORD OF IT!!??

OTS A SHADOWKHAN—Jade POINTS a ferocious finger at him.

 201
 JADE (UNEARTHLY FX)
 Bring me someone who can!

INT. FISH CANNERY—SECONDS LATER

TWO SHADOWKHAN—emerge from the darkness . . .

ANGLE—. . . and GRAB VALMONT (still wearing Shendu's ROBE).

 202
 VALMONT
 What?! Ahh! HELP!!

The Enforcers move to stop them, but Valmont holds up a halting hand as his EYES GLOW RED. CALMLY:

 203
 SHENDU
 No. It would seem matters are finally
 taking course . . .

Shendu allows the ninjas to lead him into the darkness.

ON ENFORCERS—Hak Foo, Finn, Ratso, and Chow mug in bewilderment. Beat. Finn shrugs.

 204
 FINN
 Okay by me.

INT. SECTION 13—MAIN AREA—SECONDS LATER

VALMONT emerges from darkness escorted by the TWO SHADOWKHAN; his eyes STOP GLOWING and he looks around in awe.

205
VALMONT
<gasp!> We're in Section 13 . . . the
TALISMANS!

Eyes GLOW RED again and he whispers angrily to himself.
206
SHENDU
Quiet, you fool!

TRACKING—As the Shadowkhan escort him through the "palace" Valmont's
eyes go NORMAL again and he plays persuasive.
207
VALMONT
But all we need do is swing by the
vault.
(sing-song)
This ROBE has plenty of POCKETS, Shendu
. . .

208
JADE (UNEARTHLY FX, OS)
Take the talismans if you desire them
. . .

SHADOWQUEEN JADE—sits on her THRONE before the ARCHIVE.
209
JADE (UNEARTHLY FX)
I am interested in far GREATER powers.

VALMONT—grins in pleasant surprise and prepares to leave.
210
VALMONT
Smashing! I'll just—<strain!>

But suddenly, his face contorts and his eyes close. When he opens
his eyes again—they GLOW RED.
211
SHENDU
I require no talismans, Your Majesty.
I wish only to pay my respects.

ANGLE—As Valmont bows, Shadowqueen Jade looks him over.
212
JADE (UNEARTHLY FX)
Pretty dress.

Valmont looks up at her in GLOW-EYED rage, but Jade pivots the
PODIUM so he can read the ARCHIVE.

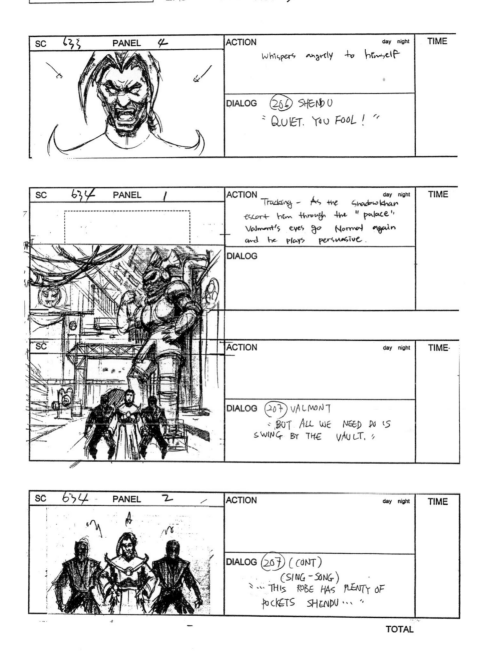

Figure 14.3 Notice the less usual Asian (vertical) format of the *Jackie Chan Adventures* storyboards. *Jackie Chan Adventures*, "Queen of the Shadowkhan," written by David Slack, storyboard by Seung Eun Kim. *Jackie Chan Adventures* © 2003 Sony Pictures Television Inc.

JACKIE CHAN ADVENTURES

EPS 20b ACT 3

X-DISS

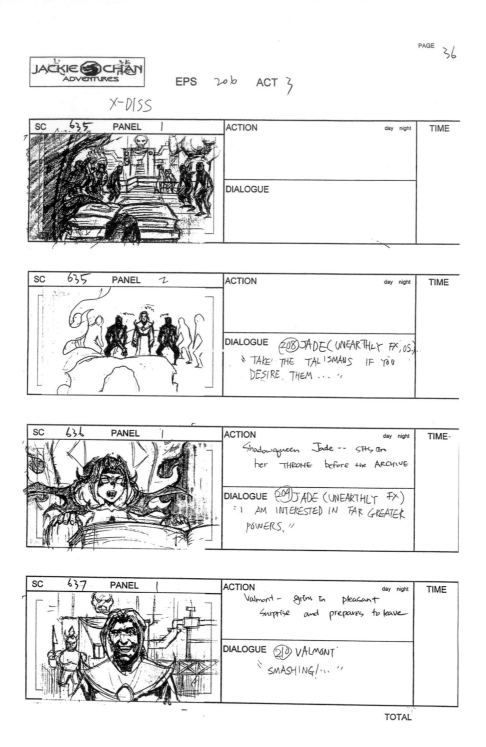

SC 635 PANEL 1	ACTION	day night	TIME
	DIALOGUE		

SC 635 PANEL 2	ACTION	day night	TIME
	DIALOGUE (208) JADE (UNEARTHLY FX, OS.) "TAKE THE TALISMANS IF YOU DESIRE THEM . . . "		

SC 636 PANEL 1	ACTION Shadowqueen Jade -- sits on her THRONE before the ARCHIVE	day night	TIME-
	DIALOGUE (209) JADE (UNEARTHLY FX) "I AM INTERESTED IN FAR GREATER POWERS. "		

SC 637 PANEL 1	ACTION Valmont - grins in pleasant surprise and prepares to leave	day night	TIME
	DIALOGUE (210) VALMONT "SMASHING! . . . "		

TOTAL

©2001 ADELAIDE PRODUCTIONS, INC.

Figure 14.3 *Continued*

213
JADE (UNEARTHLY FX)
Now read me a story, Demon.

Valmont RISES and eagerly REACHES for the book.

214
SHENDU
I would be only too glad to—

But in a flash, SIX SHADOWKHAN appear around him, and <SWISH> lay their SWORDS before Shendu to block his path, as Jade protectively clutches the book.

215
JADE (UNEARTHLY FX)
Read with your EYES, not with your
HANDS!

RED-EYED VALMONT—straightens his robes with a hint of frustration and starts translating.

216
SHENDU
Of course. <Ahem!> "To acquire the
powers of a Demon Sorcerer, one
must . . ."

WHIP TO:

INT. SECTION 13—CORRIDOR—CONT.
ANGLE—As a BATTALION of SHADOWKHAN marches past CAMERA, a LONE SHAD-OWKHAN pokes his head out of hiding and TIPTOES quickly after them.

TRACK THE BATTALION—As the Lone Shadowkhan takes his place at the rear of the procession, the Battalion hits a shadow and MELTS, one row after another, into it. The Lone Shadowkhan follows them and <SMACKS!> into a wall.

THE SHADOWKHAN—turns around and pulls down his FACEMASK, revealing himself to be JACKIE, DRESSED AS A SHADOWKHAN.

217
JACKIE
<Ow!, gasp!>

Jackie does his "rub the hurting nose" pantomime and then takes in panic, replaces his mask, SNAPS to military style attention and SALUTES as TWO MORE SHADOWKHAN walk by. After they pass, Jackie turns and SNEAKS away in the opposite direction.

INT. SECTION 13—MAIN AREA—CONT.
PAN WITH—Shadowkhan Jackie as he sneaks across the floor and hides behind a GIANT GROTESQUE STATUE.

CONTINUE PANNING TO REVEAL—Valmont and Jade at her throne, as before. Valmont suddenly stops reading.

218
SHENDU
". . . and to best harness the
dark forces —"

ANGLE—Shadowqueen Jade rails at GLOW-EYED Valmont, as he puts a thoughtful hand to his chin and mimes thinking.

219
JADE (UNEARTHLY FX)
Why do you stop?!
220
SHENDU
Forgive me, Your Highness: I could
easily translate this entire volume
for you but . . .

CLOSER—Valmont nears Shadowqueen Jade, tempting her.
221
SHENDU (CONT)
. . .TRUE POWER does not reside in
textbooks.

Jade raises an eyebrow, interest piqued.

ANGLE—As Valmont continues his coy sales pitch in b.g., JACKIE
appears among Jade's SHADOWKHAN GUARDS and starts <SHUFFLE-SHUFFLE-
SHUFFLE> comically sneaking closer.
222
SHENDU (CONT)
I could TEACH you, Dark Queen.

VALMONT—casually lays his hands on the ARCHIVE as Shadowqueen Jade,
who furrows her brow in uncertainty.
223
JADE (UNEARTHLY FX)
And why should I trust you?

RED-EYED Valmont settles, mulling this—then REACTS to o.s. and POINTS
in surprise.
224
SHENDU
Beware!

Jade turns to see . . .

THEIR POV—. . . Shadowkhan Jackie uncorks his VIAL of POTION and antics
to splash her ankle. But before he can, FIVE SHADOWKHAN whip into
frame, GRAB him . . .
225
JACKIE
<struggles>

CLOSER—. . . and YANK off his mask!

FAVOR SHADOWQUEEN JADE—reacting, as Shendu looks on.
226
JADE (UNEARTHLY FX)
You!?
227
SHENDU
(smarmy)
Do you "trust" me now?

INCL. JACKIE—Jade notes the potion in his hand, commands:

```
                          228
                   JADE  (UNEARTHLY FX)
           Take  the  potion  from  him!
                          229
                        JACKIE
           No!
```

FAST ACTION—A Shadowkhan REACHES to grab the VIAL, but lightning-fast Jackie FLICKS it into the air; and as the ninja tries to catch it, Jackie KICKS him o.s. and catches the vial himself. Then he FLIPS, twisting free from the ninjas who hold his arms and KICKS two more attacking Shadowkhan o.s. as he lands.

```
                          230
                        JACKIE
            <kick,  catch,  struggle>  <BWA!>
```

JACKIE—REACTS as . . .

A ROW OF NINJAS—produce THROWING STARS and FLICK THEM O.S.

JACKIE—still carrying that vial, dodges as <FFP! FFP! FFP! FFP! FFP!> THROWING STARS embed in the wall behind him.

ANGLE—With Shadowkhan coming at him from all sides, Jackie 1-2-3 CLIMBS a HIDEOUS STATUE and LEAPS to the CATWALK.

```
                          231
                        JACKIE
            <1-2-3  efforts>
```

ON THE CATWALK—Jackie trades KUNG-FU BLOCKS and BLOWS with FOUR SHADOWKHAN as more close in.

```
                          232
                        JACKIE
            <fighting  efforts>
```

ON SHADOWQUEEN JADE—<GHOSTLY WIND> blows her hair, and while Shendu eggs her on . . .

```
                          233
                        SHENDU
           Your  skill  far  exceeds  your  years,
           Majesty.
```

JACKIE—KICKS two SHADOWKHAN o.s, but gets PUNCHED by another. He STAGGERS backwards and TRIPS over an ORNATE RED CUSHIONED CHAIR . . .

```
                          234
                        JACKIE
            <fighting  efforts,  Ugh!,  GASP!>
```

JACKIE CHAN ADVENTURES EPS 206 ACT 3

SC 670 PANEL 1 ACTION day night TIME
INCL. JACKIE - -
DIALOG

SC 671 PANEL 1 ACTION day night TIME
Jade notes the potion
in his hand
DIALOG

SC 671 PANEL 2 ACTION day night TIME
Commands
DIALOG

SC ACTION day night TIME
DIALOG (228) JADE
" TAKE THE POTION FROM
HIM! "

TOTAL

©2001 ADELAIDE PRODUCTIONS, INC.

Figure 14.4 *Jackie Chan Adventures*, "Queen of the Shadowkhan," written by David Slack, storyboard by Seung Eun Kim. *Jackie Chan Adventures* © 2003 Sony Pictures Television Inc.

Figure 14.4 *Continued*

 EPS 20b ACT 3

SC 677 PANEL 12	ACTION	day night	TIME
	DIALOG		

SC 677 PANEL 13	ACTION	day night	TIME
	DIALOG		

SC 677 PANEL 14	ACTION	day night	TIME
	DIALOG		

SC 677 PANEL 15	ACTION	day night	TIME
	DIALOG		

TOTAL

Figure 14.4 *Continued*

JACKIE CHAN ADVENTURES

EPS 206 ACT 3

SC 677 PANEL 16	ACTION	day night	TIME
	DIALOG		

SC 677 PANEL 17	ACTION	day night	TIME
	DIALOG		

SC 677 PANEL 18	ACTION	day night	TIME
	DIALOG		

SC 677 PANEL 19	ACTION	day night	TIME
	DIALOG		

TOTAL

Figure 14.4 *Continued*

. . .and the GLASS VIAL goes FLYING out of his hand.

QUICK SHOTS:
> FOLLOW—As the VIAL flies through the air . . .
> JACKIE—hits the ground, mugs in panic, and KICKS the CHAIR
o.s.
> ANGLE—The chair slides across the floor and . . .
> CLOSE—. . .stops against the GUARDRAIL as <FUMP!> the VIAL
lands safely on the cushion.

JACKIE—mugs in relief, and then panics as more SHADOWKHAN attack
and he DIVES o.s.

 235
 JACKIE
 <Phew!, WAA!>

QUICK SHOTS:
> ANGLE—Jackie RUNS to the chair, GRABS the VIAL and LEAPS
 over the GUARDRAIL with the Shadowkhan right behind him.
> JACKIE—grabs onto a RED CURTAIN and SWINGS straight for . . .
 ➤ JADE—who cringes as JACKIE swings towards her with
 the VIAL in hand. But just as he's about to reach
 her, a SHADOWKHAN FOOT kicks into frame and . . .
 236 A/236B
 JADE / JACKIE
 <GASP!> / NO!

ON THE FLOOR—. . .the vial <SHATTERS> on the floor and PURPLE POTION
evaporates with a steamy <HISSSSSS>.

JACKIE—LANDS and stares in horror at the spilled potion two SHAD-
OWKHAN rush in to restrain him.

PUSH IN ON JADE—The <GHOSTLY WIND> still blows her hair as RED-EYED
Valmont whispers in her ear.

 237
 SHENDU
 Hear this, my Queen: your first, and
 most valuable, lesson: always destroy
 your enemies.

Valmont retreats o.s as Jade tilts her head forward, sinister.

ON JACKIE—restrained by two Shadowkhan, as a third draws his SWORD.
Jackie makes a desperate plea.

 238
 JACKIE
 Don't listen to him, Jade. He's a
 demon. I'm your Uncle . . .your
 FRIEND.

FAVOR JADE—sinister, shrugging it off.

Figure 14.5 *Jackie Chan Adventures*, "Queen of the Shadowkhan," written by David Slack, storyboard by Seung Eun Kim. *Jackie Chan Adventures* © 2003 Sony Pictures Television Inc.

JACKIE CHAN ADVENTURES EPS 206 ACT 3

SC 702 PANEL 2	ACTION	day night	TIME
	DIALOG		

SC 703 PANEL 1	ACTION	day night	TIME
	DIALOG		

SC 703 PANEL 2	ACTION	day night	TIME-
	Jackie grabs onto a red curtain and		
	DIALOG		

SC 703 PANEL 3	ACTION	day night	TIME
	DIALOG		

—

TOTAL

Figure 14.5 *Continued*

| SC 703 | PANEL 4 | ACTION | day night | TIME |
| | | IALOG | | |

| SC 703 | PANEL 5 | ACTION straight for ... | day night | TIME |

| SC | PANEL | | night | TIME – |
| | | DIALOG | | |

SC 704	PANEL /	ACTION	day night	TIME
		DIALOG		
			TOTAL	

Figure 14.5 *Continued*

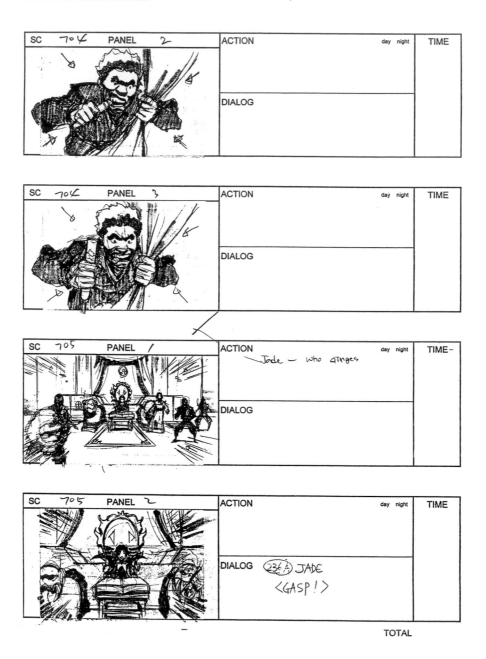

Figure 14.5 *Continued*

EPS 206 ACT 3

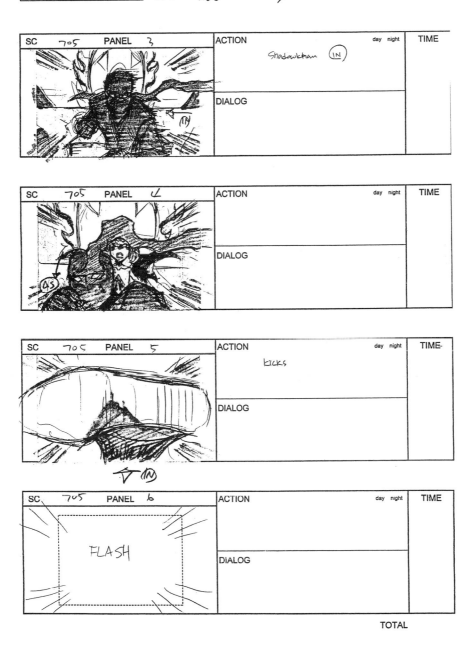

©2001 ADELAIDE PRODUCTIONS, INC.

Figure 14.5 *Continued*

239
 JADE (UNEARTHLY FX)
 <t'ch>, you _were_. But things are different
 now: I have new friends.

BACK TO JACKIE—with a new appeal.
 240
 JACKIE
 Oh? If Shendu is your friend...why
 is he stealing your book?

JADE—looks around in panic and then turns to see...

VALMONT—sneaking away with the ARCHIVE. His GLOWING RED eyes go
wide in panic as Jade points at him in b.g.
 241
 JADE (UNEARTHLY FX)
 <hiss> TRAITOR!!!

TRACKING—Valmont RACES away at almost superhuman speed.

ON JADE—<GHOSTLY WIND> swirls around as she calls...
 242
 JADE (UNEARTHLY FX)
 AFTER HIM!!

ON SHADOWKHAN—they ZIP after o.s. Shendu—revealing one ENORMOUS SHAD-
OWKHAN behind them who does not follow.

FAVOR JADE—watching o.s. Shendu, oblivious to the enormous Shad-
owkhan who STOMPS forward and...

...SPLASHES a vial of POTION at...

ECU ON JADE'S ANKLE—where the TATTOO <SIZZLE> melts away.

SMASH ZOOM—Jade takes in horror as the blue COLOR drains from her
face.
 243
 JADE (UNEARTHLY FX)
 Nooooo!!!

JACKIE—looks surprised at o.s. Jade as the TWO SHADOWKHAN release
him.

SHENDU—REACTS to o.s. Jade, as the SHADOWKHAN swarm in at him. He
RAISES A HALTING HAND.
 244
 SHENDU
 No!

The SHADOWKHAN "screech" to an instant halt, puppetlike.

CLOSER ON RED-EYED VALMONT—as he grins a confident grin.
 245
 SHENDU (CONT)
 Destroy CHAN!

WIDE—The Shadowkhan turn and ZIP o.s. the way they came.

JADE—The blue not quite fully drained from her face, strains to call
a final order.

 246
 JADE (SEMI-UNEARTHLY FX)
 No, destroy . . . THE BOOK!

THE SHADOWKHAN—INSTANTLY HALT again.

BEFORE SHENDU/VALMONT—can react . . .

. . . a single SHADOWKHAN leaps onto the WALL beside him and throws
a SMOKEBOMB at the ARCHIVE. The ominous book <BURSTS> into BLUE
FLAMES and vanishes!

Valmont takes at his hands in horror . . .
 247
 SHENDU
 NOOOOO—<AAK!>

. . . but when he looks up . . .

. . . sees JACKIE performing a flying KICK AT CAMERA . . .
 248
 SHENDU
 <oof!>

. . . into Valmont's MIDRIFF, sending him reeling backwards into the
AUTOMATIC EXIT, which closes behind him and <HYDRAULIC ZOOM>.

EXT. ALLEY NEAR SECTION 13—NIGHT, CONT.
ON PHONE BOOTH—Valmont gets spit out of the booth . . .

ANGLE—. . . and STUMBLES to the ground. His eyes STOP glowing and
he yells at himself.
 249
 VALMONT
 <Oof!> You could have AT LEAST let me
 grab the talismans!

INT. SECTION 13—MAIN AREA—CONT.
ANGLE—Jade fully returns to NORMAL as all the SHADOWKHAN disappear
with <POOFS>—all except . . .

. . . the ENORMOUS SHADOWKHAN, who plods into frame and reveals himself
to be TOHRU, as Uncle steps out of a nearby hiding place, carrying
his POTION POT.
 250
 UNCLE
 Very important rule of magic: always
 make extra . . . just in case.

JADE—looks around, dazed, as her family gathers around.
 251
 JADE
 <dazed> I have a weird feeling I did
 something bad.

 252
 JACKIE
 (firm)
 If you mean getting a tattoo when I
 told you not to, yes you did.
 (warmly)
 But if you mean destroying the
 Demon Archive . . .

JACKIE—looks to Uncle, who NODS approval. Back to Jade:
 253
 JACKIE (CONT)
 . . .we can live with that.

WIDE—Jackie takes Jade by the hand and they walk AWAY FROM CAMERA
with Tohru and Uncle (the only one of our leads not wearing ninja
clothes).
 254
 JADE
 Cool! Now can we swing by my room?
 (re: clothes)
 Black's not my color.

FADE TO BLACK and . . .

 END.

 Exercises

1. Take a joke with a story and try to write it in script format. It's okay to change the story to make it better or more visual.

2. Teachers, relate an anecdote about your day, and ask for a volunteer to write the story in script format on the board. Discuss the formatting.

3. Read a fairy tale or children's picture book out loud. Ask for two volunteers to write the story in script format on the board. It's okay to improve the story, make it more visual, and give it more action. How are the two new versions different from each other and from the original? Discuss.

4. Bring in an intriguing picture. Ask for a volunteer to start a story about that picture in script format on the board. Change off to a new volunteer, and keep changing throughout the class session so this script becomes a group effort.

5. Watch an animated videotape or DVD. Critique the structure in class. How could you improve the story?

6. Start with this sentence: "Amanda's dog Tom Boy chased Ms. Fluff the cat up a tree." Each student adds one sentence to the story in turn. Try to include some structure with goals, game plan, twists, crisis, critical choice, battle, and resolution. Discuss how the experiment worked and how the story could have been better.

7. What's the most important part of any story? Why? Discuss in class.

8. Take the premise and outline that you did earlier and write the script.

Editing and Rewriting

Getting a New Perspective

Once you've written a first draft of a script, if it's at all possible, put it away for about a week or for a few days at the very least. You've become so involved with the world in the script that by the time you've finished, it's impossible to look at it objectively. Everything is in your head, so *you* know what you're talking about. It may not be nearly so clear to a reader who does not automatically know all the details of the world you've created. Then do something else. Start a new script. Take a vacation. Go for a walk in the woods. Get the world of your script out of your head. It was your baby. It was an obsession!

When you come back to the script, you can look at it much more objectively. You've already forgotten a few of the details. You can better see what you've left out, what doesn't make sense. You're more open to seeing its flaws.

Read it through once. If you're not sure if something is quite right, then it's not. Make notes as you find problems. Buy some small sticky notepads to flag specific spots in your script, and make enough of a notation that you'll remember what was wrong there.

Use the checklist in this chapter to diagnose your script. If your script is a short one, then use your own judgment about how much structure is needed. Don't cut yourself too much slack; be open to your own criticism. But don't be too tough either. Pat yourself on the back when you see just how clever you were! Rewriting is a part of the process. Every script needs it. The fact is that rewriting is much easier than writing that first draft.

If you have someone that you can trust to give you honest feedback, that's great! Other people can see the flaws much easier than you can. You need someone who's supportive. It's better if they know how to write as well. This is why small writing groups are helpful, but evaluate the advice you're given honestly. A lot of advice from people who don't know writing structure or what you're trying to do can be discouraging and won't help much.

The First Rewrite

Get the structure right! This should be your first concern. What's your theme? What has the character learned, if anything? How does the story end? Then go back to the beginning and make sure you've set up everything right away. Nothing will help if the story isn't set up in the beginning. What is your hero's problem, and what does he want—what is his goal? Who is he opposing to get it? What terrible thing will happen if he doesn't succeed? What's your hero's character flaw, the thing that he learns to overcome in the end, the lesson that he's learned from this story? To keep your story from becoming episodic the action should progress with greater and greater potential consequences for the hero as the story goes along. All but the shortest stories should have two big plot twists or reversals, a major crisis scene near the end, and a big climactic battle with the villain. Be sure that everything ties together into one tight story.

Next work on the characters. We should immediately want your hero to succeed. We should empathize right away. Characters don't achieve a character arc unless their character flaws are established in the beginning. Character change should never come out of the blue at the end; it's always set up early. And we set up things through action, not static exposition. We have to establish not only that the character has flaws, but also that it might be possible for him somehow to change. We need to see the motivations of the hero and of the villain.

Go to the middle. You might want to add more surprises, more twists, more information that comes out and spins the story around in new directions.

If the story's too long, you must cut, or you may want to cut to increase the pace. Don't cut any of the structure points, and don't cut out the character flaw or what your hero learns. This leads to the story's theme. Don't cut the theme. Don't cut any of the important conflict. Do cut out unnecessary characters, or combine them. Cut out exposition. Audiences are interested in what's happening now. They'll figure out what they missed. Cut out anything that's repetitive. Cut out the flowery speeches, the propaganda, the preaching. Cut out unnecessary dialogue. Chop off the beginnings and the endings of scenes if you still need to cut. Often they aren't needed. Get rid of the adjectives. What you want left is the essence.

The Second Rewrite

Work more on the opening. Many readers will read the first five or ten pages, and if they aren't hooked, then the script is tossed aside. This is where the story editors and executives decide if they like your script or not. Grab your audience! You want action, not words. Make it visual. Be sure that the structure is set up in the first couple of pages.

Go to the end. Does the story build to the biggest conflict? Make it bigger! Is the story resolved quickly after that? Is there a twist that we weren't expecting at the end?

Strengthen differences! Strengthen differences between characters and the conflict each has with each other. Can you improve each character's ties to the theme? Remember that one character can be the poster child for the theme, and one can represent all that is opposed to it. One can represent what the audience might think. Look for ways to cut back and forth. Cut between dialogue scenes, then to action, then to different locations in order to contrast and draw parallels, to increase the pace where it's needed, and to heighten the suspense.

The Polish

Read the dialogue out loud one character at a time. Now fix it. Make your dialogue unique to each character. Cut exposition that you missed before. Increase the conflict in the dialogue, and increase it some more. Make the dialogue sound real. It should flow. It should have rhythm and pace. Write as clever and as funny as you can. Improve the gags.

Check your script for clarity. Do you have enough dialogue or too much? Check your script for style. Is it a good read? Be sure that you have the right length, exactly. Check the script for spelling errors, for grammar, and for typos. Be sure the format is correct.

To the Development Executive, Story Editor, Producer, or Director

If you're working as an executive, remember how it is to be on the other side of the desk. Keep learning. Read all the books and articles you can on writing and storytelling. Take seminars from the Hollywood gurus. Listen to what other development executives, story editors, or directors have to say. Learn more about the animation production process. You can never really learn too much. No matter how long you've been in the business, don't be afraid to listen to new opinions, new ways of storytelling, and new ways of working.

Remember that good storytelling skills and good structure are important, but be open to new ways that work. Don't be so attached to the rules and tricks of the trade that all the stories begin to sound alike. The audience wants something different, although not so badly that they want something that's excruciatingly boring! There may be as many opinions about what makes a good story as there are people involved in telling it.

Most of the time the development staff, the executives in programming, and the story editors take an idea or a script and make it better. They make the concept more accessible and appealing to more people or to a specific target audience. They make the story more exciting, or more interesting, or bring it together into something that's easier to understand and appreciate. But it's also possible to homogenize an idea, take the fun out or its heart and soul. It's possible to take a fresh idea and make it ordinary. The more tinkering that's done with a concept, the easier it becomes to end up with something that pleases no one. Without a specific plan and with too many cooks, it's easy to water down or completely drown the broth. This is something that writers and executives alike must guard against.

A quality product with broad appeal will provide enjoyment and bring in money for a very long time indeed. It's better to add levels to broaden the appeal of a concept than to dumb something down. Adults don't like to watch entertainment that speaks only to a small child. And kids can easily recognize when adults don't take them seriously.

Sticking to a schedule is important. In animation schedules can be very, very tight, and problems that are not expected can crop up to make them even tighter. Missed deadlines can mean big financial penalties for a production company, and when production is rushed beyond its capabilities, then quality suffers. But it's also important to get the problems fixed before going into production. Changes made later delay the schedule even more and make for huge cost overruns. Keep in good communication with the other companies involved, with producers and directors, with writers, story editors, and other executives to best decide how problems can be quickly fixed and schedules kept. In television there may not be the time or the budget to get everything perfect. Even with a big budget feature, at some point

you might have to decide that it will be good enough and move on. But do make quality a priority always!

To the Development Executives Working with a Writer

As a development executive, always try to be positive. Remember the reasons you thought a development job would be fun! What did you like about the writer's script that you're about to tear apart? There's no such thing as the perfect script. But there are always some good things. If there are a lot of good things, be sure you let the writer know.

Talk about the script's possibilities. Tell the writer that you think he can bring a lot more out of this script. Ask him what he's trying to do, specifically. What made him want to write this particular script? If it's possible to enhance the writer's vision, he'll be happier, and you'll get a better script. What did you like about the script? Why did you want to buy it? Don't lose that in the rewrites. Focus on the structure first. Go through the same process in the same order as you would if you were rewriting the script yourself.

Don't make frivolous revisions that will start a spiral of changes ending in a totally different script. If the script's properly written, one relatively minor change will set in motion a whole chain of changes because everything will be tied neatly together. When you've covered the major changes, you can attack the minor ones—maybe. Be sure your writer knows exactly why these changes are being made. End your development session on a positive note, assuring the writer that he's doing a great job!

Checklist

- The premise and theme

 o Write out what happens in the story in twenty-five words or less. Is the main plot of the story clear and uncomplicated enough so that this is possible? Is there a single cause-and-effect line? What did the main character learn? How did the protagonist learn this in fighting the antagonist/villain and achieving this one goal?

 o Is the story worth doing? Is the story classic, timeless? Or is it especially current, in some way speaking to us or to the kids of today? Does it give us an emotional experience? Does it have style? Is it funny? Is it scary? Is it mythic, something that will resonate deep within us?

 o Is the main premise original, or does it at least have an original twist?

 o Is the premise commercial, a story that would interest more than the writer's agent? Something that will appeal to a wide audience? Something that will especially appeal to kids or young adults, something that they can relate to directly? Does the story view the world from a kid's or young adult's point of view? Does it have a hook that will make it easy to promote?

 o If this is a high-concept story, is there enough meat there to warrant the length and budget for that script? Is it more than a one-line concept or a one-line joke? How

can it be expanded? The key to expansion is the antagonist or antagonists. Who is so different from the hero that conflict is inevitable? Who are possible villains? What is the hero going to learn by running up against them? How could the conflict build? How can the potential consequences for the hero build? What is the villain hiding that might come out later? A story builds by adding surprises and new information.

o Is this premise such a unique, personal vision of the writer that it gives the audience a special experience? Does this experience change them and give them something that they can take home with them? Did the writer write from his soul, simply and beautifully, telling a great story we want to see? If others beside the writer feel that this is an exceptional story as told, then this might be the best way to tell this story, even if a few of the rules have been broken. But do reevaluate the script to be sure that following the rules wouldn't make it even better.

o Is the premise believable? Is the basic action and goal of the hero believable?

o Have you avoided splintering the story into two or more unrelated tales? Do the subplots tie in so tightly that the main story would be diminished without them? Does the continuity of the story flow logically and smoothly? Can some scenes or characters be combined with others to tighten and improve the story? Any nonessentials to moving the story ahead should be edited out in later rewrites.

o Is the story focused so that you can see the reason for it? What's the central conflict? Who fights whom about what? What are the moral choices that the hero must make at each turn of the plot?

o Does it have a greater theme or issue that develops from the premise? Is this expressed through character and action, rather than dialogue? No sermons! Do images and symbols help convey and expand the theme? Did you use analogy? Is every frame focused back on that theme? Filmgoers want a movie that is really about something.

o Do you have a universal theme? Will most of the audience be able to identify with this theme?

- The arena

 o Is this a really fascinating location or area of interest?

 o Has this arena been researched thoroughly so that the details seem authentic and intriguing? Has the time period been researched well?

- The protagonist, hero, heroine, or star

 o Who's the most interesting character in this story? The main character should always be the most intriguing. If the main character isn't, make the change.

 o There should only be one main hero or heroine.

 o Is your heroine actively engaged in reaching her goal? The heroine should never be passive. She is not a victim. She is not merely reacting to the villain. It's the

heroine, not the villain, who drives the story (although in a mystery the villain may get the ball rolling by committing the crime). Is your heroine making hard choices all along the way? Does the most difficult choice (the critical choice) come during the major crisis?

○ Does your hero come on right away, remain on stage through most of the script, and remain until the very end?

○ Is your hero likeable? He may do things we don't like, but we must see his own good motivations for doing what he does. We (and the kid audience) must understand and relate to these motivations.

○ Is your hero so nauseatingly good that no child can relate? Your star should have at least one character flaw. It should be actually hurting him, keeping him from fulfilling his potential and being happy. The possibility of character change should be established right away in Act I, and we should see influences that motivate him to change throughout.

○ Is your hero dealing with events that lead to a major change in his life?

○ Do we immediately see that something from the hero's past is giving him trouble today and motivating him in this story? Our hero's character flaw should be caused by that major event or events from the past. The hero's flaw should be the source of the script. We should see it in the first few pages.

○ Is the hero's character flaw unintentionally hurting others enough to cause them real problems? We should know precisely why the hero is hurting others. His motivations will be clear and good enough that we still have empathy for him. Again, we should see this early in the script.

○ Does the hero overcome his flaw too early? This flaw is something he hasn't yet learned during the story. He'll be able to overcome the flaw at the end because of what he's gone through.

• The villain or antagonist

○ Is the villain forceful and evil? The hero is only as strong as his antagonist. The villain must be powerful enough to make the hero revise his game plan time and again. He must be strong enough to almost win. A powerful villain requires a powerful, heroic hero or heroine to best him. Some villains for a younger audience are more comedic than evil so that they're less frightening, but if there is only one villain and he's not strong, this lessens the stature of the hero.

○ The villain need not be cardboard. He can express his own values. His beliefs may be wrong. You may show his reasons for acting the way he does.

○ There should be only one main villain. One main antagonist centers the conflict. There may be other minor villains, especially in comedies or mysteries. Often animated villains have a comic sidekick.

○ Is the villain physical and real? The conflict may be centered on a disaster such as a fire. You may have an inner antagonist (the hero fighting something

inside himself). But in each of these cases, we must also have a real and visible villain.

- o Do you have the right main villain for your hero? She should be the one person or thing best able to assault the character flaw of the hero.

- o Is the villain a real opponent? She should be in competition with the hero for the same goal. That goal might be broad, as in competing for control.

- o Are the hero and villain in the same place enough of the time to be effective opponents? Are there good reasons to be in the same place so that this seems believable? It can be difficult to keep people who don't like each other together.

- o If you have a feature-length comedy or an epic, you probably need at least a couple of minor villains as different from each other, from the main villain, and from the hero as possible. Any antagonist who's not that different isn't needed. In making them as different as possible, figure out the basic differences in values between each. One or more villains may be hidden early in the script.

- Characterization (in general)

 - o Are these characters believable? Are they doing believable things and making believable, well-motivated decisions? The more unreal the story world is (as in a fantasy), the more believable the characters must be. Layer on common, everyday details to make your characters more real. Are your characters three-dimensional enough to avoid being stereotypes?

 - o Will these characters be interesting to us? If this story is for kids, are the characters kid-relatable? Allow the audience to discover themselves in the story. Are the characters doing interesting things? Do we know enough about their past, their motivations, their hopes, and their fears to care about them? Are they in dire jeopardy? Are their reactions, while in character and believable, also unexpected and out the ordinary, rather than boring? Go for the emotion. Do they leave us wanting to know more? Is there a wide variety of characters so that they form relationships and conflict and bounce off one another? All characters should be as different from each other as possible, or they're unnecessary.

 - o Is all the action and dialogue in character?

- Problems and goals

 - o Does the hero or heroine have a strong, single goal? Without this the story will split and be weak in the middle. The hero may have a problem that causes him to come up with a goal to solve it. If there's more than one goal, these must come into direct conflict with each other, putting more pressure on the hero. If he gains A, he loses B, and vice versa. (For instance, if he saves his friend, the treasure chest washes away in the rapids.)

 - o Your hero should have a goal early enough. We should see it in the first few pages of the script. We should see what motivates him toward this goal and why.

- Is the goal as lofty as possible? "To get revenge" or "to get Trick or Treat candy" is not as lofty a goal as "to rescue the world from total destruction." The goal should be positive. It's not acceptable for the hero's goal to be "to hurt someone" or "to commit a crime" unless the character is a Robin Hood or Batgirl character committing a crime against someone evil and powerful in order to help someone weak and just.

- Is this goal precise and tangible? There should be one moment when we see that the character will reach his goal. In the United States an animation hero rarely fails to reach his goal! "I want to be happy" isn't precise or tangible enough.

- The hero should never deviate from his goal. It's an obsession, never secondary.

- Is the goal the hero's own fixation? It shouldn't be merely a reaction to what the villain does.

- Does the plot line to the goal build in intensity? The hero's resolve should build. The stakes in gaining the goal should get higher. Each turning point should revolve around that goal.

- The setup

 - Do we "start aboard a moving train" (especially important in action stories)? Are we hooked right away so that we can't wait to see what happens next? Is there danger?

 - Did we begin with a good strong visual image that gives us a sense of time, place, theme, style, using metaphors, analogies, and symbols when possible? Do we set the tone of the story?

 - Is the hero and his character flaw, villain, problem/goal, and theme established quickly enough? In the first few pages of script (especially important in a short)? Or, to put it another way, are the two basic story questions of plot (the **central question**) and character set up: "What will happen?" (Will the Wild Thornberrys be able to stop the poachers and save the environment?) and "Will the hero overcome his character flaw?" (Will Shrek allow someone to get close to him and fall in love?) Do we already know the terrible thing that will happen to the hero if he doesn't get what he wants? Is the hero's problem one that we care about? Do we get a real feeling for the main character? Is that character really likeable or at least likeable enough that we're there rooting for him until the end? Is the possibility of character change set up in the very beginning?

 - Is the catalyst—the event from the outside that starts the story moving—brought in quickly enough? Is it dramatic and action packed?

 - Have we learned the parameters of this universe that's being created early on? Are the rules of the world clear to us right away?

 - Do we really know what this story is about by the middle of Act I?

 - Did you set up what we must know through action and dialogue with conflict? Or use gags? Exposition is boring. Information in the backstory (what happened

before the story) should be revealed gradually later. Even then reveal only what is absolutely essential by showing us, not telling us.

- The game plan
 - ○ Does the hero have a game plan or plan of action?
 - ○ This plan should be precise and detailed. It should start simple and grow more and more complicated as the story goes along.
 - ○ Is the hero's plan sabotaged by the actions of the villain time and time again? The hero is constantly reworking the plan as the villain attacks him and his plan goes awry.
 - ○ Did you include a major plot turn at the end of Act I, turning the action around in a new direction, and another toward the end of Act II? These plot points each require a decision or commitment by the star and raise the stakes. The plot points are like gates. Once our hero has gone through, there is no going back. Ideally, each major character goes through the gates of his own plot points in turn to make his own character arc. In fact, you'll need many twists and turns throughout the story.
 - ○ Does the game plan build? Reorganize scenes, if necessary, to make them build toward a climax.

- The middle
 - ○ Watch that the storyline doesn't split in the middle. It must be one super train, barreling down a single track, picking up speed as it goes.
 - ○ Does the action change? It should never be repetitive. (Roadrunner trying multiple ways to trick Coyote and Tom trying multiple ways to trap Jerry will work only in very short scripts.)
 - ○ Is the plot too thin to hold the audience's interest? New information provides new twists and turns. The villain may receive news about the hero. There might be hidden antagonists who are just discovered. The hero should keep receiving new data, often about the villain who's hiding things. For the hero things should be going good, then bad, then good again, alternating throughout the second act. Information leads to new action. Then there's more news.
 - ○ Does the conflict continue to build? If it's a comedy, the gags must build and get wilder. The hero and the villain must get more and more compulsive in trying to win. They become more desperate and go to greater extremes. The hero's friends may criticize him if he goes too far, putting even greater pressure on him. But be sure that in the effort to reach his goal, the hero doesn't do things that are too unbelievable or out of character.
 - ○ Is there a major high point at the middle of Act II? Everything looks rosy!
 - ○ Does the evenness of the good news/bad news cycles turn to primarily bad news after the midscript high point? There may be a big confrontation between the hero and the enemy. The hero suffers some major defeat, giving the enemy an advantage. This starts the hero's downward slide toward the major crisis.

- Have you included a big turning point toward the end of Act II?

- Is there a major crisis? In a feature this major crisis will probably be the end of the Act II turning point. When the three acts are almost equal in a TV script, the end-of-the-act turning point may be too soon for the major crisis. At the major crisis everything seems lost for the hero. Hope dies. This is the worst that could possibly happen and often the opposite of the hero's goal. The hero may be forced to confront his character flaw here. Now the hero must make a critical choice with sacrifice or commitment. This choice raises the stakes and speeds up the action, often with a ticking clock. If it comes too soon, the third act drags, but if it comes too late, there's not enough time to develop tension and suspense for the big climax. It will set up the climax.

- We should not be able to predict how the story will end.

- The hero may receive new information that leads him to have new hope and redouble his efforts to win.

- The climax

 - Do we see a physical battle leading into the climax? Is it big enough? Can it be made bigger? Tighten space and time.

 - Is the battle between the hero and the villain? Other opponents may take part, but this is a battle of good/the hero against bad/the villain.

 - Will this be the biggest conflict of the story? The whole script should build to the climax or big win where the hero reaches his goal.

 - Is this conflict more than just a physical one? Is it also a conflict of values and a way of life? Can this thematic conflict be made bigger?

- The end

 - Does the story have a twist at the end?

 - Did the hero learn something about himself and how he should treat others? Do we know that he will overcome his character flaw?

 - Does this new knowledge come at the end of the story after the climax and as a result of the climax?

 - Is this really something new that the hero has learned? Will it change his life? Is it helpful information for the audience, leading to a theme they can take home with them?

 - Did we wrap up all the loose ends of the story? Quickly?

 - Does the story have a satisfying and a happy ending? It is very rare for the animation hero to fail to achieve his goal. (Charlie Brown was an exception, as losing was a part of his character.) Are all the promises fulfilled? If it's a comedy, does it go out with a gag?

- The subplot

 ○ If the story is feature length, is there a subplot? The subplot may mirror the main action plot, but it's seen through another character's eyes. Or the subplot may be a character-driven plot with the main plot an action plot.

 ○ Does the subplot add to the story? Does it intersect and give more dimension to the main plot?

 ○ Is there a full and clear structure to the subplot? Does it start as it should after the main plot, interweave, and remain less important than the main plot? Does it resolve close to the climax of the main plot? Do we see then how it ties into the main plot?

- Scenes and sequences

 ○ Are all the scenes absolutely necessary? If we cut one, will the story still be clear? Will we still understand why the characters are doing what they must do?

 ○ Can any scenes be combined? Would a scene be more effective in another location?

 ○ Does each scene set up new questions or unresolved action to hook the audience so they'll want to watch until the end?

 ○ Does each scene build?

 ○ Have you started your scenes as late as possible and ended them as quickly as possible?

 ○ Do all the scenes have as much conflict as can be packed into them? As much action (except where inappropriate)?

 ○ Are any scenes too thin? Each scene should be doing all the following at the same time with style:

 Characterizing the people

 Creating a physical world

 Giving a narrative motion

 Whetting anticipation

 Creating and resolving mystery

 ○ Do the characters do things in an original way? Or is there a more interesting way of putting across the same information?

 ○ Is the correct character driving the action of that scene with their needs?

 ○ Have you made each sequence the very best it can be?

- Comedy

 ○ Can you make the script funnier without hurting the story?

- o Does the humor fit the story?

- o Have you set up your gags, milked them, topped them, and paid them off?

- o Will the humor work internationally?

- Dialogue

 - o Does the dialogue move the story along?

 - o Is the dialogue necessary and not repetitive with the visual information? Too much talk and not enough action?

 - o Read the dialogue out loud. Does it seem natural?

 - o Is the dialogue individual to each character so we can identify the characters by listening to the dialogue?

 - o Is the dialogue in character and believable?

 - o What about subtext, people talking around the main issues as people really do instead of blurting everything out? Do you use subtext?

 - o Does the dialogue sound like exposition, especially at the beginning? Boring dialogue? Repetitive dialogue? Are you including only the essence?

 - o Does any of the dialogue stick out and sound wrong?

 - o Is the dialogue either up to date and very contemporary or classic and timeless? Is it age appropriate? Can the youngest child understand enough?

 - o Have you used the dialogue tags of the characters that have them but not too much?

 - o Is it as funny as it can be?

 - o As clever as it can be?

 - o Polished? Have a nice rhythm?

- Budget

 - o Is this primarily a CGI or a traditional project? Plan your story with the specific expenses of either in mind. CGI often allows animation and detailed coloring to be done cheaper. It allows crowd scenes to be done much cheaper and camera moves made more easily. CGI is expensive in rendering difficult surfaces like fur or water. It is more likely to require realism with expensive, time-consuming lighting, realistic animation, and lots of special effects.

 - o Are there any scenes that are just too expensive for the budget? Could scenes be staged in a way that would be cheaper without sacrificing anything important?

 - o What about unnecessary characters? Can some be cut or combined?

 - o Could stock backgrounds, characters, animation be used without damaging the story?

 - o Are special effects too expensive as written?

- o Could you cut traditional animation costs by avoiding walking and other unnecessary and expensive action?

- Animation

 - o Does the script use the medium well? Did the writer think and write visually throughout?

 - o Is there plenty of action? Does it start with action or character?

 - o If it's a comedy, do the characters use plenty of props? Effectively?

 - o Will it be funny enough with plenty of visual gags? Scary enough? Is there a dire threat? A time factor to increase the tension?

 - o Did you give the animators something to be animated throughout?

 - o Is the action strong and exaggerated enough for the animators? If this action is for a small screen, can it be clearly seen?

 - o Are the characters loveable enough or interesting enough to make into toys?

 - o Is the story magical enough that kids will want to watch it over and over?

 - o Will it sell worldwide?

 - o Does it set a good example for kids? If this story is for TV, will it pass standards and practices tests?

- Final polish

 - o Improve each sequence as much as possible.

 - o Polish the gags. Are they as funny as they can be?

 - o Improve dialogue one last time (conflict, subtext, dialogue unique to each character, turn of phrase, rhythm, essence).

 - o Have you kept each block of dialogue to no more than about three lines? Have you used an amount of dialogue consistent with other similar scripts or fewer than three blocks per page? Does the dialogue break up the action so there's not too much description in any one area?

 - o Did you use strong action verbs and write with style and humor?

 - o Have you written in the style of that genre?

 - o Is everything very clear? To the audience? To the production staff and overseas animators? Watch colloquialisms that might be misunderstood.

 - o Do you have the right length exactly?

 - o Is your script format correct? Did you use caps where they are needed?

 - o Correct the grammar and punctuation.

 - o Check and correct the spelling and typos. Your computer's spell-check program will not catch everything. The buck stops with you. (And with inflation it's probably ten bucks that stop with you!)

 Exercises

1. Take a script that's already been produced and try to make it better. Start with the structure and take it from there. What improvements would you make?

2. Rewrite a script of your own. Then polish it.

3. Cast a script (any script) in class. Read it out loud, using the cast you chose. Next take a vote. Would you buy that script as is? If it were a feature-length script, would it make a little money? Make a lot of money? Break even? Lose money? If it were a television script, what kind of audience ratings would it make? Top ten? Top fifty? Would it lose money? Win awards? What did you like about the script? How could you improve it? Discuss.

4. Take someone else's script and give her detailed notes on improving it. Remember that you're supporting her and helping her to better implement her own vision, not rewriting it to your vision.

5. Rework your storyboard, making it better visually.

6. Cast your script. Can you improve the script now that you have actors, building on their strengths and character interpretations?

7. Record your actors as they improvise the dialogue for your story. Do you want to include anything that they've contributed in your final script?

8. Conduct a reading of your script before an audience. Hand out questionnaires to test concepts and possible endings, get reactions to jokes, and so on. Request a rating and solicit comments. If kids make up your audience, ask the questions verbally instead.

CHAPTER 16

The Animated Feature

Concerns in Greenlighting an Animated Feature

A major animation feature is very expensive to make, and studios are reluctant to take too many risks when they've got millions of dollars at stake. Many studios purchase the rights to a book or well-known character for their feature rather than buy an original **spec animation script**. Or they retell a classic myth, fairy tale, or story that's in the public domain. Some films, like *The Wild Thornberrys* and *The Powerpuff Girls*, were popular TV series before they expanded to the big screen. These stories with marquee value practically guarantee a built-in audience. Often studios commission a script for their feature based on a subject that they think will sell a lot of tickets at the box office. Features normally require a broad audience to justify costs.

Many features do badly at the box office due to poor quality in the script or in the production itself. This can be caused by a budget that's too low or a lack of experience by the studio. It might be brought about by a story that's watered down, or it could be caused by formula stories that rely too heavily on what has worked in the recent past. Audiences from a media generation who have seen so many stories long for something different. A good story is essential. When animated features do poorly at the box office, this frightens the people who will back films financially, and it becomes even harder to sell a feature story.

After *Toy Story* and *Shrek*, audiences seemed to prefer CGI films, and both Disney and DreamWorks began to shut down their traditional animation departments. Audience preferences are constantly cycling and in a state of change. In this case I think the quality of the traditionally animated stories and the power of the press had more to do with box office results than how the films were made. I look for great traditional animated films again in the future.

The Feature Script and Pre-production

The feature animation script is normally written in a format like a live-action script using master scenes that do not detail the camera shots, but it has fewer pages. Feature scripts

275

average roughly one page per minute of screen time. Normal length varies from about 75 to about 110 pages. Most theatrical animated features have a running time of approximately seventy-five to ninety minutes. The direct-to-video features run about ten minutes shorter. The Motion Picture Academy in the United States requires an animated film to be at least seventy minutes to qualify for feature awards.

At many studios in the United States an initial story treatment, rather than a finished script, is given to storyboard people (or storymen), who take it for further development visually. A treatment or outline breaks down the basic story into scenes. The storymen may then develop character, further plot out the **story arcs**, and develop scenes from this treatment. At some point the story might go back and forth between a full script and visual development, with the creative executive supervising the process. Just how much the storyboard artists contribute depends on the studio; some studios let the board people develop and change a great deal, and some don't. A writer may be writing drafts of a script at certain stages after meetings with the storymen. This development can easily take a year or longer. Some sequences may go into production while the rest of the film is still in development. Sometimes an entirely new writer or team of writers is hired to polish a final script, improving dialogue and making the film funnier. Disney's sequels to *Peter Pan*, *Dinosaurs*, and *Fantasia 2000* were each in story development for several years. Often the developed film hardly resembles the original treatment or script. And changes may be made throughout the production of the film.

Management at DreamWorks prefer a finished script before going into production. Jeffrey Katzenberg usually gets involved personally with the writer on rewrites. He closely monitors the storyboarding process and reserves the right to revise until practically the final mix. On *Sinbad* the visual development influenced the story, as the designs of Tartarus changed the concept of that domain. The character of Eris evolved so much that new casting was done, and the character was rerecorded with a new actress.

DreamWorks has also been experimenting with animatics. They include not only what's indicated in the storyboard but also intercuts or different angles so the editor has a choice, resulting in a finished film that looks more like a live-action film in its cinematography.

The Disney method, traditionally, was to go into the early stages of production using only a treatment. The treatment was further broken down into sequences. The sequences were given to teams of writers and storyboard artists, where they were tweaked until they were the best that they could be. Of course, this process sometimes improved each section to the detriment of the whole. But there might be many pitch sessions during the story process as the teams pitched sequences, brainstormed gags, and solved story problems. Pitching your sequence of drawings with enthusiasm became an art in itself. The best story elements survived.

There is no single way to approach the feature story. Each studio, and even each feature, is different, and old ways are always subject to changes as the business of animation changes.

The Direct-to-Video or DVD Feature

For direct-to-video or DVD features the process is closer to that of TV animation due to the budget restraints. The lower budget may justify targeting an audience that's not as broad as that for the theatrical feature. Who is the audience for your studio or your original project? Aim specifically for them. Original projects with no marquee value are very difficult to sell to the large companies. Before development, consider what might be needed. What is each studio's niche? Where are the gaps in their product? Differentiate your project from what is

already out there. High quality will pay off later. As a rule, the script is still initially written in master scene format. There are far fewer changes to the finished script than there are to that of the theatrical feature. At the major studios direct-to-video or DVD features are often sequels. In writing a sequel you must analyze your original cast. Who is the best character? You might want to write the sequel around him. Which characters do you keep in, and which can you afford to drop? What's the best angle for a new story? What's important to retain from the original? DVDs need added value (games, behind-the-scenes clips, artwork, etc., geared for both adults and kids). Small animation studios can produce an original direct-to-video or DVD feature on a much smaller budget than a theatrical feature and still expect to make money, as they are cheaper to make, easier to distribute, and require less money for promotion. As with TV animation, each studio has its own twist on the process.

The Television Feature

Once in a while television buyers are interested in broadcasting a feature or a feature package. In that case the budgets are probably even lower than those of the direct-to-video features. To get budgets down and interest in the films up, the television feature story will probably have marquee value rather than being an original. Sometimes old classics that are now in the public domain will be used and updated with a new twist. License fees will probably not cover the costs to make the feature, but if the title is saleable on its own, then the film can recover costs later by international sales. Of course, with budgets that are so low, the television feature may be even lower in quality than the direct-to-video feature, but that doesn't mean that the writing can't be top notch.

Feature Financing and Distribution

There are many methods used to obtain film financing. Features can be financed by internationally preselling certain rights (book rights, video rights, TV rights, game rights, certain merchandise rights) or territories (the distribution rights in certain areas). Some governments will help provide financing. Film funds or grants may be available for independent films. Europeans can obtain financing with the help of Cartoon Movie, an annual forum for European animated films. At least one company financed its feature by issuing new corporate stock.

Interesting the consumer products group or the music division of a large corporation in your concept could help to gain support for your feature pitch at that corporation. Projects need instant appeal from a logline pitch, and budgets must match realistic marketing possibilities.

Product placement is the practice of obtaining marketing assistance or fees for placing certain commercial products in a film. The animated film *8 Crazy Nights* (2003) expected almost $100 million in marketing support from the product placement in their film. However, companies that ante up good money for their product or company logo might also expect to see instant stardom for their product on film, and they could demand story or artwork changes for that ka-ching of the cash register.

Some small studios do their own financing, working on the development and production slowly in between other projects. This method, of course, can take years. Some companies have tried setting up a website about their film to help obtain financing. A website that allows visitors to see digital **dailies**, see designs, hear newly composed music, and get infor-

mation about the film might help build an audience as well. Potentially successful soundtracks or toys on a website can help attract financing. Often studios participate in coproductions to split the costs and the risks and speed the process along the way.

The completed film may then be taken to markets like Cannes in hopes of garnering awards and good buzz in order to get distribution. Or a film can qualify for an Oscar® nomination in the Feature Animation category if it has had a short prerelease showing.

Production Schedule

Most features will take anywhere from eighteen months to four years to produce. CGI features take about the same amount of time as a traditionally animated film. Serge Elissalde's French production *Loulou and the Other Wolves* was completed in only two months of preproduction (including the script), five months of production, and one month of postproduction. Dario Picciau's Italian production of *L'Uovo* was completed by a crew of only six people, including the writer and producer, working on their Macintosh computers. A television feature will probably take less time than the average theatrical feature and will probably be produced more like any other television show. Budget, experience, and the number of full-time staff working on the film determine the time it takes. Because the lead time can be much longer than that of a TV show or a game, it's more important to have an idea that will still be popular years down the road.

The Structure Needed for a Feature Audience

Although animated features are usually assumed to be for children, the film must appeal to all ages, including teenage boys (the primary demographic group targeted for films). A story with universal appeal means the kind of story that people of all ages everywhere can understand and appreciate. These stories, and the characters in them, resonate in some way in our own lives. Basic human needs and emotions are found in the myths, legends, religious stories, folktales, and fairy tales humans have loved since the beginning of time. Without some substance—some importance—an animated film may not be worth taking the time, money, and effort to make. Many look for a timeless quality that will keep the feature popular for generations.

An original project with a high concept, something that will hook the executives with its obvious marketability, may be easier to sell as long as the characters and story are compelling. The premise of a film, like that of a television show or a game, should be simple enough that you can communicate it in a logline. In the United States the film should have a "cool" factor. Teens may feel that an animated film is only for kids, so your film needs something extra to get them to the theater. In recent years this something extra has often been CGI animation. However in the United States it's usually women who make the decision to go see an animated film. Mothers don't want to take their young kids to something that will give them nightmares or model behavior that's too negative. The kids themselves want writing that respects them rather than writing that talks down to them. They usually look for something familiar. The major companies have discovered that the big-budget feature needs be an event.

Writing an original feature is much more fun and more challenging than writing for TV animation. Of course, the script must be written better, too. Each major studio has its own style. Your story should have uniqueness and universality.

Fully developed and well-motivated characters that are appealing and have an attitude are especially important in a theatrical feature. Today's kids need to be able to relate to that attitude. Many animated features are buddy comedies. Characters are usually broader than typical live-action film characters, and they're action oriented. They should be dealing with events that lead to a life change. They are less likely to be clichés. They might be less direct than characters for television, talking around problems and hiding their fears. Interesting characters make an interesting story, so animated stories may be told through the point of view of the character actors of the story (the animals, the villains, the humorous characters) rather than the more ordinary hero or heroine. The hero is often accompanied by a funny sidekick.

Figure 16.1 Adventure, comedy, fresh characters with an attitude saving the animals! Who can resist this feature from Klasky Csupo?
The Wild Thornberrys, Copyright © 2002 by Paramount Pictures and Viacom International, Inc. All rights reserved. Nickelodeon, The Wild Thornberrys and all related titles, logo and characters are trademarks of Viacom International, Inc.

Figure 16.2
The Wild Thornberrys, Copyright © 2002 by Paramount Pictures and Viacom International, Inc. All rights reserved. Nickelodeon, The Wild Thornberrys and all related titles, logo and characters are trademarks of Viacom International, Inc.

Animated features have a theme—frequently about coming of age (Miyazaki's *Spirited Away*). There is action, drama, and tears. There's humor, often smart, edgy, and sophisticated. Many recent features have included pop-culture-related gags and smart dialogue, including double entendres. There's innocence as well. Often there's a love story. Love stories provide something special to relationships by sending sparks flying.

The structure must be well written and almost as complex as that of a live-action feature; however, there must be some room in the plot for the elaboration that will be done by the storyboard artists. There will be an A-plot and a B-plot, and maybe a C-plot. The B-plot is often the love story. A minor story point may be set up early in the story, only to be paid off much later in the script. This may relate to theme, action, or character as well as humor. The older viewers in the audience will remember and "get" it. Scenes are usually shorter. A short cartoon can hold our interest with a simple plot that's merely a string of events leading to a climax, but a feature needs a tight interwoven structure to keep our interest. A feature

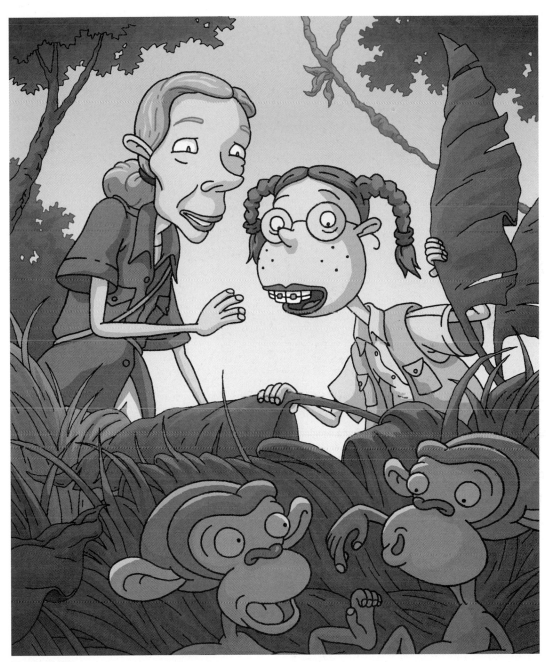

Figure 16.3

Figure 16.4

The Wild Thornberrys, Copyright © 2002 by Paramount Pictures and Viacom International, Inc. All rights reserved. Nickelodeon, The Wild Thornberrys and all related titles, logo and characters are trademarks of Viacom International, Inc.

script starts slower than a television animation script. The actual plot may take ten minutes or so to really get going. But remember there is always something happening in an animation script—something to animate, whether it's fast action or gags. The audience must be constantly wondering what will happen next. That does not mean that there shouldn't be some quiet scenes in a feature where we get to know and care about the characters and their hopes and their dreams, but even quiet scenes need attitude and conflict to make them interesting. There must be an emotional component that speaks to everyone. And the story must be visual! I think the more visual your story is, the better. Don't worry about having enough dialogue. If you can tell the story better without much, do it! The story must have wonder and heart and appeal for all ages. The best features have a deeper reflection about life that we can take away with us. A feature must be fresh and original. It must be well written!

The feature may open with a sweeping panorama, a stunning visual shot that takes your breath away. Think of the eagle's flight through the western canyons and forests and out into the valleys in *Spirit*. Think of the animals gathering for the presentation of the new lion prince early in *The Lion King*. *Bambi* opened with a pan of the forest where he was born. Or instead the feature may start with a look at character, challenging us to fall in love with the rascally cast right away. Remember Scrat trying to bury his acorn in *Ice Age*? Or what about Woody coming to the rescue of Little Bo Peep in the playroom in *Toy Story* even before the main title comes on? Or there may be jeopardy right away. In *The Iron Giant* we open with the satellite spinning in space; then within two minutes we witness a horrible storm at sea with a ship in terrible trouble. In *Lilo and Stitch* we open with a teaser before the title, showing the alien scientist on trial for genetic experimentation. His creation, number 626 (Stitch), is exiled from the planet.

However a feature may start, the main characters must be introduced and the story set up within the first fifteen or twenty minutes—the sooner the better. By then we must have a hero or heroine that we can really care for. We should know who the villain is. We need to know what the story problem is, what our hero wants, and what terrible thing is going to happen if the hero doesn't get it. We must know some of the reasons that the characters are acting as they are. The catalyst has started the story rolling, and the hero has come up with a plan. At the end of Act I something happens that spins the plot around in a different direction.

The tight structure continues. In Act II new information is revealed. Midway through we may find a high point where everything seems rosy. Then the hero has a defeat or apparent defeat, starting a downward spiral toward the major crisis. There's another major twist at the end of Act II. This might be the major crisis when all hope is gone. There's the inevitable big conflict, usually a physical conflict as well as a conflict of values. But the hero makes a critical choice. He pulls through to the climax and wins! He has learned something from the whole experience, and so have we (the audience). After the hero wins, the loose ends are tied up—quickly. Subplots were covered in Chapter 7. See Chapter 15 for a good checklist to help you develop your feature film.

Selling an Original Feature

It's usually very difficult to sell an original feature animation script because of the monetary risks that companies must take in putting out so much money for something unknown.

Some writers suggest that you write a novel first and then try to sell the book for a feature. It's probably easier to sell a feature story to a smaller company willing to produce a direct-to-video or DVD feature than it is to sell to a major entertainment giant to make into a theatrical feature. But after the success of *Jimmy Neutron: Boy Genius*, there's now proof that it's possible with the right planning to produce a hit with a property that has no prior marquee value at all. For a feature pitch you'll need a fifteen- to twenty-page treatment. If you have little or no screenwriting track record, then I'd recommend that you write a good screenplay as well. The screenplay might help you get an agent; the treatment is the normal feature animation, pitching tool. You'll need higher-quality artwork than you needed for a television pitch. You'll want a wish list of actors for your cast, some musical components, and perhaps even some sample orchestrations. If you can get an agent interested in your project, it'll be easier to get pitch meetings at the major companies. If not, use any contacts in the entertainment industry that can help you get those meetings. But be sure that your pitch materials are the very best they can be first.

Feature Films Globally

The animated feature is coming into its own globally. More animated films are being released in more countries. And these films aren't always in the model of the U.S. animated film. France's *Kaena: The Prophecy* and Miyazaki's *Spirited Away* are just two of the more serious international films, unlike most of the U.S. animated films, which are likely to be comedies. Both were targeted at an older audience, teens and adults. *Les Triplettes de Belleville* appealed to adults more than children; many Japanese films have done the same. The more diverse films that do well internationally, the more diversity there will be in feature films everywhere.

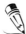 **Exercises**

1. Take the idea that you've been developing for television and develop it instead for a feature film. Remember to add a subplot. Write a treatment.

2. Do you think your feature project would make money? Why?

3. Discuss how you might make your feature project better known before you try to get financing.

4. Make a list of animated features that have been released lately. Do research on box office figures for each. Which ones were successful? Why?

5. What do you personally like to see in an animated feature? Talk to several kids. What did they like about the most recent animated films?

6. Who buys the tickets for animated films in your neighborhood? Take an informal survey.

7. How would you develop your short into a feature?

8. Make a list of animation festivals around the world that might accept the entry of an independent animated feature or an animated short. Designate which festivals will accept which (or both).

Types of Animation and Other Animation Media

Genres

Different types, or genres, of animation set up different expectations. Animation can be broken down into generally accepted categories: comedies, action/adventure stories, pre-school shows, and so on. Children watching cartoons soon learn to expect specific things in each kind of show that they watch. We learn very early in life what we like and what is more tempting to watch because it's what the older kids like.

Some of your audience will be unhappy if they watch a show because they expect it to fall into a certain category, and it disappoints them by not containing the elements of that genre. Buyers may be puzzled enough not to buy the shows that you develop! So we'll cover some of the elements of certain types of programs. But some of the very best stories will be unique and contain elements of several types, or slip neatly in between, or refuse to fit into any category at all. If they're exceptionally good stories and fresh and rewarding in their own right, they might be enormously popular on their own terms.

The Typical Children's TV Animated Cartoon

In this book when we talk about an animated TV script, we're usually referring to one for the typical, traditional children's daytime cartoon show. Most often it's a comedy. We're not referring to a prime-time animation script, which is atypical. The typical kid's animation script is very visual. It usually contains a lot of action or many visual gags—sometimes both. It tends to have less dialogue, but this varies with the current style of popular cartoon, and it varies from studio to studio and from series to series. Emotion is harder to see on a small screen, and the action must be broader in order to communicate. Also, in daytime television budget is a definite factor.

The Action/Adventure Cartoon

What is typical of the action/adventure genre? These cartoons often appeal more to boys. The action/adventure story may stem from comic books or Japanese anime. Exciting action is all-important no matter the age or gender. This genre might be more violent with hand-to-hand fighting. Does it have to be violent? It depends on the series, but I don't believe that action/adventure must always be violent as long as the action is continuous and exciting.

There's usually some comedy. For the younger audience (ages six to ten) more gags may be mixed with the action. There might be more teen angst with witty dialogue in the stories for older viewers.

Character is second to action in both age groups. This is the genre of the superhero. Villains are typically more cardboard. Heroes and heroines may be less fully developed. However a few well-written action series have proved to be extremely popular, confirming that there's a place for more fully developed characters in the action genre as well as any other so long as the action continues nonstop.

Action stories may be more serious in tone. The worlds can be complex. They often contain elements of mythology or science fiction. Internationally, action/adventure has often been harder to sell than comedy, but this genre seems to be growing in popularity worldwide.

Some structure elements stand out in the action field. This is where you're likely to find that fast-action, teaser opening. This is the place for the ticking clock, where we learn that something terrible is going to happen at a certain time if the hero doesn't save the day. These are the stories for twists and turns of the plot and multiple surprises. The hero must constantly have obstacles thrown in his way. This is the genre for the most exciting, action-packed climax.

Gag-Oriented Cartoons

The more gag-oriented cartoons are usually shorter cartoons. The plot is much less important than the pursuit of belly laughs. Many comedy writers feel that plot gets in the way of laughs and deliberately keep the stories simple, with not much more plot than funny characters trying to get out of funny situations. Internationally, children's comedy has been softer than the children's comedy in the United States.

Baby Animation

Although there has been some programming shown in the United States that is specifically targeted at babies, ages birth to three, there has traditionally been no specific market for this age group on U.S. TV. However, Israel set up the Baby Channel, targeted at this demographic. Programming is locally produced and acquired from countries like the United States, the United Kingdom, and Italy. Series introduce babies to basic concepts like animals, toys, bath time, and sleep. Programming is designed to enrich babies and develop learning and language skills. Success means more of a market for this age group.

Preschool Animation

The preschool audience is usually defined as children from two to five years of age. Programming is likely to be targeted specifically at this demographic only. Some shows like *Sesame Street* skew a little younger, and some like *Arthur* skew a little older. *Dragon Tales* had an average viewer who was four years old and a reach of ages two to seven.

It's practically impossible to get a crossover audience of older kids. Programming professionals have discovered that preschool shows have compression—that is, that viewers tend to graduate from these shows and into older programming at a younger and younger age as the show goes along. *Jay Jay and the Jet Plane* lost its audience of five- to six-year-olds. *Sesame Street*, too, has lost most of its viewers by age four. Remember that most kids don't get control of the remote until around age five or six!

Some shows also aim for a crossover audience of mothers. As for parent crossover, some experts will remind you that preschool programming is not about the parents; it's about the kids. They feel that it shouldn't matter if parents are being entertained. Parents should watch the programs with their kids because it's the right thing to do.

Of course, advertisers are more concerned about the ratings. It's harder to finance preschool programming because advertisers prefer to buy time in shows for the six to twelve age group where they'll sell more toys.

In the United States by mandate the programming must be educational or at least **prosocial**. In the United Kingdom the government has six stated goals for early learning, including personal and social relationships, communication, language, literacy and speech, math language and concepts (including shapes and colors), understanding of the world, physical development and movement, and creative development. Educational programming is not required everywhere for preschool viewers, and preschool programming from the United States and other countries with similar guidelines is often hard to sell internationally because of this. Also, internationally, shows for preschoolers may be a little more frightening and less friendly.

The educational curriculum in the United States includes learning issues and goals as a part of the development package. A need is often defined prior to developing the series, and the series is created around that learning or developmental need. Preschool program executives are expected to have an understanding of child development. Usually, a child development professional or a team of professionals from one or more universities is attached to the project before it's pitched, and they help in the creation of the series from the very beginning. In a very few cases the child development professionals are brought in after the sale of the project to help develop the series further before it goes into production. Usually the professionals are required in order to get a sale.

Whole series or individual episodes may be based on developmental issues or prosocial values like physical development, emotional development, literature, music, diversity, simple math concepts (shapes and sizes), making friends, sharing, and dealing with change. Developers should create interesting characters first and then add a curriculum. The stories should come from and out of the characters. Ideas should be fresh. What excites kids?

A balance of entertainment and educational material is needed in individual preschool episodes. If the series is too boring to kids, they won't watch. The good idea should be what drives the show; the curriculum shouldn't drive the show. The curriculum should be added to the good idea. Many programming experts would like to see more humor in the shows, but humor doesn't seem to be a requirement for many buyers, who have often disliked

slapstick comedy. It's easy to use visual humor or funny characters, but it's hard to write jokes that preschoolers will understand.

Writers for series are almost always given guidelines, and these are often extensive. Normally, writers are asked to teach only one main concept (and perhaps a couple of secondary concepts) in each episode. The concepts must be simple. Experiences in the stories should be everyday experiences. Even the smallest things are interesting to this age group. Plots must be very simple with no B-plots.

Characters should be easily relatable to kids. Create archetypes and personalities that will stand the test of time. Let the learning experience come out of the character's personalities. Empower your characters. A strong lead should be likeable and never mean in spirit. Preschool characters rarely criticize other characters. Usually, there's no real antagonist in preschool shows. Programmers don't want scary characters or too much peril. The physical universe often serves as the antagonist instead.

Let the viewers interact with the program whenever you can, and let them solve the problems. It's good to have the child viewer looking and reacting, or racing out of a chair to put a hand on the right answer on the screen. Music and song can help to pace the shows.

Think like a kid. Use wonder and magic in your ideas. Everything is new at this age. There should be no cynicism but amazement instead. TV is the window to a kid's world. Use redundancy, repetition, and familiarity. You might repeat a song (with the same words again) at the end of a show. You could repeat the episode's theme song at the end. Kids pick up more of the show's content with each repetition. Words must be easily understood. Some buyers will not allow writers to mangle words for this age group, but others allow the incorrect use of words for humor. You can define a word by its use. There are no double meanings in preschool TV. This is an opportunity to model good behavior and values. Any negative characters learn how to behave correctly by the end of the episode. These are positive shows. This programming is a safe haven for kids, a happy place, a comfort zone. The average preschool segment or story is eleven to twelve minutes in length. *Sesame Street* has portioned its show into ten-minute segments to make it easier for children under the age of two to follow.

Networks look for projects that satisfy the needs of their audience, as they perceive them. Nickelodeon has had a reputation for being cooler, more edgy. The shows there have generally been less verbal. Nick has had a more diverse audience, and the network has been sensitive to that. Disney has tended to stay away from anything that was the least bit edgy. They've been interested in ideas for series for their own characters. They've preferred a look that was unique. PBS has been more educational than Disney or Nickelodeon. PBS has looked for diverse voices in their programming. The general perception has been that moms want their children to have an educational head start before they enter school. Most networks tend to copy what is currently working on a more successful network.

Traditional buyers in the United States for preschool series have included Nickelodeon, the Disney Channel, PBS, the Learning Channel, and Discovery Kids. All have wanted programs with educational curriculum. HBO Family has also bought preschool specials and movies. The Cartoon Network has done some experimenting with preschool programming. Past programming was developed internally at Warner Bros. However, new cable channels for younger viewers have popped up internationally as well.

Pitches for new shows should be complete with a bible, artwork, and curriculum. Pitches should be simple, like the show. Pitch what's unique and fresh in that curriculum area. Pitch your great characters.

To pitch an idea for an episode of an existing television series, keep it simple. A paragraph or even a sentence may be enough. Check with your story editor. The lesson comes out of the character's personalities and out of the story.

It might be hard to break into the preschool market as a new writer with no credits. The networks often require a list of credits from their writers. Get books on child development and read them. Jean Piaget has written a great book. PBS has a website at www.pbskids.org with links to each of the websites for their preschool shows. At these show links you can find information about the curriculum and the goals of the shows. Study these. Watch preschool shows over and over. Better yet, watch with preschoolers and learn what they like and why.

Opportunities for preschool projects may be greater in home video or DVD than in series. The home video market is thriving. Video on demand is expected to be a big market. Check out video rental stores, discount stores, the local supermarket. Who are the buyers in this area? Be persistent!

Prime-Time Animation

Prime-time animation is broadcast in the evening, and it's normally targeted mainly at adults. These TV shows are hybrids between situation comedies and feature scripts, leaning more toward the sitcoms. The writers are likely to be sitcom writers rather than the usual animation writers. Budgets are much bigger, pay is much better, and there is more time to write a script. The results are more polished. The writers are normally kept on staff all year around.

Often on a prime-time series a showrunner oversees the writers. Showrunners are normally staff writers that have been promoted. They may hire the current writers and be involved in many aspects of production, including recording sessions, storyboard, and design.

Scripts for a prime-time animated show are written differently. These scripts are less visual and usually lend themselves less to classic animation techniques. The comedy is centered on the characters, who may be more realistic. Sitcoms stand out for their clever dialogue and multitude of jokes (one or more on each page).

Prime-time animation scripts are often written by committee. At some point a whole group of staff writers (seven to eighteen) sit around a table and work together. Initially, the staff may get together and brainstorm ideas for scripts. Then a writer or a team of writers might write an initial outline and/or script. On some series the staff roughs out the story and figures out the act breaks before giving it to the writer. Usually, the script comes back to the group to punch up the jokes and polish the script. The polishing process is extensive and may be 50 percent of the work. Often there is much detail and sometimes the inclusion of "in" jokes in the finished script. Scripts might run about forty to fifty-five pages in length. They're written in master scenes. On average the writers have two to three weeks to write their scripts; the team may spend another six days on the rewrite and do a second rewrite (in about three days) after the table read by the voice-over cast. Rewriting may take place after the table read, after the animatic, and again when the animation returns from overseas and is edited. The later rewrites are usually new lines that don't have to be reshot. These last changes will tend to be made because of things that are not funny after animation or seem offensive or trite (often because of the language or cultural differences overseas).

Late-Night Programming

The target demographic for these cartoons is males from eighteen to thirty-four. Edgy, irreverent comedy, adult comedy, and anime action seem to do well in this spot. In the United States the programming may be nostalgic, with the comedy playing off cartoons that the viewers once watched. Off-the-wall comedy leans toward sarcasm and irony. Cable networks allow taboo subjects, adult language, and satire. The fresh ideas may be postmodern and hip. Shows tend to be low-budget, often with limited animation produced by a tiny staff.

Interactive Games

There's a wide variety in the kinds of interactive games that use animation. There are arcade games and interactive television games. The market for wireless games is growing rapidly. There are single-player games on CD-ROMs for teens, adults, tweens, and even for preschoolers. Those for younger players are simple and mostly educational. There are games on DVDs and handheld games. Console-based games like Nintendo, Xbox, and Sony PlayStation add to the mix. There are PC and console games that come with an online component. There are a variety of websites with games for all ages, for both single players and multiplayers. Some games are played directly in the Web browser, and some are downloaded first. Some games challenge the player physically, requiring ducking, grabbing, and so forth.

There are multiplayer games for teens and adults on CD-ROMs and on the Internet. Single-session, LAN-based, multiplayer games support a maximum of sixty-four players. They begin when the players log on and end when a certain condition has been reached or the last players log off. A few session-based games like *Diablo* actually permit characters to grow and survive even though the worlds are transient.

Players can play in a persistent world that continues whether they are there or not, playing Massively Multiplayer Games (MMPs) or Massively Multiplayer Online Games (MMOGs) in competition with thousands of other players simultaneously. Many of these are Massively Multiplayer Online Role Playing Games (MMORPGs). MMPs on servers are up and running and available for play globally twenty-four hours a day, seven days a week. Originally the MMPs were text-based, but the later games like *Star Wars Galaxies* came out with sophisticated graphics. In countries with extensive broadband service MMPs are a big business. New generations of MMPs continue to come out with better graphics and more capabilities, and some are developed to appeal to a different demographic. Socialization makes them popular with adults. The fantasy role-playing MMPs are a special challenge to create and write. Players customize characters with costumes and weapons to differentiate them. The characters are guided so that in Role Playing Games (RPGs) they gain more abilities and grow more powerful, accumulating wealth and weapons, or in Strategy Games they control assets to accumulate power, wealth, and territory. Worlds are usually complex, and players travel from one end of a virtual world to the other. Research for historical accuracy for these games can be extensive.

Games must be developed with system limits and download time in mind. Early on, many games avoided first-person shooting because of the time it took to get feedback (the sound of a hit) during play. But as graphic capabilities increase, content becomes more sophisticated with greater graphic detail available to convey the fresher and less familiar concepts.

To be successful a new MMP game must grab the attention of players right away with innovative graphics and play. It's important that the game build a sense of community among the players. The worlds in MMPs are always changing. The storyline keeps evolving, altered by those players who have come and gone. Since the game doesn't stop, it never goes back to where it started. Games must be flexible enough to remain challenging to all players at all levels, no matter how they choose to play. Game design must take into account what happens when powerful players quit. Some game publishers are supporting fans as they modify game characters, environments, and even game outcomes and share their efforts with other fans. Publishers believe that this modification extends the life of their games. Many MMPs have previously been based on mythology and legend. Newer games like *The Sims Online* (a God Game) and *Toontown Online* (for kids and families) expanded into new areas.

MMPs are time-consuming to play, often taking up as much as twenty hours per week. Because of that time investment, players are likely to subscribe to only one or two titles. A game CD-ROM collects an initial retail fee plus a monthly subscription fee and can bring in more than $100 million in revenue during its lifetime. Of course, the possibilities in revenue with broader-appealing MMPs make them tempting to the large companies. The players of most single-session or multiplayer online games are primarily males from age thirteen to thirty-five.

Games are generally sold in three ways:

- The game company obtains a license from a well-known property (such as the World Wrestling Federation). Properties from merchandised characters, real people like sports figures, motion pictures, and television shows all can be licensed for game development. Game companies have been licensing blockbuster motion pictures for some time. And animated kid's shows are also popular for games. However it's only been more recently that prime-time television shows like CBS's *CSI: Crime Scene Investigation* have been licensed for game development. Motion pictures are more risky because a big-budget movie can flop and greatly lower the demand for a game in advance of the game being released. A TV show may not be as popular internationally for a game, but the show might be on the air for a long period of time, extending the life of the game and the opportunity for serial games. Wireless devices promise the likelihood of gaming subscriptions with a new episode of a game coming out each week, based on the episode that's being aired. There's also the possibility of boxed sets of the episodes being sold separately, attractive merchandising for shows with a cult following. Action adventure and mystery shows are especially appealing for gaming.

- A publisher comes up with an idea for an original game. The game publisher may hire an experienced game developer to develop the idea or farm out the project on a turnkey basis.

- A professional game developer develops a game idea for a gaming company, and the company sells the idea to a game publisher. The game company that developed the idea will be creating the game in-house.

Games are now sometimes one element of a multimedia and merchandising blitz that includes a movie, TV show, books, games, and so on. The game may be developed first, later, or simultaneously with other media.

Experienced game developers typically develop games. It's nearly impossible for the average person to come up with a game idea and pitch it somewhere. Game development requires a thorough knowledge of the game industry and the technology experience that goes with it. But if you do have that knowledge and you want to market a sophisticated title to one of the game companies, then you should do the following:

- Write down your idea.

- Prepare an easy-to-read game design document or concept proposal outlining title, genre, target platform, design interface, objectives and goals, characters, locations, story, colored pictures with the look of the game, program flow, animation lists, and sound effects. This is a sales and communication document. It may be as short as four or five pages, or it may be much longer. Document the other competitors and, most importantly, what makes your game different (and better) than any other game on the market. Remember the importance of a good story and great characters. Most players who play games want to go somewhere they've never been, be someone they aren't, and do things they could never do in real life. They want to be immersed in the world of the game. Include lots of art in your game design document. Executives need to see what the game looks like. Publishers tend to prefer games that improve gameplay and have some originality in character, story, and setting. Originality in core gameplay is risky for the publisher, and consequently a new and different *type* of game is more difficult to sell. Of course, the rewards for originality are great if your game becomes a hit. Before you develop any game, learn the demographics of the player in that genre and consider that.

- Do your research. Collect your assets. Cast by scanning bodies and heads, combining as needed; capture action with motion capture—especially fights, explosions, and other special effects; shoot photos and video from your locations for reference for your artists; gather free Internet material.

- Make an animatic. Better yet, make the game yourself. Just get something up and running to use as a demo. Keep it simple, one polished level.

- Use any connections you have at game companies, and pitch your game.

To most gamers the gameplay is more important than the story. The interactivity is very important. Gamers want to be able to control their worlds, but they want a new experience each time they play. Many older players now play games.

The Web-based PC games, played live on the Internet server with a browser or downloaded, are for the casual game player from three to ninety. The games are simpler in concept and simpler to play. They include classic card games, word games, puzzle games, and the kinds of games found in arcades. They're also simpler for the freelance game developer to produce and market himself. To be successful, these must be fun to play, simple to learn, hard to master, and habit-forming. Web-based games should be under 500 KB, or at most 1 MB. Downloadable games should be under 2 MB, or at most 4 MB. Casual gamers don't want to wait, and they don't want to read a lot of rules. Make the game easy to learn as it's played. Most gamers prefer to play the game using the mouse. Players decide their next move by looking at the screen. Their options should be obvious. Make a few hints available for better mastery of the game.

Typically, an online version that's easy to learn and whets the appetite is marketed first. Then a limited version is available for download that lacks a few of the best features. Finally, a complete version is offered with unlimited use for paying customers. Test the game on an average computer to see how it will play for the average online player.

In the future there may be more need for work by writers during the course of the initial development period. If original characters are more fully developed at that time, then the characters are less likely to change when they transfer into another medium. A motion picture company, for instance, wouldn't be able to develop franchise characters in a way that changes them forever.

Companies do hire freelance game writers. With interactive stories many alternatives must be available for the player. The writer must have the ability to look at the story from multiple perspectives and be able to keep this complex storyline moving and building in a cohesive way with the main branches eventually leading to the end. Like a maze, some of the branches may lead somewhere and some may not. What happens after each twist off the main road? A player might skip around, experiencing the story in a different sequence from another player, or miss parts of a section entirely. The world and the characters must be flexible enough to respond. The writer must make a list of essential plot points and find a way to deliver these to the player regardless of the path the player takes.

The story can't be told without the player's contribution. It's a collaboration. Often the player is a character in the story and sees what happens from that character's point of view. Player control varies from game to game. The player may choose a branching path and then watch what happens there. Or he may be able to control the action or dialogue or both. Some games allow the player to decide how much control he wants. All of these things affect the story and the way it's told.

The narrative needs to enhance gameplay, not make it more difficult. A game must hold the player's interest during repeat plays. What is the objective of the game? What does the player do? For a game to be satisfying, the player must be able to play as he chooses, and no two players will choose to play in the same way. The story must hold together in spite of it all. The player should make discoveries and gain a feeling of accomplishment as questions are answered and the story builds toward a successful resolution of the conflict.

If the player is the main character, then that character can't be developed in the traditional way. Is the player male or female? What age? The game writer won't know who the player might be, so the character must be very general. This becomes an issue if the player is the protagonist. Will the player be able to identify with such a general character? In some games the player has a chance to make some choices about the character instead. Motivation is very important to make the characters believable and interesting and, most of all, relatable. What's the point of this action, and why does the character want to move ahead?

When pace is important to the story, the developer can manipulate time by building in deadlines and penalties. If a player misses the train, he misses his next contact. If the bomb goes off, he loses fifteen minutes in his race to save the heroine.

Storytelling is both linear and nonlinear. When you're writing for interactive games, a detailed scene breakdown helps with the complexity. Index cards laid out on the floor or multiple windows open on the computer can also make the job easier. Rewriting can be very complex and difficult.

Freelance writers typically write the scripted material that's needed inside the game, not the entire game. Most writing is done for full motion video (FMV) dispersed throughout a

game. It may be written in short segments. Scripts may be written in a TV/film or animation script format, although game script formats haven't been standardized, and different companies have different formats. There is occasionally a need, as well, for a freelance writer to provide background material, a history of the world, write character biographies, flesh out character relationships, or write an introduction for a game.

Writing is also needed for character dialogue. What happens in the story? Lines are needed for multiple outcomes. In stories where the player is the main character, dialogue is extensive. Often the dialogue is in the form of questions. Dialogue may be written line by line ("Catch me if you can!"; "I can see you're a straight shooter!"; "There's a bounty on that booty!"). It's important to nail the personality of the character who's talking in the game. This writing assignment may be tagged onto the larger writing job.

Different kinds of games require different kinds of writing. For preschoolers freelance writers may script material for friendly guiding instructions, sometimes with humor. Training games might require multiple choices, often with a narrator setting up a situation.

The games based on prime-time TV shows sometimes hire the same WGA writers that write episodes for television shows. In the *Law & Order* game the player must gather evidence, hunt for clues, analyze lab results, check police files, and participate in stakeouts and interrogations. Then, as in the television show, the player takes the role of the district attorney. Storylines are complex. Players must be made to care about the characters. There's an emotional angle. These scripts may be more traditional with a preliminary treatment or outline required. However, the storyline is interactive and must be written with that in mind. A single script can run up to 700 pages. In general, games are coming out with more complex stories.

In role-playing games, like *Final Fantasy*, the writing takes place during the actual game itself. In these a game developer has to create a story that has plenty of room for action scenes, creating a world and an arena where players really want to play. The developers work closely with the design team.

Like motion pictures and television, games have ratings. These include categories for sexual content and violence in addition to maturity. There are many rating categories including several for violence alone, distinguishing between cartoon violence, fantasy violence, intense violence, and sexual violence. So consider your audience.

To get into the gaming business, familiarize yourself with a wide range of games by playing them. What makes each genre different? Study what makes them fun, entertaining, and successful.

There are many schools with gaming classes and a few with video game design or game development programs, but most of these are geared for artists rather than writers. Graduates normally start in entry-level jobs. Some companies hire entry-level game testers, who may not have an academic background in gaming.

One way to show gaming professionals what you can do is to modify an existing game, using the tools that are sometimes provided by the publishers. A good mod shows a developer that you understand game development techniques and may help you get your first job in the industry. Middleware—off-the-shelf software that game developers can use as a core for their games—will make it increasingly possible for individuals to produce games with a more polished look.

Learn to be a good storyteller. Learning and keeping up with the changing technical aspects of gaming will help you get into game development.

There are many websites that can be useful, but there are two that are exceptional: www.gamedev.net and www.gamejobs.com. You may also want to check out

www.digitalgamedeveloper.com and www.gamespot.com. Attend the Game Developers Conference that's held each spring in northern California and E3 in southern California. Check out the International Game Developers Association at www.igda.org. There are organizations for game developers all over the world. Subscribe to game magazines.

Looking for work? Yes, there are agents who handle experienced game developers. However, the average agency will not read your spec material unless an entertainment executive recommends you. When you feel you're ready, you can sniff out work yourself. Many of the game companies in the United States are in the Los Angeles area or in northern California, but there are game opportunities worldwide. Contact game publishers and find out what games they own. Call the game producers. Your best bet is to call the heads of development at smaller boutique publishers. Usually, you can talk to them directly. Game companies have not traditionally been union shops, and as a newcomer you'll probably be asked to do some preliminary writing for free in order to compete.

Some of the top game companies include Electronic Arts, Sony Computer Entertainment, Nintendo, Activision, and Vivendi Universal Games. Among the more active are Take-Two Interactive (includes TDK Mediactive), Atari, Eidos Interactive, Konami, Microsoft Games Studios, and Sega. Then there are Ubisoft, Crave, THQ, Maxis, Origin, Codemasters, Mythic, Midway Games, and Square Enix. This is a growing field, and advances in technology make the industry ever changing.

Handheld Wireless Devices

The wireless age has hit big time globally. Cell phone users everywhere will be listening to songs, motivating their exercise, reading news, watching sports highlights, entertainment, and comics, and snapping and sending photos wirelessly. In Japan one service provides a virtual girlfriend in cartoon form.

In 1997 Nokia produced a phone that allowed users to play a simple game called *Snake*. Then in 1999 the I-mode was introduced in Japan, allowing customers to send and receive data and pictures over their mobile phones. By 2001 an upgrade allowed games to be downloaded and run on the phone's memory. Soon after, Nokia prepared to launch a real-time TV phone in Europe. Cell phones in Asia were able to play forty seconds of animation by 2004. Graphics improved, and services were scheduled to provide daily comic strips for cell phones in the United States.

Games are a big part of the wireless revolution. Handheld games can be played on the run. They tend to be popular with subway commuters, travelers, people who have to wait in lines, teens. Typically, games are played for no more than ten minutes at a time.

Phones can access the Internet and play simple games with online opponents or download games like Bowling for users to play offline. Bowling became so popular at one large U.S. corporation that it was banned from play during meetings. Some of television's most popular game shows are now available on mobile phones. However, with increasing power and faster connection speeds the capabilities of wireless gaming continue to grow, and MMOGs have wireless versions. Location-Based Gaming (LBG) allows players to play scenarios based on their geographic locale. Some emphasize collecting and trading. Inter-media games are developing combining television and wireless.

To design wireless games, keep the technology in mind. Often the games use the phone's up, down, left, right, and OK buttons. The games should probably remain simple and easy

to understand for fast, on-the-fly play. Many games strive to build community. You want to tantalize the user into playing your game. Games with incentives like prizes are likely to become more popular. During and after development, games must undergo an extensive testing process to take out bugs and be sure that they will work on multiple-size screens and with multiple phones. Developers should have drawing ability and be able to write for the multiple platforms that are out there. They need to know the requirements of each phone company. As with any technology, it's constantly changing. Check out *Wireless Gaming Review* at http://wgamer.com/devicedir for information about new phones.

The Internet and Assorted Multimedia

Most people who are able to draw and write and want to create something original immediately think of the Internet. Some people are pitching scripts on the Internet both on sites specifically for that purpose and on their own sites. Some writers use the Internet to promote their talents.

It's entirely possible to have your own short animated series running regularly on your own website. The Vancouver-produced series *Broken Saints* won a number of awards including the Sundance Online Film Festival Viewers Award. The episodes were animated in anime style graphics with objects that appeared and disappeared on screen. The series used music and film-style effects to produce a new Internet experience. Interactive elements will allow storytellers to create stories with multiple paths more like games.

You can create a series, animate it with Flash, develop a list of people who might be interested in seeing your series, and e-mail your list each time a new episode is ready. Many artist/writers are doing just that. Unfortunately, even the most extensive list of interested friends and prospective buyers is unlikely to bring a lot of traffic to your website. Games and daily updates help. If your site is popular, that can mean spending more money to handle the number of visitors. Some artists take advertisements on their site. Some sell merchandise. Others have relied on viewer donations and on benefits to raise the money for their art. A successful series can be released on DVD, sold as a comic strip, book, game, or as a subscriber series. Internet shorts have been popular with Europeans and with South Americans, as well as with viewers in the United States.

The Internet is not yet secure, and it's probably not a good idea to leave even copyrighted work out there unless you're prepared for the possibility that it might be stolen. Internationally, it's not possible to prosecute copyright violations.

If you have a Flash or Quicktime cartoon finished, there are also websites that will show the cartoon. Some will actually pay you for the privilege, but the fee will probably be small. Usually, you must sign a contract authorizing the website to publish your work. Some sites grant you the right to publish elsewhere as well. The average demographic of these sites is age fifteen to forty, mostly male. Viewers are primarily students and office workers. Think mental vacation. Viewers want to be entertained. Most animation sites want cutting-edge material that's cool, hip, irreverent, funny, fresh, and fun. Material that can't be shown on broadcast TV is usually popular. Comedy, great characters, good stories, and compelling animation work best. Keep the style simple. Clarify what you want to say and keep up the quality. Some sites take popular material to other mediums. Because of download time, 500KB and less has been the preferred size for many sites. You'll need to learn to work

with the technology, making detailed storyboards to plan shots and transitions. Check out sites like WB Online, AtomFilms, Urban Entertainment, Mondo Media, and Homestarrunner.com. Some sites allow you to submit material directly to the site. If there are rules, those rules are posted. Usually, agents aren't required for submission.

Another area for animation writers and developers is the kids' sites like Disney, Nickelodeon, Noggin, and Kids WB! Much of this material is either created in-house or by smaller companies like Unbound Studios that have experience in this area.

Few writers can make a living by writing animation for the Internet alone, but the Internet holds promise in the future not only for a full-time occupation but as a part of the rainbow of possibilities in freelance writing.

Writers are also needed for corporate intranets, museum kiosks, and interactive television like Web-TV (which allows you to watch the Internet and TV at the same time). They're needed for training multimedia, references like encyclopedias, and so forth.

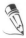 **Exercises**

1. Write a script for an established animated show. Write this script in a different genre than that of the original project you completed earlier. Research the established show by first watching it and then finding out more about it on the Internet.

2. Develop a preschool series. Work with someone (or better yet a team) in the field of child development, perhaps from a local university.

3. Develop an idea for a prime-time animated series.

4. Write a prime-time animation script.

5. Watch a late-night animated series for adults. Analyze the stories. Are these series more like daytime cartoons or prime-time shows? In what ways?

6. Make a comparative analysis of at least three different animated television or game genres. How do those differences affect the writing? Think about it, and go beyond what is in this book.

7. Buy or rent a current best-selling game. Play it and analyze it. What makes it fun to play? How difficult is it? What don't you like about it? How could you make the story better? How could you make the game itself more fun to play, keeping in mind the current technology? How can you take it further than the game developer already has?

8. Do research on different game genres and analyze what makes them different. Why does the typical game player of each play that kind of game?

9. Research the game industry.

10. Develop a game for a game console, CD-ROM, or the Internet. Before you do, analyze the successful games that are already in that category. What made them successful? What features do they have? Who plays that kind of game, and what are they looking for? What makes your game different and better?

11. If you produce a game for your own website, can you think of any new ways of obtaining income from your game?

12. Research the gaming and Internet laws internationally, especially in China, Greece, Australia, and Brazil. How might these laws affect your Internet game?

13. What's your opinion about violence in games where you're the first person shooter? What have the studies found? Do you personally think that playing these games often can change someone's personality? Why? And if so, under what circumstances?

14. Develop a game for interactive television. What are the current technological restraints?

15. Research the wireless industry and its special gaming challenges.

Marketing

Introduction

A generalized guide to marketing follows. Markets and events come and go; they change dates and locations from year to year. The industry changes. Marketing strategies vary. Each country has its own unique marketing opportunities.

Major U.S. Networks

Television network programming routines seem to be in a constant state of flux these days. Broadcasters buy a year or two ahead and develop shows all year around. It's always easier to sell a project that's similar to one that's just been successful than to sell a fresh idea, although broadcasters say they're looking for something new. The U.S. networks now have their own production arms, and some programming is coming from these production companies. Some of the networks have experimented with outsourcing their entire season's children's schedule to a single entity. So in the United States, you may want to consider pitching projects to these production companies instead of pitching directly to the networks themselves.

- August—traditionally the networks' busiest month, with everything coming in for the new fall season, scripts, storyboards, completed episodes, and so on. Occasionally, a network will launch its fall programs early to get a jump on everyone else, an August launch. Today programs might launch anytime during the year.

- October—programmers with an early fall season get an idea of what's working and what's not after the season's launch. This is the classic start of development season.

- December–February—the traditional, prime buying periods. Conventional thinking put off buying as late as possible to see what was happening in the marketplace, how shows at their own network and others were doing, and what hot trends were appearing. Now many programmers realize that hurrying the development and production

of shows at the last minute isn't always in their best interest because they don't get the best product if it's rushed. Also, if programs are bought far ahead, then purchases might be made anytime, not just during this prime season.

Cable and Syndication

In the United States there are other places to market television programming as well. TV series can sometimes be pitched to distributors or to station groups. But you'll probably pitch instead to independent animation production companies who in turn sell to networks, cable companies, or distributors. Or the independent companies will sell market-by-market and station-by-station at TV business markets set up for that purpose.

A few of the larger and more important markets include NATPE (held in the United States around January), MIP-TV (Cannes in the spring, less important than MIPCOM and MIPCOM Jr.), Cartoon Forum (designed to obtain television financing for Europeans, held somewhere in Europe each fall), and MIPCOM and MIPCOM Jr. (Cannes in the fall). Events like World Summit on Media for Children (Europe in the spring), Cartoons on the Bay (Positano in the spring), Licensing International (New York in late spring), and the international animation festivals also attract cartoon buyers.

If you attend one of the major markets like MIP or MIPCOM, there are strategies you can use. Schedule your appointments well before the event, as most buyers will be booked prior to the event. The larger markets are hectic, with many meetings crammed into a short period of time. If the buyer you've contacted is already booked, ask if there's someone else who might meet with you. Don't overschedule. Be well prepared. Research who buys what for each channel. *Animation Magazine*, *Kidscreen*, or *AWN* online can help you with that. Do lots of networking wherever you are. Get to know the buyers. At trade shows market yourself, but don't interrupt meetings in progress; wait quietly nearby for a chance to say "hello" and leave a business card. Some people recommend that you do research on who is looking for what at the major trade shows, asking questions and looking at what is available and who is buying it, rather than try to pitch when buyers are busy. Many professionals use the markets early in the year, like NATPE, to do their homework and begin to set up relationships. Then sellers make appointments to pitch or close the sale at the buyer's office or at one of the later markets, like MIP. Let the buyers get to know you briefly. Then pitch on paper after the show or pitch in the buyer's office. Another way is to pitch at one of the smaller festivals or conferences that are slower paced, such as Banff or Cartoons on the Bay. At the festivals meet buyers casually as fellow fans and let your conversation lead naturally into the pitch.

DVD and Video

DVDs and direct-to-video product often provide what's in short supply in the network TV market. This may be soft or educational material for a young audience. Also, DVDs and videos can be a profitable ancillary market to features, books, or games. In the United States Focus on Video (an entertainment software show) is held in the fall, and the Video Software Dealers Association (VSDA) holds a convention, usually in Las Vegas in July.

Marketing experts suggest that you consider your market from the earliest stages of development. Differentiate your project. Define your potential customers, find them, and go

after them. Videos can be sold on a website, but most feel that a distributor is necessary. Do your homework to discover who distributes what. In the United States stores like Wal-Mart, Target, and Best Buy sell the most DVDs. Even your local grocery store can sell your product. The Amazon Advantage Program accepts online applications for VHS or DVD titles.

Independent Theatrical Features and Shorts

Independent films are marketed many different ways. Prerelease publicity, promotion, and merchandising can help to build an audience for a film. A book about the making of a film may help. A game developed at the same time as the film and released just before or at the same time as the film can help to build an audience as well. Independents might obtain publicity, and possibly distribution, by posting dailies on a website. International markets, like the American Film Market (held in California) and MIFED (based in Milan), serve as a meeting place for those buying and selling films.

Filmmakers might try for awards at the festivals or at least nomination publicity. Independents and students can screen films at festivals like Sundance, Annecy, Ottawa, Toronto, or Hiroshima to win awards and attract the interest of distributors. Students might also enter in competitions for animated student films like those at the Academy of Television Arts and Sciences or the Academy of Motion Picture Arts and Sciences in the United States.

Games and Interactive

Original animation is also marketed for computer software, games, CD ROMS, and DVDs. The Game Developers Conference is held in San Jose, California, in the spring. The Australian Game Developers Conference takes place in December in Australia, COMDEX (a major computer show) is usually held spring and fall in the United States, E3 (games) sets up an expo in the spring in the United States, the VSDA Conference (home entertainment) is held in the summer in the United States, and the Children's Interactive Expo (multimedia) takes place in the United States in the fall.

Wireless and the Internet

Wireless is growing fast. In the United States Jamdat and Handango are two of the biggest wireless content distributors, obtaining content from development partners. You can become a partner of one or more publisher/distributors. To join the Handango Software Partner Program, go to the website for more information. The Handango site lists the games of their partners, and partnership allows access to international distribution channels.

The World's Smallest Film Festival accepts short animations and digital films, three minutes in length or less, meeting their criteria for mobile devices. Go to www.bigdigit.com/splash for more information.

See *Animation Magazine* or *AWN* online for lists of festivals for promoting your Internet short. These sources also list contact information for most of the markets listed. Gaming on the Internet is profitable and growing. Yahoo! has sponsored an Internet online film

festival in the United States in the spring. Web Marketing World is held in the United States in the fall.

Books, Comic Books, and Greeting Cards

Book festivals are held all over the world, and you can make contacts there. Comic-Con, the largest comic book expo in the world, takes place each July in San Diego, California. Many development executives attend in search of their next project. If you have an original character, contact individual greeting card companies about using your character on cards.

Toy Companies and Licensing Companies

Toy companies are unlikely to buy your idea; licensing companies might. The American International Toy Fair held in New York, the British International Toy and Hobby Fair held in London, and the Nuremberg Toy Fair take place in the winter. Licensing International takes place in New York in the late spring, and the Brand Licensing Show sets up in London in the fall. L.A. Office Roadshow, for marketing and promotional tie-ins, is held in the United States in the fall.

Licensees and retailers have become much more cautious recently. For economic reasons there is tremendous pressure for instant success. Toy companies may prefer to market something retro that has less risk. And in this global marketplace multicultural properties have increased in visibility. In the United States toy store sales profits have dropped because of price-cutting by the large discount stores. Shelf space has shrunk because some retailers went out of business and others consolidated into large chains. Some toy companies are developing their own private labels, or they're trying to get exclusive deals. Toy companies have been burned on licensing deals for animated feature films, as many of the products have not moved nearly as well as the toy companies and retailers had anticipated. Also, animated films take two to three years to produce, and what was popular when the film was first developed may not be popular when the film is released. So with all these risks in mind, the licensees may want to see in advance what support the producing studio will provide in the way of movie sequels, TV series, direct-to-video releases, books, games, and websites. Animation also competes for licensing deals with sports, fashion, music, video games, and adult TV. However, occasionally a toy company will pick up international rights to a really hot, new animation property prior to a U.S. network deal.

If a toy company is the one to initiate a TV show for one of its toys, the company may start development eighteen to twenty months ahead of release of its toy product. And the toy will probably be on the market before the TV show launches.

What Can You Do?

What can you do to promote your characters and your original concept to build marquee value? First of all, copyright your idea and your characters. And register your trademarks. Registering a copyright in the United States costs about $30; trademarks can be registered

for around $325. Remember that ideas can be stolen on the Internet. Even if you have copy-right protection, it's impossible to police much of the world.

Send press releases to the trades. Send out releases on any awards that you might win. Offer to write stories about your pitching experiences, production process, or anything else that might be of interest. Editors look for fun, first-person stories. Keep your company history, show notes, artwork, a bio, and photo of yourself and your project ready to give to the press.

You can offer to volunteer your services to the children's wards at the local hospitals. You might take your original artwork and weave a spell as a storyteller as you show your artwork to the kids. Or record your script using voice-over actors and contribute the CD to those children's wards. Have character costumes made and visit the hospitals in costume.

Volunteer your costumed characters for events at the local schools. Offer your costumed characters for local small business events (like openings) or church events or health fairs or festivals.

Sell the rights to use your characters for time-specific, local advertising. Sell limited rights for the use of your characters for merchandise (mugs, T-shirts, etc.). Of course, you should be careful that any contracts you sign would not interfere with the later sale of those characters for a TV series or feature.

Publish your own children's book with your original characters and story. It's difficult to get booksellers to distribute a self-published book, but you might be able to get some local distribution. Certainly you can donate the book to hospitals and other children's organizations. Try distributing it to pediatricians and to children's dentists. And just having the book in hand should help your pitch when you pitch your series for television.

Does your project lend itself to a self-produced video? The first *Baby Einstein* video was shot in a home basement. *Veggie Tales* was first sold out of a spare bedroom and a website. Pitch your project to publishers as a children's book. Pitch it as a comic book or a syndicated comic strip. Sell original artwork from your project. Try selling your characters for greeting cards. Pitch them for flags. Pitch your characters as plush toys. Plush toys are easier to pitch than action figures. They don't require expensive molds; they're unlikely to cause injuries; they take less time to get from idea to the shelves of toy stores. Give away a game as shareware, selling upgrades, new levels, and new characters. Sell your merchandise over the Internet. Come up with more merchandising ideas of your own!

International Marketing and Co-productions

Marketing opportunities are growing internationally. Many programmers like Cartoon Network, Disney, Fox Kids, and Nickelodeon have programming offices around the world to beam their product to an international audience. Most of these companies employ area development people who buy some original series or make acquisitions locally to broadcast along with the programming that comes from the United States. Internationally, networks in many countries have programming and development staffs that may be eager for local programming. Additionally, animation suppliers worldwide buy and sell internationally and enter into co-productions with international partners who can help with financing and distribution. Of course, it helps in getting financing for international co-productions if you have a commitment from a U.S. network first, but this may not be possible.

In the United States companies are buying anime from Japan and editing and reassembling the existing animation into a new story, better suited to a child audience, and then rerecording in English for the U.S. market. Perhaps other countries will take the opportunity to make foreign programming more suitable for their local needs.

Other Marketing Opportunities

You as an animation writer have an opportunity to make relationships that might help you market your project anytime and anywhere animation people congregate. Screenwriting contests offer a chance to get your original project read. Writer's conferences and writing consultants offer more marketing help. Be creative. Any way that works and doesn't make you enemies in the process is fair game!

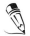 **Exercises**

1. Evaluate your idea or project for marketing potential. Is it unique? Do others beside your closest friends and relatives react favorably? Evaluate the potential of the look, the story, and the themes of your project. Is there nostalgia involved? Superheroes? Does your project have an educational component? Will viewers or parents be likely to want to buy toys or merchandise? What kind of toys or merchandise? Why? What will appeal to them?

2. Can you think of other ways to market an original project? Discuss these in class.

3. Research general marketing techniques in a library or on the Internet.

4. Discuss in class the marketing of the most current animated series or feature. What seemed to work? What could have been done better?

5. Check into companies that buy original animation in your own area.

6. Research the established ways of marketing animation in your area.

7. What do you think will most interest buyers, distributors, or an audience in your project? Why? How can you make that work for you?

8. Make a marketing plan for your own original project.

CHAPTER 19

The Pitch

Do Your Homework

Before you pitch your project, do your homework. If you're not familiar with animation companies, make a list from the credits of a video or series. Or, better yet, get a directory. You can find a directory online at AWN or buy a directory from *Animation Magazine*. Know what each company has on the air or out in the marketplace and, if possible, what they're looking for now. Find out a little about the executive that you'll be pitching. What does this decision maker like? If this is a network, study their current children's programming schedule printed in the newspaper or *TV Guide*. If this is a production company, find out what kind of animation they've produced. Consider the style and content. Ask around. If possible go to selling markets like NATPE. Attend animation seminars and events where programming and development executives speak. Do research on the Internet by searching for the company and their executives. Check out the archives at AWN. Or research at the library (*The Hollywood Reporter, Daily Variety, Animation Magazine, Kidscreen, Animatoon*).

When you call a company to set up a meeting and you don't yet know who is in charge, ask for Animation Development. Stand up as you phone so that you have more energy. Spend a couple of minutes getting to know the assistant who is the gatekeeper. Be prepared with a logline pitch. Sound enthusiastic about your idea. The assistant is probably very busy, so don't get longwinded, but she can give you valuable information, and she can help you get an appointment. Get to know her, and treat her courteously! If you're new at this, you may have to call several times until you convince her that you're a professional and deserve the time. If you have no agent, then you might want to hire an entertainment attorney to avoid signing a release form for your project. (See the information about agents.) Remember that companies always need good, new material. Call once a month, but don't be a pest! Try to make your appointment with the head of the company or the person in charge of development, if you can. You may be stuck with the lowest executive on the totem pole, but that's okay. The only difference is that the lowest executive must pitch your project all the way up the ladder. The best pitch times are probably midmorning. The executive should be awake, not yet hungry because he hasn't had lunch, not sleepy because he just had lunch, or eager to get out of the office!

309

Rehearse

Rehearse your pitch, but don't memorize it. If you have a partner, it helps to pitch together. Get your presentation down solid with the timing just right. If you can practice with a camcorder, do it. Stand if you wish. Hook your audience. Be passionate. Think of yourself as a storyteller. Your entire meeting will likely run twenty minutes or less. Some experts recommend that intriguing pitches be kept under two minutes and that the whole meeting be kept to ten or fifteen minutes maximum.

Start your series pitch with title, genre, and brief concept. Pitch the essence of your concept first. Think of a commercial. Pitch the goal of the hero in the series. Why do we have sympathy for him, what danger is he in, and how does he always win? Pitch your most colorful character caught up in the events and conflicts of your concept and its arena. Pitch the characters and their relationships, not what happens. What makes your characters interesting and unique? Pitch a character's main one or two traits and his conflicting trait. Talk about the villain. He's usually interesting. Find the element that people can relate to, and pitch that.

Sell the executives with your concept and pitch. Never tell them what they or the audience will like. Don't map out a merchandising or business plan. That's their job.

Be prepared to pitch your best and most complete idea first. Have a maximum of three or four shorter, less complete ideas ready as well. If the buyers aren't interested in your main idea, you don't want to waste this opportunity. These secondary ideas can be as short as a logline. Allow time for questions after the pitch, and be well prepared to answer them. An agent may or may not go to the pitch with you.

If you're pitching a script, pitch title, genre, hero, why we should root for him, and the danger he's in. Bullet points only! Stick to the essence. Be clear. Do not pitch individual scenes in a story. Tease, tantalize, leave the executives wanting more.

Coming In for the Pitch

Dress as you would for any business meeting—nothing distracting. A neutral color is probably better than hot pink. Look neat and well groomed. Don't eat garlic or onions just before your pitch!

Bring in a few things for a series pitch. First, you need a professional-looking bible complete with artwork for your pitch. The average length is five to ten pages. Bibles that are too long tend to get put aside for later and forgotten. Bring in larger artwork on cards that are easy to see as you pitch. Six to twenty-four cards are about the right number. Bring in a small prop or a gimmick if you can find one that really represents your project well and helps in visualizing it. Don't bring in too much. Costumes are too much, as is a keyboard. This isn't *Phantom of the Opera*. Keep it simple!

Your project is a gift! Be confident. When you arrive, make eye contact with the executive. There may be more than one. Go in with high energy, and keep it throughout the pitch. Shake hands firmly, but otherwise keep your hands to yourself. During the pitch, don't give the executives any reason to say "no."

First you might want to relax the executive by showing an interest in her. This is where that research about the executive comes in handy. You might ask a question that has to do with your project to get her involved. But do *not* start with a joke. Be relaxed, open, and outgoing. Keep this introductory part of the pitch very short. Development executives are extremely busy.

The Pitch

Tell the buyer the name of the script and the genre. Give him your agent's name, if you have one. Keep eye contact throughout your pitch. If there is more than one executive, some experts advise that you pitch mainly to one person. Hook the executives with your best idea first. Excite them! Keep your pitch entertaining. Put on your best acting and storytelling performance. Use your hands to gesture; use your face. Executives are more likely to buy an idea that is fun for them, too. Pitch in the style of the series or story you're trying to sell. If it's a comedy, pitch the fun of that series or story. Try to connect emotionally.

Maybe the buyer didn't think she needed a project like yours before you arrived, but make sure that she needs it before you leave. Don't give too much information. The more you say about a project, the more reasons someone might find to reject it. Do be prepared to pitch three or four brief episode ideas, if you're asked. Adjust your pitch to the interest level. Change your tone of voice to wake up lagging interest. If you're told that the company already has a similar idea in development, stop immediately and go on to the next idea. Don't pitch more than three or four ideas. Let the executive know that the pitch is over by asking her if she'd like to read the series bible or if she has any questions.

When your pitch is over, let the executive talk. Be prepared to answer questions like these:

- What's the basic concept? (The logline version.)

- Who's the star?

- Who's the main villain?

- Why is your series or story different? What's the twist? What's the hook? Why is your project exciting?

- How does this relate to the child viewer? Why will she like the series or story? How do the characters relate to her? Why does she care about your star?

Can they work with you? They are judging you. You don't want to do or say anything that will give a negative impression. Be honest, be positive, and go with the flow. If you don't know the answer to a question, say so. Tell the development executive that you're not prepared to answer that question right now. You can call back with the answer. If an executive interrupts you with a new idea about your project during the pitch, go with that. Even if they hand you something entirely different, run with it and don't look back. An idea that a development executive just gives away is an idea that she wants to buy. Fight for what's important to you, but be willing to make changes. There will be many changes during development.

Hand the executive a copy of your bible as you leave. Thank her for her time.

After the Pitch

The next day you may want to send a thank you letter. Thank the executive for her time. Reinforce any major selling point. Answer any question that you were unable to answer at the meeting. I know one writer who encloses (or leaves behind) a stamped postcard with the title of the project, his name as developer, and a line that mentions that this project was

pitched to that company on that date. There is a line for a signature. He feels that this gives him added protection. Others might feel that this is too negative.

Continue to work on new ideas. Give yourself a year to pitch your old project before dropping it. Keep up your contacts for the next pitch. E-mail or call about once a month or so (never more often) to touch base. Take someone to lunch if you wish. Or send out a regular (or irregular) newsletter letting people know what you're doing professionally. Projects get sold most often through long-term relationships.

Other Pitching and Selling Opportunities

A number of other opportunities exist to pitch your project or make a script available to companies that might be interested. First, let me say that there are a lot of scams out there. So if you choose to pitch in one of the following ways, do check out these opportunities *very* carefully first.

Screenwriting expos often have contests that allow you to pitch your project to a list of available producers or development executives. There are also organizations that conduct regular pitching sessions. For a fee you can attend a luncheon or other meeting where decision makers are available to meet and to hear the short pitches of the attendees.

Then there are companies on the Internet that promise writers help in getting their scripts read by those who might buy. These companies list scripts for free or for a fee. Some charge a finder's fee if the script is sold in addition to the listing charge. These companies deal mostly with live-action scripts.

It's possible to make the right contacts in these ways, but it is also possible to waste your money or risk losing your idea. I would recommend setting up meetings and making a traditional pitch, if it's at all feasible.

Student Projects

As a student you may have to pitch your project to a teacher or someone who is going to help you with financing. Does your project fit the guidelines set for the class? Can you obtain financing? Do you have plans to repay the loan, if necessary? Are safeguards in place so that the funds are used wisely and you won't run out before the project is finished? Is your project practical to do? Can you do it in the required time? Is the necessary equipment available when you need to use it? Do you have production plans, and are you able to get the necessary help? If you want to use this project as a calling card to the industry, is the subject matter something that industry people will want to watch? Is this the kind of project that the industry sells? Are you able to do a professional job, or would it be better to do something less ambitious that will have a more professional look? Is this the type of film that is likely to win awards in festivals? Would it be popular in contests? Carefully think your project through! You may want to include the answers to some of these questions in your pitch.

 Exercises

1. Develop a pitch for a project that's already on the air, and practice the pitch at home.

2. Sponsor an evening panel of animation professionals to give pitching tips.

3. Rehearse pitching with a partner. Is this easier than pitching by yourself?

4. Practice pitching in class. Videotape the pitches, if possible, so those in the hot seat can see themselves as others see them. Discuss the pitches in class, giving suggestions for improvement.

5. Invite animation professionals to class to hear your practice pitches and give you tips.

6. Research places to pitch your project.

7. Think of other ways you might find buyers to pitch your project. Discuss in class.

8. Rehearse your pitch for your own original project.

Agents, Networking, and Finding Work

Writing a Sample Script

Before you can write for an animated television cartoon, you have to write a sample script to submit to the story editor of that show. This is not a script that will be sold. Try surfing online to find an actual animation script in the genre you're writing so that you can use it as a template. Write your sample script for a show that's similar to the show you want to pitch. Or if you want to write for a specific show, ask the story editor of that show what kind of sample script he wants to see. Do not write a sample for the same show you want to pitch because the story editor will know that show too well; and he'll see only the script's flaws. You may be able to get work with only one sample script, but it's better to have several: a sample for a sitcom like *The Simpsons*, for a half-hour action/adventure, for a seven minute squash and stretch comedy, and for any other animation genre that interests you. What's most important is that your sample script is fresh and exciting. This is not the time to break the rules. The story editor wants to see if you *know* the rules. When your sample script is ready, contact the story editor you want to pitch to and ask if you can submit a sample of your writing. Be sure it's your very best! Add a colorful script cover. You can submit a copy of your sample script to an animation agent as well, but an agent is not a must to find work.

Looking for Work

Networking is very important in the animation industry. Because the industry is relatively small and writers must do quality work quickly, many story editors hire only writers they know. Join animation organizations like ASIFA and Women In Animation. Go to animation events where you might meet animation writers and story editors. Go to seminars and workshops and introduce yourself to the writers and story editors there. The important thing is

to get your name out there and repeated over and over again. Check out animation-related websites. Many animation writers have their own website, and you can e-mail them there. Just remember that good writers may be extremely busy with tight deadlines, so be brief and to the point when you ask for advice. A few professional writers have been forced to use pest control!

Agents and Managers

There are animation agents who represent animation writers. But even if you obtain an agent, you will still need to look for work on your own. Most agents are not eager to take writer-developers with no track record. And even if they do, they prefer to spend their valuable time finding work for those who can provide a better monetary return on their time. Many working animation writers have no agents at all. Most story editors will read your sample script without an agent. However it's difficult to get development people to look at an original project without an agent or entertainment attorney. Contact the Animation Caucus of the Writers Guild of America, in west Los Angeles, for a list of agents who handle writers. This is a list of all literary agents, not just those that represent animation writers. An entertainment lawyer will submit scripts for you if you wish to hire them for that purpose, and they'll negotiate any resulting contracts. But be sure you contact only entertainment lawyers so that they know the industry. Without either an agent or an entertainment lawyer, you may be asked to sign a release form, giving up some of your rights. Companies are in mortal fear of being sued!

Other Suggestions

You should be immersed in the animation medium so that you know instinctively what sounds right and what doesn't. Watch cartoons on television, and go to see the latest animated films. Rent animation at your video store. Get to really know the current series on TV. In order to write convincingly, you need to know those characters so well that you know exactly what they would do at any given time. Read entertainment magazines like *Animation Magazine*, *The AWN Spotlight*, AWN's *Animation Flash*, *The Hollywood Reporter*, *Daily Variety*, and *Kidscreen* so that you know what's happening in the animation industry, who's buying what and why, what series are popular with the kids.

When you watch cartoons on TV, make a list of the writers, story editors, and producers for each series. The story editors are the ones who will hire you. Producers can also give you an "in." Every second Tuesday *The Hollywood Reporter* publishes a list of production companies and the series that are in production. This listing includes TV animation series with credits for the series' producers and story editors. If you don't subscribe to *The Hollywood Reporter*, you may be able to find it at the library. Often the listing is out of date, but this gives you a starting point in your job hunt. Call these companies and ask for the story editor you find listed. If that story editor is not available at that company, try to talk to another. Remember that today most writers and story editors in the United States are freelancers and work at home, moving often between companies.

Ask any story editor that you contact if you can send them a sample script and if they're accepting ideas for premises (written for free) for their series. Ask them to send you a bible

of the series they're working on, a script from the series, and a few sample premises. Over-worked story editors have tight deadlines, so keep it very brief. Keep a card file on each story editor. List their latest series and any other series they've edited. From articles you've read and from talking to them, list what they like and dislike and any useful personal information that will be helpful in conversation when you talk to them again.

If you're pitching your own original projects to development people around town, keep a card file on development executives as well. You'll eventually meet a lot of story editors and development people, and you won't remember it all when you need it later. Then write and keep writing each day.

Take the time out from your writing to promote yourself and what you're doing. Be creative. Be funny. Be different in your promotional efforts so you stand out. Keep up those contacts, and don't be afraid to use them; just remember to keep it brief. Make friends with the assistant who answers the call. They can often help you get through the gate. Calling once a month or every couple of months is probably okay; calling every day is definitely counterproductive. Better yet, e-mail or write, send out funny promotional material. Eventually, story editors will start referring you to other story editors who are currently looking for material.

When you get that first assignment, write exactly what that story editor wants and needs. Ask! And always, always turn in your assignment on time.

The process sounds difficult and it is, but new writers break in all the time. You just need to be good . . . and fast . . . and most of all persistent!

Consider looking for work internationally as well. Many U.S. writers do much of their writing by e-mail for companies overseas. Contact companies outside of the United States. There's a huge market out there for U.S. animation writers. Send sample scripts, credits, and so on. If you don't live in the United States, be sure to contact local networks and production companies in your search for work.

Whether your employers are around the world or down the street, keep up your contacts. Get your own website. List credits, a bio, awards, and make sample scripts available there. Add a photo. Send out a periodic e-mail newsletter. Include helpful information along with the self-promotion, but keep it short. Call your contacts occasionally in order to establish a more personal relationship. Talk pets and family. Send flowers. Take them to lunch. Keep up the networking. Try to meet your international contacts at trade events or on business trips. Think of your writing as an international business. You are the person responsible for business development. For a freelance writer, taking the time to look for work is an important part of your career.

 Exercises

1. Watch cartoons. Start an index card on each writer, story editor, and development person you find. Normally, development people are not listed in the credits. How will you find out more about them?

2. Write a sample script. Be fresh. Make it the very best you can. Write in a different genre from what you already have.

3. Research animation agents and compile the class results. Make up a directory that can be photocopied and handed out in class.

4. What are networks and production companies buying today? Do some research on the Internet or in the library.

5. Invite an animation writer or a development executive to speak to your class.

6. Join an animation organization like ASIFA (worldwide) or Women in Animation.

7. Check out AWN. Join in some of the discussion forums.

8. Conduct a class discussion about the most popular animation series in your area. Can you see international trends? Where are these programs being produced? Animation seems to cycle in employment opportunities. How is it doing currently? How can you make a living during the down cycles?

CHAPTER 21

Children's Media

What Do Parents Want for Their Kids?

All parents want the best for their kids. Theoretically, the best entertainment inspires, educates, entertains, and helps our kids to grow all at once. It helps children to understand themselves and others and learn about the world around them. Children's programming must give our children the best in role models while never assuming that all children are the same and need the same role models. It needs to provide something for all ages but not encourage kids to grow up too fast. It must never be boring but stimulating, action packed, fascinating, and reassuring. It should provide kids with an emotional experience but never be too frightening or too violent. That's a very tall order!

The problem is that government regulators and broadcasters sometimes try to do too much. Yes, we should develop and write the very best programming that we can—always—but all programming can't be all things to every child. The tendency is to have a clinical outbreak of a single type of programming, with each program trying to accomplish the same thing while getting top ratings to boot. Then when ratings fall, networks move on to the next flavor of the month. The key is in providing a *variety* of programming. Children are different, and different children need different experiences in their entertainment. All children benefit from exposure to a wide variety of experiences.

What Do Kids Want?

Kids want and deserve to be entertained. That's simple! Life today is very stressful, even for kids. In some countries and in many urban neighborhoods mere survival is an issue. Educational programming is a good idea, but sometimes it's not entertaining. Like adults, children need some time to kick back. That does not mean that all children's media should do nothing but entertain. When parents and children alike are given more of a choice, children's needs are served.

None of us likes the same thing over and over again. But kids demand "cutting edge" only if the media creates that demand. What is new and different to a child may merely be

retro to an adult. Children do *not* require "cutting edge" programming. There is much that has been done before that will be new to them in content and style. What they require is creative programming and good programming. And what is "cutting edge" to an adult might not be appropriate for a child. Children need to go through the stages of childhood. "Creative," "fresh," and "good quality" are wanted at any age. Variety is the key.

Fads will always come and go, but the more the media latches onto a fad, the faster we all get tired of it, and the sooner it dies. Younger children will always look to older children in picking up new trends, so fads tend to trickle down. Those that watch trends point out that because of the Internet, trends today can come and go before TV programming, games, and toys can catch up.

The Perceptions of Adults

Television is losing viewers at an alarming rate. There are many reasons: the proliferation of choices in media, the fact that there are more working mothers and more children who are not available to sit and watch TV, more opportunities for sports and organized activities, more homework. If girls, specifically, abandon animation at a certain age, it's because the animation that's being developed doesn't appeal to them. Maybe the likes and dislikes of girls should be more carefully considered. And if boys buy more toys at a certain age than girls, perhaps that's because the toy makers are making more toys that appeal to boys than to girls. Neither toys nor animation belong to one sex or the other.

Animation is like the Field of Dreams. Build it, promote it, and chances are they will come . . . if it's appealing and if it's good. But an audience in any media that's been away for a while might need some coaxing to come back.

Violence and Other Bad Influences

Do we want our children to retain some innocence? Yes. Do we want them to become too cynical too soon? Of course not! Too much violence, too much sex, too much of anything can be harmful to kids. Broadcasters have Standards and Practices departments for those reasons. In prime time great numbers of kids watch the programming that was developed for adults. And although children's viewing habits should be monitored by their parents, we know that even good parents are not always around. We can't protect kids from all that's bad for them either, or they won't be able to handle real life. We need to use a little common sense. There's not much that will hurt a child in moderation. Watching a couple of violent programs will not harm a normal child. Watching nothing but violent programming or spending most of every day playing violent video games where the player is the shooter is not a good idea for any child.

The Responsibility of Writers, Program Developers, and Media Distributors

Children do learn by example. The world that kids primarily experience in real life and in their entertainment is the world that we're likely to have tomorrow. Entertainment is

extremely powerful! We must provide the very best! We need to develop media that stimulates and educates as well as media that does not. We should inspire kids to open a book, surf the Internet, and talk to other kids about the ideas and information we present. We need to show children that laughter feels good and makes any problem seem smaller.

In this huge world we live in, how can we get children to interconnect? How will we get children to realize that there are other children out there who may think differently about many things but who are basically the same as they are? How can we bring them closer together so that tomorrow is more peaceful than today?

A few years ago I traveled to a country where the struggling poor lived in makeshift villages that circled the major cities. While I was at my hotel in the capital, I watched cartoons. I had previously worked on one. As I left the city on a bus, hundreds of temporary, one-room dwellings constructed of tin, found wood, or cardboard lined the main road. There was no running water or sewage system, but there was plenty of mud. I was amazed to see that a wire had been tapped into the power lines along the highway and strung to one of the tin shacks, where a TV antenna proudly topped the roof. Undoubtedly, inside streams of children giggled at cartoons. As animation writers, you are writing for *all* kids around the globe.

We have a diverse world of children—and, yes, adults—to provide with the finest media we can create. Our audience needs to learn and to grow just as we do. They deserve to be inspired. They want to lose themselves in a story until they cry, and they're entitled to laugh until they roll on the floor! That's the challenge, and that's the fun!

Glossary

acts Animation scripts are usually written in two or three acts or sections. The acts for half-hour television scripts most commonly end before a commercial break, so these scripts should contain some suspense just before the act break to entice the audience to return.

ADR Automated dialogue replacement. Recorded dialogue that had poor original quality or new dialogue that was needed after the original recording session.

angle The camera shot. "ANGLE ON HOMER" would refer to a shot of Homer. The exact visual image here is unspecified and left to the discretion of the storyboard person. "CLOSE SHOT OF HOMER" is more specific.

animatic A series of storyboard panels or other drawings scanned or filmed together with sound to approximate the finished cartoon. This is a video or film storyboard that helps in testing story and timing before more time and money are spent. It may be used as a marketing tool.

anime Japanese animation.

antagonist The person that opposes the protagonist. Usually, that person is a villain.

antic Anticipate.

A-plot The main storyline. Often an action plot revolving around the goal of the protagonist.

arena A place or setting (the south, the circus).

backend The ancillary market, like merchandising.

back to Return to the previous scene or character.

beat outline This is a more detailed telling of the story than the premise, breaking it down into numbered scenes (beats). It is less detailed and shorter than the final script. This is a narrative description of the action, scene by scene, with many of the gags, a few of the camera angles, and a sprinkling of dialogue indicated. It's a plan or blueprint of the script.

beats (A) A breakdown of the scenes in a script. (B) A breakdown of the major action points of an individual scene. (C) Short pauses. Indicates timing in a script.

behavioral tags Repeated actions that are specific to a character, like repeatedly twirling a lock of hair.

BG (or b.g.) Background.

bible An animation bible includes most of the information about a series. There are two kinds of bibles. The first is a presentation bible, a sales tool, that includes a brief description of the show and its universe, format, the main characters and their relationships, and some very brief episode springboards, plus artwork showing characters and typical scenes from the show. A writer's bible is a more complete description of the show, designed to cover all the details for the show's writers. It includes a complete backstory of the series with myths or legends, detailed rules of the series universe, and descriptions of the main locations. Each character is described thoroughly. Usually, there's a drawing of each. If episodes have already been aired, a brief description of each episode may also be included.

B-plot A secondary or subplot that must eventually tie into the main plot. This may be a plot revolving around the villain or another character. This plot may be character-driven, as opposed to action-driven.

breakdowns (A) Animation is broken down by the animators, who do the key or most important drawings first. (B) Scripts are broken down into elements.

button The laugh line that ends a typical cartoon scene.

capper The gag that ends a sequence of related gags. It's the funniest gag and often includes a twist.

catalyst The person or thing from the outside that starts the story going. It's the reason for the rest of the story. It's the inciting incident.

cels Transparent sheets of cellulose acetate or similar plastic. Animated drawings were traditionally inked or photocopied onto cels during the animation process. These cels were then painted on the reverse side before being photographed by the camera.

central question This is the question that will be raised in our minds in the opening setup and answered at the climax. Will the Scooby gang solve the mystery?

character arc The learning curve of a character as seen over the course of the story. The changes that take place in the inner character.

click track The recording of the beat of the music. Animators need this information on their X-sheets in order to animate to music.

climax The part of the story where the action reaches its most intense moments. This is where the protagonist wins. Everything else in the story leads up to this.

close-up (CU) We are close to the subject. A head shot or a partial shot of the face. Most often the shot includes the tops of the character's shoulders as well. Precisely what the shot covers varies somewhat; there is no exact standard.

color models Colored drawings of the characters and the effects used in a production, detailing all the color codes used. These models may be painted on a cel, or they may be found in the computer files of the production.

compositing Putting the visual parts of each frame together (drawings, special effects, etc.). This may involve field and color correction for the best possible picture.

concept The idea for a series or film, as yet undeveloped.

CONT (cont. or cont'd) Continued. Dialogue or action continues from one script or storyboard page, scene, or panel to the next. Dialogue blocks should not be broken from page to page in a script but kept to one page or the other.

content What a film, television series, video, game, and so on is about. The story. This includes character relationships, theme, genre, and plot.

context The makeup of a project. This includes length, demographic group of intended audience, type of animation used, and so forth.

critical choice The difficult choice that the protagonist must make near the end of the story. The dilemma. The ultimate decision, whether to go after the treasure chest as it's about to wash over the falls, or whether to abandon the quest and save the best friend who will otherwise drown. This critical choice ideally happens at the major crisis.

crosscutting Parallel action is shown by cutting alternately between shots of two or more scenes.

cross dissolves (X or X-DISS) Overlaps of a fade out and a fade in to gain the effect of one scene gradually being replaced by the other. The X stands for a V (fade out) followed by a Λ (fade in). They're used, primarily, to indicate a change of time. Sometimes they're called lap dissolves or overlapping dissolves. Too many cross dissolves are distracting (and expensive in traditional animation).

cut (A) Ending one scene and starting another without any visual transitional devices. Cuts are used to indicate to the audience a change of view or location but not necessarily of time. (In a script, it's not necessary to type CUT TO after each scene. It's assumed that the transition is a cut unless you specify otherwise.) (B) Cutting one piece of film and joining it to another.

dailies The day's work on a film, animated and available for viewing.

demographics The statistical audience makeup for a specific entertainment production. Demographics are available on age, number of males vs. females, income level, and so on.

development Taking a basic idea and fleshing it out into a television series, film, or other project that's ready to begin production.

development deal This is a legal agreement with a network or production company to develop a TV series or film. The company usually pays for a bible, artwork, and a pilot.

dialogue block The words that make up one speech of a character.

dialogue tag Words or pet phrases that are unique to one character.

digitized Scanned. A drawing, painting, or photograph can be scanned into a computer for further processing by the computer. Sculpture can be digitized in 3D by laser.

dissolve (DISS) One image overlaps the other as it changes from one scene to the next. This often indicates a passage of time. A dissolve slows the pace of the action.

Dutch tilt A shot that is tilted diagonally so the audience feels uneasy. Used especially for suspense and mystery.

edgy A concept that is on the edge, fresh and *sharp*, rather than soft. (*The Simpsons* was edgy when it first aired. *Sesame Street* is soft.)

effects (EFX) (A) Camera or animation effects (rain, explosions, flames, etc., as opposed to character animation). (B) Sound effects (SFX).

establishing shots (EST. SHOTS) Screen images that orient the audience to locale, number, position, and physical relation of characters to each other. These are wide shots, showing the background. Used in opening and when there's a change of locale.

exposition Any information that the writers tell the audience to help them in understanding the story, the characters, and their motivations. Instead, writers should show what the audience needs to know through action and conflict.

EXT Exterior.

extreme close-up (ECU or XCU) Often a partial shot of the face.

extreme long shot (XLS or ELS) A vast area seen from a distance. Used to show the huge scope of a setting or event. It may be an establishing shot.

fade in (Λ) Exposing each frame of film with the camera or printer aperture becoming progressively wider, from 0 percent exposure (black) to 100 percent (full). A fade in is used to indicate to the audience the beginning of an idea or sequence or the start of the story.

fade out (V) Reversing the above: from 100 percent exposure to 0 percent exposure. It's used to indicate to the audience the end of an idea or sequence. And it's used at the end of the story. A normal fade out is twenty-four frames if the action is slow, thirty-two frames if there's plenty of animation and more time is needed.

favoring This shot description tells the board artist that although the shot includes more than one character, one character is primary and should be the focal point of the shot.

FG (or f.g.) Foreground.

field The area of the scene on a field chart that holds the action—usually a six field to a twelve field for traditional animation. Field size is almost unlimited in computer animation. Field charts help to compose a shot properly for the viewing screen. Not all screens are the same.

flash cut (or flash frame) This is an effect used for lightning or gunshots. It can be as short as a single frame.

flowchart A chart illustrating the overall sequence or steps in navigation or structure for complex interactive writing. Writers for games often provide flowcharts as well as scripts.

focus groups Viewers brought in for the purpose of research and the testing of concepts.

Foley effects Sound effects that are recorded live in post-production to sync with the animation.

footage Length of film or video based on a measurement of feet. This term originated with the amount of film stock that went through the camera during production.

format A television show's format includes context and content.

frames Individual exposures or images on a film or video reel. One second equals twenty-four frames of film or thirty frames of video.

fright take Big reaction, terrified.

full shots Views of the entire character.

gags Jokes. In cartoons these are most often visual jokes.

game plan A character's plan of action for reaching his goal.

genre The type of a project such as comedy, action/adventure, mystery, sci-fi, and so on.

high angle (HA) A bird's-eye view. Looking down. A down shot.

high-concept A highly commercial story with a hook that can be communicated in a few sentences (*Muppet Babies*, *Teletubbies*, *Spiderman*).

holds A character is still for a few frames. This can be done in traditional animation by holding the cel in place in front of the camera for several frames. However, in computer animation a hold tends to look like the VCR is on freeze frame. So a digital character is kept moving slightly (a moving hold) by shifting weight, moving an arm, blinking, and so on.

hook The concept that makes someone want to buy a project. An idea that's instantly recognized as being fresh and profitable.

I & P Ink and paint.

INT Interior.

intercut To cut back and forth between locations.

interstitials Shorts that are aired between other shows. Sometimes these are educational.

joke pass The staff writers of a prime-time animated series get together after a story is roughed out and work on the gags, adding more, making those that are already there funnier, and deleting those that don't work.

jump cut A shot that appears to jump, caused by a quick cut in time. Characters can seem to fly to new positions.

lead writer In prime-time animation the main credited writer of an episode. The lead writer writes the first draft outline and script.

limited animation Animation that does not move as fully as the average animation does. Cels can be held for multiple frames. Parts of the body can be placed on separate cels to save drawing and coloring costs. Some of the action can be staged off screen. Limited animation saves money.

lip-sync Animating the mouth to match the previously recorded dialogue or song. Animated dialogue is usually seen (about two or three frames) before it's heard.

logline A powerful description of a project or story told in twenty-five words or less, as you would see it in a *TV Guide* listing. The best loglines include the title, genre, hero, and goal. Used in pitching.

long shots (LS) These take in the entire area of action. They may be establishing shots.

low angle (LA) An upshot. A worm's-eye view.

major crisis This is the worst thing that could happen to the protagonist, the dark before the dawn. Everything seems to be falling apart. It looks like the protagonist will not only lose his goal but that the reverse will happen.

manga Japanese graphic novels. The demographic for manga is broad and includes adults. Subject matter covers almost anything.

master scenes These scenes are indicated by a main location and time of day *only*. No specific shots. (Typical script slug line for a master scene: EXT. THE CASTLE—DAY.) Most TV animation scripts list the camera shots, so the writer is for all practical purposes the director as well. Features and CGI scripts are generally written in master scenes with the storyboard artists adding the other shots when they do the board.

master shot The shot of the entire scene, covering all dialogue and action in the widest and longest shot that's practical, so the action and space relationships are understandable.

match dissolve A scene transition. An element from the first scene is lined up and matched visually to another element in the next scene. A pretty young girl in one scene becomes an old witch in the next. Position in scene is the same.

medium close-up (MCU) (A) Upper torso and head shot. (B) Close-up with the top and bottom of the head cut off.

medium long shot (MLS) Covers the character's full length but does not show the setting in its entirety.

medium shot (MS or M shot) The definition is not precise. Halfway between an establishing shot and a close-up. Or a full-figure shot.

milk To get the most out of a gag.

modeling Translating a design into a 3D model that can be animated. Models can be built in a computer several ways (using patches, polygons, NURBS, etc.).

montages Series of very short, related clips edited into a whole. These can show passage of time or background.

motivations What drives a character and makes him do what he does.

ninety-degree rotation The camera is turned ninety degrees to the right or to the left so that an east/west (horizontal) pan will appear to be an up and down pan (north/south or vertical pan). The camera can rotate clockwise or counterclockwise. A ninety-degree rotation is a change of location, but not time.

omit (or omitted) Scene previously there has been deleted.

one-shot (1-shot) One person on the screen.

option A buyer pays a fee for exclusive rights for a property for a specific length of time.

origin An origin story is a backstory. This is an episode depicting the origins of a series and its characters and sets up the format.

OS (or o.s.) Off stage.

OSL Off stage left (actor's left when facing the audience).

OSR Off stage right (actor's right when facing the audience).

OTS Over the shoulder.

outline A plan or blueprint. (A) In cartoons this is a more detailed telling of the story than the premise. It is less detailed and shorter than the final script. This is a narrative description of the action with scenes, gags, a sprinkling of dialogue, and usually a few camera angles indicated. (B) In multimedia an outline is used instead to describe the content of a website.

overlays (OL or OLAY) Levels that go on top of other levels, giving dimension (such as a bush that's in front of the animated characters). In traditional animation overlays are inked, photocopied, or pasted onto cels.

over-the-shoulder (OTS) The camera or viewer is positioned to look over the shoulder of a character to see the action.

package More than one creative element of a project is already in place, such as a writer and a popular actor for the voice of the main character in a feature.

pan shots Pan stands for panorama view. Panning is a change in location, not in time. In traditional animation the background moves but the camera does not. If the BG is panned to the right we seem to be moving to the left, and vice versa. Suns and moons are avoided in the BG, as pan BGs are often used in cycles that repeat! In traditional animation, panning and trucking at the same time are difficult for the camera. Forty-eight inches is the average pan BG length.

pass (A) The polite way buyers have of saying they don't want to buy your series, script, or idea for an episode. (B) In traditional animation the artwork may take multiple exposures, or passes, of the camera to get special effects like ghosts, mist, and so on.

payoff A gag has its payoff or completion after being carefully set up. The payoff brings the laugh.

pencil tests A series of animation drawings in pencil, filmed or videotaped, and projected to see how well the animation works.

pilot The first episode or partial episode that's written for a series. This may be a sales tool.

pinscreens Screens with hundreds or thousands of retractable pins, lit from two sides. Frame by frame certain pins can be retracted or partially retracted to shorten the shadows and lighten an area to change the image.

plot The skeletal storyline. The writer's choice of events and their placement in time.

plot point Each important milestone in your plot.

plussing Adding to the project. Making it better.

polish A small and, usually, last revision of a script. Freelance writers are normally expected to complete a first draft, revision, and polish of their commissioned script.

POV Point of view.

praxinoscope An early device to simulate motion, patented in 1877, using a colored strip of paper on the inside of a rotating cylinder. Similar to the zoetrope. Invented by Emile Reynaud in France.

premise (A) A brief summary of a TV episode idea, usually about a page in length. It normally includes all the plot points. Its purpose is to sell the story. (B) What a story is about, the idea, notion, or concept that inspired you.

presentation The verbal or written pitch to sell a project. The written presentation for an animated series is the presentation bible.

prosocial Programming that teaches good social skills such as sharing, independence, and listening.

protagonist The main character that drives a story forward. This term is used interchangeably in this book with star, hero, or heroine because it's the star or hero that normally drives an animation story, making the hard choices. Strictly speaking, a protagonist is not always a hero in all stories, and a hero is not always the protagonist. The catalyst that actually starts a story moving may be the antagonist rather than the protagonist, especially in a mystery.

punch line The one-line payoff of a joke. The funny part. The surprise.

push in The camera moves closer to the artwork. A truck-in.

read rewrite In prime-time animation the rewrite that's done after the table read.

rendering The computer data for each scene is processed into images for viewing during the production process or for final output.

repeat pan (R pan) A background that has identical images on each end. It repeats in a cycle.

resolution After the climax, we learn the details of how the story ends. The resolution should be wrapped up quickly.

retakes When animation production is complete, the producers and executives view the product to check for quality. Any mistakes are fixed before it's shot or rendered again.

reverse angle The opposite view.

rigging Adding a skeleton to the model in CGI animation so that it can be animated more easily.

RV Reverse view.

SA or S/A Same as or same action.

sample script (A) The script that freelance writers provide to help them get a job in TV cartoons. This is not a script that will be sold. This script is written exactly as if the writer was writing an episode of an existing series. The sample script is never an episode of the same series that the writer is pitching to sell his services. (B) An average script from a series, used by the writer to craft his own script.

SC Scene.

scenes Units of the script. Each scene contains a single event or conversation between characters that takes place during one period of time and in one single place and moves the story forward toward a climax and resolution.

screen directions These are camera shots listed in the script (such as ESTABLISHING SHOT OF THEME PARK, CU ON MARY). Screen directions are written in all capital letters.

script package A deal in which a writer is guaranteed a certain number of scripts.

slug line The line that introduces each scene. The slug line includes whether the scene is an exterior or interior, the location, and the time of day. It's written in caps (such as INTE-RIOR HAUNTED HOUSE—MIDNIGHT).

soft A concept that tends to be more cuddly and younger as opposed to being more edgy and older. *Strawberry Shortcake* as opposed to *South Park*.

spec animation script A script written on speculation in hopes of getting it sold afterward.

spine The spine is the driving force. Each character has a driving force, an unchanging essence of that person that drives his entire life (to be secure). This is different from the character's arc, which changes during the course of the story. Actors often work from the spine of a character. A story also has a spine, an all-encompassing driving force that drives everyone in the story.

springboards Short, one-paragraph premises. They tell the basics of each story with a beginning, middle, and end. They include the main characters in the story, what the protagonist wants and the theme, if there is one.

staging A scene is staged so that the design is pleasing. The characters are posed in a way that the action is clear to the audience even in silhouette.

stinger The sharp point or climax of a joke. The laugh line that ends a typical cartoon scene.

story arcs The paths and changes that take place from the beginning of the story until the end.

storyboard The script in visual form with the dialogue underneath the artwork. This is the first visualization of the story showing all camera shots, and it's what the production crew will use to complete the project.

story dynamics The different patterns of change present in a story at any one time.

story editor The person who is responsible for obtaining the scripts for the series. Story editors often help develop the series, hire freelance writers, and help the writers complete a workable script for each episode of the series. Sometimes story editors will write some episodes themselves.

storylines The plot of a particular story or episode. The premise.

story summary In multimedia the narrative treatment for the story. This is sometimes called a walkthrough.

table polish In prime-time animation the final polishing of the script by the writing staff. Producers are in attendance.

table read In prime-time animation the actors sit around a table prior to the recording session to read through the script. Based on notes from the table read, another rewrite is done afterward. The table read is especially important for feedback on the jokes.

tag (A) A short ending to a story. In a comedy this is often an ending gag. (B) The description given to each character when they first appear in the script. This tag itself is not written in caps, but the character name is listed in caps at this first appearance *only*.

take (A) To look away from a person or object, then suddenly turn back. (B) A sequence of recording without a stop.

thaumatrope A device with a card or disk containing pictures on either side that appear to blend into one when the device is twirled.

theme A timeless truth. The values expressed, the lesson that the protagonist learns, the central message of the story. Forgiveness wins out over revenge. Not all cartoons have a theme, but many do. A feature animation script almost always has a theme.

three-shot (3-shot) Three people on the screen.

ticking clock A story device that puts the audience on the edge of their seats. We learn that something terrible and often life-threatening will surely happen at a specific time if the hero doesn't take action to save the day before then.

tilt field Camera turned at an angle.

timing A film is timed to best tell the story in a specific format (short, feature, etc.). A scene is timed for mood and pace. Animation timing is normally fast. An action can be perceived in just a few frames. Comedy and gags require fast timing in order to be funny. Action is also paced quickly. Animation timing is all-important. Some directors time their animation to a metronome or to music.

treatment (A) A narrative description of a story including a description of major characters and most of the scenes. Similar to a beat outline. A TV cartoon normally goes from premise to outline to script. A feature script normally goes from treatment to script. The feature animation treatment is often written as a pitching tool and may be identical to a live-action treatment. (B) In multimedia, the narrative treatment describes the key elements and structure of a project in narrative form.

truck-ins or truck-outs In traditional animation the camera moves as though on a truck. The art does not move, but the camera does. If the camera trucks in (or toward) an image, we seem to be moving toward it, and vice versa. Trucks make something significant—the audience will be involved. The speed of a truck has meaning; quick trucks give an emotional jolt. Trucks indicate a change in location, not time. (For the traditional camera, panning and trucking at the same time can be technically difficult. A five field is the smallest field that should be used in trucking down; a six field is better. There are 120 moves from a six field to a twelve field, and they should be exposed in multiples of eight or four for the camera. Computer trucks are almost unlimited.)

turnaround time The length of time you have to write your story from assignment to deadline.

turning point A major reversal or twist in the action usually appears at the ends of Act I and Act II. Something happens to spin the action around in another direction.

TV cutoff A picture is broadcast uniformly, but not all TV sets pick it up and project it the same. Some of the edges may be lost on some sets in the process. TV cutoff is an arbitrary average of loss for the artist to compose his picture within. Field guides are available on cel so that artists can compose important parts of the drawing within the area that will always be seen.

tween Age between being a child and a teen. Starts between ages eight and eleven. Ends several years later when a child is truly a teen. Girls may go through this stage as much as two years before the average boy. Kids this age consider many things as babyish, but they may not be ready for rebellion and sexuality.

twist A turn in the plot or story elements. A surprise.

two-shot (2-shot) Two people on the screen.

underlays (UL) Levels that go under or in back of the main characters (such as the railing of a ship that the characters are leaning on).

VOD Video on demand.

voice-over (VO) (A) The character's voice is heard, but he isn't physically present at that location at that time. He may be narrating. We may be listening to his thoughts. The character is not merely off screen or off stage (OS) nearby beyond the view of the camera. (B) The recorded voice of a character.

walkthrough In multimedia this is the treatment, written in narrative form. It's a description of the story and the main interactive features.

walla Background hubbub in a scene, as from a group of people talking, reacting.

wide Expanding the shot and what we see.

wipes Scenes seem to wipe off a predecessor and wipe themselves on. These are a transition of place. In traditional animation these are done in camera. In CGI they're completed on the computer. They can be done left to right or right to left. They can be replaced by zip pans or cross dissolves.

wire frame The framework of a CGI model.

worm's-eye view Low angle. The camera is looking up at the shot.

WS Wide shot.

xerox (A) The photographic process of transferring a drawing onto a cel. (B) In traditional animation the department where the animation drawings are photocopied onto cels.

zip The character anticipates an exit, then holds. But instead of animating out, the artist takes the character off with sound effects and smoke or dust animation on screen to create the impression of the character having exited so fast that our eyes couldn't follow the action.

zoetrope An early device, using a moving cylinder with drawings inside, to simulate motion. Similar to the praxinoscope. A succession of slits acts like a shutter on a projector. This "wheel of life" was the forerunner of the motion picture. Invented in 1834 by George Horner.

zoom The camera pulls in or pushes back. In traditional animation this is a physical move of the camera, not just a movement of the lens.

Index